Teaching and Evaluating Music Performance at University

Fresh perspectives on teaching and evaluating music performance in higher education are offered in this book. One-to-one pedagogy and Western art music, once default positions of instrumental teaching, are giving way to a range of approaches that seek to engage with the challenges of the music industry and higher education sector funding models of the twenty-first century. Many of these approaches – formal, informal, semi-autonomous, notated, using improvisation or aleatory principles, incorporating new technology – are discussed here. Chapters also consider the evolution of the student, play as a medium for learning, reflective essay writing, multimodal performance, interactivity and assessment criteria.

The contributors to this edited volume are lecturer-practitioners – choristers, instrumentalists, producers and technologists who ground their research in real-life situations. The perspectives extend to the challenges of professional development programs and in several chapters incorporate the experiences of students.

Grounded in the latest music education research, the book surveys a contemporary landscape where all types of musical expression are valued; not just those of the conservatory model of decades past. This volume will provide ideas and spark debate for anyone teaching and evaluating music performance in higher education.

John Encarnacao lectures in music at Western Sydney University, Australia. His book, *Punk Aesthetics and New Folk* (2013/2016), is an alternate history of popular music argued through the analysis of recordings that span the period 1926–2011. He has also published essays on Throbbing Gristle, Courtney Barnett and Angela Carter. As a guitarist, singer, songwriter, composer and improviser he has some 30 releases to his credit.

Diana Blom, Associate Professor of Music at Western Sydney University, has published on higher education music performance and preparing new music for performance. She is co-author (with Matthew Hindson and Damien Barbler) of *Music Composition Toolbox* (2007). A composer and keyboard player, she has co-curated several CDs for release.

ISME Global Perspectives in Music Education Series

Senior Editor: Margaret Barrett

Leadership and Musician Development in Higher Music Education
Edited by Dawn Bennett, Jennifer Rowley and Patrick Schmidt

Leadership in Pedagogy and Curriculum in Higher Music Education
Edited by Jennifer Rowley, Dawn Bennett and Patrick Schmidt

Teaching and Evaluating Music Performance at University:
Beyond the Conservatory Model
Edited by John Encarnacao and Diana Blom

Teaching and Evaluating Music Performance at University

Beyond the Conservatory Model

Edited by John Encarnacao and Diana Blom

Routledge
Taylor & Francis Group

LONDON AND NEW YORK

First published 2020
by Routledge
2 Park Square, Milton Park, Abingdon, Oxon OX14 4RN

and by Routledge
52 Vanderbilt Avenue, New York, NY 10017

Routledge is an imprint of the Taylor & Francis Group, an informa business

British Library Cataloguing-in-Publication Data
A catalogue record for this book is available from the British Library

Library of Congress Cataloging-in-Publication Data
Names: Encarnacao, John, editor. | Blom, Diana, 1947- editor.
Title: Teaching and evaluating music performance at university : beyond the conservatory model / [edited by] John Encarnacao and Diana Blom.
Description: [1.] | New York : Routledge, 2020. |
Series: ISME global perspectives | Includes index. |
Identifiers: LCCN 2020001301 (print) | LCCN 2020001302 (ebook) |
ISBN 9781138505919 (hardback) | ISBN 9780429328077 (ebook)
Subjects: LCSH: Music in universities and colleges. | Music–Instruction and study–Evaluation.
Classification: LCC MT18 .T35 2020 (print) | LCC MT18 (ebook) |
DDC 780.71/1–dc23
LC record available at https://lccn.loc.gov/2020001301
LC ebook record available at https://lccn.loc.gov/2020001302

ISBN: 978-1-138-50591-9 (hbk)
ISBN: 978-0-429-32807-7 (ebk)

Typeset in Times New Roman
by Swales & Willis, Exeter, Devon, UK

Contents

Figures

Tables

Contributors

Adrian Barr completed his PhD thesis *Transcendent experiences in experimental popular music* in 2013. The project combines self-reflective research with phenomenological interviews with experimental popular music practitioners about the significance of the "transcendent" in their music-making practice. He has since honed his skills in creative practice, improvisation, collaboration, technology and transformation, applying them to digital strategy, product management and design thinking within Musica Viva Australia and the NSW Department of Education. Adrian is a strong advocate for music education for all ages. He is currently enjoying the discovery and playfulness of improvisation with his young family.

Diana Blom, composer and keyboard player (piano, harpsichord, toy piano), has published on higher education music performance and higher education popular songwriters, the artist as academic and preparing new music for performance. She has co-curated several composition/performance/CD projects including: *Shadows and Silhouettes – new music for solo piano with a Western-Chinese confluence*; *Antarctica – new music for piano and/or toy piano*; and *Multiple Keyboards – new music for pianos, toy pianos*. Scores and CDs are published by Wirripang Pty. Ltd., Orpheus Music and Wai-te-Ata Press. *Music Composition Toolbox*, a co-authored composition textbook, was published in 2007. Diana is Associate Professor of Music at Western Sydney University.

Monica Brooks is a piano-focused musician, composer and improviser hailing from the Blue Mountains west of Sydney, Australia. During her B.Mus at Western Sydney University, Brooks studied non-traditional music-making practices such as computer-based performance and free improvisation. Brooks has used improvisation as a base method for composition, as well as a key approach when working with larger groups. This includes current and former projects for solo piano, Great Waitress ensemble, Electronic Resonance Korps (the ERK), West Head Project and choral ensembles such as Broads to Men. Over the last few years, various projects have allowed her to perform at festivals and spaces such as Music Unlimited (Wels), All Ears (Oslo), Taipei Contemporary Arts Centre (Taipei), Café Oto (London),

Göteborgs Kunsthall (Gothenburg), Bergen Kunsthall (Bergen), Vivid (Sydney), iiii Festival (Wellington), MONA FOMA (Hobart), Ausland (Berlin) and Festival of Slow Music (Ballarat).

Glen Carruthers has been Dean of Music at Wilfrid Laurier University (Canada) since 2010. He was formerly Dean of Music at Brandon University (Canada) and Chair of Music at Lakehead University (Canada). He has presented conference papers and lectures in 18 countries and has published widely in the fields of musicology and tertiary music education. His articles have appeared in such journals as the *Musical Times, Music Review, Journal of Musicology, International Journal of Music Education* and *Arts and Humanities in Higher Education*. Carruthers is a contributor to several books in English, German, French and Japanese including, most recently, the *Oxford Handbook of Community Music*. He was Chair of the ISME Commission on the Education of the Professional Musician 2012–14, was named an honorary member of the Canadian University Music Society in 2016, and received the Canadian Association of Fine Arts Deans Academic Leadership Award in 2018.

Naomi Cooper is a freelance musician and academic based in Sydney, Australia. She recently graduated with a Doctor of Philosophy which investigates the practice of community choir directors in Australia. Her current research interests include teaching and learning practices within community choirs and community choir traditions within the Estonian diaspora in Australia. Naomi currently directs a number of primary school, secondary school and community choirs and has worked as a sessional academic for vocal studies, choir, music analysis and popular music studies at Macquarie University and Western Sydney University. Naomi also trained as a classical and contemporary guitarist and performs regularly in solo and ensemble contexts.

John Encarnacao is a guitarist, singer, songwriter and improviser with some 30 releases as an artist under his own name or with groups including The Nature Strip, Warmer, Espadrille, π (with Jon Drummond), Love and Death (with Nic Dalton) and Smelly Tongues. His book, *Punk Aesthetics and New Folk* (2013 and 2016), is an alternate history of popular music based on the ubiquity of "punk aesthetics", argued through the analysis of recordings that span the period 1926–2011. He has also published essays on Throbbing Gristle, Courtney Barnett, Robyn Hitchcock and Angela Carter. He lectures in music at Western Sydney University, Australia.

Diane Hughes is an Associate Professor in Vocal Studies and Music at Macquarie University. She has an extensive background in popular singing pedagogy. Her work within the industry has involved artist development and recording. Diane's research interests include vocal artistry, pedagogy, recording and performance; current research includes industry and singing, emotion and voice, the singer-songwriter, cultural musicology and recording processes. Research on singing in schools led her to become an advocate for the

development of cross-curriculum voice studies in school education. In 2014, Diane received an Australian Office of Learning and Teaching Citation for an outstanding contribution to facilitating student engagement and learning through the design of innovative contemporary music curricula. Her contributions more broadly have also been recognised with an Outstanding Professional Service Award from the NSW Professional Teachers' Council (2014) and a National Certificate of Recognition from the Australian National Association of Teachers of Singing (2018).

Lotte Latukefu is Head of Performing Arts at Excelsia College, Sydney, Australia. Prior to that she lectured in the Faculty of Creative Arts at the University of Wollongong for 18 years. She studied at the Canberra School of Music, Queensland Conservatorium of Music, Manhattan School of Music and University of Wollongong where she completed her PhD. In 2015 she undertook a Research Fellowship at the Royal Northern College of Music (RNCM). Recent and current research includes collaborative learning, practice-led research in music, and socio-cultural approaches to teaching and learning singing at tertiary level.

Eleanor McPhee has been an instrumental teacher and ensemble director for 20 years and was awarded, in 2014, her PhD in music from Western Sydney University for her investigation into the ways that instrumental teachers learn to teach. This thesis was awarded the Australian Society for Music Education Callaway Doctoral Award, presented on a biennial basis to the best doctoral thesis from an Australian university in the area of music education. Eleanor has taught into various areas of music skills and performance at the University of Wollongong, the Sydney Conservatorium of Music and Western Sydney University and, most recently, was the National Education Content Manager for Musica Viva Australia where she developed the new schools touring show for TaikOz. When not performing and teaching, Eleanor helps to organise the *Honk! Oz Festival of Street Music* which recently completed its fifth year in Wollongong.

Annie Mitchell is an Associate Professor in Southern Cross University's Contemporary Music Program and national award-winning teacher of theory, musicianship, musicology, composition/arranging, education, ensemble and piano. Her research includes pedagogy, community music, adult education, edutourism and musical careers on cruise ships. Annie is double bassist in three orchestras and pianist in big bands.

Brendan Smyly is an academic and musician who maintains interests in various fields of inquiry and performance. His PhD thesis presented an oral history of an infamous rock music venue in Sydney, and instigated a refreshing look at the social and cultural underpinnings that supported the formation and distribution of independent music in the city at the time. Smyly's performance career has spanned several decades, appearing as a saxophonist and singer in a wide variety of genres and an even wider variety of venues. His work

includes mainstream TV and radio appearances, as well as work in more out-lying contemporary contexts, with field-recording-based compositions and electro-acoustic improvisations being a current focus. Smyly teaches music performance, sound technologies and musicology at Western Sydney University.

Ian Stevenson is a specialist in the field of audible design with over 30 years of experience as an audio engineer, producer, artist, educator and researcher. He is currently senior lecturer in music and sound design at the University of Technology, Sydney. Ian has worked in the theatre on West End and tour-ing productions in Europe and Australia, in broadcast on commercial and public radio and television, live sound and record production for contempor-ary classical and popular concert music, post-production, and in high-tech audio product management. His research interests are in the areas of sound design, sound studies, sound pedagogy and musical interfaces.

Raymond Strickland is a 2017 Bachelor of Music (Dean's Scholar) graduate at Western Sydney University. With over 30 years' experience as a musician, he is passionately interested in performance, composition and its supporting technology. He has come to academia late in life, and embraced the new and the alternative, landing a long way from his early '70s Blacktown begin-nings. His experience with the performance of Annea Lockwood's "Piano Burning" has been an eye-opening one, and he has developed his capacity to explain and explore the process, particularly through interaction with acquaintances outside his university colleagues who have needed assistance to understand how such performances could be viewed as anything other than vandalism.

Irina Verenikina is an Associate Professor in Educational and Developmental Psychology at the School of Education, Faculty of Social Sciences, Univer-sity of Wollongong. She holds a M. Sci. (Honours) from Faculty of Psych-ology, Moscow State University, and a PhD in Educational Psychology from Russian Academy of Education. Irina is a full member of the Australian Psy-chological Society. Her research interests relate to the application of socio-cultural psychology and Activity Theory to the study of teaching and learning in a variety of contexts, including higher education, educational technologies, inclusive education, early childhood education, literacy and music education.

1 Teaching and evaluating music performance at university

A twenty-first century landscape

John Encarnacao and Diana Blom

The editors of this volume undertook undergraduate studies in the late 1960s (Blom) and early 1990s (Encarnacao). Notwithstanding that the late-Sixties /early-Seventies period was rich in experimentation in terms of composition, performance and the application of this experimentation to education (see Chapters 2 and 6), and that popular music was beginning to make its presence felt in the academy by the early 1990s, in each period there was a concentration on what was often called "principal study". Most often your principal study was an orchestral instrument, if not piano or voice, pursued towards an end of excellence in the field of classical music. On the fringes were those whose principal study was composition or musicology. In all these cases, the assumption was of an acolyte/mentor relationship, the object being a performance career in an orchestra or chamber group, commissions for your compositions, or the alternation between dusty archives and university classroom.

This is a simplistic and reductive image of course, and challenges to these traditional roles and relationships took place at different times in different places. While one-to-one teaching continues to thrive in some primary and secondary schools and in private studio practice, careers in classical music performance, composition and analysis have become a smaller fraction of the vocational possibilities available to school-leavers (if ever they were truly numerous) and much lower in terms of their aspirational priorities. At the same time that the capacity for conservatoria and universities to continue to deliver one-to-one tuition has been challenged by economic rationalism, research and practice have increasingly demonstrated the benefits to be gained from collaborative and group learning, whether in performance or other types of study. This book documents several approaches to teaching and evaluating music performance at university that, while looking forward rather than back, seek to be inclusive, rather than dismissive, of earlier forms of pedagogy.

Over recent decades, the tertiary sector of education has been increasingly constrained by financial imperatives, and this is nowhere truer than in the arts. There has been a widespread transition towards class-based teaching and evaluation of music performance as the conservatory model of one-to-one tuition and a focus on classical music is questioned by institutions. Although there have been some notable examples of research into class-based teaching and assessment

of music performance (Blom and Biernoff 2002; Blom and Poole 2004; Blom 2006; Pulman 2009; Kerr and Knight 2010; Blom and Encarnacao 2012a, 2012b), the time for a compendium of recent perspectives on these approaches is long overdue. The Bachelor of Music at Western Sydney University (WSU)[1] was founded upon strategies that looked forward to this new academic landscape. This book is drawn from over two decades of the implementation of innovative strategies in the program, but also includes perspectives from academics teaching elsewhere in Australia, as well as a welcome contribution from Glen Carruthers, Dean of Music at Wilfrid Laurier University, Canada.

Dawn Bennett notes that changes to the education sector in Australia over the past 25 years have been "overwhelming" (2008: 66) citing as one example that most music conservatories amalgamated with universities over that period. Carruthers sees music learning being enhanced through these institutional marriages "by the breadth and depth of collaborative opportunities" (2012: 33). Western Sydney University was established in 1989 as the result of the amalgamation of two existing Colleges of Advanced Education. The music program, established in 1994 under Emeritus Professor Michael Atherton's leadership, deliberately chose to locate music-making within a faculty that included theatre and dance, to develop meaningful synergies for cross-art form and interdisciplinary expression within "broader class-based approaches" (Blom 2008: 101), rather than the one-to-one model.

Discussing the English national curriculum for music, Garnett (2013) identified two distinctions of practice – the behaviourist psychology paradigm of "becoming proficient in a range of musical behaviours and skills" and the constructivist psychology paradigm where musical learning is considered "to be essentially to do with cognitive development" (161). He finds that it is "the separation of musical thinking and musical making, that results in the narrowing of musical learning" (171). This view is reinforced by Carruthers' comment that "a traditional musical performance that emphasizes brazen athleticism and personal capital at the expense of reflective historicism and community capital is, in the long run, untenable … since music cannot be wrested from socio-cultural and political contexts and meanings" (2012: 36). The music program at WSU introduces small and large group performing at first-year level with opportunities for solo performing in later years but not individual instrumental/vocal lessons. Rather, it offers students a range of engagements with performing: idiomatic and non-idiomatic improvisation, large and small group performing, collaboration with composers, exploring digital and analogue platforms and integrating them into existing practice, producing music from entirely digital means, plus writing and reflecting about their performing and that of others through concert reviews and essays. Lucy Green's (2002, 2008) seminal writings on "informal learning" recognised that students learn from each other in groups/bands and this adds to a growing range of performance teaching approaches, many discussed in our book.

The chapters of this book offer a range of ways to engage students in music performance in practice and in theory, as individuals and as collaborators. In doing so, it discusses the exploration of both new and more established approaches, certainty and uncertainty, successes and challenges. Both teacher and student responses are valuable to the discussion. Chapters are grouped according to the student experience, teaching approaches – student collaboration and performance practice – professional development, and evaluation. Other commonalities emerge. These chapters present learning scenarios that require students to consider what music is. In Chapter 2, Blom and Strickland conduct a dialogue about what performing Annea Lockwood's 1968 avant-garde work "Piano Burning" offers to the student. This raises issues of ready-made compositions and the notion of "playing" the piano, the role of the performer, the role of the score and authenticity, and what is a musical work. Chapter 6 investigates student response to performing avant-garde scores of the 1960s, the improvisatory frame scores of English composer Bernard Rands and Americans Terry Riley and Kirk Nurock. Blom, Smyly and Encarnacao note that the democratisation at the heart of the scores draws out student thinking on the roles of composer and performer, consideration of the role of colour, texture, pattern and improvisation in music, and invites self-evaluation of the group's creative outcome. This move "back to the future" also opens minds to what music is or might be. In Chapter 10, Encarnacao, Smyly and Brooks discuss their teaching approaches for free (non-idiomatic) improvisation and how assessing student performances in this area seeks to capture group creativity, ensemble interaction and artistic outcome, while, at the same time, again asking students to think about what music actually is. It also suggests to students that there are ethical and philosophical principles that undergird any musical engagement; elements that the study and practice of free improvisation lay bare.

Three chapters examine teaching approaches which draw on behaviourist and constructivist principles. The semi-autonomous ensemble discussed by McPhee in Chapter 3 offers students collaborative and peer learning opportunities, plus fresh interpretations of repertoire, brought about by having freedom to experiment, that results in expansive learning. Personal issues of ensemble leadership and conflict, however, were not so easy to resolve as in a teacher-directed ensemble. Chapter 7 outlines the process and outcomes of a professional development program designed to give support to instrumental music teachers moving from one-to-one teaching to group teaching. The personal attitude of individual teachers to the changes was a challenge, and a need for institutional support to embed long-term change was acknowledged. Careful planning of the program by Mitchell invited participants to discuss best practice in one-to-one and group teaching and workshops; how to handle a student cohort with a diverse range of skill levels; managing behaviour in group teaching; and assessment criteria, among other issues. In Chapter 8, Mitchell discusses the opportunities and challenges of teaching practical lessons on guitar, bass, keyboard, drums and voice in group lessons. Best practice includes peer learning and peer motivation by drawing together students of mixed skill levels,

composing arrangements which facilitate this range of levels, encouraging and mentoring student leadership of ensembles, and student input into repertoire choice. Challenges include pressure on teaching staff to achieve high quality standardised outcomes, handling personal and social student conflict and disruptive behaviour, staff with negative attitudes to group teaching that they pass on to students, and facilitating the development of notation reading of students in large ensembles.

Teaching singers and singing can occur in a range of contexts. In Chapter 4, Hughes discusses the unique challenges of learning and teaching contemporary singing in groups, while targeting a transformative learning experience for the students. Through the motivation of collaborative and community focused lectorials and tutorial learning environments, reflexive strategies facilitated transformational insights encouraging student realisation of the singing-self. Engaging all first-year music students in choir singing requires adept handling of a range of previous student experiences and attitudes to singing. Borrowing from her experience with community choir direction, Cooper (Chapter 9) discusses how repertoire choices, learning repertoire aurally and through notated scores, ensemble skills, vocal technique development and director approach can all benefit the choir but also lay the groundwork for student career-thinking in choral participation and direction. In Chapter 13, Latukefu and Verenikina draw play, an accepted method of training actors, into vocal education, in particular for the development of abstract ideas. These concepts, which need to be learnt, become the rules of the students' play, and are achieved without tension through the playful goal of the game.

Performing with and through digital and analogue interfaces is discussed in three chapters. Students performing in an iPad Orkestra ensemble were interviewed by Stevenson and Blom for Chapter 5. Their responses reveal how the experiences of digital natives can either enable or impede the development of projects. This can result in both expanded and reproductive learning. In Chapter 11, Stevenson discusses his thinking behind the development of an integrated conceptual and pedagogical framework for learning and making electronic music. As also noted in Chapter 6, the lines between the roles of composer, performer and instrument builder can be blurred. Performativity and interactivity are at the heart of the discussion and Stevenson finds students either rise to the challenges or revert to personal interests. In Chapter 12, a third-year subject is discussed in which students must engage with technology, theatricality and/or visual media to expand their practice. Encarnacao, Stevenson and McPhee draw on their own creative practices to encourage students to move beyond the proscenium arch of the performance stage towards exploration of what are often collaborative ventures.

Evaluation of music performing is not always summative assessment. By asking students to evaluate their performing and that of others using video analysis, and to write up this experience, McPhee and Blom engage them in reflection, practice-led research writing, and the use of technology as a facilitator to one's rehearsing and performing evaluation. These strategies are documented and discussed in Chapter 15. In Chapter 14, Stevenson subjects music performance assessment rubrics to content analysis, noting the broad range

of concepts and characteristic values revealed. These resonate with Burnard's (2012) map of 33 mediating modalities for music, which range from temporal (extemporisation, arrangement, live, virtual, composition-performance, de-composition, re-composition, etc.) to technological (hi-tech, low-tech, digital, digital-media, production, reproduction, etc.) as well as Bennett's (2008) table of categories of study as emphasised in course philosophies.

While student learning is a thread throughout the book, Barr and Blom's autoethnographical insights (Chapter 16) into a student's development from undergraduate entry, through post-graduate study to career, offer an overview of how a music curriculum and overseas study opportunities can shape musical taste, performance experiences and ultimately career direction. How music performance is taught, and the range of approaches offered, shapes student thinking in relation to their own career paths as performers, teachers, arts managers, review writers, audio engineers, music therapists, composers, theorists and so on. It may encourage open-mindedness and exploration, or a restricted and genre-focused view of what music is. Bennett notes that, after early criticism of conservatories not preparing graduates for the real world of musical experience (2008: 60), these institutions are starting to engage with career-thinking, diversifying beyond one-to-one teaching. Including jazz, contemporary and world musics, business skills and community music programs, among other initiatives, has meant considerable change in response to both external and internal influences (62). She finds that student musicians often seek a broad understanding of many different types and styles of music to become well-rounded musicians (65). Within music performance teaching there is an opportunity for students to "be challenged to think about potential specialist, support, embedded, teaching and other roles that align with their interests and strengths" (Bennett and Richardson 2016). Our book is not about music careers, yet the approaches in this book go a long way towards establishing readiness for a diverse range of careers.

The book offers a range of teaching approaches involving large and small groups, what Percy Grainger called "musical team-work" (Grainger, in Carruthers 2018: 50), collaborative and individual performing drawing in technology, theatricality, a wide repertoire range and improvisation. We have brought the views, experiences and voices of teaching staff and students from several institutions into the chapters, discussing frankly what works, what has not worked and what has potential to work with further thinking and refinement. Carruthers notes that "as music and musicians and their roles in society change, so institutions that teach (and students that learn) must change apace" (2012: 35). This notion is shared in all aspects of this book, which we hope adds to thinking about teaching music performance at undergraduate level in the twenty-first century landscape.

Note

1 The University of Western Sydney (UWS) changed name to Western Sydney University (WSU) in 2015.

References

Bennett, D. (2008). *Understanding the classical music profession – The past, the present and strategies for the future*. Farnham & Burlington: Ashgate.

Bennett, D. and Richardson, S. (2016). What do we know about the work of performing arts graduates? *Loudmouth* (Music Trust E-Zine), May 9. http://musictrust.com.au/loudmouth/what-do-we-know-about-the-work-of-performing-arts-graduates/, accessed 21 January 2019.

Blom, D. (2006). Beyond the cover version: Encouraging student performers to produce original interpretations of popular songs. *International Journal of Music Education*, 24 (2), 159–167.

Blom, D. (2008) Teaching class-based music performance at tertiary level: Focusing theory on practice. In D. Bennett & M. Hannan (Eds.), *Inside, Outside, Downside Up: Conservatoire Training and Musicians' Work*. Perth, Australia: Black Swan, 101–109.

Blom, D. and Biernoff, L. (2002). Non-Western ensembles: Crossing boundaries and creating interstices in cross-cultural educational contexts. *Research Studies in Music Education*, 19, 22–31.

Blom, D. and Encarnacao, J. (2012a). Student-chosen criteria for peer assessment of tertiary rock groups in rehearsal and performance: What's important? *British Journal of Music Education*, 29 (1), 25–43.

Blom, D. and Encarnacao, J. (2012b). Assessing undergraduate jazz and rock group music-making: Adding to the classic(al)recipe. *Music Paedeia: From Ancient Greek Philosophers toward Global Music Communities. Proceedings of the International Society for Music Education 30th World Conference, 2012*, Thessaloniki, July 15–20.

Blom, D. and Poole, K. (2004). Peer assessment of tertiary music performance: Opportunities for understanding performance assessment and performing through experience and self-reflection. *British Journal of Music Education*, 21 (1), 111–125.

Burnard, P. (2012). *Musical creativities in practice*. Oxford: Oxford University Press.

Carruthers, G. (2012). Conservatories and universities: Emergent new roles. In Weller, J. (Ed.), *Educating Professional Musicians in a Global Context. Proceedings of the 19th International Seminar of the Commission on the Education of the Professional Musician, International Society for Music Education*, Philippos Nakas Conservatory, Athens, Greece, 32–36.

Carruthers, G. (2018). Percy Grainger and community music: Rethinking higher music education. In Forrest, D. (Ed.), *Proceedings of the International Society for Music Education 33rd World Conference on Music Education*, Baku, Azerbaijan, 50–58.

Garnett, J. (2013). Beyond a constructivist curriculum: A critique of competing paradigms in music education. *British Journal of Music Education*, 30 (2), 161–175.

Green, L. (2002). *How popular musicians learn: A way ahead for music education*. London and New York: Ashgate.

Green, L. (2008). *Music, informal learning and the school: A new classroom pedagogy*. Farnham & Burlington: Ashgate.

Kerr, D. and Knight, B.A. (2010). Exploring an industry-based jazz education performance training programme. *International Journal of Music Education*, 28 (4), 301–312.

Pulman, M. (2009). Seeing yourself as others see you: Developing personal attributes in the group rehearsal. *British Journal of Musical Education*, 26 (2), 117–135.

Part I

Student experiences 1

2 Reassessing what we call music

Investigating undergraduate music student response to avant-garde music of the 1960s–early 70s through performing Annea Lockwood's "Piano Burning"

Diana Blom and Raymond Strickland

Introduction

Annea Lockwood's "Piano Burning" (1971a) is a piece in which the instrument is destroyed. As such it presents an opportunity for a particular type of learning for undergraduate music students. The process of rehearsing and performing "Piano Burning" is similar, in many ways, to the process required for other works for solo piano, Anne Boyd's *Book of the Bells* (1981), for example. Both works involve one performer and one piano, and require practice and rehearsal. The piano needs to be prepared for both events, strings over-tuned "as high as possible so as to get maximum sound when they snap from the heat" (Lockwood 1971a: 48), plus other preparation,[1] for the former, strings tuned to specified temperaments for the latter. In performance, both works offer an interesting aural experience, with an audience adding to the ritual of both events. And both require uninterrupted, undistracted "performance integrity" (Godlovitch 1998: 39) in order to establish and preserve a mood. There are, however, several differences. As the piano is destroyed during performance, to perform "Piano Burning" a second time, another piano is required while a second performance of Boyd's can take place on the same instrument. Lockwood suggests the use of an upright piano as best for her performance, whereas Boyd does not designate any particular size or shape of piano. The Lockwood work is visually spectacular, while a *Book of the Bells* performance offers little that is visually new and challenging. During a performance of the Lockwood work, the performer becomes an (attentive) audience member, the piano literally performing the work without human assistance, while during Boyd's work, the performer remains focused and active at the keyboard. These differences introduce new elements into questions of what is music and what is performance.

This chapter discusses the preparation and performance of "Piano Burning" through a dialogue between an undergraduate music student (Strickland) and

a teaching music academic (Blom). It focuses on issues that emerge from the practice and from the literature about the work to seek an understanding of what the piece can offer students educationally in relation to what we call music. Like Christopher Small (1998), writing in reference to a symphony concert, we will attempt "to tease out the complex texture of meaning that a musical performance – any musical performance, anywhere, at any time – generates … to enrich our experience of it" (14). The chapter begins with discussion of the background of "Piano Burning" and its context in the 1960s, the role of the performer and the audience, the text score and issues of authenticity. It responds to the following question – what is the educational merit of introducing first year university music students to performing "Piano Burning" by Annea Lockwood?

Methodology

The study drew on two methodological approaches, practice-led research and student–teacher dialogue. The music student and the music academic discussed issues which arose during their preparation and performances of the work (student and teacher in 2014; teacher in 2000 and 2004) through a practice-led research paradigm, combined with Plato-like dialogue. Rubidge's (2004: 06) definition of practice-led research as "research … initiated by an artistic hunch, intuition, or question, or an artistic or technical concern generated by the researcher's own practice" which is "important to pursue in order to continue that practice", was fully in play. The *practice* was performing "Piano Burning" but also the *educational practice* of introducing first year performance students to the work, and other avant-garde music of the 1960s, through a lecture. Issues which emerged from our practice are joined with those raised in literature about "Piano Burning" and other works of this genre and time period, shaping our dialogue.

While there is research into student–teacher dialogue at school and university levels, none to our knowledge has focused on the more unusual combination of an undergraduate music student and music academic researching together, as in this chapter. We therefore drew on a range of ideas from several studies, both within the student–teacher dialogue topic and also research using conversation as an underpinning method. Discussing dialogic scaffolding in a study of upper primary school students, Rojas-Drummond et al. (2013: 19) noted how more "complete and complex … [thinking emerged] … as the dialog among all participants evolved". From studying effective teacher-student dialogue in biological education, Kinchin (2003: 113) proposed a model with six steps, four of which were particularly useful to our methodology – the "production of individual concept maps to promote reflection upon understanding held by teacher and student … comparing concept maps to target an initial dialogue … identif[ying] overlap illustrated by commonly held ideas and links in concept maps … [and] focus[ing] on the personal relevance of the topic for the student within the novice/expert overlap". To some extent, this relates to Johnson and Gott's

(1996) concept of "neutral ground ... in which a largely ... undistorted communication takes place between ... [student] and researcher ... in relation to the researcher's and [student's] ... frames" (565–566), an idea drawn from their investigation into the validity and reliability of the evidence of young children's ideas. Here "... interpretation must attempt to understand what a [student] ... is saying on his or her own terms and the researcher must guard against imposing meanings from his or her frame of reference" (566). Deliberate discussion between, in our case, mature-aged undergraduate student and academic was chosen to explore a particular topic – neutral ground – established through shared performance of the work. We understood that opinions may differ, but that we "may contrast [our] ... perspectives using argumentation, seeking eventual consensus" (Rojas-Drummond et al. 2013: 13). We found that complete and complex thinking did emerge. The researcher/performer pairing also reflected aspects of one of Rogoff's "mutually constituting planes" of socio-cultural activity – "apprenticeship" – in which "people participat[e] in community activities that have as part of their purpose the development of mature participation by less experienced individuals" (Rogoff discussed in Rojas-Drummond et al. 2013: 11).

Background of "Piano Burning"

"Piano Burning" is one of a suite of pieces, *Piano Transplants* (1968–1982), by Lockwood in which pianos already beyond repair are burned, drowned, partially buried in a garden or gradually taken by the tide. Creating an environmental focus, the suite was created in synchronous homage to Christian Barnard's pioneering heart transplants (Lovely Music 1999). Lockwood herself is a "transplanted" composer, born in New Zealand and now living and working in USA.

"Piano Burning" was written in 1968, the year of Shostakovich's *String Quartet No. 12*, Berio's *Sinfonia* for soloists and orchestra, Ligeti's *Continuum* for harpsichord, Carlos's *Switched-on Bach*, Stockhausen's *Aus den sieben Tagen* and the publication of Sculthorpe's *Irkanda IV*. Issue 9 of *Source* magazine[2] published the score of "Piano Burning" in 1971. Over the years this publication's issues included other compositions with an overt environmental focus such as Lockwood's *Tiger Balm* (1971b). Within Issue 9 is a diverse range of pieces reflecting the explorative nature of composition in Western art music during this period – the "parascientific experiment" and "aesthetic expression" of *English Phoenemes* (Lora-Totina 1970); *Fur Music* (Howe 1970), a largely conceptual piece engaging several senses in addition to hearing; and *Mödius Strip-Tease* (Slonimsky 1965), arguably a music theatre piece.

In an interview with Tara Rodgers (2010), Lockwood explained that initially she simply wanted to record a fire but being aware of the numerous defunct pianos around London prompted her to refine the notion into over-stringing one so as to include a sonic exploration of strings snapping. The idea for

"Piano Burning" was realised at a small festival on the banks of the Thames. An audience gathered and unintentionally became part of the recording. At first, Lockwood thought "the recording was useless ...", "... but the thing became a beautiful visual spectacle" (Rodgers 2010: 123). The composer has described her work as "explorations of the world of natural acoustic sounds and environments" (biography, Lockwood 2009: 45), and "Piano Burning" as using "a kind of 'live-electronics' [with] ... amplification and modulation" (Lockwood 1991: 148). Here, recording technology is "a 'facilitator' allowing [the composer] to transport and store sounds, especially those from nature" (Hinkle-Turner 2006: 33). Hinkle-Turner (2006: 31) talks of Lockwood's interest in "musical creation for meditative and healing purposes", and as an example, finds sounds heard from a performance of "Piano Burning" including the "sound of string breaking, wood burning, and microphones melting" (32) conjure this mood/sense.

BLOM: I give a lecture on avant-garde scores of the 1960s and 1970s to first year music performance students which informs their introduction to performing the scores, Terry Riley's *In C* (1964), David Bedford's *White-field Music 2* (1968) and Kirk Nurock's *War and Night* (1973). In these works, the score is part improvisation and part notation, what I call a framed improvisation score. "Piano Burning" is what Jeff Pressing (1994) calls a text piece with the score comprised of text only. Both of these score styles, plus graphic scores, overtly allow "underdetermined" (Godlovitch 1998: 86) aural and visual interpretative possibilities. "Piano Burning" questions the role of the performer – a preparer and lighter of the fire, rather than a continuous player of the keyboard. As a student at the University of Sydney in the late 1960s, despite the serialism of Schoenberg, Berg, Webern, Babbitt and others holding sway in academia in the Western world, many different musics were being heard. Peter Sculthorpe was teaching ethnomusicology, especially the musics of Bali and of Japan. He was also teaching composition and musical influences from both of these musics and these were heard in his compositions and those of his students such as Anne Boyd and me. I heard music of Italian composer Luciano Berio, remember vividly his *Sequenza V* (1966) for solo trombone played in a red stretch fabric bag, and a performance of La Monte Young's *Piano Piece for #1* (1960) involving a piano, a bale of hay and a bucket of water. Everything was under scrutiny and up for exploration: sound, performance and score notation styles. My motivation now is to encourage today's music students to broaden their concept of what is music and what is performing. To me, "Piano Burning" is sort of an environmental piece although I recognise the electroacoustic role. What do you think?

STRICKLAND: "Electroacoustic" is such a broad-ranging term nowadays. Any acoustic sound, recorded electronically and integrated into one's compositional practices, could fall under this category. It is more akin to experimental work, rather than simply recording an orchestral performance.

Lockwood did identify her work in those terms. For "Piano Burning", there is interest in the actual sounds and how the reframing of the event can tell us something about ourselves. Lockwood doesn't actually interfere with the sounds; it is more of a live happening. It is presenting all of the sounds audible from within the piano through a PA system. They include environmental, mechanical and verbal. In light of the microphones, also picking up all of the sounds around the piano, it could be labelled as a live *soundscape*; similar to her later works, "A Sound Map of the Hudson River" (Lockwood 1989) and "A Sound Map of the Danube" (Lockwood 2008).

The role of the performer, performing environment and audience in "Piano Burning"

Three performances of Lockwood's "Piano Burning", all on Western Sydney University campuses, form the basis for discussion of the sound and vision of the performance process. Cook (2001: 05) finds this area has often been ignored by musicologists in favour of "a primary concern with musical works as the works of their composers … [with the performer] at best an intermediary … [and at worst, a] middleman". In arguing for the idea that "music performs meaning" (31), Cook comments on how, through "the grammar of performance" (5), "language … marginalizes performance … [which] leads us to construct the process of performance as supplementary to the product that occasions it or in which it results" (2). We talk about "just playing" music, or about "music 'and' its performance" (2) as if performance was not integral to music. Cook compares this to how "we might think of poetry, as a cultural practice centred on the silent contemplation of the written text, with performance (like public poetry reading) acting as a kind of supplement" (5). He recalls Schoenberg's supposed comment that "the performer, for all his intolerable arrogance, is totally unnecessary except as his interpretations make the music understandable to an audience unfortunate enough not to be able to read it in print" (1). But the role of the performer in "Piano Burning" must be discussed.

"Piano Burning" is what Godlovitch (1998: 109) describes as a - "readymade"[3] piece which "experiments with musical agency". It falls, perhaps, into his "prepared found sound" description where "typically, some sound-making device is set up to ensure a specific quality of sound … [and] requires active intervention in sound production" (113). Performers are in his words, "*sounders*" (114) rather than "*performers*", the former "draw[ing] attention to [a] non-musical, acoustic phenomenon" (113). Bandt (1983: 28) would determine "Piano Burning" as having "the physical environment as model … [and] fundamental sound modifier". She lists the key features of physical environments – natural or man-made, spatial dimensions, sound absorption rates, light and water availability, proximity, cleanliness, safety and resources, time and place – all with musical consequences which need to be considered, and all relevant to Lockwood's *Piano Transplants* which require

the audience to "leave the traditional concert space" (Lee 1999: 62) and find a "specific place of musical performance".

BLOM: In my first performance of "Piano Burning" I think safety concerns took precedence over artistic and sound considerations. Two subsequent performances have tried to even this out, balancing maximum visual effect from all angles and distances and optimum sound dispersal, with a flat, sheltered area, clear of grass and building, but with power source availability.

When I performed the work, I found I was making decisions on some of the preparation issues that arose in relation to how much fuel was needed and the placement of the piano. This made me think, who is more important in the realisation of this work, the performer or the composer? While these were decisions made before the performance itself, they impact on the performance and I learnt, from one performance, to reconsider these parameters. This is different from practising a piano piece for performance where, however good the preparation, the performance also has to be played well. In "Piano Burning" the preparation is crucial as once the performance is underway, there's nothing the performer can do to change the outcome. Because of this difference, I accept sounder as a term for the performer in "Piano Burning". If the preparation is correct, then the piece performs itself which leaves me free to move around the work, talk with audience members, become an active audience member and gain different aural and visual perspectives – very liberating!

STRICKLAND: In the preparation and presentation of the event, there are various roles for many participants and for our discussion I hope to include them when referring to the sounder. Before being involved with this event, I would have said that the composer is the most important agent. With the benefit of our discussions, my opinions have changed. Once full credit to Lockwood as composer is acknowledged the audience becomes more important than either the composer or the sounder. Lockwood has found a penetrating form of expression through the performance of nature, swaddled in the powerful symbolism of the piano and all focus is on the burning piano but that seems to be a catalyst for communal experience that ensues (sounder/s included). This is not to diminish the sounder's importance but for me the performative role of the sounder has not been established.

Godlovitch argues against readymade pieces being called a musical performance. This piece may exhibit artistic merit but for Godlovitch there is no primary causation requiring a craftsperson or some standardisation of these skills through a conservative guild. A work presented with only found sounds falls short of his minimum requirement. He argues that works containing found sounds – having an absence of any significant primary causation – not requiring skill or methodology, delegates the performer's role to little more than that of a presenter. He believes that the sounder merely

"draws attention to non-musical, acoustic phenomenon" (Godlovitch 1998: 113). Anything contributing to its artistic merit is attributed to the sounder's intelligence for being able to spot it. Readymade work is "event framing" (116) and producing a score for such an event simply outlines a set of directives for the sounder.

Godlovitch is positively rational and very convincing, drawing an unambiguous line. However, from my experience I found there was a skill/methodology requirement as Diana had mentioned, relating to the site and preparation, none of which can be haphazard but rather must be carefully planned. I don't distinguish between naturally occurring and volitional agency when defining performance and so, to my mind, the piano is also a performer. In this case the performer comes second to the audience's importance. However, the level to which an audience is able to emotionally engage with such a presentation results in a more inclusive, and thus constructive, definition of performance.

BLOM: Thanks for bringing the audience into our discussion as it plays a crucial role in "Piano Burning". As sounder, I found myself interacting with the audience in a way I have never done as a "traditional" pianist where I'm tied to the keyboard and score.

STRICKLAND: During the afternoon, leading up to the 2014 UWS "Piano Burning", the seemingly abandoned piano attracted a regular stream of curious students. It was inspected, touched, stroked and had its keys tested. It evoked questions and its presence was a performance before the actual event. It was a communal event with no inducement to participate, one merely had to be open to new experience. The audience engaged with the piano as if it was consciously performing for us both visually and aurally. The end of the performance was not marked by the demise of the microphones but the toppling of the piano's metallic harp structure, and on cue the crowd dispersed.

BLOM: I remember the 2000 performance. Because of weather which threatened to be damp, a breeze which came and went, and the fact that it was my first performance of it, in front of colleagues and students, we erred on the side of generosity with fuel using turpentine, wood and blocks of fire starter. This departed considerably from the score's instructions and resulted in a presto, dazzling performance which was also a departure from the score but which the audience loved. What was important was that the piano itself turned out to be too defunct – the strings had rusted and didn't break and therefore an important aural component to the work was missing, similar to Lockwood's first performance (Rodgers 2010: 123).

STRICKLAND: Whether by design or good fortune, the format chosen for "Piano Burning" is perfect for drawing an audience's attention to the hitherto unheard sounds from the piano. This is not dissimilar to Cage's *4' 33"* (1952) in which the silence is ideal for drawing the audience's attention to the ambient sounds of the venue. Many components of our event – environment, strong visual and aural elements, audience response – contributed to this

performance, displaying artistic merit in many ways. Unexpectedly, the performance becomes a one-off event, never to be repeated exactly the same way. You had to be there to experience the audience vibe. This performance was inclusive, with audience and performer attending as equal participants. The audience transcended the obvious in that we were simply burning an old abandoned piano, something which divided some of the many curious passers-by throughout the afternoon, leading up to the performance. Along with their tactile fascination for the piano, they would ask questions with their responses varying from positive to negative.

The communal aspect of music is powerful. I found that simply telling people that they are participating in a significant event softened the barriers between performance and audience. During the night's performance itself, the event continued conscripting passers-by, just as the abandoned piano had done earlier that afternoon – drawing an audience rather than relying on pre-publicity.

Regardless of my favourable expressions about the piece, I don't see myself attempting to compose in this same genre. This would require much greater communication skills than I currently possess. It would also require a more confidently refined perception of the role of "Piano Burning" in the overall scheme of art. It does, however, make me reassess what we can call music and the power of its communal aspect. This reassessment leaves me yearning to be more experimental in expression and still pursue a sense of authenticity within that expression.

"Piano Burning" – the score and authenticity issues

Score

Applying Schoenberg's directive to read music in print, quoted above, rather than requiring a performer to sound "Piano Burning", brings to mind Cope's (1993) definition of concept music, in which "concept philosophy is often implied only in the score and is not 'real' to the audience ..." (173). Comparing concept music to some minimal music, Cope considers the former to be "extremist and more powerful and often more interesting in premise than in the performance situation – if there is one". One's conceptual experience of the score of "Piano Burning" is far from a blank sheet because despite Lockwood's score for "Piano Burning" occupying only half a page, images of a burning piano permeate the 1971 No. 9 issue of *Source Magazine* including the front and back covers.[4]

The score for the work appears as a texted paragraph backgrounded, rather than foregrounded, to a photograph of a burning upright piano, a performance of the work, with the composer in the foreground (Figure 2.1). The impression is that the image of the burning piano and composer are more important than the texted content which struggles to be read

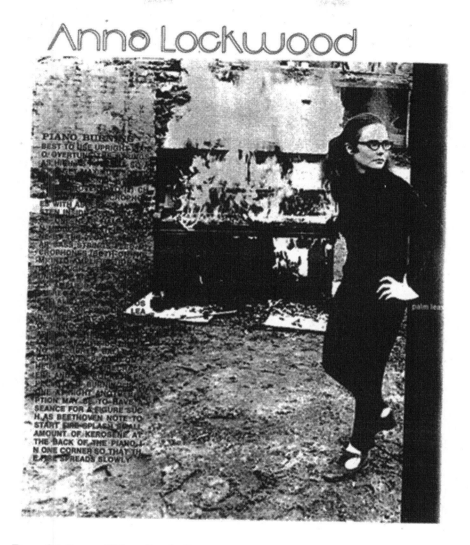

Figure 2.1 Score of "Piano Burning"
Source: Music of the Avant Garde #9, p. 48, with permission from the composer

against the dappled black and white photograph.[5] Some instructions are tech-
nically explicit: "best to use upright piano, overtune the strings as high as
possible so as to get maximum sound when they snap with the heat"; others
more suggestive, requiring performer interpretation – "splash small amount
of kerosene at the back of the piano in one corner so that the fire spreads

slowly" and "coloured balloons can also be placed on the piano also fire-crackers and sky rockets especially if the burning is done at night". Some instructions require preparation more suited to the 1960s than today which raises basic authenticity issues – "cover two cheap dynamic microphones with asbestos and fasten inside the piano" (Lockwood 1971a: 48). With Lockwood's suggestion for a séance to be held, there *is* an imagined per-formance in the mind from silent reading of the score – some sound and lots of vision.

BLOM: Both of us have had variable success with performances of "Piano Burning". However, as Nicholas Cook, discussing music performance as process and product, has said – "no one performance exhausts all the possibilities of a musical work within the Western art music trad-ition, and to this extent ... [our] performance might be thought of as a subset of a larger universe of possibility" (Cook 2001: section 11). I initially expected, at the first performance, to see fire, hear the sounds of burning and of flames and the pinging of breaking piano strings. But the physical reality of the piece is not fully experienced until one hears and witnesses a performance, and this includes heat and smells, and any dangers associated with fire.

STRICKLAND: I found Lockwood's score to be instructive and accessible. It doesn't automatically exclude performers with little or no notation skill and this style of scoring helped to allay insecurities that I carried about my own public performances. It puts performance into more of a socially beneficial context than I'd ever considered before. The points that Cook raises above ring true with my experience. Our performance was all that I expected and then more, in that the score sufficiently predicted an outcome but then the performance surpassed this.

Authenticity

In the 1980s and early 1990s, debate about authenticity and performance practice took place amongst early music scholars and practitioners. Issues embraced hardware, that is "authentic" Baroque violins with gut strings versus modern violins; and software, that is, the interpretation of contem-porary treatises and how to perform the music. For early music specialist Robert Donington (1989), "authenticity is compatibility between a piece of music and the performance of that piece of music. Compatibility of sound and sense is for that reason alone an essential aspect of authenticity" (122). However, despite Prokofiev's own 1932 recorded performance of (unwrit-ten) hesitations on the opening pair of staccato crotchets in his "Gavotta" op.32/3 (1918), which leave no doubt that they are an upbeat, the hesita-tions are completely absent in the recordings of many other pianists. The lack of consistency between sound and score in the composer's

performance leaves the contemporary performer able to ignore the wishes of the composer's performance practice; to follow and interpret them as faithfully as possible; to follow the score (which in this case doesn't have the hesitations marked in); or to openly acknowledge the recontextualisation of the work with each performance. Taruskin (1992) sums this up: "To hear it is to be finally convinced that, since texts outrank performers even when the performer is the composer, texts outrank composers, too" (320).

We found that while some of the authenticity issues in "Piano Burning" are largely connected with the score's use of asbestos, and microphones, there are larger issues at play in a performance of the work.

BLOM: Any issues of authenticity for me focused around achieving the most effective performance to elicit a strong audience response. And there was the score requirement of asbestos. We wound damp cloth around the microphone wires to replace the asbestos, a straightforward solution and the wires burnt out after quite a long time.

STRICKLAND: In relation to the specifics of the score requirements, I noted that Lockwood had played her piano for some 40 minutes, as the flames and heat slowly grew to a state in which it was too dangerous for her to carry on. Local occupational health concerns had our piano barricaded from the moment the flames were lit. No playing occurred but we were very fortunate in that our microphones were also functional for some 40 minutes into the proceedings. Considering that our event focused entirely on the piano and the resulting sounds, I conclude that we were steadfast with Lockwood's intentions to avoid any attempts at the "subjugation of sounds" or "to abstract" or apply "external organisational methods or manipulations of internal structure" (Smith 1996: 395). Authenticity was ultimately bestowed upon it by the audience reaction. Prior to ignition, the audience was briefed and subsequently delighted with the outcome.

To what degree do we pursue authenticity? Even if we were able to recreate the event with the same instrument, recording equipment, same techniques, sounder, audience, location, weather etc., that moment in history and its perspective is lost to us. Lockwood's political environment and motivation have evolved since (some devolved). She could not have fully appreciated what she had accomplished until after the event. Lockwood's event was a unique performance but so too are subsequent performances. The mechanisms, logistics and appreciation for Lockwood's intention will vary and the individual audience member will have his or her own response. To paraphrase Keylin (2015), through the indeterminacy of the outcome, the audience will assemble the composition. Natural phenomena are objective, impersonal and disregarding of an artist's intent. If the ideal scenario is to ensure that every event is a one-off performance, I am convinced that our performances have achieved it.

What is a musical work?

The aural aspect of "Piano Burning" lies close to Russolo's "limited circle of sounds", part of his manifesto towards new possibilities for sound and music beyond the usual, written in 1913, and is therefore challenging as "music".

STRICKLAND: Before being introduced to "Piano Burning", I had encountered examples of aleatory and minimalistic works, through first year music performance and musicology subjects in my undergraduate degree. I had previously read about Dada and the Fluxus movement in a series of Craig Schuftan books relating to pop culture. Outside of university, I have had no experience of such performances. Subsequently and in advance of our event, I found such works as Terry Riley's *In C* or any John Cage piece for a prepared piano, to be far more accessible than say LaMonte Young's *Piano Piece for David Tudor #2* or John Cage's *4' 33"*. Within the former, there were pitched sounds and rhythms which more intuitively identifiable as music. The latter examples given require a more open-minded attitude. Some prior research would certainly enhance the experience but more importantly, these pieces require presence at a live event. Without an audience, they could appear as academic conjecture. This calls into question the earlier Schoenberg comment, about the performer being unnecessary. The performer, the audience and the environment of the event are very necessary, despite everyone who can read English being able to read the text score of "Piano Burning".

On later reflection, I feel that to be considered art, a piece of work must touch someone on some level below the superficial. We don't all recognise this when it happens, nor are we all open to equal depths of this experience. Given the contradictory nature of existence, we do seem to share varying levels of subjectivity, even if as a result of culture. These shared subjectivities can give the illusion of the existence of objectivity. John Carey quotes a reluctant Arthur C. Danto, stating that "what makes something a work of art is merely that it is thought to be a work of art" (Carey 2005: 18). The claim to "art" status is unstable and is logically nonpermanent. It is not such a dangerous leap to step outside of one's cultural expectations and listen for naturally occurring music around us.

Art is most useful when it is a social or community experience. Therefore what is important is how an audience responds to it. Hopefully, the experience exposes one to alternative or more expansive ways of thinking. Witnessing "Piano Burning" in 2014 broadened my outlook as to what we call art, music and performance and forced me to consider the audience's role when assessing a piece's validity. The highly visible eagerness of the audience to indulge these notions led me to accept Lockwood's claim that "all sound is inherently musical, interesting and valuable" (Pestova 2013). This sentiment includes non-volitional, natural forms of sound, as well as the more conservative notions of music making. Geoff Smith (1996) paraphrases Cage when he states that "music does not emerge but the perceiver enters in" (23). My

understanding of this is that we need to be open to alternative possibilities and listen for them, so as not to place expectations or limits on what may ensue from the experience.

For me, future performances of works by composers such as Cage and La Monte Young will benefit from the positive associations I now have with Lockwood's work. Even if performed at another time to a less enthusiastic audience, I will not think any less of "Piano Burning" itself. This performance had its own unique character and audience response. The remaining metal frame is to be prepared and presented as an artwork in its own right. I will always associate the score with our own performance of it.

BLOM: I remember Lockwood's glass pieces being discussed in the 1970s while I was a music student, and that liberal musical thinking at the University of Sydney was when my ear, eyes and mind were opened to what music is. This is similar to Raymond's experience through his performance of "Piano Burning". As a pianist and composer, performing "Piano Burning" always offers something new, as with performing Boyd's *Book of the Bells*. Thinking back to our opening paragraph in this discussion, and the three "Piano Burning" performances I've been involved with, the big difference between the Boyd and the Lockwood is in the role of preparation. The former requires retuning but then the performance can be manipulated in real time; for the latter, the performer/sounder plays no role so preparation is everything. "Piano Burning" sets out to conquer some of the infinite variety of noise-sounds in relation to the piano, use of fire, technology and audience role, resulting in both composer and performer/sounder being "producer[s] of unorthodox sounds" (Whiteoak 2002: 32).

Conclusions

Undergraduate students come from a wide variety of musical backgrounds and influences. They bring with them preconceived notions relating to music and performance and whether information is a help or hindrance to their professional futures. Prejudices are often challenged by peers, so to maximise the music education (and financial) benefits of a music degree, any markers of achievement/evaluation must be as inclusive as possible to embrace different student musical presage. Establishing a starting point through a work such as "Piano Burning" encourages students to freely pursue a direction of their own discovery and interests, broadening the spectrum of ideas as to "What is music?" and "What is a performance?" and validates any future decisions made on artistic matters. Educationally, these questions promote a more "complete and complex" (Rojas-Drummond et al. 2013) style of thinking. Rather than draining precious enthusiasm from students, they delve, through practice and academic investigation, into comparisons between conventional performances and others which experiment with "musical agency" (Godlovitch 1998).

While the student–teacher dialogue approach was not the main focus of the chapter, the less common research collaboration of mature-aged undergraduate student and academic resulted in some commonalities with the approaches raised in the methodological literature, and some new elements. We found Kinchin's (2003) mind mapping use. il as it established shared and different experiences and thinking from which the study could be developed. Adopting non-verbal cues to encourage discussion was useful in reminding the academic not to lead all dialogue but wait for a different style and thinking to emerge from the student. Discussion took place through meetings and email, but also bouncing off each other's ideas as the chapter developed. The teacher found the student's cultural and philosophical insights into "Piano Burning" particularly revealing, especially those drawn from his performance of the work, and this will inform her future lectures on the subject.

Contemplation around authenticity and the performer's role introduces the audience's engagement, score notation styles, primary agency and also symbolism for discussion. These complex introspections prompt creative consideration of the merits of naturally occurring sounds. The engendered complexity of these matters are of enormous benefit to the deep thought required for real-life problem-solving. Discussions on such matters as Lockwood's description of "Piano Burning" as exploring natural environments and live-electronics require respectful enquiry and collaborative experimentation. High-functioning graduates, able to work with the gains and limitations of our "limited circle of sounds" (Russolo 1986), and with an appreciation for the importance of the performer, audience and piano as being equal participants (requiring a sophisticated social sense in itself), reap the benefits here.

As a gateway drug into more confronting expressions of art, "Piano Burning" is a dramatic and stimulating way to introduce a student to the notion of all sound being "inherently musical, interesting and valuable" (Lockwood in Pestova 2013), whilst not seeming to aggressively confront prejudices to the contrary. It may be difficult for a new music student to sit through a performance of Cage's *4′ 33″*, whereas a communal event such as "Piano Burning" can be penetrable and fun, becoming an inclusive fundamental to the idea of what music is. Despite still being labelled "experimental", we find that to perform "Piano Burning" requires the same performance integrity and attempt to discover meaning that any musical performance generates, doubly so, perhaps, because of the gender of the composer. For Small (1998: 8), "musical works exist in order to give performers something to perform". If we understand musical scores as "scripts in response to which social relationships are enacted" (Cook 2001: 31), we allow the many "underdetermined" (Godlovitch 1998: 86) interpretative possibilities, analytically inherent in the score of "Piano Burning", to become "present and self-evident in the interactions between performers, and in the acoustic trace that they leave … [and thus] music performs meaning" (Cook 2001: 31).

Notes

1 For example, Lockwood (1971a) stipulates that "two dynamic microphones ... [be] fasten[ed] inside of piano – place one near hammers in middle register and one by the pedals and near bass strings" (48).
2 Officially referred to as *Source: Music of the Avant Garde*.
3 The first dictionary use of the phrase "readymade" in this context (under the name of "MD" presumably Marcel Duchamp), is found in *Dictionnaire Abrégé du Surréalisme* (in Obalk 2000).
4 Footnote: there are other score versions of "Piano Burning". This chapter engages with the original 1971 publication.
5 Asked for the original text instructions for the piece, Lockwood responded that "the seance was unique to that first 'Piano Burning', not repeated in subsequent burnings. I myself do not have a copy of the text which appears in *Source* (which is the original text) but here's my transcription of it as best I can:

Piano Burning
Best to use upright piano
Overtune the strings as high as possible so as to get maximum sound when they snap with the heat
Cover two (2) cheap dynamic microphones with asbestos and fasten inside of piano
Place one near hammers and one by the pedals and near bass strings
Feed microphones (both of them) into amplification and through speakers around the area – also jack amplification into a stereo tape deck
Be sure to also wrap asbestos around microphone lead wires that are inside of piano and extend wrapping to three feet of lead wire outside of piano
Coloured balloons can also be placed in the piano also firecrackers and sky rockets especially if burning is done at night
Another option may be to have a seance for a figure such as Beethoven
Note to start fire splash small amount of kerosene at the back of the piano in one corner so that the fire spreads slowly
I haven't looked at that score for decades so it's interesting to me how little I took for granted. Nowadays I wouldn't need to stipulate the PA set-up, for example, but the placement of the mics is a neat reminder. No firecrackers possible these days, alas, and Beethoven has retired from the scene."

Personal correspondence between the composer and editors of this book,
30 January 2019

References

Bandt, R. E. (1983). *Models and processes in repetitive music*. Unpublished PhD thesis, Monash University.
Boyd, A. (1981) *Book of the bells*. London: Faber Music.
Carey, J. (2005). *What good are the arts?* 2nd ed, London, UK: Faber and Faber Ltd.
Cook, N. (2001). Between process and product: Music and/as performance. *MTO: A Journal of the Society of Music Theory*. https://mtosmt.org/issues/mto.01.7.2/mto.01.7.2.cook.pdf, accessed 25 February, 2020.
Cope, D. (1993). *New directions in music*. Wisconsin: WCB Brown and Benchmark.
Donington, R. (1989). The present position of authenticity. *Performance Practice Review*, 2 (2), 117–125.
Godlovitch, S. (1998). *Musical performance: A philosophical study*. London: Routledge.
Hinkle-Turner, E. (2006). *Women composers and music technology in the United States – Crossing the line*. UK: Ashgate (1971).

Howe, N. (1970). 1fur music. *Source – Music of the avant garde*, issue No. 9, 60–63. (Ed.) Larry Austin. California: Composer/Performer Edition.

Johnson, P. and Gott, R. (1996). Constructivism and evidence from children's ideas. *Science Education*, 80 (5), 561–577.

Keylin, V. (2015). Unauthored music and ready-made landscapes: Aeolian sound sculptures. *Gli spazi della musica*, 4 (2), 68–85. www.ojs.unito.it/index.php/spazidella musica/article/view/1358/1216, accessed 27 August, 2017.

Kinchin, I.M. (2003). Effective teacher-student dialogue: A model from biological education. *Journal of Biological Education*, 37 (3), 110–113.

Lee, M. (1999). Annea Lockwood's Burning Piano, Scruffed Stones, and Noble Snare: Feminist politics and sound sources in music. *Women and Music*, 3, 59–69.

Lockwood, A. (1968–1982). *Piano transplants*. www.annealockwood.com/compositions/pianotransplants.htm, accessed 26 June, 2017.

Lockwood, A. (1971a). Piano Burning. *Source – Music of the avant garde*, issue No. 9, 48. (Ed.) Larry Austin. California: Composer/Performer Edition.

Lockwood, A. (1971b). Tiger Balm. *Source – Music of the avant garde*, issue No. 9, 48. (Ed.) Larry Austin. California: Composer/Performer Edition.

Lockwood, A. (1989). *A sound map of the hudson river*. New York: Lovely Music, Ltd. LCD 2081.

Lockwood, A. (1991). Annea Lockwood. *Contemporary Music Review*, 6 (1), 147–150.

Lockwood, A. (2008). *A sound map of the Danube*. New York: Lovely Music, Ltd. 3 CD Set. LCD2083.

Lockwood, A. (2009). Our crowd – Four composers pick composers. *Leonardo Music Journal*, 19, 44–45.

Lora-Totina, A. (1970). English Phenomes. *Source – Music of the avant garde*, issue No. 9, 11–16. (Ed.) Larry Austin. California: Composer/Performer Edition (1971).

Lovely Music. (1999). Artists: Annea Lockwood. www.lovely.com/bios/lockwood.html, accessed 25 February, 2020.

Obalk, H. (2000) The unfindable readymade. *Tout-Fait The Marcel Duchamp Studies Online Journal* 1 (2). Retrieved from www.toutfait.com/issues/issue_2/Articles/obalk.html, accessed 13 July, 2016.

Pestova, X. (2013) 5 questions to Annea Lockwood (composer, sound artist). *I care if you listen*, 26 July. Accessed at https://www.icareifyoulisten.com/2013/07/5-questions-to-annea-lockwood-composer-sound-artist/ on 25 February 2020.

Pressing, J. (1994). *Compositions for improvisers: An Australian perspective*. (Ed.) J. Pressing. Bundoora, Victoria, Australia: La Trobe University Press.

Rodgers, T. (2010). *Pink noises: Women on electronic music and sound*. Durham and London: Duke University Press.

Rojas-Drummond, S., Torreblanca, O., Pedraza, H., Vélez, M. and Guzmán, K. (2013). 'Dialogic scaffolding': Enhancing learning and understanding in collaborative contexts. *Learning, Culture and Social Interaction*, 2, 11–21.

Rubidge, S. (2004) Artists in the academy: Reflections on artistic practice as research. Downloaded 27 2 20 file:///C:/Users/Diana/Downloads/ArtistsintheAcademy.pdf

Russolo, L. (1986). *The art of noises* (trans. Barclay Brown). New York: Pendragon Press.

Slonimsky, N. (1965). Mödius Strip-Tease. *Source – Music of the avant garde*, issue No. 9, 64–66. (Ed.) Larry Austin. California: Composer/Performer Edition. (1971).

Small, C. (1998). *Musicking*. Hanover, USA: Wesleyan University Press.

Smith, G. (1996). *Composing after cage*. Unpublished Doctoral thesis, University of Hud-
 dersfield, UK. Retrieved from http://eprints.hud.ac.uk/6915/, accessed 28 January, 2016.
Stockhausen, K. (1996). Electroacoustic performance practice. *Perspectives of New Music*,
 34 (1), Winter, 74–105.
Taruskin, R. (1992). Tradition and authority. *Early Music*, 20 (2), 311–325.
Whiteoak, J. (2002). Unorthodox adlibbers. *Sounds Australian*, 59, 30–32.

Teaching approaches

Student collaboration

3 All together now

Semi-autonomous ensemble building through collaboration

Eleanor McPhee

Introduction

In recent times the university environment for music has been subject to economic pressures (Bentley et al. 2013; Harman 2005, 2006) with decreased traditional performing opportunities for music graduates (Bennett 2013; Letts 2000). Some institutions have attempted to adjust to provide a "learning experience that produces multi-skilled and adaptable graduates who are self-monitoring and self-directing" (Lebler 2007: 205). This has led to positive developments in the ways that students learn and academics teach performance, changes that require a pedagogical shift from content delivery to capacity building in which the development of self-directed learning becomes an explicit goal (Lebler 2007). Capacity building requires students to take on much of the work that was traditionally the teacher's domain (Blom and Encarnacao 2012; Blom and Poole 2004; Coombes et al. 2013; Green 2006; Lebler 2007) and in order to facilitate this, teachers must move away from a didactic and instructional approach and take a guiding role. Contemporary pedagogy has taken a pendulum swing from "sage-on-the-stage" to "guide-on-the-side" representing a change in focus from teacher to learner (McWilliam 2008: 265). McWilliam convincingly argues for the importance of "meddler-in-the-middle", a definition that "positions the teacher and student as mutually involved in assembling and disassembling cultural products" (263).

A recent prioritisation of group music-making over a default focus on soloists by conservatoires responds to the economic pressures outlined above in a way that allows for student-centred learning whilst positioning the role of the teacher as "meddler-in-the-middle". Facilitating opportunities for learning from peers within a community of practice, group music-making builds the skills necessary for the diverse musical activities undertaken by the contemporary musician (Bennett 2013; Rogers 2002). This chapter discusses the experiences of groups of second year students in an undergraduate music program. The second year performance unit within which this learning takes place is unusual because, rather than utilising a more traditional passive transmission form of music teaching in which the staff member dictates the musical and creative direction of the ensembles, it incorporates the informal learning practices of a garage

band (Green 2001; Jaffurs 2004) where learning is autonomous, self-directed and rarely utilises the feedback of a director. It does this through an understanding, shared by teacher and students, that the teacher's role is one of facilitation and the student ensembles will function as communities of practice (Lave and Wenger 1991) in which all participants use their unique experiences and expertise for the good of the group.

The following questions guided this study:

* How do students build ensembles with minimal teacher intervention? What is the process?
* What are the strengths and weaknesses of working in this way according to the students and staff member?
* What were the expansive learning outcomes[1]?

Literature review

Small ensembles involve a unique form of musical and social collaboration because they do not utilise a leader in the form of a conductor. In recent years research has investigated issues emerging from this type of collaboration including leadership (Murnighan and Conlon 1991), group dynamics (Blum 1986; Butterworth 1990; Ford and Davidson 2003; King 2006), verbal and non-verbal communication (Bayley 2012; Davidson and Good 2002; Ginsborg and King 2007; Goodman 2002; Williamon and Davidson 2002), issues of rehearsal (Ginsborg 2009), creativity (Reid and Bennett 2014; Wilson and MacDonald 2012) and, in the case of student ensembles, assessment practices (Blom and Encarnacao 2012; Blom and Poole 2004; Burt-Perkins and Mills 2008; Harrison et al. 2013). A further issue becomes apparent, when considering the role of the small or chamber ensemble in a teaching and learning context, which is that of identifying and describing the types of learning gained from ensemble building activities that only indirectly involve a teacher or director. This is not something that has been comprehensively investigated. Some notable exceptions, however, are Burt-Perkins (2008), Burt-Perkins and Lebler (2008) and Burt-Perkins and Mills (2008), all investigations of aspects of the same study, the Learning to Perform Project which examined student learning in a United Kingdom conservatoire with a view to providing a "new understanding of how Western classical musicians are created and how their learning experiences and outcomes can be enhanced" (Burt-Perkins 2008: 2). One of the outcomes of this research was that musical expertise is not achieved through a narrowing of focus; rather, students are more likely to become successful musicians if they engage in "expansive learning".

Expansive learning has been defined as "participation in multiple communities of practice inside and outside the formal educational setting; opportunities to extend identity through boundary crossing" (Fuller and Unwin 2003: 411). The concept of "communities of practice" was developed by Wenger (1998) to describe the situated learning that occurs in actual working practices (Lave and

Wenger 1991; Orr 1996; Wenger 1998). Lave and Wenger define a community of practice as "a system of relationships between people, activities, and the world; developing with time, and in relation to other tangential and overlapping communities of practice" (98). For music students, a small ensemble is a community in which musicians share common goals and negotiate musical and communicative meaning with other musicians.

Burt-Perkins and Lebler (2008) note that, for music students, expansive learning situations might be:

> working in a range of musical genres, teaching their instrument to others, working in schools, reflecting on their own learning or engaging in any other activity that takes them outside of their immediate area of expertise, or that encourages them to work creatively to enhance their learning.
>
> (10)

Participating in small and semi-autonomous ensembles represents a way in which students can engage in expansive learning as these ensembles create an environment that facilitates student reflection, encourages creativity and, particularly in the second year performance learning environment of Western Sydney University (see Context section below), takes students outside their areas of expertise. Crucially, Burt-Perkins (2008) notes that expansive learning depends on a concurrent depth and breadth of knowledge to build a broad approach to learning, and learning through others is a key part of this. The student participants in the Learning to Perform Project were able "to build on their concept of what it is to be a musician". Furthermore, both giving and receiving critique improves learning (Burt-Perkins 2008).

Of particular relevance to expansive learning in this chapter is the idea of working creatively to enhance learning. Research suggests that creativity involves a two-stage process of idea generation and idea evaluation (Basadur et al. 1982; Silvia 2008) and neuropsychological studies suggest that the strict evaluation of ideas constrains idea generation (Nijstad et al. 2010; Sowden et al. 2015). Within the realm of performing arts, research has found that training in improvisation has an enhancing effect on performance and performers who improvise score higher on creativity measures (Benedek et al. 2014; Fink and Woschnjak 2011; Kleinmintz et al. 2014). Kleinmintz et al. (2014) found that musicians trained in improvisation scored higher on fluency and originality in divergent thinking tasks as compared to non-improvising musicians and non-musicians. From this the researchers hypothesise that "deliberate practice of improvisation may have a 'releasing effect' on creativity" (1).

The outcomes of the Learning to Perform Project, as they relate to a student's development of expansive learning in conjunction with research on creativity to enhance learning, will be used as a frame for the discussion in this chapter, to view students' experiences in semi-autonomous ensembles in order to further describe the benefits of the expansive learning experienced by students.

Methodology

Context

The unit under investigation is a second year group music performance unit in the Bachelor of Music degree at Western Sydney University, taught by two colleagues and myself. This unit does not take a traditional approach to group music-making, as the cohort's prior musical learning experiences range from the traditional conservatoire model of one-on-one instrumental lessons through to peer directed popular music-making practices. All students have undertaken units exploring a variety of approaches to improvisation in first year which it is expected will inform their performance thinking.

For this unit, academic staff proposed potential ensembles and suggested repertoire to students based on the musical skills of the class, many of whom nominated participation on more than one instrument. Following this presentation, students chose three ensembles in order of preference. The unit coordinator allocated students to ensembles following their preferences as much as possible but also took into consideration each ensemble's requirements. Once ensembles were formed, the students had seven two-hour rehearsal sessions over a semester to prepare a ten-minute program for assessment with a mid-semester assessment taking place after the third rehearsal. Students also received a number of lectures on issues to do with aspects of group performance, including group dynamics, group formation, roles of group members and leadership issues.

At the first rehearsal ensembles were provided with sheet music[2], between one and four pieces depending on the complexity of the music. My colleagues and I then discussed with each group the musical contexts of the repertoire choices using recordings as examples. From this point each group was required to create a performance with minimal teacher intervention. My role was not to direct the ensembles in a traditional sense, rather it was to serve the students by providing encouragement, musical advice and suggestions as each ensemble required. Staff divided their time between ensembles and this resulted in each ensemble working with teacher input for 30–45 minutes and working autonomously for the rest of each two-hour period.

The ensembles under investigation are:

- Year 1 of study: a choir of 18 students; a 1920s silent film ensemble of clarinet, tenor saxophone, tuba, piano and kit; and a guitar ensemble created to perform Steve Reich's *Electric Counterpoint*.
- Year 2 of study: a choir of 12 students; and a 1920s silent film ensemble of alto and tenor saxophones, trumpet, guitar, bass, piano, kit and electronic Foley sound effects performed live from an iPad.

Participants

Participants took part in one of two one-hour focus group discussions and were all members of the aforementioned groups. The 2013 focus group was made up of five students, three from the choir and one each from the Reich guitar and Silent Film groups. The 2014 focus group had eight participants, five from choir and three from Silent Film groups (see Table 3.1). All were invited from the researcher's ensembles, however one participant expressed interest in being involved from an ensemble which operated in a similar manner – the Reich ensemble.

The researcher as participant

I placed a learning framework on students through repertoire choice. So, for example, the Silent Film ensembles were given a selection of repertoire from the Bradford Theatre Silent Film Collection[3] and a selection of short films from the silent era to choose from. I did not allow students to strip the audio from more modern films or use their own music choices because I wanted all the ensembles to think carefully about the aesthetic and communicative potential of a particular genre. Once students had researched, discussed and deeply considered the context for their music I continually communicated and reinforced the idea that all ideas and suggestions are equally valid and every suggestion from all ensemble members should be tried out and considered. Beyond this framework, I saw my role very much as "meddler-in-the-middle". I entered

Table 3.1 Focus group participants

Participants from year 1 ensembles			
William*	M	Clarinet	Silent Film
Adrian	M	Guitar	Guitar
Nyree	F	Alto	Choir
Rebecca	F	Soprano	Choir
Richard	M	Bass	Choir
Participants from year 2 ensembles			
Warwick	M	Bass	Choir
Tiffany	F	Alto	Choir
Jade	F	Soprano	Choir
Jack	M	Bass/Piano	Choir
Peter	M	Tenor	Choir
Luke	M	Trumpet	Silent Film
Michael	M	Tenor Saxophone	Silent Film
Mark	M	Bass	Silent Film

*pseudonyms

each rehearsal space at different times across the two-hour period and each group presented a segment of what they were working on. I listened, offered suggestions and we discussed these suggestions as a group, applied the ideas that arose from these discussions and experimented. Perhaps due to the fact that students were free to experiment without teacher help for a large part of each rehearsal, my suggestions tended to be mostly to do with issues involving each ensemble's ability to communicate effectively within a large performance space; issues such as balance, diction and stage presence.

Data collection

All students were invited via email to participate in the focus groups after each unit had finished. Focus group discussion was chosen to be an appropriate data collection method because it encourages "interactions among participants [which would] stimulate them to state feelings, perceptions, and beliefs that they would not express if interviewed individually" (Gall et al. 1996: 308). Furthermore, it allows participants to "consider their views in the context of the views of others" (Patton 2002: 24). Focus groups also allow the researcher the opportunity to observe the interaction and discussion processes of the group (Cohen et al. 2007; Ticehurst and Veal 2000). The questions posed to each focus group (Table 3.2) were designed to be open-ended enough to encourage in-depth discussion and reflection.

Data analysis

A constant comparative method (Glaser 1992; Glaser and Strauss 1967; Strauss 1987) was used to analyse the focus group data. This involved identifying themes in the data and comparing these with previous themes and classifications in order to make connections between themes (Boeije 2002). The process was conducted using the browser-based mixed methods data analysis software package, Dedoose (2014).

Table 3.2 Focus group questions

What were the rehearsal processes used to learn your repertoire?

How was ensemble leadership negotiated?

What were the strengths of working autonomously?

What were the weaknesses/problems with working autonomously?

How did you negotiate creative conflicts?

What particular strategies did you find useful in your rehearsal process? Where did you learn these strategies?

Results and discussion

Three themes that illuminate the processes of semi-autonomous ensembles emerged strongly from the data:

* the communicative skills utilised for the rehearsal process;
* the planning and organisational skills needed to learn ensemble repertoire; and
* the creative skills used to build a performance that is unique to the performers.

Of equal relevance to these themes is the ways that these issues revealed themselves and impacted upon each other during the seven-workshop rehearsal period, beginning with the score itself. Discussion, therefore, will follow the order in which the issues appeared for the ensembles. A flow chart of this process appears below (Figure 3.1). This is followed by discussion of one ensemble that did not follow this rehearsal process along with a hypothesis as to why this difference appeared.

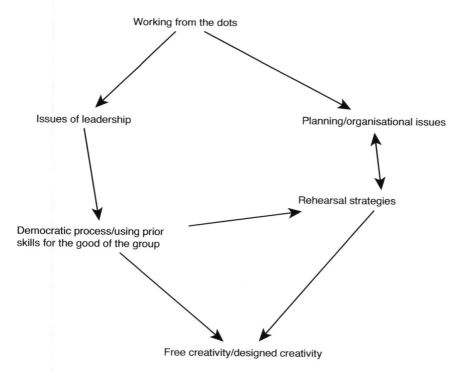

Figure 3.1 Rehearsal process chart

The beginning: working from the dots

All ensembles were given a selection of repertoire to work on, chosen by the teachers. This posed a number of challenges for the ensembles, the biggest being the initial difficulties of reading complex sheet music as many students were used to working in an aural and improvisational mode and, in the case of the choirs, many had not previously been exposed to the unique difficulties of sight-singing. For the students who came to the classes from contemporary traditions that focus on aural learning, the difficulties of sight-reading were compounded by the perceived lack of creativity inherent in notated music.

ADRIAN: I personally, I mean I know this is an academic no-no but I personally hated that piece. ... you had to get all the parts as is because if you changed one note then the whole harmony is ruined. (Guitar – Reich Ensemble).

Adrian went on to note that his ensemble found the Reich very inflexible but he found some scope for creativity through varying the timbre and this became a way of learning to appreciate the piece for this ensemble.

ADRIAN: It's another restriction that you had to reduce your creativity to something else. So instead of "oh we can improvise with it", it's "what other things can we do to make this our own?" It was restrictive but it was good in that way. (Guitar – Reich Ensemble).

This belief in the inflexibility of notated music held true even for the wind players who were all excellent sight-readers and were also very comfortable improvising in the early jazz style of their music.

WILLIAM: ...playing with written music like that, especially for the Silent Movie ensemble, I knew it wasn't going to be incredibly creative, you know, it was just going to be reading and playing like, ensemble playing kind of thing. (Clarinet – Silent Film Year 1).

For these groups, being handed sheet music removed them, as an ensemble, from the creative, aural and improvisational rehearsal processes that were the norm for most of them, informed by their own practices as musicians and the first year undergraduate performance experience. On the other hand, the sheet music became a powerful organisational tool for rehearsal planning as its rigidity as a visual artefact made it a stable and unchanging element:

WILLIAM: If there were differences, or if someone was playing something a bit out you can always kinda see what they're doing and run through it that way, so there was always something physical you can go off. (Clarinet – Silent Film Year 1).

Rehearsal planning and strategies

Learning unfamiliar repertoire in a limited time frame, the ensembles found that they needed to come up with a plan in order to learn the music in an efficient manner. As organisational and rehearsal planning issues arose the ensembles responded with rehearsal strategies. None of the ensembles mapped out a rehearsal plan from the outset nor had a clear approach for the seven workshops as a whole. All rehearsal planning was done in a reactive way to problems as they arose and, initially, all the ensembles organised their rehearsal time around the amount of music that they could get through in each two-hour workshop.

ADRIAN: ... like today we'll try and get the first 80 bars or something like that because it was a very complicated piece. It's not like verse-chorus, verse-chorus, it just evolves, the Steve Reich piece, so we'd just try to do as much as we can. (Guitar – Reich Ensemble).

EM: That's a reasonable way of planning....

NYREE: I think so too [but] we found that some people didn't go away and do that. Then you'd go back to where you were the week before, so you kind of didn't progress as much as you'd hoped. (Alto – Choir Year 1).

Nyree's comment provides a glimpse into the rumblings of discontent that were growing in some of the ensembles when she places blame on the rehearsal preparation of others for a perceived lack of progress. I believe that the problem lay in the enormous difficulty in learning a vocal part without its full context, rather than the fault lying with any individual member's lack of preparation. The choirs also came to this realisation because their next strategy involved the use of recordings and active, score-based listening during rehearsals as well as the creation of rehearsal tracks in music software to aid practice at home. This strategy is something all the ensembles arrived at although only the choirs created their own rehearsal tracks, a reflection, perhaps, of the greater difficulty of sight-singing as compared to sight-reading on a melody instrument. Rebecca and Nyree describe the distinct purposes of their recordings:

REBECCA: The individual recordings were to learn our parts by themselves. (Soprano – Choir Year 1).

NYREE: So we actually had a solid idea of what it was. (Alto – Choir Year 1).

REBECCA: Then we'd always try and stick to it as a group. That's what the larger recordings are for. (Soprano – Choir Year 1).

The wind groups also worked with recordings of professional performances, not to learn the music but to get the repertoire stylistically correct:

WILLIAM: Especially in that style of music, you don't want to break too far from what it is, ... for silent movies. If you start breaking things down, you start

making it a bit too crazy, you kind of lose what it's about; because it's about traditions, that sort of music. (Clarinet – Silent Film Year 1).

All the ensembles recorded their rehearsals and critiqued these as a group in order to more easily identify problems:

WILLIAM: And we recorded as well just so we can look back and go, "All right, we need to tighten this section up..." or this harmonic content needed to be worked on. (Clarinet – Silent Film Year 1).

Learning from peers

The issue that Nyree alludes to in the rehearsal planning and strategies section, that of the different abilities and skill levels of rehearsal members, led to the ensembles developing strategies to facilitate peer-learning. The students were all reluctant to be seen to be teaching their peers and they all framed their discussion in terms which highlighted the various expertise of all ensemble members. Thus, for this student body, there were no weaker and stronger students, rather each student had unique skills which could be brought into service for the good of the group as the situation required. This is highly commendable and very different from my own experiences as an undergraduate music student in a degree that was taught following a classical/conservatory approach where one-on-one learning was the primary mode for performance. This tended to lead to competition amongst peers and a strong sense of where one fitted in the hierarchy of talent and ability. The difference is perhaps in part due to the fact that a large number of students in these ensembles were not participating on their principal instruments and many volunteered for roles outside their strengths for the good of the ensemble as a whole. An example of this is Jack, a guitarist who asked to sing in the 2014 choir and then volunteered to play piano so the ensemble could perform an arrangement they particularly liked.

Strategies to facilitate peer-learning without calling attention to weaker performers involved groups breaking into smaller sectional rehearsals and reworking music to highlight individual strengths. The choirs and Reich group utilised some form of sectional as a peer-learning tool with varying success. The choirs found that sectionals were useful in order to learn individual parts but also useful as a peer-learning tool because they allowed stronger peers to help the weaker without the possible confrontation and embarrassment of the whole ensemble as an audience.

TIFFANY: ...we broke into our alto group; because there was two parts. Two of us could play piano and kind of sight-read so we kind of worked it out and went along with that. But I think in most of the groups there was at least someone in their part that could play the piano or work it out and if not, one of the other guys would step up and say, "Hey, this is how it goes." There were a variety of people who couldn't sight-read, which made it harder but in the end we pulled through, [with help from] the people who could. (Alto – Choir Year 2).

This quote illustrates the ways these students frame a possible issue of stronger and weaker musicians as simply one of students using unique strengths for the good of the group. In this case, the pianists positioned themselves as "teachers" of the non-pianists because they had necessary and unique skills, not because they were somehow stronger musicians.

The guitar group took a different approach to the use of sectionals as a learning strategy. Whereas the choirs separated into groups for each vocal line, the guitar ensemble adopted a buddy system consisting of one proficient sight-reader and one weaker sight-reader. Adrian felt that this highlighted the differences between ensemble members and was a hindrance rather than a help.

ADRIAN: Since we were in pairs, if someone was sort of lagging behind in ability then it was pretty obvious because there'd be the one part and you'd just hear the differences, it'd put you off. (Guitar – Reich Ensemble).

Leadership

Problems inherent in negotiating leadership loomed large for all groups but one. In each ensemble, either a leader appeared organically or leadership was shared between ensemble members depending on the nature of the musical problem and the unique skills of the leader. Discomfort with the leadership role was mentioned:

ADRIAN: We'd try to do that without being... we were trying to be sensitive about it, saying, "Look, you're not playing this part well enough. Maybe you should stick to these sorta notes, not play as much..." It sounds slack but as a group performance, you're sort of looking at your part but also looking at the thing as a whole; especially if you're like assuming the leader position then you have to sort of... I dunno. (Guitar – Reich Ensemble).
EM: Lead?

Whether a group developed a single permanent leader or the leadership was shared between many, all leaders shared a common sense that they had skills developed prior to this context that could serve the ensemble, and this understanding was the impetus behind assuming a leadership role. William describes prior leadership experiences he brought to his ensemble but is quick to point out that all ensemble members were equally motivated to produce a good performance.

WILLIAM: We were all playing and stuff, but I may have made a few more suggestions than other people and try to run it a bit more because I've had a bit of band experience, running charts and stuff. It is frustrating if a rehearsal isn't run well; if you just ran through something and you're just not getting anywhere and you're just not addressing certain issues...

it's really frustrating. But there were other people who were focused and wanted the same thing, wanted good outcomes from the rehearsal. (Clarinet – Silent Film 1).

Leaders were also able to describe leadership skills acquired in non-musical contexts and clearly articulated the transferability of these.

ADRIAN: It just happened naturally, I think; just 'cause I do that sort of stuff at work, training and delegating and that sort of stuff, and just noticing different habits of people. Like, mucking about. It wasn't like I planned on doing that sort of thing, it was just like, "Hey, come on, let's just get it started." It just happened. (Guitar – Reich Ensemble).

Perhaps as a result of the strong sense of collegiality across both student year groups, none of the leaders were prepared to admit to taking charge of the rehearsal process. Instead, there was a firm and shared understanding that leadership occurred passively and perhaps a little reluctantly as the previous example attests.

Whether ensembles developed a single leader or shared leadership, they all shared a very democratic rehearsal process in which every member shared in the decision-making and the leader's role was to ensure the smooth running of this democratic process. This gave rise to a "leader as facilitator" model of ensemble leadership.

MARK: You're all collectively wanting to make a good project, you're all reaching for the same goal and everyone seems fairly equally motivated to do that. So all you need is for someone to make a few suggestions. (Bass – Silent Film Year 2).

Both choirs were initially the exceptions to the "leader as facilitator" model. Both had a single assertive and highly organised member who took control of the ensemble from the beginning. Over the course of the first three workshops these leaders unilaterally made musical and organisational choices and the other ensemble members came to believe that they had no say in the steering of the ensemble and lost motivation.

NYREE: You kind of lost your sense of wanting to do it. (Alto – Choir Year 1).
REBECCA: Yeah, it was no longer a collaboration, it was more of a… being instructed to do things. (Soprano – Choir Year 1).
RICHARD: Told to. (Bass – Choir Year 1).
REBECCA: Everybody started to zone out and then started to, you know, go in their own worlds and kinda not concentrate. (Soprano – Choir Year 1).

As a response to this problem, both choirs developed remarkably similar and formal democratic processes to solve the leadership issue. They decided that

all musical suggestions from group members would be tried out to ensure that all ideas were heard rather than dismissed out of hand. Generally this meant that the group could see in practice whether something worked or not. When differences of approach still persisted the issue was put to a vote. Jade noted that there were quite a few assertive people in the choir but most problems could be solved with clear and non-accusatory communication. To the credit of both leaders involved, one stepped back to allow another leader to take her place and the second worked with the democratic processes implemented by the group.

Creativity

Once the repertoire was learnt the ensembles found that they could then introduce some more creative thinking. Two distinct types of creativity emerged during this process. The first is a type that Schön (1987) calls "a kind of designing" (175) in which the performer must make creative choices within the parameters of the directions given by the notation. The second is the freer creativity that improvisation and arrangement allows. Although all the groups came to the first workshop with an attitude that notated music precludes a creative approach as seen in the discussion of the score, they came to appreciate the designing and problem-solving skills gained from working within a more restricted creative frame.

ADRIAN: ...we had a bit of... timbral individualism so we could make it our own. A lot of his music is very... we had to pretty much keep it the same – which was all right. It's another restriction that you had to reduce your creativity to something else. (Guitar – Reich Ensemble).

Improvisational creativity was accommodated as much as possible through music choices. The Silent Film groups' scores were of a genre in which improvised chorus sections were a usual performance practice and the choirs were given at least one piece of a more experimental nature[4] to allow students to create their own arrangements of the score. Even in this freer creative mode, the students still had a sense of restriction in that they had to work stylistically within the genre of the score although they came to see this as being an interesting creative problem rather than lacking in creativity as they had in the beginning.

WILLIAM: But that was a creative thing, tailoring it to the film and of course, we picked the film And we did have to improvise in sections. But even in that, a lot of us, me and the sax player, we're playing jazz stuff where we swing. In the twenties music they don't have swing yet, they have this sort of ... almost back beat quaver thing. So you can't go swinging it because that would be wrong for the style. That was a bit restricted but it was cool because

it was the kind of thing like 'how do I develop this melody, I'm not used to this style...' (Clarinet – Silent Film Year 1).

The Silent Film groups found that the film itself was a powerful scaffold for creative thinking because when arriving at the point where the music was learnt, as Mark noted, "the temptation is to just keep drilling down to make the music more and more tight". The film forced a change of approach because it required the music to be taken apart and rearranged to fit with the film and then improvised sections were used to make the film and music coordinate.

One of these things is not like the other

The Silent Film group in the second year of the study was the only group that seemed to have no creative conflicts. As Mark stated: "our group just seemed to gel right from the beginning". This group had a reluctant leader in Michael, much like many of the other group leaders, and, like the others, Michael was able to lead in a way that gave every ensemble member a voice.

MICHAEL: I just took on the leader role 'cause I was there first setting up and no one else seemed to want to but most of the time I was worried because everyone else is so good. (Tenor Saxophone – Silent Film Year 2).

A notable difference between this group's rehearsal process and the others is their improvisational approach to rehearsal. Whereas all other groups began the rehearsal process from a read-through of the score and allowed the score to dictate all rehearsal decisions until quite late in the semester, the 2014 Silent Film group spent 15 minutes or so at the beginning of each rehearsal just jamming or "fiddling around", a process that Schutz (1951) describes as "tuning in" (92). This jamming process affected the ensemble's rehearsal process in two ways. Firstly, it allowed the ensemble to create improvised material which became the middle section of the final performance; secondly it developed into a non-verbal and communicative tool. Luke commented that this was his preferred way of communicating musically: "Why try to explain something when you can just blow?" The issues raised during the course of the semester and the students' solutions to these are tabled below (Table 3.3).

Conclusions

The students built ensembles semi-autonomously, with minimal teacher intervention, by responding to problems in a reactive way as they arose from an initial reading of

Table 3.3 Student devised rehearsal strategies

	Issues raised	Student devised strategies
Communicative strategies	Negotiating leadership	• Alternate leaders • Allow various leaders for specific areas of expertise • Use some rehearsal time to create sectionals so that smaller groups can work simultaneously • Try leading by playing/demonstrating rather than describing • Lead by asking such questions as "Which parts do you have problems with?", "How do you want to approach the phrasing of section A?"
	Resolving conflicts	• Make time in rehearsal to ask every member to comment and systematically try every member's suggestions whether you like the idea or not • Where creative conflicts can't be resolved, vote on outcomes • Use the last ten minutes of rehearsal to reflect on the rehearsal, plan for the next one and air any conflicts that might arise
Planning and organisational strategies	Structuring rehearsal time	• Begin each rehearsal with a warm up or improvisation session to help members notice each other's sound, style and playing gestures • Plan objectives for each rehearsal • Have a plan of what you want to achieve each week
	Coordinating the rehearsal	• Don't always work front to back. Think of the music in terms of units which can be worked on independently of the whole. • Record/video sections of rehearsal when problems arise in order to remember the intricacies of the issue when practising alone • Systematically give segments of time to specific musical issues i.e. 15 mins on dynamics, 15 mins on balance and blend, 15 mins on breathing and diction etc.
	Other organisational issues	• Use social media or email to easily communicate outside scheduled rehearsal time • Make time for the whole ensemble to practise outside class time • Share recordings within the group

(*Continued*)

Table 3.3 (Cont.)

	Issues raised	Student devised strategies
Creativity issues	Creativity within the bounds of notation	• Find recordings of your pieces. Compare a variety of interpretations. There might be more scope for creativity then you think. • Take an experimental approach to the stylistic markings in the music; is there such a thing as too loud? Too soft? Too articulated? • Vary the tempi. How does this change the character of the piece? • Experiment with the instrumentation, structure, arrangement • Improvise

the score. No planned approach appeared at the outset. Although all students had been involved in highly creative music-making processes prior to this unit, the use of a score seemed to lead to a passivity of approach in the students, following an expectation that the score itself would drive the rehearsal process. This attitude to notated music in all ensembles except one resulted in the students initially measuring early rehearsal success based on the quantity of music learnt. This resonates with Reid and Bennett's investigation of music students' beliefs about creativity (2014). When this quantitative measure wasn't achieved, the students searched for rehearsal strategies that would more effectively facilitate music learning according to the amount of score accurately learnt. These strategies were the use of recordings, situations to facilitate peer-learning in the form of sectionals and finding non-confrontational and encouraging ways to give feedback.

Issues to do with leadership arose in conjunction with the development of strategies to facilitate music learning. Like other studies (Burt-Perkins and Mills 2008; Davidson and Good 2002; King 2006), this one highlighted the difficulties that students are faced with when required to collaborate effectively and take control of their own leadership. All groups were very committed to the group music-making process and the inevitable assessment of these ensembles really didn't create friction in the way seen in other studies of this nature (Burt-Perkins and Mills 2008; Harrison et al. 2013). This was a surprise to me as meddler-in-the-middle, and resulted in the unusual ensemble role of the "reluctant leader", a departure from prior research on ensemble leadership (Davidson and Good 2002; King 2006).

Unsurprisingly, issues of leadership and negotiating conflicts were seen as a big weakness in working semi-autonomously according to this student group and these are discussed above. The strength of working semi-

autonomously was considered to be the freedom to experiment. The students recognised the potential for designed creativity (Schön 1987) in notated music toward the end of the rehearsal process and changes in their beliefs about this from the beginning of this process to the end were substantial. Although this change was also found by Reid and Bennett (2014), I found the disconnect between creative practices and notated music assumed by many students to be surprising given that this group, unlike Reid and Bennett's (2014), had had immersive prior experiences in contemporary, aural and improvisational musical practices. This prior training should predispose them to take a more original and creative approach to the notated music presented (Benedek et al. 2014; Fink and Woschnjak 2011; Kleinmintz et al. 2014). My recommendations on addressing this are discussed in the postscript of this chapter.

The expansive learning outcomes of this process grew from the twin issues of designed creativity and leadership and are entwined. In this semi-autonomous context the students had to take active control of their learning, and leadership tensions were an inevitable result of this process. The students were able to describe and understand the ways that their prior skills and experiences benefited their music learning and they shared in a fluid leadership role as individual skills could meet the needs of the ensemble.

Expansive learning is also evident in changing attitudes to musical creativity. Students discovered, through the process of ensemble building, that musical creativity and notated music were not mutually exclusive. A passive approach to preparing notated music "*it was just going to be reading and playing like, ensemble playing kind of thing*" became an active, questioning and reflective approach "*That was a bit restricted but it was cool because it was the kind of thing like 'how do I develop this melody, I'm not used to this style ... '*". The ensemble that incorporated free improvisation into their process from the beginning found a way to broker a relationship between ensemble communication and leadership issues and creativity because their process of "tuning in" led to a system of non-verbal communication that subverted the potentially emotion-laden leadership issues of the other ensembles.

An action research postscript

The issues discussed in this study are by no means finite as they are drawn from subjective discussions on the processes of a small sample. Nevertheless, they provide some preliminary insight into the unique educational environment of the semi-autonomous ensemble. A notable issue for me, as their "meddler-in-the-middle", was to find ways to draw connections between the students' improvisational prior learning experiences and their approaches to notated music. I will be teaching first year choirs who will then become the third second year cohort to participate in this study and I plan to make these relationships explicit. Perhaps this will lead to a situation in which the creativity measured by

Kleinmintz et al. (2014) in originality and fluency scores can be evidenced as musically informed creative decisions from the outset.

Notes

1 Expansive learning is defined in the following section.
2 Although the ensembles under investigation here used sheet music, others were involved in an ensemble process that worked from recordings and lead sheets to build a performance.
3 For more information on this see Thorp, J. and McPhee, E. (2011). Alternate sound tracks: Silent film music for contemporary audiences. *Screen Sound Journal*, 2, 64–74.
4 Kee, J. P. (1993). Lily in the valley [score]. In T Backhouse (Ed.), *Move On Up: An A Cappella gospel songbook for choirs and quartets*. 24–26. Bondi, NSW: École de Fromage.
 Maierhofer, L. (2005). Om shanti om [score]. In L. Maierhofer (Ed.), *Sing and Swing: Das Chorbuch*. 215. Rum/Innsbruck: Helbling Verlag.

References

Basadur, M., Graen, G. B. and Green, S. G. (1982). Training in creative problem solving: Effects on ideation and problem finding and solving in an industrial research organization. *Organizational Behavior and Human Performance*, 30 (1), 41–70.

Bayley, A. (2012). Ethnographic research into contemporary string quartet rehearsal. *Ethnomusicology Forum*, 20 (3), 385–411.

Benedek, M., Borovnjak, B., Neubauer, A. C. and Kruse-Weber, S. (2014). Creativity and personality in classical, jazz and folk musicians. *Personality and Individual Differences*, 63, 117–121.

Bennett, D. (2013). *Understanding the classical music profession: The past, the present and strategies for the future*. Aldershot: Ashgate.

Bentley, P. J., Coates, H., Dobson, I. R., Goedegebuure, L. and Meek, V. L. (2013). Academic job satisfaction from an international comparative perspective: Factors associated with satisfaction across 12 countries. In P. J. Bentley, H. Coates, I. R. Dobson, L. Goedegebuure and V. L. Meek (Eds.), *Job satisfaction around the academic world*. 239–262. Berlin: Springer.

Blom, D. and Encarnacao, J. (2012). Student-chosen criteria for peer assessment of tertiary rock groups in rehearsal and performance: What's important? *British Journal of Music Education*, 29 (1), 25–43.

Blom, D. and Poole, K. (2004). Peer assessment of tertiary music performance: Opportunities for understanding performance assessment and performing through experience and self-reflection. *British Journal of Music Education*, 21 (1), 111–125.

Blum, D. (1986). *The art of quartet playing: The Guarneri String Quartet in conversation with David Blum*. New York: Cornell University Press.

Boeije, H. (2002). A purposeful approach to the constant comparative method in the analysis of qualitative interviews. *Quality & Quantity*, 36, 391–409.

Burt-Perkins, R. (2008). Learning to perform: Enhancing understanding of musical expertise. *Teaching and learning research programme research briefing 47*, London.

Burt-Perkins, R. and Lebler, D. (2008). 'Music isn't one island': The balance between breadth and depth for music students in higher education. In M. Hannan (Ed.), *Proceedings of the 17th international seminar of the Commission for the Education*

of the Professional Musician. 10–14. Australia: International Society for Music Education.

Burt-Perkins, R. and Mills, J. (2008). The role of chamber music in learning to perform: A case study. *Music Performance Research*, 2, 26–35.

Butterworth, T. (1990). Detroit String Quartet. In J. R. Hackman (Ed.), *Groups that work (and thosethat don't)*. 207–224. San Francisco, CA: Jossey-Bass.

Cohen, L., Manion, L. and Morrison, K. (2007). *Research methods in education* (6th Ed.). London: Routledge Falmer.

Coombes, P., Danaher, P. and Danaher, G. (2013). Transforming learning through capacity-building: Maximising life and learning support to mobilise diversities in an Australian pre-undergraduate preparatory program. *The International Journal of the First Year in Higher Education*, 4 (2), 27–37.

Davidson, J. W. and Good, J. (2002). Social and musical coordination between members of a string quartet: An exploratory study. *Psychology of Music*, 30 (2), 186–201.

Dedoose. (2014). *Web application for managing, analyzing, and presenting qualitative and mixed method data (Version 5.0.11)*. Los Angeles, CA: SocioCultural Research Consultants, LLC. https://www.dedoose.com/, accessed 31 July, 2014.

Fink, A. and Woschnjak, S. (2011). Creativity and personality in professional dancers. *Personality and Individual Differences*, 51 (6), 754–758.

Ford, L. and Davidson, J. W. (2003). An investigation of members' roles in wind quintets. *Psychology of Music*, 31 (1), 53–74.

Fuller, A. and Unwin, L. (2003). Learning as apprentices in the contemporary UK workplace: Creating and managing expansive and restrictive participation. *Journal of Education and Work*, 16 (4), 407–426.

Gall, M. D., Borg, W. R. and Gall, J. P. (1996). *Educational research: An introduction* (6th Ed.). New York: Longman.

Ginsborg, J. (2009). Focus, effort and enjoyment in chamber music: Rehearsal strategies of successful and "failed" student ensembles. In A. Williamson, S. Pretty and R. Buck (Eds), *Proceedings of the International Symposium on Performance Science*. Utrecht: AEC.

Ginsborg, J. and King, E. (2007). The roles of expertise and partnership in collaborative rehearsal. In A. Williamson and D. Coimbra (Eds), *Proceedings of the International Symposium on Performance Science*. Utrecht: AEC.

Glaser, B. G. (1992). *Emergence vs. forcing. Basics of grounded theory analysis*. Mill Valley: Sociology Press.

Glaser, B. G. and Strauss, A. L. (1967). *The discovery of grounded theory: Strategies for qualitative research*. Chicago, IL: Aldine.

Goodman, E. C. (2002). Ensemble performance. In J. Rink (Ed.), *Musical performance: A guide to understanding*. 153–167. Cambridge: Cambridge University Press.

Green, L. (2001). *How popular musicians learn: A way ahead for music education*. Burlington, VT: Ashgate.

Green, L. (2006). Popular music education in and for itself, and for 'other' music: Current research in the classroom. *International Journal of Music Education*, 24 (2), 101–118.

Harman, G. (2005). Australian social scientists and transition to a more commercial university environment. *Higher Education Research & Development*, 24 (1), 79–94.

Harman, G. (2006). Adjustment of Australian academics to the new commercial university environment. *Higher Education Policy*, 19 (2), 153–172.

Harrison, S., Lebler, D., Carey, G., Hitchcock, M. and O'Bryan, J. (2013). Making music or gaining grades? Assessment practices in tertiary music ensembles. *British Journal of Music Education*, 30 (1), 27–42.

Jaffurs, S. E. (2004). The impact of informal music learning practices in the classroom, or how I learned how to teach from a garage band. *International Journal of Music Education*, 22 (3), 189–200.

King, E. (2006). The roles of student musicians in quartet rehearsals. *Psychology of Music*, 34 (2), 262–282.

Kleinmintz, O. M., Goldstein, P., Mayseless, N., Abecasis, D. and Shamay-Tsoory, S. G. (2014). Expertise in musical improvisation and creativity: The mediation of idea evaluation. *PLoS ONE*, 9 (7), 1–8.

Lave, J. and Wenger, E. (1991). *Situated learning: Legitimate peripheral participation.* Cambridge: Cambridge University Press.

Lebler, D. (2007). Student as master? Reflections on a learning innovation in popular music pedagogy. *International Journal of Music Education*, 25 (3), 205–221.

Letts, R. (2000). (More than) 100 ways that globalisation affects music. *Music Forum*, 6 (5), 31–39.

McWilliam, E. (2008). Unlearning how to teach. *Innovations in Education and Teaching International*, 45 (3), 263–269.

Murnighan, J. K. and Conlon, D. E. (1991). The dynamics of intense work groups: A study of British string quartets. *Administrative Science Quarterly*, 36 (2), 165–186.

Nijstad B. A., De Dreu C. K., Rietzschel E. F. and Baas M. (2010). The dual pathway to creativity model: Creative ideation as a function of flexibility and persistence. *European Review of Social Psychology*, 21 (1), 34–77.

Orr, J. E. (1996). *Talking about machines: An ethnography of a modern job.* Ithaca, NY and London: IRL Press, an imprint of Cornell University Press.

Patton, M. Q. (2002). *Qualitative research and evaluation methods* (3rd Ed.). Newbury Park London New Delhi: Sage Publications.

Reid, A. and Bennett, D. (2014). Becoming and being a musician: The role of creativity in students' learning and identity formation. Presented at the *20th International Seminar of the Commission for the Education of the Professional Musician*, July 15–18 2014, 15–23. Belo Horizonte, Brazil: International Society for Music Education.

Rogers, R. (2002). *Creating a land with music: The work, education and training of professional musicians in the 21st century.* London: Youth Music.

Schön, D. A. (1987). *Educating the reflective practitioner.* San Francisco, CA: Jossey-Bass Publishers.

Schutz, A. (1951). Making music together: A study in social relationship. *Social Research*, 18 (1), 76–96.

Silvia, P. J. (2008). Discernment and creativity: How well can people identify their most creative ideas? *Psychology of Aesthetics, Creativity, and the Arts*, 2 (3), 139–146.

Sowden, P. T., Pringle, A. and Gabora, L. (2015). The shifting sands of creative thinking: Connections to dual-process theory. *Thinking & Reasoning*, 21 (1), 40–60.

Strauss, A. L. (1987). *Qualitative analysis for social scientists.* Cambridge: Cambridge University Press.

Ticehurst, G. and Veal, A. (2000). *Business research methods: A managerial approach.* Sydney, NSW: Longman.

Wenger, E. (1998). *Communities of practice, learning, meaning and identity.* Cambridge, USA: Cambridge University Press.

Williamon, A. and Davidson, J. W. (2002). Exploring co-performer communication. *Musicae Scientiae*, 6 (1), 53–72.

Wilson, G. B. and MacDonald, R. A. R. (2012). The sign of silence: Negotiating musical identities in an improvising ensemble. *Psychology of Music*, 40 (5), 558–573.

4 Transformational insights and the singing-self

Investigating reflection and reflexivity in vocal and musical group learning

Diane Hughes

Introduction

In various cultural and historical contexts, recognition of the singer and/or the singing-self is unquestionable. However, for some, identifying as a singer is complex (see Pascale 2005). The pedagogical aims and transformational insights discussed in this chapter highlight that vocal and musical development, with associated artistic sensibilities, may be supported by collaborative learning strategies and contexts. The chapter focuses on group learning and teaching in a tertiary level undergraduate context. The research findings reported in this discussion contribute to interrelated understandings primarily aimed to facilitate transformative learning.

While musical endeavour usually requires shared experiential learning between musicians (and audiences), traditional instrumental learning characteristically involves one-to-one pedagogy (Lebler 2006: 41). This is particularly true of the master-apprentice approach to teaching and learning singing (Callaghan 1998: 25) where technique, repertoire and expression are directed and/or modelled by the master-teacher and learned or appropriated by the student-apprentice. In contrast to the master-apprentice approach, music may now be learned in various ways and can encompass collaborative "informal" learning strategies (Green 2014: 211–212) within a formal learning context (Hughes 2017: 187; Hughes, Monro, Power et al. 2014: 7). Furthermore, a collaborative musical environment provides opportunities for students to explore, create and interact; it facilitates *group learning* that "occurs as a result of peer interaction" (Green 2002: 76). This aligns with collaborative learning theory which typically involves a constructivist approach. For example, King (2008) discusses the significance of social constructivism in relation to peer interaction in, and with, the learning environment (425). In many ways, such peer interaction emulates real-world musical expectations and practices.

The research findings discussed in this chapter identify that a combination of individual and group reflective processes, supported by collaborative real-world contexts and interaction, establish a "dialogic" (Alexander 2010) teaching environment in which a community of musical learners both engage and emerge. The discussion builds on previous research that identified specific curricular

components in vocal studies – namely, vocal and musical creativities, individuality, artistic development and presence, musicality, technologies, and industry practices (Hughes 2017: 182–187). These components were designed to "foster" (Hughes 2017: 188) development of the individual singer. While this discussion also addresses individual vocal learning, the chapter identifies the ways in which the singing-self emerges within a group learning context and examines associated "transformative capabilities" (Hughes 2017: 184, 187).

The following discussion considers the development of the individual student within weekly dialogic (lectorial) and collaborative (tutorial) learning environments. By embedding an informal collaborative context into formal vocal studies curricula, the approach to learning and teaching is distinctly different to traditional pedagogy (Hughes 2015a: 254, 2017: 177). Forming a stream within a Music major and nested within a Bachelor of Arts degree program, vocal studies consists of three sequential subjects – foundation, intermediate and advanced – and is "underpinned by the principle of ongoing singing development and skill acquisition, including critical and reflective thinking and a resultant level of practical autonomy" (Hughes 2015a: 266). The suite of subjects is continually updated to incorporate industry developments; methods of delivery and class sizes have also evolved over time. For example, traditional lectures have been replaced by lectorials, large classes that are "collaborative and interactive" (De La Harpe and Prentice 2011: 4), which precede the smaller student-centred practical tutorials of up to twenty-five students. The realisation of purposively designed assessment tasks and learning outcomes for each level of study (Hughes 2015a: 264) involve dialogic, creative and reflective processes for both formal and informal peer collaboration/interactions.

As this chapter focuses on changes in student perception and transformational insights, the specifics of curricular design and assessment tasks (Hughes 2015a: 256–264), together with detailed curricular components (Hughes 2017), are beyond the scope of this discussion. Instead, the chapter begins by outlining particular pedagogical aims of the contemporary vocal studies and the ways in which curricular design targets individual learning (Hughes 2017: 183–184) within the group context. Student feedback on subject efficacy, together with specific pedagogical aims, informed the research questions that focused on perceptual changes, collaborative strategies and the realisation of the singing-self. The findings identify that a combination of reflection and reflexive action, together with collaborative and interactive contexts, can precipitate perceptual change, transformational insight and resultant transformative learning. The research findings, therefore, attest to the ways in which musical learning may assist both individuality and self-realisation. The chapter concludes with implications for individual learning in the group context.

Pedagogical aims and contexts

Through a range of integrated, analytical, practical and creative tasks (Hughes 2015a: 256–261), the approach to learning in vocal studies in a tertiary level undergraduate program facilitates student initiative in the development of

a complex skill set. It does so in the interrelated context of contemporary popular singing (foundation level), the song (intermediate level) and artistry (advanced level). The overarching pedagogical aim is to facilitate individual learning within the group context (Hughes et al. 2014: 7); specific pedagogical aims differ for each level of study. The foundation subject has non-auditioned entry. The learning objectives at this introductory level enable exploration of the voice as a musical instrument capable of healthy and expressive communication (Hughes 2015a: 264). Learning objectives in the subsequent intermediate level include documented critical listening exercises, and exploration of stylistic song nuances and expressive techniques (Hughes 2015a: 264). At the advanced level, students "identify, demonstrate and integrate individual artistry" (Macquarie University 2017).

Group learning and dialogic interactions

Group learning within each level of study, and within vocal and musical contexts, occurs in several ways. Firstly, the dialogic environment of lectorials provides a level of interaction that is ongoing and sequentially based. Secondly, this environment provides opportunities for critical listening and for listening to others through active student engagement with artist examples and peer analyses, and in collective singing exercises. However, and as Green (2002) explains, "musicians learn not only from listening to each other, but also from watching each other" (82). In tutorials, the opportunities for observing others is heightened as peers sing both individually and collectively. Perhaps, though, the most significant aspects of group learning occur through peer exchanges and the "talking" (79) that occurs in creative interactions. Green elucidates, "[i]n band rehearsals, skills and knowledge are acquired, developed and exchanged via peer direction and group learning from very early stages, not only through playing, talking, watching and listening, but also through working creatively together" (79).

Working collaboratively and creatively is evident in vocal ensembles that are facilitated in the foundation and intermediate levels of study. In these ensembles, students collaborate as they explore musical concepts and vocal expression in their collective arrangements (or compositions) of their chosen songs (Hughes 2015a: 260–261). During ensemble development, students are encouraged to exchange ideas in weekly tutorials and in subsequent non-timetabled student-initiated rehearsal sessions, and online through ensemble discussion forums. At the advanced level, learning interactions continue in lectorials and tutorials; further collaboration occurs in recording and performance assessment tasks with peers, musicians and technicians. When discussing the relevance of collaborative learning, King (2008) highlights that collaboration extends beyond the social context to also involve the "physical environment" (425). This is particularly relevant to the pedagogical aim of providing real-world learning experiences (Hughes et al. 2014) such as those encountered in recording and performing environments. Therefore, students in vocal studies record and

collaborate with recording engineers. They perform in a theatre with tiered audience seating and emulate structured industry performances and practices; they engage with sound technicians as they utilise the performance space that includes reinforced sound and stage lighting. In addition to providing aural feedback and awareness of the idiosyncratic sound of each voice (Hughes 2015b, 2017: 186), technologies (e.g., vocal loopers, amplification) are used in real-world applications (Hughes et al. 2014: 7).

The learning processes leading to performances involve tutorials that provide pre-performance practice and feedback opportunities. Students engage so that they become "co-creators in their formal learning" (Macquarie University 2015: 3); they interact in tutor-led informal feedback discussions in tutorials in which they are usually constructively supportive of each other. This latter point is unquestionably one of the "ground rules" (Lakey 2010: 35) for effective group learning: "The learning break-through available to the participants is a product both of their own motivation and responsibility *and* [original emphasis] of the considerable support of their group. It's the combination that makes it possible" (Lakey 2010: 30). The supportive environment is often noted by students in anonymous subject evaluation responses that include "[there is] a much greater focus on practical elements [in vocal studies] and helping each other in our tutes". The interrelatedness of progressive self-awareness and individual confidence is particularly evident in responses such as being "more socially open towards other students" and increased confidence that could lead to undertaking "a leadership role in a team environment".

Considerations and analyses of real-world practices

While singing may be an individual and/or collective activity, the ways in which students identify as singers varies. Indeed, the singing-self may be determined by a range of life experiences (e.g., social, cultural, educative) (Welch 2017). This extends to self-identification as a non-singer (Pascale 2005), albeit that everyone with a functioning voice can usually sing. For some, the ability to identify with the singing-self is therefore problematic, and the transition in perception and acknowledgment of the singing-self can be confronting (Hughes 2013: 16). The impact of the digitised music environment in which it may be challenging for the contemporary singer to be heard (Hughes et al. 2016: 108) adds to potential complexities. The opportunities to share songs online with varying degrees of success (Hughes et al. 2013) are now extensive (e.g., individual websites, YouTube, iTunes, various streaming sites) (Keith et al. 2014) and often invite public and/or immediate critique.

Considerations and analyses of real-world practices are facilitated in these vocal studies subjects through various reflective and reflexive assessment tasks (Hughes et al. 2014: 7–8; Hughes 2015a: 259). Reflection on practice, devoid of reflexive action (Schön 1991) or thought on future application, has the potential to limit or negate its effectiveness. When reflection is limited, it is habitually descriptive. Reflection is therefore distinct from reflexive action which involves

subsequent "reinterpretation" (Tanaka et al. 2014: 110) of actions or the implementation of altered understanding in action. While there are opportunities at each level of study for individual reflection and documented reflexive action in journal entries (Hughes 2015a:, 2017) and in post-performance written statements, "personal reflexivity" (Willig 2001: 10) linked to individual artistry is particularly encourag̱ ̱d in the advanced subject. In this context, artistic reflexivity involves associated research on or personal consideration of "values, experiences, interests, beliefs ... and social identities" (Willig 2001: 10). Additionally, strategically positioned self and/or peer reflection provides, at times, a cathartic opportunity where group cooperation or communication may have been challenging or even compromised. Usually, though, reflection presents an opportunity for analysis of learning and creative processes where individual contributions are clearly articulated, enacted and examined. The difficulty often associated with assessing individual contributions in a group context (Falchikov 1993: 275) is therefore largely avoided or mitigated.

Facilitating reflexivity

Weekly journal questions in these vocal subjects are typically linked to specific content and learning objectives; the questions are aimed to lessen descriptiveness while encouraging critical engagement. Ballantyne and Baker (2013) identify a similar structured reflection strategy that assists "students in seeing the links that exist between theory and practice" (80). Illustrating the reflexive strategies employed in vocal studies, students often reflect through journal entries in ways that aid, even motivate, individual development (Hughes et al. 2014: 7–8; Hughes 2015a: 259). Individual progress is usually documented as intrapersonal action such as evident in these subject evaluation responses: "[I] found my own style" and "[learning experiences enable] self vocal discovery". Student journal entries document changes in individual perception and transitions such as from a focus on musicality to embodied singing, vocal technique to emotive expression, and practice to holistic performance.

The processing of individual experiences is an essential principle of transformative learning. The theoretical underpinnings of transformative theory are steeped in the constructivist convention that, as individuals, we internalise our experiences so that "meaning exists within ourselves" (Mezirow 1991: xiv). Cranton and Taylor (2012) describe the internalised experiential process as the method by which "we interpret our own experiences" (5). Mezirow (2003: 58) further elucidates and highlights the relevance of reflexive action: "Transformative learning is understood as a uniquely adult form of metacognitive reasoning. Reasoning is the process of advancing and assessing reasons, especially those that provide arguments supporting beliefs resulting in decisions to act".

As transformative learning leads to the development of individual meaning and resultant perceptions/actions, formal education has the capacity to inform, impact and transform. The ability for learning to change the self is embedded in the premise that learning, and by implication the facilitators of that learning

(Thurman and Welch 2000: xii), may be transformative. As a means of high-lighting transformative potential within vocal studies, a distinction between reflection and reflexive action is offered in each subject; levels of reflection (Kember, Jones, Loke et al. 1999: 21–25) are used to assess individual critical engagement. Students are encouraged to explore reflection that extends beyond documenting content and process to include "premise reflection" (Mezirow 1991: 108). In this way, students are guided to critically reflect and to challenge assumptions in ways that open "the possibility of perspective transformation" (Kember et al. 1999: 23).

While the pedagogical aims of these vocal studies subjects include the documentation of transformational insights, perspective transformation is a particular aim at the advanced level. Students in the advanced subject are required to consolidate their vocal learning by implementing *artistic traits* suited to their *individual goals*. Lakey (2010: 20) cites the relevance of goal setting that is in addition to course learning objectives and suggests: "Each participant needs to state exactly what she or he wants to learn, concretely and realistically … The very act of learning goals reminds participants [in the group learning environment] of their power". Lakey's concept of individualised goal setting is reminiscent of the goal setting introduced in the advanced level as a means by which students reflect on and document their motivation to sing. This begins in Week 1 with journal questions such as (i) What are my goals?, and (ii) How am I going to achieve these goals? For most advanced vocal students, the artistic self becomes progressively evident in opportunities to explore creativity and through learning aimed to develop artistry. The ways in which students position their artistry, such as through original songs and/or through creative interpretations of cover versions, is left to the individual student. In anonymous subject evaluation responses, students will typically refer to transformational aspects such as the subject content and singing enabled "getting to know myself". The transition to the artistic self is elusive for some students, although, when this is the case, the concept of *the artist* is usually explored in relation to actually being *a singer* not as someone who sings.

Research questions, design and scope

The primary research impetus was to explore reflection and reflexivity in vocal and musical learning. The research was undertaken in the third year Music capstone subject between 2014 (see also Hughes 2017: 182–186) and 2017. Students undertaking the Music capstone subject were purposively sampled due to the expectation that this particular subject would be comprised of students who were finishing their degree; offered in the last session of third year, students are required to complete this subject in order to graduate with a major in Music. As such, participants would have already undertaken a selection of music subjects from vocal, production, guitar, world musics and/or popular music studies. Human Ethics approval to undertake the research was obtained.

Given that education has the capacity to both inform and change student perceptions, the research findings address the primary questions of (1) What types of teaching practices facilitate transformational learning?, and (2) In what ways do learning experiences (e.g. collaborative and/or performance) contribute to students being able to achieve their aspirations? These considerations led to the development of the sub-set questions of (i) What facilitates changes in student self-perception?, (ii) What learning strategies and practices precipitate change/s in student perceptions?, and (iii) How do students view individual development and learning? The research was conducted through questionnaires that comprised twelve closed and open-ended questions. Specific questions included: "Can you describe what reflection means to you?", "Can you describe a time in your learning in your studies when reflection led you to change or to develop your singing or music?", "What motivates you to sing or to be involved in music?", "Can you identify a defining moment when you thought of yourself as a singer or musician?", and "When and/or how is a singer or musician [considered to be] an artist?" By responding to such questions, participants actively engaged in reflecting on their learning experiences. A total of fifty-two students voluntarily and anonymously completed the questionnaires (25 x males, 26 x females, one unspecified gender; numbered #1–#52 below). Of the participants, forty-nine were Music majors; three participants did not specify a major; twenty-five participants were identified as having undertaken vocal studies. Responses from those participants who had undertaken vocal studies are quoted below to illustrate the emergent themes; corresponding participant numbers appear after each direct quotation cited.

Findings and emergent themes

Data analyses and coding of participant responses led to the identification of three emergent themes. These themes encompassed reflexive strategies that facilitated transformational insights, collaboration and community as motivation for learning, and transformative self-realisation through learning.

Theme 1: reflection and associated reflexive action facilitate transformational insights

All participants (N=52) were able to describe the process of reflection. While a majority of participants identified that reflection benefitted their learning (n=41; 79%), only just over half of the participants also noted that they *usually* reflected on their learning (n=28; 54%). However, when specifically asked to describe a time in learning in music subjects when reflection led to vocal or musical development, a majority of participants (n=36; 69%) offered examples of when this occurred. Interestingly, reflection that was either transitory (n=4; 8%) or deemed to be ineffective (n=7; 13%) was also identified. Examples of tenuous reflection included "at times [reflection] did highlight issues however at other times it was a bane" (#8).

For those participants identified as having undertaken vocal studies ($N=25$), a majority viewed reflection as being beneficial to their learning ($n=22$; 88%), were inclined to reflect on their learning ($n=16$; 64%), and that reflection or reflexive action furthered their formal learning ($n=21$; 84%). These results presumably highlight that vocal students were familiar with reflection and subsequent action due to the overarching pedagogical aim and implementation of reflection and reflexive content. Several types and contexts of reflection were found to facilitate reflexive action in vocal studies. For example, reflection and subsequent reflexive action on and in formal learning highlighted the role of listening/reviewing past performances for the purposes of "self-discovery" (#11) and development ($n=8$; 32%). Similarly, reflection and reflexivity were noted as furthering a range of vocal skills ($n=10$; 40%). Reflection and reflexive action were viewed as outcomes of "a focus on process and motivation" (#29); the processing of new information/understanding was identified as enabling reflection. Reflexive action was also identified in relation to assessment tasks. For example, reflection on a recording task and associated repertoire led to a reassessment of "the difficulties of the songs I choose" (#8). Other participants who had undertaken vocal studies noted that reflection in formal learning enabled artistic growth ($n=9$; 36%) and "really helped me review my own work and focus on my artistry and practice" (#51). While the implementation of "theoretical aspects" (#33) of subject content were viewed as enabling an individual approach to the singing voice, reflexive action was identified as transformational: "Practising [exercises] before singing brought change to my individual voice making it stronger and forming individuality" (#28); "vocal studies helped me ... to reflect upon my voice and create something original and individual" (#50).

Theme 2: collaboration and community as motivation for learning

In the context of motivation for learning, participants ($N=52$) identified several motivational contexts and/or assessment tasks which aided, even *inspired*, musical learning and subsequent development. These included collaboration and/or community ($n=19$; 37%), performance ($n=19$; 37%), practical ($n=14$; 27%) and creative ($n=8$; 15%) contexts. The distinction here between performance, practical and creative contexts possibly alludes to different perceptions of "performance" (e.g., live and recorded). Experiential learning, however, that emulated "real-life" (#30) included "[live] performances, they give you real experience" (#15). Similarly, effective *collaborative* strategies in learning were identified as providing opportunities for new experiences ($n=14$; 27%) that included "meeting people who are doing what I do, giving me a feeling of purpose, appreciation and support" (#18) and "working with fellow classmates – being motivated and inspired by them" (#52).

The input of fellow students within the learning *community* was also valued in ways that included listening to peer works/performances, revision with peers and peer feedback. While an inherent passion was identified as a primary

motivation in and/or for musical endeavours (*n*=22; 42%), some participants (*n*=11; 21%) noted that it was the interaction with others in various contexts (including collaborative performance and/or social contexts) that provided the actual motivation for musical engagement.

Theme 3: self-realisation as transformative learning

Participants were specifically asked whether there was a time or a defining moment that led to their self-realisation as a singer or musician. For some participants, self-realisation was not linked to a particular time or moment (*n*=8; 15%). A majority of participants (*n*=38; 73%), however, offered examples of such instances. In the examples provided, twenty-nine participants identified specific learning contexts through or in which self-realisation occurred. These encompassed formal learning (*n*=20; 38%; including tertiary, school and/or choral training) and informal learning (*n*=9; 17%; including live/"gig" performance, eisteddfod and musical cast member). Individual development through undertaking vocal studies was identified as providing the impetus for perceptual change from singer to artist: "From a young age I always considered myself a singer, but I saw myself as an artist during my studies at [university]" (#30). Of particular note were those participants (*n*=6; 12%) for whom self-realisation or defining moments were elusive. Interestingly, three of those participants did not identify as being a singer or a musician. Two of these participants avoided such labels noting that self-identification either constrained creativity or was constantly changing through being creative.

The significance of creativity and creative process in relation to being an artist was also identified by participants (*n*=19; 37%) who viewed creative expression as facilitating artistic recognition: "It's all about being creative and unique and giving a little bit of yourself to the audience" (#12). Similarly, performing was identified as a contributing factor in relation to actual self-realisation (*n*=20; 38%). In this latter context, the performance experience was identified as enabling valuable interactions in pre-, during and post-performance settings. Validation by others or through being paid to perform was identified (*n*=11; 21%), as was the realisation of performance/artistic intent (*n*=8; 15%). Post-performance validation through group learning formed the focus of this reflection: "After performing my last [showcase] in vocal studies ... the feedback from the class boosted my confidence and made me feel appreciated as a singer" (#52). However, reflection was also evident in responses where self-realisation was not specifically determined in terms of a time or a defining moment (*n*=5; 10%). In these instances, sociocultural validation was implicit to self-realisation and identity construction such as "being a musician/singer all my life forms my identity" (#16).

Conclusion

The research findings identified the various ways in which changes in self-perception can occur and, as such, they illustrate the specific relevance of reflection and reflexivity for learning. While several levels of reflection may

be evident (e.g., Kember et al. 1999), it is typically higher order premise reflection that may lead to perceptual changes and transformative learning (Mezirow 1990a: 18). Reflection that leads to perceptual change is also supported by other theorists. For example, Heidegger (1969: 23) suggests "[w]hen thinking attempts to pursue something that has claimed its attention, it may happen that on the way it undergoes change". However, Mezirow (1990b: 354) aptly deduces that "reflective discourse and its resulting [transformational] insight alone do not make for transformative learning". It is the post-insight action or reflexivity that is most relevant to transformation.

Reflection and reflexivity (Theme 1) are identified as underpinning the learning processes and resultant changes of perception, as the following example highlights: "Looking back now I am able to witness my progress and changes as an artist which helps me understand who I am, where I come from and where I want to go" (#50). The findings reveal that, unlike components of "competitive individualism" (Lakey 2010: 29), individual transformation may be supported by collaborative and community processes (Theme 2) in which individual confidence and skills develop (such as through experiential learning and reflexivity) and subsequent validation, perceptual changes and realisation occur (Theme 3). This is consistent with the latter phases of transformative learning theory that include the acquisition of competence and self-confidence that lead to a "reintegration ... dictated by one's perspective" (Kitchenham 2008: 105). Such transformation, however, does not negate the reality that, for some students, transformative learning may be tenuous or eluded. This finding further serves to highlight the relevance of strategising for individual learning within the group context.

Perhaps the greatest challenge for individual learning in the group context is to facilitate meaningful reflection and reflexive action that can lead to changes in perception, transformational insights, action and subsequent transformative learning. Despite the reporting by most participants that reflection benefitted their learning, there were some participants who could not specifically relate reflection to individual development. While it could be argued that all learning typically involves a level of reflection, not all reflection results in further learning or reflexive action. Indeed, facilitating integrity in reflective documentation is vital to its efficacy (see also Latukefu 2010: 212–213). The strategy of posing weekly questions to encourage considered reflection is therefore key in facilitating critical engagement in processes. It also potentially limits the capacity for students to "launder diaries" (Bruno, Galuppo and Gilardi 2011: 539) or to write generic journal entries. Irrespective of the reflection intent, however, reflection and reflexivity are significant transferrable skills that can have workplace relevance as Eraut, Alderton, Cole and Senker (2002: 145) highlight: "Individuals can be helped to become capable learners, who can be both more reflective and more self-directed, more proactive and more able to recognise and use emergent learning opportunities".

As outlined in this discussion, the pedagogical aims of the respective vocal studies subjects facilitate learning in a range of collaborative, real-world

experiences/practices. The findings attest to the relevance of such real-world experiences/practices in formal education that enable students to authentically experience, reflect on, and prepare for individual goals. This real-world grounding, together with the learning scaffold that centres on reflection and reflexive action, ma⸗ facilitate individual learning within a community of learners. Specifically in relation to the self and contemporary vocal studies, the collective findings and emergent themes identify that learning contemporary singing within a group context is conducive to developing individual transformational insights, subsequent action and resultant transformative learning.

References

Alexander, R. (2010). *Dialogic teaching essentials*. Cambridge University. www.serwis. wsjo.pl/lektor/1316/FINAL%20Dialogic%20Teaching%20Essentials.pdf, accessed 30 October 2017.
Ballantyne, J. and Baker, F. A. (2013). Leading together, learning together: Music education and music therapy students' perceptions of a shared practicum. *Research Studies in Music Education*, 35 (1), 67–82.
Bruno, A., Galuppo, L. and Gilardi, S. (2011). Evaluating the reflexive practices in a learning experience. *European Journal of Psychology of Education*, 26, 527–543.
Callaghan, J. (1998). Singing teachers and voice science – An evaluation of voice teaching in Australian tertiary institutions. *Research Studies in Music Education*, 10 (1), 25–41.
Cranton, P. and Taylor, E. W. (2012). Transformative learning theory: Seeking a more unified theory. In E. W. Taylor and P. Cranton (Eds.), *The handbook of transformative learning theory: Theory, research and practice*, 3–20. San Francisco, CA: John Wiley & Sons, Inc.
De La Harpe, B. and Prentice, F. (2011). *Final report for the "lectorial" project: Trialling the use of "lectorials" to enhance learning and teaching in large classes*. Melbourne, Australia: RMIT. https://mafiadoc.com/final-report-for-the-lectorial-project-trialling-the-rmit-university_59f0a90b1723dd2535ae3387.html, accessed 26 February 2020.
Eraut, M., Alderton, J., Cole, G. and Senker, P. (2002). Learning from other people at work. In R. Harrison, F. Reeve, A. Hanson and J. Clarke (Eds.), *Supporting lifelong learning, volume 1: Perspectives on learning*, 127–145. London and New York: RoutledgeFalmer.
Falchikov, N. (1993). Group process analysis: Self and peer assessment of working together in a group. *Innovations in Education & Training International*, 30 (3), 275–284.
Green, L. (2002). *How popular musicians learn: A way ahead for music education*. Farnham, Surrey; Burlington, USA: Ashgate.
Green, L. (2014). *Music education as critical theory and Practice*. Surrey, England: Ashgate.
Heidegger, M. (1969). *Identity and difference*. Translated by Joan Stambaugh. New York, Evanston, London: Harper & Row, Publishers.
Hughes, D. (2013). An encultured identity: Individuality, expressivity and the singing-self. *Australian Voice*, 15, 13–19.
Hughes, D. (2015a). Assessment and feedback in curricula design for contemporary vocal studies. In D. Lebler, G. Carey and S. Harrison (Eds.), *Assessment in music education:*

From policy to practice, 251–268. Dordrecht, Heidelberg, New York and London: Springer.

Hughes, D. (2015b). Technologized and autonomized vocals in contemporary popular musics. *Journal of Music, Technology and Education*, 8 (2), 163–182.

Hughes, D. (2017). 'Art' to artistry: A contemporary approach to vocal pedagogy. In G. D. Smith, Z. Moir, M. Brennan, S. Rambarran and P. Kirkman (Eds.), *The Routledge research companion to popular music education*, 177–189. Milton Park, Oxon: Routledge.

Hughes, D., Evans, M., Morrow, G. and Keith, S. (2016). *The new music industries: Disruption and discovery*. Cham, Switzerland: Palgrave Macmillan.

Hughes, D., Keith, S., Morrow, G., Evans, M. and Crowdy, D. (2013). What constitutes artist success in the Australian music industries? *International Journal of Music Business Research*, 2 (2), 61–80.

Hughes, D., Monro, V., Power, A., Lemon-McMahon, B., Powell, S. and Cooper, N. (2014). Approaches to singing: 'Snapshots' of Australian contexts. *Australian Voice*, 16, 1–11.

Keith, S., Hughes, D., Crowdy, D., Morrow, G. and Evans, M. (2014). Offline and online: Liveness in the Australian music industries. In V. Sarafian and R. Findlay (Eds.), *The State of the music industry*, 221–241. Toulouse, France: Presses de l'Université des sciences sociales de Toulouse.

Kember, D., Jones, A., Loke, A., McKay, J., Sinclair, K., Tse, H., Webb, C., Wong, F., Wong, M. and Yeung, E. (1999). Determining the level of reflective thinking from student's written journals using a coding scheme based on work of Mezirow. *International Journal of Lifelong Education*, 18 (1), 18–30.

King, A. (2008). Collaborative learning in the music studio. *Music Education Research*, 10 (3), 423–438.

Kitchenham, A. (2008). The evolution of John Mezirow's transformative learning theory. *Journal of Transformative Education*, 6 (2), 104–123.

Lakey, G. (2010). *Facilitating group learning: Strategies for success with adult learners*. San Francisco, CA: John Wiley & Sons, Inc.

Latukefu, L. (2010). Breaking through the frames of custom: A sociocultural approach to learn singing. In S. Harrison (Ed.), *Perspectives on teaching singing: Australian vocal pedagogues sing their stories*, 205–226. Bowen Hills, QLD: Australian Academic Press.

Lebler, D. (2006). The master-less studio: An autonomous education community. *Journal of Learning Design*, 1 (3), 41–50.

Macquarie University. (2015). *Learning for the Future: Learning and teaching strategic framework 2015–2020*. www.mq.edu.au/__data/assets/pdf_file/0009/131103/l-t-strate gic-framework-white-paper-2015-screen-friendly.pdf, accessed 13 October 2017.

Macquarie University. (2017). *MUS304 Advanced Vocal Studies*. http://unitguides.mq.edu. au/unit_offerings/72885/unit_guide, accessed 13 October 2017.

Mezirow, J. (1990a). How critical reflection triggers transformative learning. In J. Mezirow (Ed.), *Fostering critical reflection in adulthood: A guide to transformative and emancipatory learning*, 1–20. San Francisco, CA: Jossey-Bass Inc., Publishers; Oxford: Jossey-Bass Limited.

Mezirow, J. (1990b). Conclusion: Toward transformative learning and emancipatory education. In J. Mezirow (Ed.), *Fostering critical reflection in adulthood: A guide to transformative and emancipatory learning*, 354–376. San Francisco, CA: Jossey-Bass Inc., Publishers; Oxford: Jossey-Bass Limited.

Mezirow, J. (1991). *Transformative dimensions of adult learning*. San Francisco, CA: Jossey-Bass Inc., Publishers; Oxford: Jossey-Bass Limited.

Mezirow, J. (2003). Transformative learning as discourse. *Journal of Transformative Education*, 1 (1), 58–63.

Pascale, L. (2005). Dispelling the myth of the non-singer: Embracing two aesthetics for singing. *Philosophy of Music Education Review*, 13 (2), 165–175.

Schön, D. (1991). *The reflective practitioner: How professionals think in action*. Aldershot: Ashgate.

Tanaka, M., Stanger, N., Tse, V. and Farish, M. (2014). Transformative inquiry. *Research Group*. www.transformativeinquiry.ca/downloads/files/transformativein quiryv4.pdf, accessed 10 January 2017.

Thurman, L. and Welch, G. (2000). Fore-words to this book: Sunsets, elephants, vocal self expression and lifelong learning. In L. Thurman and G. Welch (Eds.), *Bodymind and voice: Foundations of voice education* (Revised ed.), xi–xxiv. St John's University Collegeville, Minnesota: The VoiceCare Network.

Welch, G. (2017). The identities of singers and their educational environments. In R. McDonald, D. J. Hargreaves and D. Meill (Eds.), *Oxford handbook of musical identities*, 543–565. Oxford, UK: Oxford University Press.

Willig, C. (2001). *Introducing qualitative methods in psychology: Adventures in theory and method*. Buckingham, UK: Open University Press.

5 The iPad Orkestra ensemble

Creative and collaborative learning

Ian Stevenson and Diana Blom

Introduction

This chapter explores self-directed creative and collaborative discovery as a mode of engaging the digital native (Prensky 2001) in new and effective learning experiences. This approach arises in response to the emerging landscape of electronic music practices surrounding wireless tablet devices and their associated software "ecosystems" (Messerschmitt and Szyperski 2003). Some technologists teaching today immigrated early to the digital world and as a result face challenges in assimilating their learning experiences with those of their students. Embracing the less structured and rapidly evolving world of low-cost computing devices and even lower-cost software instruments requires rethinking the essential skills needed by the contemporary musician to support their ongoing evaluation and creative use of such resources. This chapter considers student feedback from an initial experiment in self-directed creative and collaborative discovery using iPads as a mode of engaging music students in group electronic music-making practices. It examines the metalearning (Biggs 1985) strategies adopted by the digital native and in doing so assesses the necessary re-adjustment of pedagogical assumptions required, and resources available, for successful results in this new and evolving context.

Background

Assessment design

The student feedback examined in this study was collected in a second-year ensemble performance subject where students were offered a range of repertoire to suit the instrumental skills of the group. Through a process of negotiation with their peers and tutors, small ensembles ranging from 2 to 10 performers were formed to undertake rehearsal and performance of the selected repertoire over a 13-week period. One contrasting option offered to students was to develop, as a group, an entirely new piece employing the musical resources of an Apple iPad. This approach was encouraged by a university-wide project that

saw the distribution of iPads to all commencing students in an effort to update the teaching and learning practices of students and academics.

While the iPad offers a great range of tools for learning aspects of music and for music production, an exploratory and experimental approach was taken in this project, to allow students themselves to discover how best to exploit the musical affordances of the iPad. This approach represents a radical departure from the task of interpretation of existing notated and recorded repertoire usually undertaken in the subject and it is the purpose of this chapter to try and unpick the implications and various factors at play in this move. We start by considering the position of the iPad in the current state of hardware and software technology and by considering the relationship of young student musicians to this technology.

Factors in the emerging landscape of software ecosystems

Messerschmitt and Szyperski (2003) introduce the metaphor of an "ecosystem" to describe the complex web of relationships involved in current software. These authors foresaw the unique nature of software as an entity discrete from either data or computing hardware. They understood both that "software becomes integral to the lifestyle of its users" (5) through the widespread adoption of mobile and ubiquitous computing technologies and the fact that software expresses, represents and in fact produces human organisational and social processes. Their prescient analysis imagined the context in which the emergence of the software market places such as Google Play, iTunes and the Apple App Store collapsed all media including books, magazines, music, film, TV and software applications into a small number of distribution outlets integrated within consumers' mobile devices. Following Messerschmitt and Szyperski's conception of an ecosystem, these virtual marketplaces served both the producers and consumers of software by providing a unified platform or environment to connect the desires of consumers and end-users with the ambitions of software designers.

What Messerschmitt and Szyperski did not foresee was the rapid decline of diversity subsequent to the introduction of Apple's iOS operating system in 2007 and Google's Android operating system in the same year. These software platforms enabled the success of the Apple iPhone, released in 2007, and the Open Handset Alliance Android phone devices starting in 2008, and the subsequent development of the Apple iPad in 2010 and various versions of the Android tablet devices in the same year. In the years following these developments, the term "software ecosystem" took on the new meaning of an exclusive choice between the two competing systems.

The hardware that developed in parallel with these software ecosystems, particularly the Apple iPad, offered a new level of convenience and affordances. These developments facilitated the transformation of music software to become an entertainment product in itself, thus reverting to an earlier model of music as a form of domestic entertainment in which ordinary people learned to "play"

music rather than merely to listen to music. The widespread adoption of the iPad saw a rapid proliferation of music apps available through the Apple Apps Store, many incorporating the sophisticated features previously only available in expensive professional hardware and software. In fact, one of the key selling points of the iPad was the availability of Apple's *GarageBand* software on it, suggesting that the iPad could do for music production what the iPhone had done for photography. That is, make an artform ubiquitous, convenient and democratic and put professional results in the reach of ordinary hobbyist consumers.

One challenging question within this software ecosystem is how the user can discover new, interesting and useful music tools within the App Store through which all software must be acquired. Does this feature of the ecosystem tend towards diversity or does it limit the choices made by users? For the music educator, given the rich history of electronic music practice represented within some App Store offerings, we wonder what new approaches to ensemble music performance this new ecosystem might encourage and how might students learn through it.

How do young musicians encounter and adapt to new music technologies?

The concept of the "digital native" introduced by education researcher Marc Prensky (2001) suggests that there has been a generational change in expectations, responses and approaches to learning exhibited by current students and that this requires a change in thinking and approaches to teaching by those of the previous "digital immigrant" generation. For example, Prensky points to the attitude of the digital immigrant that reading a software manual might be a useful way to more fully understand its operation, compared to the expectation of a digital native that well-designed software will teach them how to use it by using it. Following Messerschmitt and Szyperski's analysis of software as both an expression or representation of social or technical processes, and as an understanding of the needs and wants of users (as modelled by the software designers), immigrant educators may question the potentially limited "know-how" embedded in these designs as a constraint on the musical creativity of their students.

From a software ecosystem perspective, the iPad and available software become agents or actors (Latour 2007) in a network of pedagogical engagement that includes the institutional assessment context, the student's own musical and music technology background, plus the musical background of the software developers. We are interested to identify to what extent the processes engaged in during software selection, negotiation, rehearsal and performance preparation, linked into and reproduced the existing musical knowledge of the student participants or expanded and extended their knowledge and experience. We are also interested to see whether the increased autonomy and apparent control of the project enabled through handing over responsibility for repertoire generation and instrument selection had a positive impact on student attitudes towards their learning and music-making.

Autonomy, metalearning, expansion and reproduction

Biggs (1985: 192) defines metalearning as "a subprocess of metacognition that refers specifically to learning and study processes in institutional settings, and more particularly to students' awareness of their motives, and control over their strategy, selection and deployment". Biggs found that an important factor in effective learning was a student's development of and recognition of an "internal locus of control" for their learning. His ideal or deep learner is "motivated to actualise an interest and develop competence in particular academic subjects" (186) and they exhibit learning strategies that aim for meaningful learning, read widely, and inter-relate their learning with previous relevant knowledge. Metalearning requires an awareness, by the student, of the congruence between their motivation and learning strategy. A student's background and previous life experience will have a strong impact on their metalearning capacities and there remains debate over the extent to which metalearning can be taught.

In view of Prensky's assertion that software embeds an understanding of a given process (software embeds "know-how") and that digital natives have an expectation that software will teach them how to use it, a question arises regarding the "locus of control" in the creative learning endeavour. As Biggs (1985) has asserted, this locus of control lying within the student themselves is a key factor in effective or deep learning. To what extent does the provision of seamless or transparent "know-how" within the software interface facilitate meaningful learning experiences that allow knowledge to be both scaffolded and expanded is an open question. There is a risk that software ecosystems both filter available knowledge and tend towards a "reproductive" approach to music-making or an aspect of "utilising" rather than "internalising" (187).

Methodology

Three focus groups were conducted in 2014, 2015 and 2017 with 3–4 students in each group. Focus groups were held after the half-way performance assessment to peers. Focus group discussions lasted on average 40 minutes and were audio-recorded and transcribed for later analysis. Pseudonyms have been assigned to the participants. The 2014 group included three male participants: Aaron, Don and Derek. The 2015 group comprised four males: Jude, Neil, Roy and Lex, and the 2017 group consisted of two females and a male: Ruth, Nora and AJ.

Each group was asked about issues arising from their experience of developing an ensemble performance using iPads. A series of general open-ended questions asked participants about their objectives for the performance and their means of achieving these. Participants were asked to discuss their feelings and perceptions about the outcomes their group achieved; where they saw this experience leading them in the future; and asked to evaluate the strengths and weaknesses of the iPad as a musical instrument.

They were asked to evaluate the iPad and its associated software ecosystem as a platform for self-directed learning and asked to describe their methods of discovery for software tools and musical ideas. The questions shown in Table 5.1 emerged from the literature and previous teaching of the iPad Orkestra.

The researchers discussed the expected outcomes and established a set of analysis codes based on the key themes identified in the literature. After an initial independent coding by the researchers, a comparison and discussion produced a new set of revised codes. These codes were subsequently reduced into two valence groups related to the central focus on knowledge and learning: enabling factors and expanded knowledge and learning on the one side; and inhibiting factors and reproductive knowledge and learning on the other. A further set of codes described the methods of discovery employed by the participants (see diagram in Figure 5.1). The diagram indicates that participants' existing knowledge was implicated in both reproductive and expanded approaches. This parallels Biggs' (1985: 186) characterisation of surface and deep learning. In examples of deep learning, students reproduce what they already know and expand their knowledge by linking to new discoveries, whereas in surface learning students do not move beyond the reproductive stage.

Results: what the participants say

Enablers and enabling

Participants acknowledged that previous positive experiences with the iPad or their level of comfort with the technology enabled them to progress quickly with the creative task. Several of these participants identified as digital natives (Prensky 2001), Don (2014) reflecting that: "I think it worked well because we're all Gen Y ... we're all tech-savvy".

The ease of use of the iPad for this group was both an enabler and a risk or a constraint to creativity or expression. Jude (2015) noted that: "It's ridiculously accessible If you have an iPad, you download a free drum pad program. Get your friend to download a free piano program. And you can play something". However, issues around musicianship and musical values arise and "you can debate with someone musical ... somebody [who] plays an instrument, [whether someone] who played [the iPad] could play it (the instrument) or not" (Jude 2015). Ruth (2017) noted that with some *GarageBand* instruments "you were more like a conductor than like a player". The iPad enabled rapid experimentation: "you could quickly just pull something up and see how it goes, if it doesn't work, scrap it, move on to the next one" (Derek 2014).

A positive enabling attitude was also identified as a factor. Participants were eager to discover new things and to find out "where can we go from here" (Don 2014). The iPad was seen as a platform for creativity: "the only limit with the iPad is our own imagination" (Aaron 2014), and as stimulating musical innovation "really trying to I guess push those boundaries ... trying to think

Table 5.1 Interview questions

Question	Source of question
What were you trying to achieve with the iPad Orkestra this semester (both halves)?	Prior teaching experience of the iPad Orkestra ensemble; the subject's learning goals.
How did you go about making this happen?	Messerschmitt and Szyperski (2003): evaluating affordances of software/hardware ecosystems.
How do you feel about the outcome?	Messerschmitt and Szyperski (2003): evaluating affordances of software/hardware ecosystems and their ability to meet the desires of users.
What would you like to do next?	Messerschmitt and Szyperski (2003): evaluating affordances of software/hardware ecosystems and their ability to exceed existing user desire in order to fulfil a need for tools for professional practice.
What uses do you see for iPad Orkestra type music?	Prior teaching experience of the iPad Orkestra ensemble.
On the basis of your experience in this subject, what are the strengths and weakness of the iPad as a musical instrument?	Messerschmitt and Szyperski (2003): evaluating affordances of software/hardware ecosystems; Biggs (1985: 190): evaluating impact of students' experience and background on their metalearning capacities; Prensky (2001) and Biggs (1985): evaluating transparent 'know-how' within the software interfaces and their impact on meaningful learning experiences; Biggs (1985: 187): evaluating software ecosystem use in terms of 'reproductive' or 'expanded' approaches related to 'utilising' rather than 'internalising' models of learning.
How well did the assessment tasks or the learning activities that are described in the learning guide match with the outcome you achieved? What constraints did the task description impose?	Biggs (1985: 191): evaluating "internal locus of control" as a factor in metalearning.
How is the iPad particularly useful for self-resourced, self-motivated learning?	Prensky (2001: 3): evaluating the iPad's capacity to "teach us to use it"; Biggs (1985: 192): assessing the iPad as a catalyst for deep learning and the student's metalearning through awareness of the congruence between motivation and strategy.
What sort of resources would you need to facilitate this type of learning?	Messerschmitt and Szyperski (2003): evaluating affordances of software ecosystem, software discovery processes and potential

(Continued)

Table 5.1 (Cont.)

Question	Source of question
	limitations of the iPad for music-making and learning.
What other uses do you make of the iPad in your music-making?	Biggs (1985: 186): evaluating student's capacity to "inter-relate [learning] with previous relevant knowledge" and thus facilitate deep learning.
What learning uses do you see for iPads in any of the BMusic subjects?	Biggs (1985: 192): evaluating the "students' awareness of their motives, and control over their strategy selection and deployment".

a little bit outside the box" (AJ 2017). This attitude was often associated with a strong and positive group dynamic where "we were all very considerate of each other's feelings. We were never like 'that's a bad idea.' We always listen" (Ruth 2017).

One factor that linked this personal attitude to group cohesion was a lack of attachment that might otherwise have characterised performance with traditional instruments. As Lex (2015) said, "we're always happy to give up ideas as well". The iPad was considered neutral in terms of instrumental and personal identity. Roy (2015) thought "it may have been different if there was an emotional attachment to what we're doing. Like … 'this represents me'. It's more about let's get in and enjoy it. I think that helped".

Enjoyment was clearly an enabler in terms of the learning process with Nora (2017) noting "I'm enjoying … the team that I'm in. I'm really … enjoying discovering new things and ideas and styles of playing". Aaron (2014) linked enjoyment to self-evaluation: "I thought it was good, I mean, like, you can see I'm enjoying myself a bit too much".

Neil (2015) found the lack of constraint in terms of the musical outcome helpful: "I think working it out is good. I think, one, you have to find it, which is always a good thing. Means you're doing the work. But, two, … [it enables you to find] what suits you as a performer".

In contrast to this, some constraints were helpful. The use and availability of time was crucial:

> for achieving things, yes. I could've ended up there with my VCS3 [synth app], finding wonderful sounds for ever and a day and then come to rehearsal, and "oh, I've got nothing. I'm still playing around." So, it's good to have boundaries.
>
> (Roy 2015)

Neil (2015) agreed; "we were really limited with the time, so we had to pick something that we could actually achieve, something at the end of the short

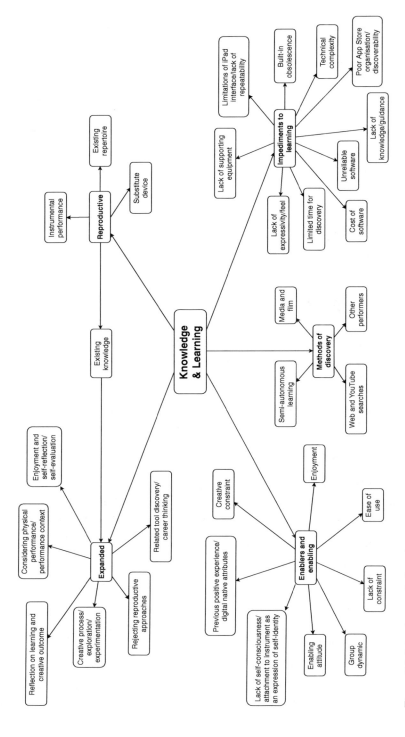

Figure 5.1 Interview analysis codes

time". It is noted below that this lack of time was also seen by some as an impediment to developing really creative responses to the task.

Expanded knowledge and learning

A determination to avoid merely reproducing existing skills or emulating conventional musical approaches enhanced learning and creativity. The term "iPad orchestra" used in the task description suggested this kind of reproductive approach to some students, which they rejected. Don (2014):

> did a bit of research and mainly what I found was groups that just made [conventional] music together [with] their iPads or tablets. At first, I was thinking just … of [an] orchestra as in a classical orchestra type of thing. I thought, "Oh, if we have to do something like that, it might not be something I want to do." But I thought, "Ah, you're widening the term into anything [performed by] a group."

It wasn't only classical or orchestral music that was being rejected by participants. They rejected iPad arrangements of popular songs. Derek (2014) discovered iPad bands that "just played 'The Lion Sleeps Tonight', and I thought, 'Really? … Can't you do something a little bit more different than 'The Lion Sleeps Tonight'?'". Derek saw the task as an opportunity to expand his musical practice: "if you're doing the more experimental stuff, it's more interesting because … it's not something you can make with an instrument".

Often the resources offered by a particular music app stimulated creative approaches. Starting from the work of a known artist was another fruitful approach to developing novel musical outcomes. Don's (2014) group had employed an app created by Icelandic artist Björk for an interactive album. He felt "That's something we could probably use … and … I showed the other two and we thought, 'Where can we go from there?'" Derek (2014) added:

> I think we were definitely trying to experiment and make it as interesting as possible … we kind of built around this particular app … and, so we decided to kind of do a progressive thing, that's what we ended up doing, I think. Just kind of built off that app, really.

Taking musical inspiration from a known musical source was another approach. The theme music of the *Doctor Who* televisions series was the starting point for Roy (2015).

> Originally, we had a score. But we felt that maybe that was … too limiting and … my own personal taste was reflected in the use of synthesizers. And so I thought, "Why don't we make this more of a soundscape while keeping the *Doctor Who* theme in the piece."

Jude (2015) expanded on the process: "We all researched [synthesizer] apps on the iPad that would be optimal for using ... So, we had a range of apps that each of us brought in, which we then blended to make the sound work together". Derek (2014) linked the iPad to other technology: "I was very excited when I found out that you could plug it into *Pro Tools* and record it because then there are so many possibilities there".

These approaches indicate a process whereby participants provided their own scaffolding in their learning, building on their existing knowledge, leveraging techniques they already knew and resources they discovered in the practices of other artists. This signals a movement from reproducing their existing knowledge, to reproducing the knowledge of others, finally to expanding, developing and originating their own musical ideas, resulting in a deep learning experience.

Useful generalisable discoveries were made in the context of experimentation. For example, Aaron (2014) reflected that he "did learn about the way I could expand around ... different frequencies". Ruth (2017) felt that:

Even though it's not training you in a theoretical sense ... it's quite good for training the ears. I think it helps to identify "Oh, that sounded really good, that worked together, those instruments blended" or "they clashed". It just starts building up that intuition that I think is an unspoken thing about musicians. It's [a] kind of important part.

Recognition of an internal locus of control and awareness of metalearning was apparent in the accounts of several participants. Neil's (2015) attitude towards receiving feedback reflects this: "Then someone comes in and says, 'This might need changing, because of this.' And then suddenly it's a new light on it, and it's a way that you can really tighten the performance". Jude (2015) noted that when he was offered feedback "I found it really easy to sort of not go, 'Oh no, we're doing something wrong' rather than, 'This is an opportunity to learn and say well let's approach this differently or include these ways of doing it'". Derek (2014) felt that the process:

definitely forced us to look into it ourselves ... after the first week or so, kind of based on the fact that we had to discover all this stuff ourselves. I did probably more research into it than I would have done otherwise ... I think I put in a lot more effort than I would have otherwise. And I know ... the way that I learn, I think that was a lot healthier for me, in particular.

Another factor in achieving a rich learning experience across all three year groups was pure enjoyment. This was often linked with positive self-evaluation. Reflecting while watching a performance video, Aaron (2014) "thought it was good, I mean. Like, you can see I'm enjoying myself a bit too much ... And it sounded all right in my opinion". Jude (2015) reflected "I think the outcome ...

was very different to what I had originally thought might happen. But it was still fun".

In the 2017 group, Nora noted "I'm enjoying, the team that I'm in I'm really enjoying discovering new things and ideas and styles of playing". For Ruth (2017), the iPad ensemble:

> kind of gives us as a group a chance to learn together. We would often do sounds and stuff and it would sound terrible and we would laugh about it, but because it's new to all of us, I think it gave us that kind of freedom where we weren't being self-conscious at all.

Some participants displayed "career thinking", indicating that these learners were looking beyond the immediate assessment requirements towards how their learning might be applied in the profession. Aiming for a teaching career, Jude (2015) saw:

> ... the use of iPads, as very useful in a classroom ... to do a similar thing. Give them a number of weeks to get something together. Let them choose the apps that they need for it and perform in front of the class.

Nora (2017), thinking about applications of the iPad in a music therapy career, had "had experience with adults with disabilities, trying to play the iPad, [now] knowing what's available is really good for developing those skills for those people that could not necessarily play a real instrument".

Speaking for her group, Ruth (2017) noted that "we all kind of come from contemporary music, so we thought if we did actual songs with some real instrumentation and we added in the iPads that could actually be something beneficial for us down the line in our careers".

Impediments to learning

Participants encountered several impediments to learning through the iPad. The app stores weren't always helpful because of the number of apps, its lack of organisation and the fact that many are "rip offs" (Don 2014) of the best version. Some apps were too expensive. Lack of knowledge and guidance thwarted a "two man do[o]-wop" (Derek 2014) looping idea seen on Jimmy Fallon's show. Derek (2014) brought the idea to the group but "we never actually figured out how to do that". Love of a particular vintage synthesizer from the 1970s was a short-term impediment for Roy (2015) who ultimately found "it didn't add to what we were doing".

Unreliable software that "crashes every single time" (Derek 2014) was an impediment. Students were aware of built-in obsolescence as a disincentive, understanding the need to keep up with new software and hardware "or you just get left behind and just die out" (Derek 2014). One impediment to engagement could be other people's negative attitudes, with AJ (2017) noting they ask "what do you do in iPad orchestra? You press buttons?"

Lack of time was an impediment to learning. Exploring apps and creative ideas takes time, and within a 13-week semester, only so much time could be spent searching for apps. Roy (2015):

> would've liked to have done more, well, just fully creative. Do something original of our own that grew from what you know each week. But I don't think we would've had the time to have done it under the constraints that we had.

Another spoke of trying to screen share but finding, even after a Google search on how to create a network, no useful information emerging thought "We'll leave that for later" (Derek 2014). Replicating old synthesizers "so you could build sounds" (Jude 2015) took more time than the semester allowed.

Because the iPad Orkestra was expected to perform twice a semester, and students were moving out of the conventions of instrumental performance, the physical aspects of performing with an iPad and the performance environment was a major challenge. While participants wanted to "integrate it completely into the performance … like in theatre" (Jude 2015), impediments were noted in achieving this goal. In particular the touch response of tapping glass has "a delay, [which] can throw things out a lot" (Lex 2015), especially when four people are "trying to do the right thing" (Neil 2015). Music stands were enabling for a rehearsal but viewed as an impediment to performing. If the aim was to perform standing up, thereby adding "a bit of showmanship [rather] than us sitting down" (Don 2014), then the cables needed to be long enough, and performing without the stands was preferable.

Connecting other devices to the iPad revealed some impediments to learning. Having only one mixer for the group introduced several problems. It "meant that we can really actually only have one finger on it [and this] limited us to what we could do" (Nora 2017). Also, because the mixer "is a digital one, and we practised with the old school ones … it limited us to what we could do" (Nora 2017). Plugging a guitar into the iPad and using it as a pre-amp worked well "but the sound quality … [was] really bad. Sort of not worth it" (Aaron 2014). The expressive facility of the iPad was brought into question, as "you can't get the human feel through the iPad" (Ruth 2017), and for AJ (2017), "it's definitely not a real instrument, [more] a simulation". Yet for Nora (2017) it was an instrument of possibilities – "if you can imagine it then there's a good chance you can make it happen".

Derek (2014) acknowledged that the iPad was small and flexible,

> but really, if you were a DJ, performing in a club or anything, and you were centre stage, you probably wouldn't get a nice, warm reception without all of your gear around you. If you just had an iPad there, and … your gear is all on your iPad, you just wouldn't … get the same sort of vibe.

The importance of stage balance was also highlighted by their experience, Don (2014) noting he couldn't hear what he was doing "because you [two] had the low frequencies and I was doing what I do and I go, 'I can't actually hear what I'm syncing'".

However, the students imagined ways to enhance their stage presence in future performances:

> One of the ideas that I had for our next performance, [if you could] find a way of getting the iPad to talk [wirelessly] to a mixer, I would have liked to have been able to walk around, and it would have been nice to have a bit of interaction.
>
> (Derek 2014)

Roy (2015) expanded on the theme of stage presence: "… you want the dramatic theatrical aspect of it. I think we really needed that … to get a connection with the people, that would've been really useful".

The semi-autonomous learning environment, while largely enabling, raised discussion of how leadership of the group occurred. It also saw some musical comparison with others with Roy (2015) saying "I think you guys are more musicians than I am [because you read music better than I do, and] I would've liked to have done more, well, just [be] fully creative". When asked about conflict within the group, Nora (2017) noted "you wanted to play a song from the start … you were itching to play a real song", indicating different ways of working, with the response from AJ (2017), "I'm still itching to play a real song … to play a real instrument".

Reproductive knowledge and learning

As noted above, certain approaches to using the iPad such as reproducing exiting repertoire were rejected as not leading to new knowledge or valuable creative outcomes. Approaches such as plugging an instrument into the iPad were explored for "possibilities with guitar pedals and effects and stuff like that" (Aaron 2014) but were not pursued as using the iPad as a substitute device was not regarded as musically interesting. Using the iPad as "a conventional instrument that you could actually perform music that people already know" (Aaron 2014) did not lead to useful results.

However, utilising existing knowledge was often a stepping stone to more expansive approaches or a pragmatic fall-back that resulted in more satisfactory outcomes.

Building on existing knowledge

Students showed an awareness of integrating knowledge they have already trialled and used. Considering known musical styles sometimes led to expanded thinking. Derek (2014) considered "recreating computer game music … the

kind of iconic themes like *Super Mario*" but while suggesting this, still looked ahead to perhaps creating "a mash-up of a couple of those" which would be a different outcome to creating a copy of a game theme. Seeing a documentary on how Björk makes music and had created an app for the iPad, led one participant to find the app *Sol..'ce*, and this took him from *GarageBand* into a new sound world. Lex (2015) told how he'd used an iPad for his secondary school final year music composition submission, using a DJ app, drawing in astronomy sounds from a website, plus live vocal ensemble, but with *GarageBand* "in the background just sitting there waiting". Ruth (2017) used *GarageBand*, iPad's default music app, as a basic tool, in one case "predominately to get the ideas down so I don't forget them" using the recording function. All of these students were building on previous positive experiences which enabled further expanded exploration and creativity.

Extending reproductive thinking from the known to experimentation was seen when participants spoke of how they do, or could, connect the iPad to other devices. Connecting the iPad through Bluetooth with other things to "I guess, experiment that way and see what we can control" (Neil 2015) was one possibility.

Performing with iPads as a "touring band [that] ... if you did it really well ... could go pretty far [when group members find] a central theme to our music and in the way that we create it" (Don 2014). Here, the concept of a touring band is drawn into the iPad music-making community, especially when the group members share common musical thinking.

Reproductive knowledge was used as a fall-back when something too complex was encountered during the creative process. One software app, *Tabletop*, "looked too complicated to me, so I didn't use it ... I found using a keyboard app was easy for me ... I could create different sounds, but still use the keyboard" (Neil 2015). Here Neil, a keyboard player, preferred a topography he knew yet was prepared to explore new sound worlds, the reproductive facilitating expanded sound thinking.

Methods of discovery

Within this project student participants were given very little in the way of learning resources. Therefore, it is interesting to observe how the participants went about resourcing their own learning.

The process of exploring sound and creating musical outcomes on an iPad is "very similar to preparing for an essay ... looking at how others have made it work, finding material that's going to work and then the rest of the time ... putting it into action" (Ruth 2017). Ruth acknowledged this research needed to be undertaken before the creative work could commence. So where did the information come from? Don (2014) used "YouTube searches and Google searches about apps that can create music". He also "saw a documentary on ABC [TV], about Björk and how she makes music" from an app that she developed. Participants learned from their peers. Derek (2014) had seen a friend "... use one of

the iPads as kind of a second screen for ... *Pro Tools*". The online learning resource *Lynda.com* to which students have institutional access proved useful. Don (2014) noted that "I've liked using Lynda, I've been doing my own little bit of extra learning and looking through audio videos". In contrast, Derek (2014) stated that he had "looked on Lynda.com as well for iPad music, and they mainly had [technical instruction], I thought, 'That's not what I need to know.' ... It's more creative stuff that I was looking for then".

Describing how YouTube videos could be useful, Ruth (2017) explained that:

> we would generally try and find artists that are using the iPad in ... a similar way. We found a really interesting video by [New Zealand artist] Kimbra ... It was just her on her iPad ... we found that really interesting ... but ... it's sometimes hard to know exactly [what apps were used].

The Apple App Store proved frustrating. Ruth (2017) described her experience: "So, we download quite a few [apps]. Some of them work and some of them don't. But, it's really trial and error. Some of them are hopeless and then some of them are great".

Discussion

The creative and collaborative learning that took place with the iPad Orkestra revealed several pathways. We have characterised these learning processes as either expanded or reproductive. Knowledge and learning could be expanded in the creative process through exploration and experimentation, through related tool discovery, the rejection of reproductive approaches, consideration of physical performance and the performance context, reflection on the creative learning and creative outcome, and through enjoyment, self-reflection and self-evaluation. Reproductive processes were not always a negative force. Existing knowledge was often a trigger or platform for launching into new software, new hardware combinations and new sound exploration. The university subject housing the iPad Orkestra required a performative outcome and this saw discussion of known performance modes move to thinking about and trialling new ways of performing with iPads. Challenges that required more time than the semester allowed saw a fall-back to reproductive thinking taking place to move the process along.

Guiding this learning were several factors that affected the process and outcome. Impediments to learning could be lack of time, lack of support and guidance, lack of supporting equipment, limitations of the iPad interface including its lack of expressivity and feel, the cost of software, the amount of software and poor App Store organisation that made discovery difficult, and at times the unreliability of software. Built-in obsolescence was in the back of participants' minds and at times, technical complexity required a different path. Enabling factors were more focused on the group members themselves and included the group dynamic, an enabling attitude, previous positive experiences of the digital

natives, a lack of self-consciousness and a sense of connection to the instrument as an expression of self-identity, plus enjoyment, that all drove the exploration onwards. Similarly, ease of use and the balance between creative constraint and lack of constraint encouraged a satisfying creative outcome.

From the experience of creating with iPads, several methods of discovery were noted. Knowledge was drawn from friends, media and film, other performers, the semi-autonomous group learning environment, and web and YouTube searches.

Lessons for educators and digital immigrants

A typical pedagogical approach in the tradition of electronic and computer music training might start from the principles of sound synthesis and progress through elements of composition and performance with electronic music systems. Or, as has been seen in examples of group learning in laptop orchestras over the last decade (Trueman et al. 2006; Wang et al. 2008), provide a predesigned framework including a scored composition or at the least a palette of sonic resources and a unified control system on which to develop a performance. In contrast, the approach taken through the iPad Orkestra relies on student-directed collaborative learning, on a student's own capacity to resource and explore a path to new musical discovery, and to collaborate with others. The hardware and software ecosystems offered by the iPad and other tablet computing devices contrast with the conventions of scored ensemble instrumental performance in which this project was embedded. Within this field of emerging musical practices, real opportunities for metalearning (Biggs 1985) present themselves. In the research presented here, student musicians have shown themselves to be capable of transforming this assessable creative and collaboration context into opportunities for discovery and deep learning.

References

Biggs, J. B. (1985). The role of metalearning in study process. *British Journal of Educational Psychology*, 55, 185–212.

Latour, B. (2007). *Reassembling the social: An introduction to actor-network-theory.* Oxford: Oxford University Press.

Messerschmitt, D. G. and Szyperski, C. (2003). *Software ecosystem: Understanding an indispensable technology and industry.* Cambridge, MA, USA: MIT Press.

Prensky, M. (October 2001). Digital natives, digital immigrants. *On the Horizon*, 9 (5), 1–6.

Trueman, D., Cook, P., Smallwood, S. and Wang, G. (2006). PLOrk: The Princeton laptop Orchestra. *Paper presented at the International Computer Music Conference 2006*, New Orleans.

Wang, G., Trueman, D., Smallwood, S. and Cook, P. R. (2008). The laptop orchestra as classroom. *Computer Music Journal*, 32 (1), 26–37.

Part II

Student experiences 2

6 Back to the future

A role for 1960s improvisatory scores in the 21st century university music performance program

Diana Blom, Brendan Smyly and John Encarnacao

In the late 1960s music education finally began to draw on contemporary classical composition techniques in the classroom. Universal Edition, UK, for example, published several music scores by composers Bernard Rands, David Bedford and George Self for use in the school music classroom. These improvisatory framed scores introduced school students, for the first time in 20th century music education, to modern classical music sounds which emerged from the ideas and music of John Cage, Edgard Varese, Karlheinz Stockhausen, Krysztof Penderecki, Peter Maxwell Davies and György Ligeti. The scores are concerned with a range of ideas including pointillism, texture, electronic sounds and indeterminacy. For composer, music educator and author Brian Dennis writing in 1970, they also offered colour, that is, the imaginative use of pure sound qualities with textures and sound patterning, to students in that decade and beyond. This chapter discusses early 21st century undergraduate music student responses to preparing and performing improvisatory framed scores from the 1960s–1970s that engage a large number of players in group music-making. The scores offer non-traditional approaches to score reading and improvisation, and an engagement with a seminal time in the history of music education when contemporary composers and educational thinking aligned and elements of musical organisation seldom discussed in classical music were brought to the fore. This chapter explores our students' responses to all of these aspects, their thinking on the relationship between composer and performer in the scores, their familiarity with the music and the musical approaches represented, and what they thought of their engagement with the pieces.

The exploration of sound, notation, and ways of making sound in school music programs was driven by the work of Orff in Germany in the 1950s, the influence of Cage on R. Murray Schafer in Canada in the 1960s, the work of Maxwell Davies and John Paynter and Peter Aston in the late 1960s and 1970s in the United Kingdom, projects in the United States which invited composers into music education in the 1960s, plus the publication and dissemination of these ideas. The creative activities of exploring, improvising, composing, listening and performing music came to be recognised as important and integral components of music education. The advice of these composers, and their ability to harness and adapt the accessible sounds and composition techniques of music

of the avant-garde in the 1960s and 1970s for students, meant that contemporary composition and music-making changed the focus of many music curricula. With the development of alternative notation strategies such as graphic scores, and exploratory approaches to sound, for example in the music of Cage and Penderecki, and later the return to tonality, student composing and performing capabilities and contemporary art music sounds and techniques found a meeting point. The integration of the improvisatory scores under discussion here in school music education acted as a catalyst for student composition approaches not beholden to historical trajectories of Western art music. Through some of these scores, music is presented in terms of play,[1] where any sound has potential and scoring is a matter of finding communicative solutions to the imaginative play of sounds that are not necessarily related to traditional music scoring.

Throughout the 1960s, a number of music educators recognised the difference between students creating in the visual arts, and recreating in music, and introduced composing activities for teachers to use in the classroom. George Self (1967) offered ideas incorporating sound and silence with simplified notation which would make it possible for "average children" to compose music (3). His ideas were "… unashamedly propagating the use of contemporary music as an end in itself" (Walker 1983: 92). In 1961 a performance of Maxwell Davies' *O magnum mysterium*, composed especially for students of the small country grammar school in southern England in which he was full-time teacher of music, was televised. One of the first British composers to work with students on a regular basis (Walker 1983: 87), Maxwell Davies used structures which allowed free improvisation and basic manipulations of simple movements like loud and soft, short and long by students, encouraging his students to think about the compositional process (88).

In *Sound and Silence*, Paynter and Aston's influential book on creative music-making published in the United Kingdom in 1970, students and teachers were introduced to composing and performing activities through contemporary and earlier musical styles, through sounds and trends in 20th century music shaped into 24 imaginative projects. These included: serialism's atonality and dissonance; sound experimentation (Paynter and Aston 1970: 27) on one instrument, offering pieces by Carlos Chavez, Bela Bartok, Stockhausen and Olivier Messiaen (34) as examples of such exploration; silence and sound as the raw material of music through works by Cage, Christian Wolff, Morton Feldman and Earle Brown (214); Cage's use of chance operations to determine which sounds shall occur and when (61); the new sounds of the prepared piano (116); and recording technology as a sound source (134). Paynter and Aston, both composers, linked student composing, performance and self-expression with contemporary arts practice (4) and wrote of artists helping us come to terms with life and its problems:

> Like all the arts, music embodies the reactions of its makers to life as they live it and as they see it lived around them. Of course, a musical work does not have to be an obvious piece of social commentary, although, in

a sense, this happens inevitably. By its own nature music makes a comment. This is why the music of our own day is more relevant to us and to our situation than music of any other time. To understand the art of the present is to understand ourselves.

(201)

Brian Dennis (1970) designed material to help teachers "... who would like to introduce truly modern music ..." into their classrooms (1). He expressed concerns about teachers becoming unfamiliar, and therefore losing contact, with contemporary arts practice: "The health of an art is in danger if those who teach it fall too far behind those who practise it" (1). His projects offered exploration of silence and sound, improvisation within defined pitch sets, ways of notating or charting improvisatory frames, hearing and playing new and familiar sound sources, electronic sound sources, and pieces using graphic or symbol notation. Dennis referred to the work, ideas of, and discussions with, such contemporary composers as George Self, David Bedford, Stockhausen, Luciano Berio, Cage and Cornelius Cardew in relation to his own work as a composer. In doing so, he gave the teacher, as reader and creative musician, a feeling of being on an equal footing with these other composers, sharing their ideas (23).

Like Paynter and Aston, and many other music education resource writers such as Richard Addison (1968) and George Self (1967, 1976), Brian Dennis was a composer. Publisher Universal Edition invited composers Bedford, Self and Rands to write works for the classroom. The result was the *Music for Young Players* series, individual scores published in the late 1960s and early 1970s employing contemporary and at times improvisatory techniques within tightly controlled structures or frames. This close relationship between professional composer and the school environment in the UK during the 1960s and 1970s resulted in an impetus to composing activities which, unlike the US creative projects, has continued into the 21st century. Publications such as those described above offered teachers and students new vocal, body and instrumental sounds, new sound sources including sounds of the environment and electronic music technology, and new notations with which to experiment, explore, improvise and compose. They introduced the work of contemporary musicians into the classroom, and involved children of all musical abilities in acts of music-making, both performance and composition, at an intellectual and physical level commensurate with their ability and their work in other subjects (Walker 1983: 89).

Through the ideas of such composers as Keith Humble, Peter Tahourdin and Geoffrey D'Ombrain, Australian children were introduced to exploring sounds with "anything that can be hit, blown, scraped or plucked [as a potential source of sound, and] ... a pair of portable stereophonic tape recorders, a microphone and a mixer" (Tahourdin 1968: 29). The projects in Geoffrey D'Ombrain's (1969) book often began with free experimentation and "the assumption that musical elements must first be experienced as sounds" (preface – no page

numbers). Published in the same year, Arnold (1969) introduced the concept of chance music, citing works by Harrison Birtwhistle, Bedford and Maxwell Davies as examples. Humble noted that "recent tendencies in composition require, firstly, the musician to improvise or to create and, secondly, the public, to participate" (1969: 11).

Methodology

In 2012, 77 first-year undergraduate music students were asked to prepare and perform improvisation scores composed in the 1960s and 1970s, in a university (not conservatorium) music department that adopts a largely class-based approach to teaching performance. This cohort of music students from a broad range of musical backgrounds was given the scores as a way of engaging a large number of players in group music-making, while offering a non-traditional approach to score reading and improvisation. We wanted to find out if the improvisation scores were still relevant for students in the 21st century and if so, how this was so, and what the students' responses were to playing the scores.

The 77 students that participated on the day had been placed in four groups of 20–25 students each. As in previous years, the tutors (Smyly and Encarnacao) facilitated the session, to some extent conducting but more guiding the students through the pieces, discussing the composers' intentions and acting as a sounding board regarding how to interpret scores that leave much to the performer. Two groups played Terry Riley's *In C* (1964) and David Bedford's *Whitefield Music 2* (1968); and two groups played Kirk Nurock's *War and Night – a natural sound piece* (1973) and Bedford's *Whitefield Music 2*. A two-hour lecture in a previous week had introduced students to music of the 1960s—1970s avant-garde. The lecture began with Blom's personal response to first hearing two pieces in the early 1970s: Terry Riley's *A Rainbow in Curved Air* on LP, and Ligeti's *Sequenza V* (1966) for solo trombone in concert. It then outlined a history of music of this time introducing conceptual art, including Yoko Ono's work, minimalism, the new notations of La Monte Young and Earle Brown, the Polish sonorist composers and their link to the score notation of Bernard Rands' *Sound Patterns 1* (1967), Terry Riley's *In C* (1964), and the sounds and score notation of Penderecki's *Threnody for the Victims of Hiroshima* (1960) and Cathy Berberian's *Stripsody* (1966). The lecture aimed to show students how the scores they were about to work with are deeply embedded in the history of the musical changes of the late 1960s and early 1970s. Terry Riley's *In C* is a quintessential minimalist piece – semi-aleatoric with a strong tonal centre. David Bedford's *Whitefield Music 2* (1968) was published as part of a Universal Edition late 1960s–early 1970s series. For from 6 to 36 players, the score has a page of "Directions for Performance" which explains the "Meaning of the Signs", "Meaning of the Numbers" and "Procedure for Performance" – that is, the notation (see Figures 6.1 and 6.2).

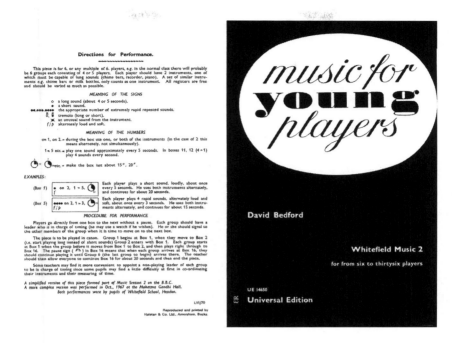

Figure 6.1 David Bedford, *Whitefield Music 2*, frontispiece and directions for perform-
ance. Reproduced with permission from Universal Edition

Nurock's *War and Night* is found in *Scores: An Anthology of New Music* (John-
son 1981). This book is a treasure trove of works by composers such as Alvin
Lucier, Meredith Monk, Charlemagne Palestine, Christian Wolf, Joan La Bar-
bara, Frederick Rzewski, Laurie Anderson, Robert Ashley, Annea Lockwood,
Earle Brown, Trevor Wishart and Terry Riley. The anthology's introduction out-
lines its aims:

> The most important and distinctive feature of this anthology, however, is
> that the pieces are all readily performable by a wide range of people –
> musicians and nonmusicians both – and have been collected specifically for
> this purpose …There are scores here that require no prior musical training
> at all in order to be performed. Others demand some understanding of
> musical notation or familiarity with certain instruments. Quite a few have
> parts which can be learned easily by nonmusicians and then performed
> along with a few experienced players … These scores have an obvious and
> special value in a wide variety of teaching situations, particularly college
> and adult-workshop courses in any aspect of contemporary music, compos-
> ition, experimental theatre, modern dance, or 'intermedia'.
>
> (Johnson 1981: x)

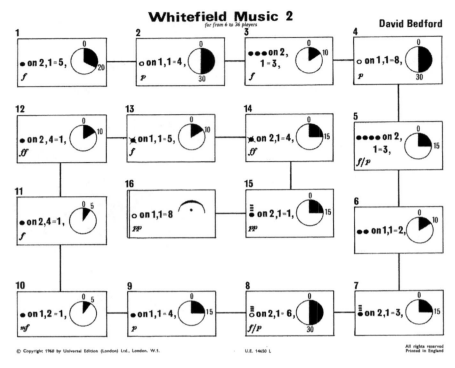

Figure 6.2 David Bedford, *Whitefield Music 2*, score. Reproduced with permission from
Universal Edition

During the teaching, to support the students' perception of the workshopped
material, recordings were made and listened to as a group afterwards. Students
were then able to make judgements from the perspective of both players and
listeners. A questionnaire was distributed to the 77 students – 64 responses
were received. It asked seven questions about familiarity with the scores, the
roles of performer and composer and of notation in such scores, student views
on the pieces and on the artistic outcome of their group, and skills and compos-
itional thinking learnt from performing the works, drawing from our own
musical experiences as improvisers, from previous years' teaching this reper-
toire, and from the literature (see Table 6.1).

Findings

What other music like this have you encountered?

Just below half of the students felt they had not encountered other music like
this before working with the Terry Riley, Kirk Nurock and David Bedford

Table 6.1 The questionnaire

Question	Source
What other music like this have you encountered prior to working with scores by Terry Riley and David Bedford?	Dennis (1970)
Who is more important in the realisation of these pieces, the performer or the composer? Why?	Johnson (1981)
How are these ways of notating music meaningful and successful?	*Music for Young Players*, UE (late 1960s–early 70s)
What do you think about pieces like these?	Dennis (1970)
What did you think of the artistic outcome of your group's performance?	Previous experience of authors
What skills did you learn from rehearsing this improvisation frame that you might find useful in your musical practice?	Walker (1983)
How did working with these scores change your views on music composition?	Arnold (1969)

scores (see Table 6.2). High school music and primary school choral experience had introduced the sounds of Stockhausen, Ligeti, Sylvano Bussotti and the minimalists to a handful of students. Contemporary classical composers of the 1960s–1970s were known to seven students including four composers/works introduced in the lecture. Popular music artists of that period, including The Residents, Pink Floyd, Frank Zappa and The Beatles, were identified by four students. Recent sound worlds of Japanese experimental band Fushitsusha with its electric guitarist and singer, Keiji Haino, and Muse, were recalled, plus a student's own improvising. Finally, the dense vocal texture of a cappella and barbershop was related to the works.

Who is more important in the realisation of these pieces, the performer or the composer? Why?

The performer was considered the more important in the realisation of these pieces for 32 of the students, "because [the pieces] sound different every time" and because "they have to be willing and prepared to invest their own [ideas] into [the music]". This "investment" could be about interpretation, an issue raised by 13 students, with the performer seen as more important because "the composing/instructions are quite vague and can be interpreted in a plethora of ways", and it was "up to [the performers'] interpretation". The composer was considered more important by 11 students because "the ideas [of] the piece are developed by the composer" who "guides the interpretation" of the performer and so "the technicality of the player is redundant" but the player "must constantly be involved by creating new sounds". The ambiguity of this last quote about the two roles became stronger in this response – "I feel the composer, as

Table 6.2 Other music like this encountered prior to working with scores by Terry Riley and David Bedford

None	*33*
Primary school pieces as part of Sydney Singers	1
High school pieces (including Stockhausen, Ligeti and Bussotti, minimalism)	5
John Cage	2
Steve Reich's *Electric Counterpoint*	2
Alvin Lucier	1
Laurie Anderson	1
Possibly *Threnody* – Penderecki	1
Cathy Berberian	1
Clips on YouTube (e.g. Yoko Ono)/heard similar but can't remember the composer	2
The Beatles' "Revolution #9"	1
Frank Zappa's weirder music	1
Pink Floyd	2
Spencer Dryden from Jefferson Airplane	1
What is Music? Festival – The Residents	1
Keiji Haino/Fushitsusha – Japanese composers	2
Experimental jazz bands and orchestras	1
Execution Commentary – Muse	1
"Improvising to a delay or loop pedal by myself sounds relatable"	1
Barbershop harmonies/a capella	1

this piece is played completely differently each time according to how the performer feels". A significant number – ten students – felt that composer and performer were equally important in the realisation of the pieces.

How are these ways of notating musically meaningful and successful?

The responses to whether these ways of notating are musically meaningful and successful were overwhelmingly positive – in fact there was only one comment that could be construed as negative. A high number of responses – roughly one in five – remarked upon the freedom for interpretation engendered in the scores. This was framed as "giv[ing] the performer more artistic freedom" and "stretch-[ing] the boundaries of the imagination of performing". There are mentions of the use of the performer's intuition and freedom within structure. Some of these remarks overlap with what students received as new models for their own composing. "It's useful to my music", as one student summed it up. These pieces, with their unorthodox symbols and aleatoric structures "open your mind to notating music in your own way". The pieces provide "an alternative to traditional notation" and even challenge students ontologically – the pieces "help us to explore different views of what is notating". More broadly, many students

simply remarked upon the newness of the approach to notation for them, "invoking a sense of curiosity" and encouraging creativity.

Roughly one in six students remarked on the democratisation promoted by these scores. Students observed that as many of these pieces do not require the reading of traditional notation, they are much more accessible than the majority of musical scores. "Easily comprehendible, even by non-music readers" wrote one; another notes that "you don't necessarily have to know how to … play an instrument; you can use sounds with your mouth, hands etc." One phrased this in terms of the music not being "exclusive to practiced musicians", indicating an awareness of the social and class-oriented aspects of musical literacy.

What do you think about pieces like these?

The students were overwhelmingly positive (57) about the pieces – "I like them and I would like to listen to more pieces like these". For several there was a change in thinking over time, or a liking for one aspect but not another: "At first I hated it. Thought it was boring, but now I love it. I enjoyed it a lot". Others found them "fun to play. Very interesting and challenging. I couldn't be a listener though", with others noting them as interesting "but I don't think I will listen to/perform them voluntarily". For one, "they are interesting as soundscapes but I can't consider them 'music'". Some found the pieces "interesting but I can't connect" and a vocalist wrote, "I think they are interesting but for a singer, horrible to perform". Only three were totally negative because the pieces "sound like crap".

What did you think of the artistic outcome of your group's performance?

The majority of responses about the artistic outcome of their group's performance were positive. Students found the outcome "intense and challenging" and "interesting and unique", with some highlighting specific musical qualities – "dramatically brilliant. Worked and gelled well together". Eight students gave responses which contained both positive and negative sentiments and not always in that order. For example, "I struggle to appreciate the music as a listener, but over the last three weeks I've come to really enjoy playing it" moved from negative to positive, whereas "It was often initially exciting and creative, but tended to lose energy as the piece moved on" and I "would prefer to participate than to listen back" began with the positive and moved to the negative. Only one student found the outcomes sounded "ridiculous". Positive comments revealed a preference for the rhythm that holds *In C* together rather than the more free-form Bedford score, held together by the conducted downbeats, "due to how more familiar [*In C*] sounded". This brings into question issues of subjectivity and personal musical experience when selecting this repertoire. The Nurock and Bedford were "rather strange, weird, interesting", "amazing", "slightly ethereal" and "exotic". Comments were split between how the pieces sounded and how the group worked together, concerned more with the

playing. Responses such as "I thought it was intense. If we had some prior experience with each other I believe the dynamic could have been moved in sync", "a very different sound" and "interesting dynamics and a vast range of vocal effects" focused on how the pieces sounded. Responses focused on playing together highlighted several key is.ues: "everyone seems onto the performance which comes out in the recordings", "it heightened our ability to concentrate as we had to pay attention to ourselves as well as what was happening around us" and several commented on the fun aspect finding the pieces "very 'in-your-face' and entertaining". It was apparent from responses that many students have had no experience of large ensemble playing before arriving at university with words such as "challenging" and "interesting" frequently used. One student made a distinction between "art" and "music", stating that although artistic, the scores produced "not really good" music. Yet for a group of students, the pieces "changed the way we viewed music and what can be interpreted as music" and "made me think about my perception of music".

What skills did you learn from rehearsing this improvisation frame that you might find useful in your musical practice?

Skills learnt were spread across a range of "hard", that is, musical issues, with only three students noting "soft" personal issues of confidence, and collaboration with people. The musical issue with the most responses (12) was about "working in an ensemble with different rhythms and instruments playing at once while focusing on one part", a basic of any ensemble playing but particularly so for scores with an improvisation component. Eleven responses were about being open-minded, "open to less traditional methods", "losing my tunnel vision as to how I look at music composition" and "that nothing is wrong. No notes or sounds are incorrect. It is up to an individual to perform the way they want to". Related to this was an emphasis on listening, "focusing on sounds rather than notes or words specifically", making quick decisions, communicating and "to continue playing no matter what happens around me". Two expressed a performing attitude to "stay in the moment. Nothing before or after matters, only the music that is performed now" and to "let the music flow, which has helped me as a musician". Related to this were five comments about being able to relax "because there is no stress on a time signature", "not worrying so much about the notes of a scale and being more loose on timing". This left space for ten students to think about interpreting the scores, whose format was new to most, and "to take an organic approach to music interpretation". The specifics of learning new playing techniques was a skill taken from the pieces by seven students, including "unique ways of playing an instrument", implementing "unorthodox sounds into your composition", "the use of non-traditional methods when playing or creating music" and finding "that you could do so much more than sing with your voice – music can be made out of everything". Two found the scores useful for honing sight-reading skills and for four students, the pieces

focused them on the importance of dynamics "where there is no real melody line", noting "shifts in dynamics and time management".

How did working with these scores change your views on music composition?

In hindsight, the framing of this question, by assuming some positive effect, may have invited negative responses. Although these were still a small minority, there were eight of them (or nearly 15% of responses), most a succinct "they didn't" (change the student's views on composition) but one a cynical "won't get paid to play this". But again, overwhelmingly, the response was positive, most students offering some variant of the idea of discovering something new. This breaks down into three types of remark, the first given by over a third of respondents that they now had "a wider perspective on what counts as music", that there are "new areas" and "new ways", "different voices" possible. There are "new ideas" and "other forms" possible; one student wrote that these pieces "allowed me to think outside common practices".

This leads to the other two ways students addressed the "new" thinking of these pieces, as expressed by another third of the cohort discrete from those just mentioned. Many referred to rules or boundaries – that these no longer existed or were not what they'd previously imagined. A couple of students used the phrase "anything is possible". "It made me realise that the realm of composition is very open", wrote another. Related, but with a slightly different emphasis, is the idea that traditions are not as binding as students may have previously thought. "Rigid" and "strict" are words used by students to indicate the elements of composition that no longer need to be adhered to. "Sound can be sculpted in a much less rigid world"; "music doesn't have to be typical"; "music is not always in sync"; "can be very random – doesn't have to be specific styles" – all of these expressions are evidence of students opening up to possibilities in composition and performance that were previously impossible to imagine. Together with other modules in the degree, these scores give students tools with which to construct their own fusions of improvisation, electronics and elements from traditions and genres already part of their skill set when they entered university.

Conclusions

Two factors were noted as being influential in shaping responses: familiarity, or lack thereof, with the look and sound of the scores; and experience, or lack thereof, with ensemble playing. The majority of students were positive about the music they produced from the scores with the tonality of Riley's *In C*, in particular, receiving more positive responses than the Bedford symbol score and Nurock texted score which were often perceived as weird, amazing, exotic, but interesting. The three different styles of improvisatory framed scores and the resulting sounds were unfamiliar to around half of the students, the other half linking them to a range of largely experimental classical and popular musicians.

This interesting body of music indicated what students listen to and have been engaging with in schools. What also emerged was often a lack of experience of playing with other musicians – ensemble playing – so this style of collaborative music-making, combined with the unprecedented, for these students, nature of the scores, brought out the expected and the unexpected. Skills such as improving sight-reading and rhythm-reading were raised less often than an emphasis on dynamics and their ability to shape a sound world, the importance of listening while continuing to play, and the many ways the scores could be, and were, interpreted. The democratisation of the scores, through their three different notation styles, encouraged thinking about whether the performer was more important than the composer and how compositional thinking was affected. Being performers, the majority of students considered the performer more important in the works, and while several pragmatic students couldn't see a use for writing music using this style of notation and score shape, for many the works opened minds, brought a new awareness to the musical possibilities of sounds they might not have previously considered musical and to new strategies with which to notate music.

Recording the students' performances of these three scores gave them the opportunity to consider the results from the perspective of a listening audience, and this is evident in many of the comments. These varied responses reminded Smyly of his overarching music educator philosophy, a belief implicitly or explicitly communicated through his engagement with these students in this compulsory first-year unit, that music education should be inclusive and accepting of all music. He feels his role as a predominantly first-year educator is to open students' ears to the possibilities of collective sound-making.

In an article titled "Marching backwards into the future ...", Burke (2014) noted that the introduction of the English creative music movement into the Victorian state secondary education curriculum in Australia in the 1970s failed due to the inability of the Victorian Education Department "to develop a rationale for progressive music education or to retrain its music teachers in ways to develop effective child-centred curriculum initiatives for creative music education" (51). It was replaced in 1995 by "standards-based education" (42). For Burke, "a knowledge of past practices can offer understanding to present-day school music operations and hopefully identify looming pitfalls" (51). Drawing this into the university music level, we have found, from our own observations and from the responses of the participants in this study, that the introduction of scores composed 40–50 years ago was a move "back to the future" which is extremely fruitful for the development of musical thinking, ensemble skills, repertoire expansion, acknowledgement of musical parameters beyond pitch and rhythm, and for opening minds to what music is and might be.[2]

Notes

1 For more on the idea of play as a tool in music performance teaching, see Chapter 13.
2 See also Chapter 2 on Annea Lockwood's "Piano Burning".

References

Addison, R. (1968). *Begin making music – A first book of musical experiments for young people*. Edinburgh: Holmes McDougall.

Arnold, D. E. (1969). *Music alive! An introductory course for secondary schools*. Sydney: G. Ricordi & Co. Pty. Ltd.

Bedford, D. (1968). *Whitefield music 2*. London: Universal Edition.

Burke, H. (2014). Marching backwards into the future: The introduction of the English creative music movement in state secondary schools in Victoria, Australia. *British Journal of Music Education*, 31 (1), 41–54.

D'Ombrain, G. R. (1969). *Music now – A discovery course for secondary students*. Australia: Cassell.

Dennis, B. (1970). *Experimental music in schools: Towards a new world of sound*. Oxford: Oxford University Press.

Humble, K. (1969). Creative music in the classroom. *The Australian Journal of Music Education*. October, 5, 11–13.

Johnson, R. (1981). *Scores: An anthology of new music* (selection and commentary by Roger Johnson). New York: Schirmer Books.

Nurock, K. (1973). War and night. In R. Johnson (Ed.), (1981) *Scores: An anthology of new music* (selection and commentary by Roger Johnson). New York: Schirmer Books, 28–30.

Paynter, J. and Aston, P. (1970). *Sound and silence*. Cambridge: Cambridge University Press.

Self, G. (1967). *New sounds in class*. London: Universal Edition.

Self, G. (1976). *Make a new sound*. London: Universal Edition.

Tahourdin, P. (1968). Electronic music in the classroom. *Australian Journal of Music Education*, April, 2, 25–29.

Walker, R. (1983). Innovation in the music curriculum: 1. New ideas from Canada and Great Britain. *Psychology of Music*, 11 (2), 86–96.

Professional development

7 A professional development program to facilitate group music performance teaching

Annie Mitchell

Introduction

Undergraduate music programs are constantly undergoing rethinking and change. In 2009 the undergraduate Contemporary Music degree at Southern Cross University (SCU) underwent a major course review. This degree had been based on the conservatory model of one-to-one tuition in five instrumental[1] studios (guitar, voice, keyboards, bass, drums). A significant outcome of this review was a change in focus from one-to-one tuition to small group teaching of first year music performance subjects in each studio. In 2012 the small group model was expanded to music performance subjects in second and third years, with group classes and one-to-one lessons alternated on a fortnightly basis. Although the rationale underpinning these changes related to budgetary, staffing and time efficiencies, the changes occurred in an ideological context of pedagogical debate over the continued relevance of conservatoire-style music teaching and the superiority (or otherwise) of one-to-one tuition over group teaching. Part of this debate was how teaching staff can be introduced to models for new learning environments.

To facilitate the transition from one-to-one to group teaching, and in response to teachers' demands for support in group teaching pedagogy, I created and facilitated a two-day professional development program (PDP) for instrumental teaching staff. The questions underpinning the research project were:

i) What were the outcomes of the PDP?
ii) What challenges were encountered in the PDP?
iii) What are the implications for PDPs and university music curricula?

The PDP sought to address the delivery of curricula through the identification of best teaching strategies, ensure an equivalence of standards and practice in different studios, integrate current technology into delivery and learning environments, and to analyse and disseminate the learning outcomes and implications for music education and music educators. Broader aims of the program were to motivate colleagues in accepting responsibility for their ongoing professional development and interrogation of their pedagogy, and to provide an exemplar of

professional training responsive to current changes in the music higher education sector. The PDP and its outcomes were also presented in a report distributed to the program's participants.

This chapter reports on the facilitation of the PDP, its immediate outcomes, and responses to the research questions that emerged from the process. Chapter 8 discusses longer-term implementation of PDP recommendations, group teaching strategies for instrumental music and broader implications for curriculum development, music education and the training of beginning music teachers.

Literature review

Models for new learning environments

Rather than the one-to-one master-apprentice tradition, pedagogical models need to align with the professional demands and performance models required by the twenty-first century music industry. Ensemble classes are a particularly beneficial example of contemporary, industry-related learning environments. Liertz (2007) flags the need for effective performance-based curricula suited to the music career requirements and contemporary social and professional practices of twenty-first century pluralistic values. New models have emerged in Australian tertiary music education that are significantly student-centred, self-directed, self-managed and self- and peer-assessed. These include: a "community of practice" model (Lebler 2006); small group model (Daniel 2004); peer-assessment in musical performance methodology (Daniel 2004); and "a holistic training strategies framework" (Liertz 2002). These models, however, "assume a level of technical ability, musical expertise and knowledge of performance criteria that the student brings to the learning environment and on which the student builds" (Mitchell 2012: 78). They also assume that teaching staff will make and accept the transition to a new teaching model. Diversifying and broadening the interaction between university curricula, the industry and the broader community optimises opportunities to create and refine new learning environments and to design professional development programs that will help teaching staff transition to a new learning/teaching environment.

Professional development for instrumental music teachers

While university education is the pinnacle of institutionalised learning, it is an alarming fact (of itself) that in Australia while academic qualifications are required for appointment to the position of university lecturer, no formal teaching qualifications are necessary for instrumental teaching. Though universities provide courses to qualify students for teaching vocations at primary and secondary school levels, there is a dearth of teacher training for instrumental teachers (Mills and Smith 2003), a situation identified in the UK where "this responsible and important job is often undertaken with little or no training" (University of Reading 2003: 6). Disconnection and isolation are themes that

resonate through instrumental learning, training and teaching and these factors need to be addressed "through opportunities for sharing practice, and for professional development particularly in generic areas of teaching" (Gaunt 2007: 46). Liertz (2007), reporting on European research, notes "the pedagogical emphasis has shifted from teaching to *learning, learning how to learn*, and *lifelong learning"* (6). Commitment to lifelong learning is imperative for the continued development of a musician's performance practice and a music teacher's pedagogy. Lifelong learning can be greatly enhanced through systematic, strategic, scaffolded and sustained professional development, "… a process that takes place on a continuous basis within the context of the teaching setting" (Hussey et al. 1999; Newman 1998; Olebe 1999, all in Bowles 2000:11–12) not the ad hoc, opportunistic short-term fix that frequently occurs.

Sparks and Hirsh (1997 in Bush 2007) identified conditions that enhance the effectiveness of professional development: "when it is result-based, centred on the curriculum or standards, rigorous, sustained and cumulative, and can be linked directly to what occurs in the classroom" and focused on "specific, higher-order teaching strategies" (United States Department of Education, [USDOE] 2000: 60 in Bush 2007: 10). Other conducive factors are when the professional development is related to current research (Yarbrough, Price and Bowers 1991), topics are of importance to the participants (Colwell 1997), the delivery of professional development is high quality (USDOE 2000 in Bush 2007) and when teachers are motivated and self-reflective. For Conkling and Henry, "subject matter expertise, collaboration, ongoing enquiry into teaching and learning, and reflective practice are consistent threads in the professional development school literature" (Conkling and Henry 1999: 24). The Professional Development School model of the Holmes Group (Conkling and Henry 1999; Henry 2001) focuses on long-term change – "it is holistic and encompasses the entire education system" (Henry 2001: 24) and guided by principles of a community of learning, teaching and learning for understanding, and linking theory to practice (24).

Methodology

The project, overall, had three phases. In Phase One, which this chapter reports on, participants engaged in a professional development program aimed to identify best practice teaching strategies for group classes in instrumental music. Phase Two involved integrating these identified best practices and teaching strategies into the Contemporary Music undergraduate curriculum, and in Phase Three the results and success of this process were evaluated. Phases Two and Three are reported in Chapter 8.

Half of the instrumental lessons in SCU's Contemporary Music performance major were replaced with group classes in 2012, thus changing the delivery to one half-hour one-to-one lesson and a one-hour group class per fortnight, plus a one-hour weekly studio workshop of combined year levels. The workshop is an interactive masterclass for all students studying a particular instrument,

where each week a different technical, stylistic or interpretative concept or theme is explored. To capture information across the stages of the project, five qualitative data-gathering approaches were used: questionnaire, observation of the teaching practices of colleagues, focus group discussions, written reports from participants and autoethnographical study of my own pedagogical practice. In each stage of this project the participants were the instrumental and ensemble teachers in the Contemporary Music program.

The questions given to PDP participants were:

i) What are the best teaching strategies for delivering music performance subjects through group classes?

ii) How do you address the challenge of teaching in groups where there is a diverse range of musical and/or learning abilities?

iii) What parts of the curriculum content for music performance subjects are most suitable/least suitable for teaching through group classes?

iv) In what ways can your studio instrument be used to teach in small groups?

v) How do you integrate different learning styles into your delivery of music performance subjects?

vi) What criteria do you use for the assessment of instrumental music skills and performance?

vii) What strategies do you use for managing student behaviour in group classes: conflict resolution, motivation, attention, checking for learning, time management?

viii) What are the best outcomes you have achieved from teaching instrumental music through group classes?

ix) What significant problems have you encountered teaching instrumental music through group classes?

x) How have you addressed these problems? Was the problem-solving successful?

Professional development program

The methods described by Bennett and Stanberg (2006: 5) in an introductory undergraduate unit for aspiring music teachers were similar to many strategies I adopted in the PDP and sought a balance between participant-centred approach, workshop format, discussions, games, debate and peer-teaching exercises. I included current relevant research as well. The PDP workshop covered two days, with each day divided into three two-hour themed sessions followed by a daily review: Day One – how students learn music, learning environments, teaching/learning styles (see Table 7.1) and Day Two – curricula and planning, assessment and standards, resources, technology and research (see Table 7.2).

Table 7.1　Professional development program: Day One

Session	Activities
How students learn music	*Introduction*: aim, outline and anticipated outcomes of program *Research*: summarise research results, identify approaches already used, application of research findings to Contemporary Music course *Learning Styles*: relate Kolb's (1984) Learning Cycle to teaching (concrete experience, reflective observation, abstract conceptualisation, active experimentation); identify uses of kinaesthetic, aural, visual and written learning styles *Communication*: role-play scenarios of different learning styles; discuss pedagogical implications and communication techniques
Learning environments, teaching contexts	Discuss establishing productive learning environments, identify threats *Best Practices*: staff demonstrate their most effective teaching strategies in one-to-one, ensemble and workshop classes *Behaviour Management*: role-play of conflict scenarios; demonstrate poor and effective responses *Motivation*: brainstorm what motivates students/teachers; integrating motivational activities into curricula; rewarding positive behaviours *DiSC*: discuss personality types – dominance, influence, steadiness, conscientiousness (DiSC Profile 2010)
Learning styles	Discuss teaching styles and their application: activist, reflector, theorist, pragmatist (Mumford and Honey 1992) Identify *content* and *skills* in instrumental music subjects Discuss strategies for skills development Demonstrate strategies for accommodating cohorts with diverse abilities; checking for learning Identify uses of various levels of teaching: directing, demonstrating, facilitating, observing, intervening, correcting, coaching Review progress of Day One

Table 7.2　Professional development program: Day Two

Session	Activities
Planning and preparation for teaching	*Curriculum Design*: identify areas of one-to-one, ensemble and workshop subjects suitable for group teaching, those needing individual instruction *Lesson Planning*: each participant planned a lesson according to a template, integrating several teaching strategies *Time Management*: identify time-wasting activities, discuss time management
Assessment, moderation, standards	*Criteria*: review/rewrite assessment criteria in relevant subjects *Performance Examination*: watch excerpts of student performances; mark according to criteria sheet; discuss and moderate marking differences

(Continued)

Table 7.2 (Cont.)

Session	Activities
	Discuss giving feedback (spontaneous, planned, critical) *Studio Standards*: participants reveal two areas where their studio does well/needs to improve; two aspects of curriculum their students find difficult or hard to accomplish Discuss strategies to achieve these objectives/improve outcomes
Technology, resources, course development, teams	*Technology*: reveal new technologies available for instrumental teaching; discuss methods to increase interaction between instrumental and production students/studios Explain working of new electronic drum laboratory/keyboard laboratory and applications for group teaching *Short Courses*: brainstorm ideas for small group short courses *Team Building*: discuss team building, working co-operatively, setting and sharing goals, changing silo culture of working alone *Goal Setting*: task about setting two goals (short-term, medium-term) that are SMART (DuFour, Eaker, Karhanek 2004): specific, measurable, achievable, results-oriented, timely
Review	*Summary*: review achievements of Day Two Revisit research questions; discuss publication of outcomes Participants to submit short individual reports addressing research questions

Outcomes from the professional development program

The expected outcomes from the PDP were the identification of best teaching practices, assessment approaches, competence in group teaching for participants, thorough integration of Unit Statements (Subject Learning Guides) into teaching, equivalence of studios, utilisation of state-of-the-art technology to enhance group teaching, and research publications and applications for grant funding for further pedagogical research. The results, however, were rather mixed. Immediate outcomes of the PDP and responses to questions i–vii given to participants, are reported here. The outcomes of longer-term aims (Project Phase Two and Three, and questions viii, ix and x given to participants) are reported in Chapter 8.

i) The following strategies were identified by participants as *best practice* in one-to-one teaching. Participants felt concepts should be limited to three in each class, ensuring the concepts relate to each other. Explain how to

practise, relate this to very specific tasks and demonstrate how to do tasks. When teaching new co-ordination or technical skills, break the task into small segments then intervene to address any co-ordination issues in each segment of the task. Similarly, practise compositions in sections by dissecting music into small manageable pieces; when mastered, connect sections together. Address emerging issues as they arise, intervene and correct, then check for learning regularly in future classes. The utilisation of technology is also beneficial. Video students' performances and/or use a mirror in the studio so students can self-assess their practice habits and performances. This moderates the evaluation and also disseminates the responsibility for critical and negative comments among the teacher and learners.

Ensemble classes are considered an excellent vehicle for group work pedagogy. Fundamental to their construction and success are teamwork, collaboration, equity and self- and peer-assessment. Good practice in ensemble teaching commences with initially discussing the purpose and objectives of the ensemble, musical and personal band dynamics, students' responsibility for their own equipment, behaviour and for learning their own parts, and contextualising each person's role in the group. It is especially important to recognise the role of the singer, how their ability and vocal style influences repertoire choice, and how such choices can make or break the group. Specific musical issues need to be anticipated and a management strategy embedded: managing volume, playing in time and attaining sounds and rhythmic feels authentic to different stylistic genres. Interpersonal attributes such as rehearsal etiquette, giving and receiving constructive feedback, punctuality and attendance (all essential professional qualities in the music industry) need to be understood and exhibited. Ensemble classes are particularly beneficial for developing performance skills in rhythm and groove playing, playing one's instrument in the correct function (solo, lead, accompaniment) and playing with balanced volume, tone and phrasing.

Workshops can also be an excellent group learning environment, with opportunities for solo or group performance, interaction between performers and class audience, playing together in pairs or small groups, discussion of specific musical concepts or challenges, observation, reflection and peer-assessment. Workshops may also allow mentoring of less experienced or less proficient students by students who are more advanced, where the mentor continues to learn by adopting a teaching role. Although having well-structured, planned delivery in workshops is highly desirable, allowing some flexibility to create an engaging and animated environment is also beneficial. This can be achieved by incorporating "Question time" in the lesson, with questions related to a theme, curriculum topic or learning concept. For motivation, annotate real-world stories of students' and teachers' engagement in the music industry and illustrate learning topics with examples from current popular music events such as gigs, concerts and festivals. Playing along with music recordings, viewing DVDs and accessing YouTube are all useful interactive strategies for teaching music in groups.

The importance of acknowledging and rewarding positive behaviours and successful achievements (of students and teachers), whether musical, academic, ethical or social, was found to be a fundamental principle underlying good pedagogical practice in any context. The best teaching strategies for delivering music performance subjects through group classes are for groups to be small, between three to six students of (ideally) equivalent performance levels. Students can then be taught in an ensemble or an instrumental studio group where individuals perform, and often alternate, separate musical parts; e.g. rhythm, chords, lead, accompaniment, soloing. Students can also play along with recordings, videos and the teacher.

ii) The *diversity of musical and/or learning abilities* was found to be one of the greatest challenges for group teaching. One way to address this is by setting a range of goals for students and graduating assessment to the achievement of different grades, so learners with lower abilities aim to pass the subject, while more advanced students are set more challenging tasks and extension activities, thereby following pathways to achieve grades of Distinction or High Distinction. Where individual practice is possible in group lessons (such as in keyboard or drum laboratories), students are able to work at their own level of achievement, so a variety of activities can be included in the one class or an activity presented at varying levels of difficulty.

iii) Certain parts of the *curriculum content* of music performance subjects were found to be suitable for teaching through group classes. Much time can be saved by delivering content in group classes, to avoid the repetition of giving the same information to several students individually. This can apply to curriculum content, assessment and administration of the subject. Areas of the curriculum that involve learning the same repertoire or parts of the same piece, practising grooves (e.g. where one student plays chords and another bass or lead lines) and improvising (where one student improvises over accompaniment played by the other student) are well-suited to group classes.

iv) *Studio instruments* can be used in innovative ways to teach in small groups. Piano studios and keyboard laboratories are easily adapted to group work. Piano parts can be divided between left and right hands, melody, chords and bass line, solo and accompaniment, with students taking turns to play each part, thereby learning the different musical functions of each role. This approach can also be adapted to guitar groups, specifically to learn different skills in lead and rhythm guitar playing. Brass and wind instruments, and also vocal groups, can practise parts in sectional harmony through small ensembles. Similarly, small ensembles of rhythm section players can definitely benefit from learning in groups, so their playing is balanced, rhythmically tight and accurate, and stylistically appropriate for the selected genre.

v) A variety of *different learning styles* can be integrated into the delivery of instrumental music subjects. Kinaesthetic learning styles are prevalent in instrumental music teaching, as performance is the primary activity. This is supported by aural learning, where students are required to listen to and

analyse music. Visual learning occurs by watching performances, either live or recorded, and skill demonstrations, followed by students emulating the demonstrated practices. Visual learning is also engaged when reading music scores. Oral learning is developed through discussion, reporting and consultation. Several levels of teaching were identified as being practised by the instrumental music teachers including directing, demonstrating, facilitating, observing, intervening, correcting, coaching, enabling and self-directed learning.

vi) While *criteria* vary according to each assessment task, general criteria used to assess performance were found to be *sound* (tuning, intonation, timbre, balance); *musicality* (technique, rhythm, pitch, preparation, soloing and improvisation); *stylistic interpretation* (groove, style, melodic nuances, harmonic nuances); and *presentation* (stagecraft, engagement, communication with band and musical direction). These criteria were used for assessment prior to the PDP, but were refined and made consistent through each studio as a result of the PDP.

vii) *Strategies used for managing student behaviour in group classes* – conflict resolution, motivation, attention, checking for learning – are described below. To resolve conflict in a group situation, it is often wise to remove the conflict from the group by taking the student out of the room to discuss the matter, hopefully preventing the situation from impacting on the rest of the group or escalating into a larger problem. However, if the conflict concerns the whole group, as in an ensemble, a group discussion with predetermined, equitable behavioural guidelines may be useful. Knowing students' backgrounds, interests and extra curricula musical activities and integrating these into the learning environment are highly motivational strategies. Attention to individuals is problematic in group classes, where the teacher needs to give equal attention to each student, but pressures such as students experiencing difficulties, students at different achievement levels and more demanding personality types can disrupt the equilibrium. Teachers must be mindful of sharing their attention, allow students to self-direct their work and follow up on students needing more support in consultation time rather than in class. It is important to give adequate attention to high achieving students, who are frequently left to direct their own learning and not extended with challenging activities when they can easily achieve the work being set. The PDP participants recommended frequent checking for learning by having students perform set tasks, demonstrate specific skills, report their progress in practice journals, evaluate their progress through self-assessment and discuss the learning of colleagues through peer-assessment. Checking for learning can occur frequently and at strategic times in the curriculum, which can be divided into short, scaffolded modules that are evaluated before progressing to the next module. This was seen as a motivational strategy and an efficient method to identify students who are not motivated or who are experiencing difficulties in doing the work.

Challenges to the success of the professional development program

Some of the greatest challenges to the success of professional development relate to institutional support, program management, continuity of staffing, staff dynamics, sustaining pedagogical reform and the owr rship and management of change. For a program to successfully absorb significant change, particularly when change is imposed by institutional pressures such as budgets and recruitment, support by the institution is critical. Success should not be measured by the achievement of budgetary and enrolment targets to the detriment of pedagogical rigour and academic standards.

In the year following the PDP, several staffing changes occurred, resulting in some participants not continuing to work at the university and a change in program leader. These changes disrupted the continuity of this project, making it difficult to ensure that the teaching practices the PDP was designed to implement were actually being practised. It was also difficult to ascertain the extent to which individual teachers were practising new pedagogies or maintaining their previous habits.

Ownership of change was found to be a collective responsibility, shared by the institution, academic colleagues and also students. While participation in the PDP was voluntary, the prevailing attitude to group teaching in instrumental studios was generally negative. The ideology of one-to-one delivery as the benchmark of instrumental music teaching remains firmly embedded in the philosophy of many teachers and many of their students, whether independently acquired or perpetuated by teachers.

The individual personalities of participants and their attitudes to the changes being addressed greatly impact on group dynamics. Positive behaviours exhibited by participants included co-operation in undertaking activities, desire to learn group teaching methods, shared experience and expertise, genuine endeavour to improve their pedagogy and willingness to try new delivery approaches. Negative behaviours that need to be managed in an intense professional development environment include individuals pursuing their personal agendas to the detriment of the group's objectives (e.g. advocating for their studio and personal preferences rather than the interests of the program as a whole); participants dominating discussions and not adhering to workshop etiquette; silent resistance or covert sabotage of activities by not co-operating; sitting on the fence and not engaging in a genuine manner or offering input; not respecting or valuing the input of colleagues; and participants engaging only tokenistically by paying lip service to agreed changes in policy and practice but then continuing to teach in their habitual manner afterwards.

As facilitator, this was a challenge to my leadership. The PDP was designed to engage the participants in the facilitation of the program and involve them in learner-centred activities. Inclusive program management strategies consisted of making a different participant responsible for getting the group back in the room after each break, accompanying this procedure with a variety of musical selections that reflected their personal tastes, doing group movement exercises

to alleviate fatigue and playing short ball games to open up ways of thinking and problem-solving. Various teaching strategies were employed in the session modules to cater for a diversity of learning styles. These strategies included reading, discussion, debate, role-playing, disclosing, brainstorming, participants demonstrating short teaching scenarios, reflecting, problem-solving, interrogating curricula, reviewing assessment, watching and marking videoed performances and small group work. Most of these strategies worked successfully, but some participants showed resistance to role-playing. In hindsight, the use of an external facilitator for PDPs would bring more objectivity to the group dynamic. Although an external facilitator may not be an expert in the content area, in this context it appears that colleagues do not readily distinguish between their peer's role as a facilitator and their regular collegial role in the department. An external facilitator may then encounter less resistance to some activities and ideas.

From this scenario arises the issue of trust. For the objectives of a workshop to be successful and for the achievement of genuine reform and change, participants need to trust each other to engage genuinely in activities, to honestly answer challenging questions about their teaching and pedagogical philosophy, to follow through with the PDP recommendations and to be transparent about how sustained, effective or unsuccessful the changed practices have been. Trust must also exist between the facilitator and participants, and between this cohort and the university management advocating the curriculum changes. Equity and trust, along with a common goal, participants and participation, self-interest and selflessness (Harris and Harris 1991) and shared power (Henry 2001) have been identified as critical attributes for successful collaboration.

Conclusions and implications for PDPs and university music curricula

Curriculum renewal and pedagogical development are dynamic and continuous processes. This research, therefore, is ongoing and currently informing the implementation of more group work in other music higher education institutions and further curriculum review in SCU's Contemporary Music program. Recommendations from the PDP included:

- focusing on a limited number of concepts per class (ideally three);
- being strategic in choosing curriculum parts for group teaching. Content, assessment and administration often suit group teaching. Skill development and interpretation may be more suited to one-to-one teaching;
- diversifying and innovating teaching strategies to maximise learning in ensemble classes, workshops and group classes, such as having students play their instruments together in various roles (melody, rhythm and accompaniment);
- accommodating diverse learning styles (aural, visual, kinaesthetic);
- standardising achievement, levels of learning and assessment across studios.

An important educational outcome from the PDP was recognition by participants of different learning styles of students, mindfulness of a range of student behaviours (positive and negative) and their impact on the learning environment. The implication of this upon a PD learning environment is very significant: not only must a PDP be inclusive of the various learning styles preferred by participants, but the positive (constructive) and negative (destructive) behaviours and personal issues exhibited by participants (in their teaching as well as in PDPs) need to be addressed. This emerged as the greatest challenge of this process.

The PDP was in response to staff concerns and complaints about the introduction of group classes into a curriculum that had previously centred on conservatoire-styled one-to-one delivery. Contemporary Music staff voiced concerns about reduced one-to-one teaching time, catering for students with different levels of expertise on their studio instrument in group classes, managing class behaviour, addressing learning difficulties of particular students, effective teaching strategies and time management. The PDP reinforced the need for staff (particularly casual staff) to demonstrate subject preparation, e.g. lesson planning, and for staff to demonstrate adherence to the Unit Statement rather than teaching their personal curriculum. According to the measures raised in the literature – that successful professional development is results-based, curriculum-centred, linked to classroom activities (Sparks and Hirsh 1997 in Bush 2007), focused on higher-order teaching strategies (USDOE 2000: 60 in Bush 2007: 10), holistic, and framed on principles of a community of learning, teaching and learning for understanding, and linking theory to practice (Henry 2001: 24) – I felt the PDP achieved its goals.

Embedding long-term change, however, is a complex and problematic process. The professional ideologies and teaching philosophies of staff were challenged by the shift of focus from one-to-one to group teaching, and asking staff to identify best practice in both teaching approaches drew attention to similarities and differences. This change can also affront the instrumental studio teacher's professional identity, most of whom have been educated through the master-apprentice model which is central to their own pedagogy. Interrogating one's own teaching strategies is an important critical and reflective tool, for teachers may copy learned behaviour or passed-down methods without sufficient thought to their effectiveness or relevance. The isolated environment of one-to-one studio teaching may exacerbate the resistance that some music teachers have to professional development and to diversifying their pedagogical practices.

Likewise, the professional aspirations of performance major students support a preference for one-to-one studio learning. Student feedback from performance major students features consistent requests for increased one-to-one class time. Such requests are difficult to justify in the context of delivery statistics at Southern Cross University, where students in each of the music performance subjects receive 105 hours of class time per semester plus 36 hours of concert (whole-of-cohort class). This is more than four times the contact time of the

three core music education third year subjects, and more than double the contact time of the music theory subjects. This scenario indicates that the issue is not one of contact time, but one of perception. Group classes, workshops, concert and other non-individual learning provisions are, apparently, not generally highly valued. The perceived superiority of one-to-one teaching may indicate performance student self-identities as "dreamers" (Huhtanen 2004) who have not reconciled the unlikelihood of a solo performance career with the reality of a career that encompasses performance, teaching, creative work and possibly production. Such portfolio careers entail group performance and group teaching, so training for this diverse vocation would benefit from a varied pedagogical approach in which group teaching was securely integrated.

"Successful restructuring in music teacher education will depend on the extent to which independent, but interrelated, goals are transformed into mutually beneficial actions" (Henry 2001: 27). There appears to be a sector-wide need for systematic, structured and progressive professional development that is integrated into academics' annual workloads, and supported, philosophically and financially, by the institutions where they are employed. Professional development is a shared responsibility between higher education providers, specific programs and their staff, as each party benefits from its success. Academic professional development is the collective responsibility of the institution, the program and its academics, not primarily the professional and financial responsibility of individual teachers. Specialised contextual training in the microteaching environment of small group teaching seems to be overlooked, generally undertaken on the initiative of a few motivated individual researchers and practitioners. The specific pedagogical support appropriate for music teachers and other academics teaching creative work in studio, laboratory and small group environments is not fulfilled by generic institutionally-based professional development. This concern has also been voiced by Bush (2007: 13) and Brophy (1993). Systematic and progressive professional development relevant to one's discipline, pedagogy and creative practice can improve the ethos of teaching staff by deconstructing cultures of resistance and isolation. Teachers can then engage in professional development and pedagogical interrogation as a positive rather than confrontational or tokenistic exercise. Self-analysis and critical reflection are valuable professional attributes which can be engendered in music teacher training. Zeichner (1992: 297) advocates for commitment "to helping prospective teachers internalize the dispositions and skills to study their teaching and to become better at teaching over time, that is, to help teachers take responsibility for their own professional development".

The professional development program and the research conducted into it and discussed in this chapter have implications beyond SCU's Contemporary Music program. By invitation, I have acted as consultant and advisor to colleagues whose programs are facing similar reforms at other Australian tertiary music institutions. The PDP was designed for facilitation in other institutions and is adaptable for teaching in other disciplines, especially creative arts and disciplines involving professional practice. PDPs based on similar principles are

currently being designed for supervision of practice-based music higher degree research (HDR) projects, team teaching of interdisciplinary creative arts subjects, and supervision of interdisciplinary creative arts Honours and HDR projects. Researching into the facilitation and outcomes of the PDP provided a much deeper analysis of the program itself, of the teaching practices of colleagues and of my own pedagogy. Such interrogation is valuable in informing, enacting and assessing educational change.

Note

1 Throughout the chapter, the word "instrumental" generally incorporates instrumental and vocal teaching, the voice in this context considered as an instrument to be taught in the same way as guitar, keyboard etc.

References

Bennett, D. and Stanberg, A. (2006). Musicians as teachers: Developing a positive view through collaborative learning partnerships. *International Journal of Music Education*, 24 (3), 219–230.

Bowles, C. (2000). The self-expressed professional development needs of music educators. *Texas Music Education Research*, www.tmea.org/assets/pdf/research/Bow2000.pdf, accessed 24 February 2016.

Brophy, T. (1993). Evaluation of music educators: Toward defining an appropriate instrument. Unpublished paper. https://files.eric.ed.gov/fulltext/ED375029.pdf, accessed 29 February 2020.

Bush, J. E. (2007). Importance of various professional development opportunities and workshop topics as determined by in-service music teachers. *Journal of Music Teacher Education*, 16 (2), 10–18.

Colwell, R. (1997). Professional development residency program. *Quarterly Journal of Music Teaching and Learning*, 7, 76–90.

Conkling, S. W. and Henry, W. (1999). Professional development partnerships: A new model for music teacher preparation. *Arts Education Policy Review*, 100 (4), 19–23.

Daniel, R. (2004). Innovations in piano teaching: A small-group model for the tertiary level. *Music Education Research*, 6 (1), 23–43.

DiSC Profile. (2010). The DiSC Profile. *From William Moulton Marston to Inscape to Wiley*. Retrieved from www.discprofile.com/what-is-disc/history-of-disc/, accessed 24 February 2016.

DuFour, R., Eaker, R. and Karhanek, G. (2004). *Whatever it takes: How professional learning communities respond when kids don't learn*. Bloomington, IN: National Educational Service.

Gaunt, H. (2007). One-to-one tuition in a conservatoire: The perceptions of instrumental and vocal teachers. *Psychology of Music*, 36 (2), 215–245.

Harris, R. C. and Harris, M. (1991). Symbiosis on trial in educational renewal. *Researcher*, 7 (2), 15–27.

Henry, W. (2001). Music teacher education and the professional development school. *Journal of Music Teacher Education*, 10 (2), 23–28.

Huhtanen, K. (2004). Once I had a promising future (facing reality as an ex-promising pianist). *Australian Music Forum*, 10 (3), 21–27.

Kolb, D. (1984). *Experiential learning: Experience as the source of learning and development*. Englewood Cliffs, NJ: Prentice Hall.

Lebler, D. (2006). The masterless studio: An autonomous education community. *Journal of Learning Design*, 1 (3), 41–50.

Liertz, C. (2002). *Developing performing confidence: A holistic training strategies program for managing practice and performance in music*. Master of Education Honours Thesis, University of Canberra, www.canberra.edu.au/researchrepository/items/565a6033-018c-d5a0-b8eb-dfe933a3457d/1/, accessed 24 February 2016.

Liertz, C. (2007). New frameworks for tertiary music education – A holistic approach for many pyramids of excellence. *Proceedings, 8th Australasian Piano Pedagogy Conference*. Australian National University, http://citeseerx.ist.psu.edu/viewdoc/download?doi=10.1.1.498.778&rep=rep1&type=pdf, accessed 29 February 2020.

Mills, J. and Smith, J. (2003). Teachers' beliefs about effective instrumental teaching in schools and higher education. *British Journal of Music Education*, 20 (01), 5–27.

Mitchell, A.K. (2012). Raising the bar. *Educating professional musicians in a global context: Proceedings of the 19th International Seminar of the Commission for the Education of the Professional Musician*. International Society for Music Education, 78–83.

Mumford, A. and Honey, P. (1992). Questions and answers on learning styles questionnaire. *Industrial and Commercial Training*, 24 (7), 10–13.

Sparks, D. and Hirsh, S. (1997). *A new vision for professional development*. Alexandria, VA: Association for Supervision and Curriculum Development.

University of Reading. (2003). Qualifications in music teaching in professional practice (course outlines), accessed 24 February 2016.

Yarbrough, C., Price, H. E. and Bowers, J. (1991). The effect of knowledge of research on rehearsal skills and teaching values of experienced teachers. *Update: Applications of Research in Music Education*, 9 (2), 17–20.

Zeichner, K. (1992). Rethinking the practicum in the professional development school partnership. *Journal of Teacher Education*, 43 (4), 296–307.

Teaching approaches

Performance practice

8 Implementing group teaching in music performance

Annie Mitchell

Introduction

As detailed in Chapter 7, in 2009 the Bachelor of Contemporary Music (BCM) degree at Southern Cross University (SCU), an Australian regional university, underwent a major course review that resulted in a shift from individual practical music lessons to group classes. A research project was conducted in three phases. Phase One is reported in Chapter 7, where participants engaged in my professional development program (PDP), aiming to identify best practice teaching strategies for group classes in instrumental music. Phase Two of the project involved implementing and integrating the identified best practices and teaching strategies for group music performance teaching into the SCU Contemporary Music undergraduate curriculum. In Phase Three the results and success of this process are evaluated, and significant pedagogical opportunities and challenges arising from teaching practical music through group classes are discussed. Phases Two and Three are reported in this chapter.

Three major questions framed the research:

i) What were the best outcomes achieved from teaching instrumental music through group classes?
ii) What significant problems were encountered teaching instrumental music through group classes?
iii) How were these problems addressed? Was the problem-solving successful?

In this chapter, new learning approaches most productive for group delivery are discussed, key motivational factors and resources that contribute to student development are highlighted, and the suitability of various assessment instruments for group teaching are evaluated. The quality of delivery of the practical music component of the Contemporary Music degree through this format had profound educational implications as these subjects form a significant component of the students' first year experience and the core of the Performance major. Evidence of student learning and satisfaction are estimated with this chapter being richly informed by student feedback, staff research participants' questionnaires and comments, follow-up observation of instrumental teaching

practices, and interrogation of my personal group teaching pedagogy. Program change and curriculum development are dynamic, evolving trends in higher music education. The chapter concludes with discussion of group teaching strategies for instrumental music, broader implications for curriculum development, and the training of beginner music teachers, then longer-term implementation of PDP recommendations.

Literature review

The following section reviews literature on: (i) the debate between one-to-one teaching and group teaching, (ii) group teaching pedagogy, and (iii) the transition from university to the workplace for beginning music teachers.

One-to-one teaching versus group teaching

The arguments in favour of one-to-one instrumental teaching as a superior methodology seem to be "... based on subjective rather than objective data" (Daniel 2004: 27), grounded in tradition and common experience rather than emanating from definitive proof of superior outcomes. Daniel noted that, in practice, the superiority of one-to-one teaching is reinforced, or strongly implied, when the inclusion of group classes is additional or supplementary rather than their being considered as possessing equivalent pedagogical value and integrity. His research affirmed that one-to-one tuition in Australian higher education was perceived as "the crux of the learning environment" (23). However, this crux of the learning environment has been criticised for its non-transparency, student dependency and potential to inhibit student self-responsibility and the development of an individual voice (Gaunt 2006: 46 in Liertz 2007: 4). The relevance of conservatoire-style music training, stemming as it does from a privileged nineteenth century European culture, is questionable in today's global society with its vastly different social constructions, demographics, educational provision and access, vocational opportunities and utilisation of technology. Liertz (2007: 2) challenges the status quo, advising of "the need to revise the traditional style master-apprentice mode of teaching, in ways that reflect the pluralistic values of the 21st century". While these themes represent a broad ideological debate, there are specific pedagogical issues relating to one-to-one teaching and Daniel (2004: 26) summarises these as "time inefficiencies and time serving[1], conservatism and tradition, monocular learning and cloning, imitation and repetition; and the potential for rebellion and frustration".

Group teaching pedagogy

The literature exposed several significant pedagogical issues. Many instrumental teachers have minimal or no training (University of Reading 2003: 6), and can obtain a teaching position at tertiary level without professional academic qualifications. Instrumental teachers primarily imitate the manner in

which they have been taught (Mills and Smith 2003; Daniel 2004). There-fore, many instrumental teachers adopt one-to-one teaching. In a study of ter-tiary piano students and tertiary graduates who had specialised in piano, Daniel (2004) found their knowledge and experience of small group method-ologies to be virtually non-existent, and, conversely, that students who have been taught through group classes are more likely to include group teaching in their own pedagogy.

Whether due to financial, resourcing or ideological pressures, group instru-mental teaching is becoming more prevalent in music higher education provi-sion (Daniel 2004; Young et al. 2003; Mitchell 2012). However, pedagogical developments appear to be inconsistent, individualised and not embedded in the broader culture of instrumental teaching. Institutional professional development is typically directed at lecturing, administration and the utilisation of new tech-nologies, not at specialist microteaching environments. Effective group teaching pedagogy facilitates student-centred, interactive and self-directed learning. Teaching instrumental music in groups creates a more social and stimulating learning environment (Hallam 1998), enabling students to observe and assess each other's practice (Swanwick 1996) and develop greater independent learn-ing (Hallam 1998). Group teaching requires meticulous planning of lessons and is dependent on students practising set work and completing "homework" so they keep up with the required levels of performance. "One of the fundamental goals is the development of a structured, focussed and progressive program of study, in an environment which should be at all times interactive and engaging" (Daniel 2004: 30). Seipp's (1976) study (in Gaunt 2007) comparing trumpet major students taught individually and in group classes demonstrated equivalent progress and standards of achievement for each group, excepting in sight-reading, where the group-taught class achieved higher levels due to ensemble activities.

The transition from university to the workplace for beginner music instrumental teachers

Musicians have multiple roles and must be accordingly multi-skilled, not limited to just performance achievement, especially solo performance. Some of the major professional development concerns of beginner teachers were continuing their musical growth, developing their professional teaching abilities and improving their organisational skills (Roulston et al. 2005). Beginner teachers also emphasised the benefits they received from mentoring by experienced teachers (Roulston et al. 2005) and by experienced teachers modelling good teaching and performance practices (Conkling and Henry 1999). Professional development partnerships can be, according to Conkling and Henry (1999: 21) "the primary vehicle for a socialization process through which college music majors shed their student identities and become music teachers". They identify four facets of this process: synthesis of musicianship, collaboration, enquiry into teaching and learning and reflection (22). The professional development

requirements identified above are relevant to the ongoing professional development of tertiary music teachers.

Phase Two: implementation of group teaching

Phase Two involved integrating the best practices and group teaching strategies that were identified in the research and through the PDP into SCU's new Contemporary Music undergraduate curriculum. This occurred on four levels: through Music Practice subjects, by replacing half the one-to-one lessons in the Performance stream with group classes, by offering a dual streamed BCM course from 2017 for auditioned and non-auditioned applicants, and by focussing on ensemble classes in first year.

Music Practice I–IV are practical subjects designed for students with limited skills on an instrument and for students undertaking study on a second instrument. Classes are divided into single instrument offerings (i.e. guitar class, keyboard class etc.) and delivered by weekly classes for small groups (four to eight students). The diversity of student abilities and knowledge of the instrument present significant challenges in these classes. Students' abilities range from complete beginner to intermediate proficiency. Strategies such as planning a range of activities to suit a variety of individual levels, having more advanced students tutor beginner students, pairing up students of similar abilities to work together and using more proficient students to demonstrate to the class, are useful. The reality of much class delivery in this small group format is that students are encouraged to work independently as the teacher moves around them, attempting to supervise a collection of mini individual lessons rather than a cohesive whole-of-group approach. A balance between these two approaches (group strategy teaching and self-directed independent work) is preferable, i.e. some group activities and some independent work, including all members of the class in a collective performance outcome whilst allowing each student to progress at an appropriate individual pace and receive some individual attention.

Group classes in performance stream

The driving force behind changing practical music delivery from one-to-one to group teaching was to achieve financial, time and resourcing efficiencies. In 2012, the delivery of practical lessons in the Performance subjects (Performance I–IV) changed from weekly half-hour one-to-one lessons to alternating these each fortnight with a one-hour small group class. Both modes of delivery were supplemented by a weekly instrumental one-hour workshop plus a weekly two-hour concert class. The curricula found most suitable for group classes included information-based content: chord and scale knowledge, chord voicings and fingerings, all activities not dependent on individual feedback and attention. Approaches to improvisation were learned in pairs or groups of three, with one student playing rhythm through chord progressions, another playing a bass line, and one improvising by applying scales, modes or arpeggios over the harmony;

then the group swapping roles. Similarly, students practised different functions of their instruments by playing in pairs or threes, swapping between lead/ melody, rhythm accompaniment and bass lines; singers performed similar roles by part-singing. These teaching strategies were easily facilitated by the various functions of electronic musical equipment: keyboards with drum patterns, brass and bass sounds. Students enjoyed working in pairs or threes on material, particularly keyboard students who practise predominantly by themselves.

Auditioned and non-auditioned course entry

In recognition of the continued demand for one-to-one instrumental tuition from teaching staff and some students, a major concept shaping the design of a further review of the BCM degree, implemented in 2017, is parallel admission pathways. This course structure comprises a Specialist Stream for students majoring in performance or songwriting/composition, accepted through competitive audition, and a Portfolio Stream for students studying a broader range of subjects, not requiring audition entry. Students in the Specialist Stream study through one-to-one lessons, ensemble class, workshop and concert class. Students in the Portfolio Stream learn through group classes. In addition to performance and songwriting/composition, other majors include music education, sound production, new media arts and screen. This broad-spectrum course structure aims to attract a larger cohort studying in non-audition streams, these enrolments supplementing the more intensive and higher cost audition streams.

Group teaching through ensembles – best outcomes

Ensemble classes, small and large, are an integral component of the refreshed degree, implemented in 2017. This group focus underpins the practical offerings in first year, with all students required to perform in one small performance ensemble plus one large ensemble, either choir or guitar. The large ensembles are ideal vehicles for the refinement of group teaching pedagogy, with a diverse cohort in each class bringing a range of abilities, ages, prior knowledge and learning styles to the learning environment, i.e. a mixture of students studying voice or guitar for the first time learning with students who specialise in the instrument. The teaching philosophy underpinning this practical focus aims to teach as much of the first year course objectives as possible through ensemble participation. Learning objectives include fundamental music theory and notation, aural musicianship, instrumental and ensemble skills, plus soft skills of teamwork, stagecraft, and occupational and workplace health and safety. The large ensembles in voice and guitar accommodate the high proportion of voice and guitar students admitted to the BCM, these two instrument studios being much more in demand than keyboards, bass and drums. Students are allowed to participate in both large ensembles.

A highly successful strategy in Choir has been to make this ensemble available to all BCM students. Whilst the ensemble is an assessable component of

two consecutive first year subjects, students from second and third year can voluntarily join the Choir. Younger students are inspired by the expertise and enthusiasm exhibited by senior students in concert class and public performances, and are mentored by the good ensemble practices that senior students model in rehearsals. Learning music through large ensembles has proved very effective for low achieving students lacking confidence, who develop skills in a safe, enjoyable and social environment. The large guitar ensemble comprises a similar cohort of students with diverse abilities and experience on this instrument. One successful approach to choosing and teaching repertoire to a diverse, complex class cohort is to select or compose arrangements comprising several parts with different musical functions – melodies written for good readers, chords for rhythm players, single line bass parts and opportunities for improvised solos. Small instrumental ensembles develop from highly teacher-directed in first year, to increasingly independent, student-directed ensembles in second and third years. Student-directed ensembles work well when students have high prior learning, supported by effective facilitation (and intervention where necessary) by the teacher.

Ensemble direction and arranging

In the third year of the BCM, I teach the subject Ensemble Direction and Arranging, which is core to the Music Education major and includes many Performance major students. This subject aims to train preservice teachers in the creative and practical aspects of secondary school teaching, therefore it combines composition and performance objectives. The creative objectives comprise composing and arranging music for ensembles common to secondary education (SATB choir, big bands, small orchestras, classical, jazz and contemporary ensembles); the practical activities are class performances of arrangements in these styles, plus conducting and musical direction of these large group ensembles. The musical craft of arranging and the practical skills of conducting and ensemble leadership are developed in a supportive and peer-teaching environment that prepares students for education practicum, for directing their own bands or community ensembles and for arranging their original compositions or versions of selected repertoire.

The most successful teaching strategies for this group class were the facilitation of student leadership (managing ensemble rehearsals as students took turns to conduct and direct), modelling (demonstrating conducting repertoire as class practised as a group) and peer team teaching (having members of one small ensemble teach, rehearse and conduct an arrangement to a performing ensemble, then groups swapping roles). The subject culminated in a conducting exam with the class divided into small ensembles, each student having 30 minutes to present, rehearse and conduct their ensemble through the performance of a small arrangement at sight. Students conducted and rehearsed their arrangements in class, performed them in SCU's concert class, and adopted them as teaching resources on education practicum.

Ensemble performance, conducting and musical direction prepare aspiring music teachers for practical aspects of music teaching and nurture a collegial, collaborative learning environment where students share ownership of the creative learning process. These leadership-building activities develop adaptability, versatility and transferability of skills, which are valuable attributes of professional musicians and teachers.

Resources

The selection or creation of suitable resources and arrangements contributed greatly to the success of small and large ensemble classes. In the Choir, students collaborated in the choice of repertoire, frequently suggesting recent popular releases or traditional rock or funk hits which I arranged. These choices were balanced with challenging jazz arrangements, so the repertoire offered a diversity of genres, styles, techniques and nuances to interpret. This approach allowed students a significant level of ownership of the material and of the ensemble, which is highly motivational. The Choir debuted at a public Twilight Concert in May 2017, reviewed here by BCM Course Co-ordinator Dr Matt Hill: "The choir performed three songs, one of which was students' choice which enabled the students to have a strong sense of ownership in the ensemble".

Pedagogical challenges: significant problems and problem-solving

In the BCM, group instrumental classes were usually short (one hour duration), intensive and complex learning environments, with high pressure on the teacher to achieve standardised, quality learning outcomes in cohorts whose practical skill levels ranged from beginner to advanced, and whose backgrounds varied from very limited musical experience to extensive professional work in the contemporary music industry. This environment allowed little opportunity for individual attention, e.g. providing detailed feedback for a student working on a special piece, or a student working through a unique approach to composition/improvisation. It was also difficult to address or correct individual flaws in technique. Such delivery relied on significant independent practice by the student in readiness for each class including practise of technical work, score reading, facility and repertoire. However, this needed support, as students must be taught how to practise correctly and have their progress individually monitored. This highlighted the need to integrate one-to-one and group classes carefully. In group teaching environments, it was difficult to respond to student questions that require extensive detail or are tangential to the lesson's intended content, where information was either too advanced or too easy for other class members to grasp. Such questions also frequently arose in lectures and theory classes, and it was incumbent on the teacher to either answer the question in a way that meaningfully informed the whole class, or defer answering the question for an individual student consultation.

Problem management and conflict resolution

The dynamics and construction of a group class or ensemble require much consideration. Aspects to consider when making subgroups include ensuring that skill levels are appropriately distributed. This may be placing students of similar ability in the same group, or building an ensemble with mixed ability players, e.g. lead singers of high ability plus backing vocalists with lower-level skills, principal guitarists plus secondary guitarists. This does not always imply that principal guitarists play melody and solos, but that the role they are playing in a particular piece is most important. Awareness of the various musical layers of music and the function of instruments within the repertoire was imperative. Students could swap between roles for different pieces, and so learned a variety of essential ensemble skills: lead, accompaniment, rhythm playing, harmonisation. The curriculum needed to be integrated horizontally so that tasks in practical music classes were strongly related to learning that students were currently engaged with in other subjects. Vertical integration was also essential, with skills and content building sequentially from one subject to the next in a stream (major specialisation) of study. One recommendation for lesson planning was to divide practical lessons into 10–15 minute sections: present content, let students explore and play with content, listen in and provide individual feedback, then get students to comment on each other's playing, thus engaging students in independent work followed by group evaluation. This strategy nurtured an environment of peer learning, with more proficient students mentoring students with less experience and/or expertise, and peer collaboration on suggesting ways to achieve and improve performance outcomes. For continuity, weekly tasks were set with each new lesson beginning by following up on these, followed by the introduction of new material.

In addition to the musical dynamics of each group, the personal and social dynamics were hugely influential. Knowing any background personality issues in advance helped the teacher to manage personal relationships within the group and to foster constructive communication, teamwork and collaboration. Including senior students with first years in the Choir was most helpful, as the senior students were generally better trained in ensemble performance, modelled good behaviour and group work practices, and were co-operative and less inclined to tolerate time-wasting, disruptive behaviour and distractions. Teachers could leverage on this positive student dynamic and use the older students to assist in leading, directing and mentoring the classes.

Attitudes and perceptions

Resistance by some staff to co-operate with, and support or try, group teaching remained. Despite identifying curriculum content that is effectively and efficiently taught through group classes and having resources available to facilitate this, pressure to return to one-to-one instrumental tuition persists. A gradual increase in one-to-one lessons replacing group classes was negotiated and

implemented from 2014–2016. The resistance to group instrumental teaching was clear, showing that half of the group classes reverted back to one-to-one. The effectiveness of both types of delivery was reduced where a lack of integration between one-to-one and group teaching existed. Negative attitudes can result in group classes being undermined, possibly through a lack of collective will to have them succeed. Such attitudes were evident in some staff and also echoed by some students. However, much of this negativity stemmed from a problem of perception that ensemble and group classes have lower pedagogical value and offer less educational opportunity than one-to-one lessons, even though group classes and particularly ensembles produced high levels of musical development and quality outcomes. Through my professional playing in orchestras and big bands, I have observed that most members, even adult and semi-professional or professional musicians, need continual improvement in their ensemble playing. It is one thing to be able to play through a repertoire, however, to successfully perform repertoire within a large musical ensemble requires different levels of musical skill and musicianship. Additionally, ensemble musicians need a portfolio of group work, teamwork, communication and leadership skills; essential vocational attributes for most professions.

An ongoing problem is that despite performance subjects having high levels of student engagement and face-to-face teaching hours, (in 2017, 56.5 teaching hours per semester in BCM Performance subjects compared with 24–36 teaching hours per semester for theory subjects), the notation and sight-reading skills of many students, even in third year, were inadequate. This made teaching large ensembles very difficult and time-consuming, with much rehearsal time wasted helping students through their parts, rather than being able to rely on their sight-reading ability to play fluently and refine higher-level group performance skills. The co-operation of instrumental teachers in improving music reading outcomes through specific reading activities in their instrumental studios was essential.

Phase Three: results, success, implications and recommendations

Responses to group instrumental classes, from students and staff, have not been very positive, voicing concerns about limited class time, lack of individual attention, and the disparity between student abilities and experience. However, student feedback about ensemble classes (large and small) highlighted the popularity of this type of group delivery. Formal student evaluations of the subject Ensemble Direction and Arranging from 2010–2017 averaged 4.28/5; student evaluations of teaching of this subject over the same period averaged 4.75/5. Such consistently high quantitative ratings, supported by positive qualitative statements by students, indicate high student satisfaction with this subject's content and its delivery, much of which was group ensemble performance and direction. Broader applications of the group teaching strategies I used in Ensemble Direction and Arranging were evident when students undertook education practicum, reporting how beneficial this vocational training was in preparing

preservice teachers for the practical requirements of secondary school teaching. These claims were supported by SCU's School of Education who were responsible for the placement, management and assessment of students on education practicum. "The School of Education commends Dr Mitchell on the excellent learning outcomes that BCM/BEd students accomplish as a result of her course development and teaching" (Dr Marilyn Chaseling, Deputy Head of School of Education 2012).

The success of any subject depends on evidence of student learning. Choir students reported improvements in confidence, ear training, intonation, singing harmonies, group work and blending in ensemble (Choir Student Feedback 2017). Student feedback also attested to improved self-efficacy: "It's been great for developing my voice and confidence with vocals; I can practise my sight reading and my ear training improves against the other part singers" (Choir Student Feedback 2017). Some non-vocal students who joined the Choir commenced singing in SCU's Concert Class and began singing publicly in their own bands, demonstrating improved vocal skills and enhanced confidence in displaying these.

Following another course review in 2016, the performance subjects, over a teaching semester of 12 weeks, offered each student nine half-hour one-to-one lessons, a weekly two-hour instrumental workshop, weekly two-hour concert class, and three one-hour group instrumental classes. This curriculum design provided evidence of continued intense delivery in the performance stream, notably with increased one-to-one lessons and reduced group instrumental classes compared with the 2012 BCM model. This shift also reflected ingrained attitudes that one-to-one teaching is a superior form of delivery, perpetuated by some staff and instilled in students. However, this curriculum design leveraged on outcomes from the previous course review, by strategically using the three group instrumental classes for the delivery of the major musical concepts in that subject (such as the introduction of new content like the scale syllabus, interpretation of charts and repertoire in a new musical genre, or the development of improvisation skills over advanced harmonic progressions). Therefore, despite the resistance in some quarters to group instrumental teaching, initiatives towards group teaching more generally have made an impact and continue to be integrated into the program. Positive and lasting outcomes include using group classes for mass delivery of broad musical concepts and information, interactive practical activities such as playing different roles in a musical arrangement, and particularly a greater importance on ensemble classes.

Implications for higher education, curriculum, group teaching, community engagement

Broader implications for curriculum development lie in recognising the pedagogical opportunities available to group music classes and large ensembles. University concerts and public events are valuable performance opportunities, motivational activities that keep students interested and challenged. Assessments

can be designed with sufficient flexibility to include public performances as instruments of progressive, participatory or summative evaluation. For example, the SCU Choir and large guitar ensemble debuted successfully at a public Twilight Concert in May 2017, the event fulfilling the dual purposes of assessing students for subject evaluation and representing and showcasing the Contemporary Music program. The event was attended by senior university management who noted how well the Choir was received by the public, and the value of making the degree program visible beyond the university. The large guitar and vocal ensembles can be used as flagships for the Contemporary Music program and Southern Cross University, at graduations, concerts, and public and community events. The potential of the Choir is being extended by fostering the inclusion of interested SCU staff.

In 2016 a partnership was created between Southern Cross University and Lismore Symphony Orchestra (LSO), a local community orchestra of approximately 40 musicians who perform five to six concerts annually. Since the creation of this partnership, the orchestra has been based on SCU's Lismore campus, using the university as its rehearsal and performance venue. Frequently, LSO concerts involve a large regional choir. The SCU-LSO partnership provides opportunities for proficient students to perform in the orchestra or sing in the choir, extending the learning activities for BCM students to classical repertoire performance, participation in large and well-attended performances, through active community engagement.

Implications of the professional development program

Two course reviews of SCU's Bachelor of Contemporary Music degree have resulted in an increase in group teaching of practical music, through some increased delivery of instrumental group classes, but particularly through a heightened focus on ensemble classes and large ensemble groups. It is evident that instrumental teachers need regular professional development to enhance their pedagogy of group teaching and refresh their approaches to practical delivery. As with much professional development, the most dedicated and competent teachers tend to avail themselves of such opportunities, while teachers in more need of upskilling often avoid rigorous scrutiny, interrogation and renewal of their teaching practices. We could, therefore, be preaching to the converted.

The recommendations[2] from the PDP of: focussing on a limited number of concepts per class (ideally three); being strategic in choosing curriculum parts for group teaching; diversifying and innovating teaching strategies to maximise learning in ensemble classes, workshops and group classes; accommodating diverse learning styles; and standardising achievement, levels of learning and assessment across studios, have, in general, been successfully implemented in the BCM. However, the pedagogy of group teaching still needs improvement, refinement and greater acceptance.

To refer again to my years of performance in several orchestras and big bands, I am convinced that group performance and ensemble playing are some

of the most challenging but essential musical skillsets required by professional and amateur musicians. It is evident that despite a personal education of years of one-to-one lessons, often culminating in conservatoire training, many instrumentalists still can't play effectively and sympathetically in an ensemble. They may be technically proficient, have high sight-reading abilities and knowledge of repertoire, but often can't play in time with a group, lack the aural perception to attain a balanced ensemble sound, and have little awareness of the role of their instrument, their role in an instrumental section, and their specific contribution to the large ensemble group. Therefore, group music pedagogy and regular professional development is fundamental not only to instrumental music teachers, but also to school teachers, leaders of community music ensembles, and conductors and directors of professional orchestras and bands.

Recommendations

In making recommendations aimed to improve group performance pedagogy and consequently the learning outcomes of music education programs and attributes of tertiary music graduates, I advocate a multimodal framework similar to Solbu's many pyramids of excellence model (Solbu 2007 in Liertz 2007: 7). Liertz (2007: 6–7) has expanded this model and proposed a holistic approach that includes multimodal delivery, shared [or peer] learning, engagement with community and industry, formal and non-formal learning styles, self-directed and lifelong learning, self and peer assessment, and team teaching. Training needs to develop attributes required for musical careers in the twenty-first century such as flexibility, creativity and autonomy (Smit 2007 in Liertz 2007: 6). The concept that students whose musical education has included group instrumental classes are more likely to include this delivery in their pedagogy is an essential consideration in the vocational training of music education students. In their future roles as primary or secondary school music teachers, community or industry musical directors or band leaders, a significant proportion of workload is firmly situated in the group learning environment: whole-of-class practical activities, ensemble, school band, orchestra, choir, musical theatre.

With work-integrated learning and community engagement initiatives advocated in institutional strategic plans, such as Southern Cross University's (2011) goal to "engage with our geographic communities and communities of interest and mutual benefit" (8) by defining and maintaining "a set of strategic partnerships with professions, industry and education providers", music performance education can be greatly enhanced through participation in community choirs and orchestras, bands, music education practicum and professional placements.

Rather than being competitive and mutually exclusive, one-to-one teaching and group teaching may be complementary and genuinely integrated, scaffolding each other within holistic, well-designed, structured, developmental pathways of study. Group teaching and learning must be recognised, accepted and valued, by both teachers and students, as important pedagogical methods and learning experiences. A focus on group learning, rather than group teaching,

that is inclusive of teachers, learners and ideas, is highly recommended. This pedagogy can be enhanced by relevant, systematic and strategic professional development and mentoring by experts. Whether we embrace or resist it, group teaching of practical music is here to stay.

Notes

1 Working in a safe job and doing as little as possible while waiting for the time when they can retire.
2 See Chapter 7 of this volume for more detail.

References

Conkling, S. W. and Henry, W. (1999). Professional development partnerships: A new model for music teacher preparation. *Arts Education Policy Review, 100* (4), 19–23.

Daniel, R. (2004). Innovations in piano teaching: A small-group model for the tertiary level. *Music Education Research, 6* (1), 23–43.

Gaunt, H. (2007). One-to-one tuition in a conservatoire: The perceptions of instrumental and vocal teachers. *Psychology of Music, 36* (2), 215–245.

Hallam, S. (1998). *Instrumental teaching: A practical guide to better teaching and learning.* Oxford: Heinemann.

Liertz, C. (2007). New frameworks for tertiary music education – A holistic approach for many pyramids of excellence. *Proceedings, 8th Australasian Piano Pedagogy Conference.* Australian National University, http://citeseerx.ist.psu.edu/viewdoc/download?doi=10.1.1.498.778&rep=rep1&type=pdf, accessed 29 February 2020.

Mills, J. and Smith, J. (2003). Teachers' beliefs about effective instrumental teaching in schools and higher education. *British Journal of Music Education, 20* (01), 5–27.

Mitchell, A. K. (2012). Raising the bar. *Educating professional musicians in a global context: Proceedings of the 19th International Seminar of the Commission for the Education of the Professional Musician.* International Society for Music Education, 78–83.

Roulston, K., Legette, R. and Trotman Womack, S. (2005). Beginning music teachers' perceptions ofthe transition from university to teaching in schools. *Music Education Research, 7* (1), 59–82.

Seipp, N. F. (1976). *A comparison of class and private music instruction.* Unpublished PhD thesis. West Virginia University.

Southern Cross University. (2011). *Southern Cross University Strategic Plan 2011–2015.* Retrieved August 18th, 2015, from http://scu.edu.au/strategicplan/.

Swanwick, K. (1996). Instrumental teaching as music teaching. In G. Spruce (Ed.), *Teaching music.* London, Routledge, 193–208.

University of Reading. (2003). Qualifications in music teaching in professional practice (course outlines), accessed 24 February 2016.

Young, V., Burwell, K. and Pickup, D. (2003). Areas of study and teaching strategies in instrumentalteaching: A case study research project. *Music Education Research, 5* (2), 139–155.

9 Introducing first year music students to the community choir experience

Skills for lifelong enjoyment and for the portfolio career

Naomi Cooper

In recent decades, community choirs have multiplied around Australia. This trend has seen choirs move beyond the more traditional choral societies and church choirs to offer a broader range of repertoire, governance structures, learning styles, goals and performance types. Within this context, it is therefore increasingly important for music students to have an understanding of the variety of choirs in existence in Australia. This chapter discusses the Western Sydney University (WSU) choir module, housed as the final component of the first year of music performance studies. The chapter discusses how a wide range of students' musical and choral experiences is handled in the first-year university choir. Issues include repertoire choice, notated scores versus learning aurally, vocal technique development, ensemble skills, rehearsal technique and director approach.

The five-week first year choir module in the WSU Bachelor of Music degree program seeks to provide students with positive and meaningful experiences that can lead to lifelong enjoyment of singing and also contribute to their careers, which are likely to take on a portfolio nature. The module is structured in a different way from, for example, choir units offered at Sydney Conservatorium of Music, which prepare for public concerts at the end of each semester and usually include "oratorio and large choral works in association with the Sydney Conservatorium Symphony Orchestra, the Sydney Conservatorium Chamber Orchestra, or the Early Music Ensemble" (The University of Sydney 2018). The WSU choir does not learn or rehearse traditional classical repertoire and there is no formal performance outcome. The teaching consists almost entirely of an aural transmission approach, with very little emphasis placed on the notated musical score.

The module design has been shaped by several factors. The degree program does not follow a conservatorium structure; it instead embraces a diversity of musical forms and encourages a range of approaches in exploring them. The choir module has also been designed to reflect community choirs in Australia in terms of the repertoire and teaching and learning practices that are widespread in the community choir scene. The majority of Australian community choirs are non-auditioned and do not expect members to be able to read musical scores. As a result, many directors choose to teach largely via aural transmission,

meaning they select repertoire that is compatible with an aural approach. The students enrolled display a wide range of experiences, echoing the context of community choir singing in Australia. This means that a similar repertoire and teaching approach are appropriate for students in the choir module and it gives them a taste of the community choir experience.

I had my first community choir experience in this module at WSU. I fell in love with the sensation of singing in harmony with a roomful of other people and my imagination was captured by being exposed to songs from all over the world in languages I had never heard spoken or sung before. Following the completion of my undergraduate degree, I pursued research into directing community choirs in Australia through Honours and PhD degrees and sought to learn to direct choirs. Now, ten years after studying the university choir module, I work as a professional choir director, conducting primary school, secondary school and community choirs across Australia and teach the WSU choir module.

The role of first year music performance units

The Bachelor of Music program at WSU takes an "eclectic, modern and inclusive approach to music repertoire, performance and sound design" in order to prepare students for a wide range of possible careers as professional musicians including music education, music direction, artistic direction, performance, composition, sound design and research (Western Sydney University 2018a). Students study two music performance units in their first year of the program. These units use performative experience to challenge students' fundamental understandings of music-making by providing them with experiences very different from what most have had previously. Exploration of experimental (see Chapter 6) and improvisatory (see Chapter 10) musics push many students outside of their comfort zones and these processes involve questioning definitions of what does and does not constitute music (see Chapters 2 and 10). While singing in a choir does not present the same challenges as undertaking free improvisation, it does challenge students in other ways.

Students enter the choir module with a range of experiences. While they are all musicians, many do not consider themselves to be singers or say they have never sung. Those individuals often face the module with trepidation, fearing failure or humiliation, and feeling confronted by the vulnerability of the singing voice as an instrument. Others have sung with bands or in a singer/songwriter context, though oftentimes those singers have had little or no training. Some are trained singers but may not have experience singing in parts or blending with other voices. For many students, this is their first experience of singing in a choir. Previous choral experience has usually been in school or church choirs, which are not always directed by choral specialists. At the commencement of the module when students are asked what comes to mind when they think of a "choir", most respond with a description of a traditional church choir. They are usually surprised to learn the number and diversity of choirs that exist across Sydney.

The current climate of choral singing in Australia

Church choirs and traditional choral societies have existed across Australia for a long time, as have the singing traditions of various cultural groups. While these choirs continue, organic diversification has taken place in recent decades as a result of "the influence and convergence of particular musical, social, cultural and political factors, at the local, national and international levels" (Rickwood 1998: 69). The variety of choirs available for Australians to participate in is now greater than ever before including choirs for beginners through to professionals, a range of repertoire (classical, contemporary, sacred, secular, early music, gospel, popular, "indie", world music, folk, barbershop, original compositions, newly commissioned works, *a cappella*, accompanied, music of various cultural groups and much more), varying performance goals, membership structures and learning styles. It is valuable for students to have an awareness of this branch of community music in Australia both for their own enjoyment of choral singing and for future employment opportunities. The lecture for the choir module aims to inform students about community choir practices across Australia by providing them with a snapshot of a number of these diverse choirs.

The current community choir landscape emerged from the Australian *a cappella* scene that developed through the 1980s and 1990s. The *a cappella* scene:

> reshaped the landscape of community choral singing by creating a fresh, open approach that had broad secular appeal and operated outside institutional choral traditions. It was driven by a desire to democratise singing and to create a contemporary "hip" engagement with unaccompanied harmony singing.
>
> (Rickwood 2013: 63)

The scene was defined by its interaction with concurrent political movements including feminism, multiculturalism, indigenous rights, labour rights, gay rights and social justice (Downie 1995; Rickwood 1997; Smith 2005).

This type of *a cappella* singing erupted in Sydney in the mid-1980s where a number of choirs emerged within a small space of time. A few important groups established in this period include Mesana Salata, Voices From the Vacant Lot, Café of the Gate of Salvation and Solidarity Choir. Mesana Salata, which formed in 1983, was a female vocal group performing music from the Balkans (Mara Music 2018). Voices From the Vacant Lot was established in 1985 singing eclectic music from across the globe. Several members of Voices From the Vacant Lot went on to establish other vocal groups (Voices From the Vacant Lot 2018). Tony Backhouse started Café of the Gate of Salvation in 1986 because he was passionate about gospel repertoire and there was not a choir singing that music in Sydney at the time (Backhouse 2010). Solidarity Choir was "founded in 1987 to sing 'Nkosi Sikelel' iAfrika' at a civic reception in the Sydney Town Hall for Oliver Thambo, the President in exile of the

African National Congress" (Heatwole 2016). Since that time, Solidarity Choir has continued to perform as a politically activist choir, particularly for the struggle for freedom both domestically and abroad. These groups presented opportunities to sing repertoire very different from traditional choral repertoire and has been largely *a cappella*. Rickwood (1998) described this new *a cappella* scene as 'much more fluid and informal than conventional choirs' (75). For her, "the diversity inherent within the a cappella repertoire, in fact, enable[d] it to attract a far greater participation rate than choral music based solely on the British tradition" (75). Many other groups arose soon after and these choirs continue today with the exception of Mesana Salata, though some of its members went on to sing with Martenitsa Choir (Mara Music 2018). International influences contributed also, such as workshops by Sweet Honey in the Rock (USA), Frankie Armstrong (UK) and Siphiwo Lubambo (South Africa) (Rickwood 1997, 2013).

The *a cappella* scene has since developed into a flourishing movement of community choirs with new groups continually starting up and where "one in three choirs has been running for less than five years" (Masso 2013: 3). While it is difficult to know how many choirs exist across the country, the Australian National Choral Association (ANCA) stated, 'ANCA has over 1000 members Australia wide, with the majority being choirs' (ANCA 2018). Most of these choirs "have an 'open door' policy" with only one-fifth auditioning their members (Masso 2013: 8). Only 8% of community choirs require singers to be able to read music and of the non-auditioned choirs it is only 1% (Masso, 2013: 8). This context of community choral singing informs the design of the WSU choir module.

Design of the choir module

The scope of the five-week choir module (consisting of one lecture and four workshops), its placement within the degree program and the experience of the students participating have resulted in a design which aims to expose students to a variety of experiences and to develop their skills as much as possible in the time available. The choir module is constructed to allow students to experience participation in a large ensemble, develop vocal awareness and technique, experience performance of varied choral repertoire (including notated, aural and improvised choral music) and to experience choral rehearsal and conducting processes.

Ensemble skills and the choral rehearsal

The workshops are facilitated in a way that reflects a community choir rehearsal or workshop situation. The students participate as singers in a whole-class choir of 30–40 students. This provides an opportunity for students to participate in a large ensemble. The university does not have any musical ensembles (choirs, orchestras, concert bands, wind bands etc.) for students to participate in on an

ongoing basis as part of the degree program. Performance units throughout the course focus on small ensemble and solo experience, usually student-led and semi-autonomous rather than led by a conductor or member of staff (see Chapter 3). The choir module therefore offers an opportunity for students to partake in a directed ensemble. Many students have not participated in an ensemble of this kind in or outside of school, making this their first experience of this type of ensemble.

A large part of performing in an ensemble consists of listening to the other parts and understanding the role of one's own part within the whole. I use activities and games to introduce and lead students to these skills. The first activities utilise movement, rhythm and the spoken word to facilitate the listening process. I introduce part-work by leading students in a movement exercise that layers a three-metre stepping pattern over a four-metre stepping pattern. Informal discussions take place between moments of music-making and here we discuss the need to work together with members of one's own part but still listening to the other part to stay in time and understand the relationship between the parts, such as anticipating when the downbeats will synchronise. Aside from the challenge of physicalising polymeter, it is interesting to observe how challenging the music students find this task and the ways in which it reorients their listening and awareness of others. Next, I introduce the spoken voice with more complex listening activities. Speech-based exercises provide an unthreatening introduction for those worried about singing and allow for a smooth transition to singing.

Notated scores and aural learning

Aural transmission (Chadwick 2011; Kennedy 2009; Townsend 1996) is a process where the director models each phrase of each vocal part for the choir in order to teach a choral arrangement. Scores may or may not be distributed but the learning is still largely aural with the score used as a visual reference for what singers are hearing (Cooper 2014). This approach is often used for reasons of inclusion so that anyone can participate regardless of their musical training or experience (Chadwick 2011). In light of the number of non-auditioned choirs and choirs that do not require their singers to be able to read music in Australia (Masso 2013: 8), it makes sense that aural transmission is the predominant teaching approach for many community choir directors in Australia (Cooper 2018: 265–270). Aural transmission is also valued for the way in which musical nuances can be demonstrated by the director and replicated by the choir with an ease of communication that is not possible through a score (Chadwick 2011: 158–159, Townsend 1996: 88). These nuances include tone, articulation, diction, vocal technique and expression. Recent approaches to music education have embraced music from a multitude of cultures around the world and ethnomusicologists have challenged teachers to adopt teaching practices that align with the way music is taught in the culture to which it belongs (Campbell 1991). Aural learning is a part of this process in many instances.

Students are accepted into the Bachelor of Music program through audition and interview or occasionally through demonstrated music performance through the Australian Musical Examinations Board (AMEB) (Western Sydney University 2018b). Many students accepted into the program have strong popular music performance backgrounds but do not have strong score-reading skills. Two compulsory first year music theory units are designed to increase students' music literacy and aural skills to a level suitable for tertiary music study. While keyboard laboratory work is included, sight-singing is not part of these units. Relying on students' ability to confidently read choral scores is not possible and not always the most appropriate teaching method for the repertoire. The spectrum of music literacy among students, the shortcomings of scores in articulating vocal nuances, the use of repertoire from musical traditions where scores are generally not part of the culture, its widespread use among community choirs in Australia and the intention to make the module as accessible as possible to inexperienced singers underpin my decision to use an aural transmission approach. I do, however, distribute scores for some of the repertoire so students can read the lyrics, follow the structure and refer to the notation. At times I draw their attention to the harmonies they are singing and hearing in the room, and their relationship to the notation and relevant theoretical understanding.

Repertoire

The module aims to expose students to a range of choral repertoire that is representative of the diversity of community choirs in Australia and the many singing cultures reflected among them. Upon completion, students have an awareness of the possibilities of community choirs in Australia beyond their initial understanding.

As with any community choir workshop, the repertoire I choose to present is entirely dependent on the students in each workshop group. The skill level, experience, personalities, enthusiasm and attitudes of each student in rehearsal directly impact repertoire selection. As I only have four workshops with the students, decisions are made quite quickly during the first workshop because these variables cannot be known in advance. I introduce part-singing with some short rounds that are interesting but relatively straightforward (usually Maori, Ghanaian and native American rounds). It is important for students to achieve a satisfying sound quite quickly to boost their confidence. The way in which I introduce the first song (to simply sing it, and say "it's easy: the whole song is just four lines") is critical in convincing students that they are all capable even if they do not consider themselves singers. If the students appear relatively comfortable singing in parts, I will then encourage them to walk around the room to hear their part against the other voice parts and to listen across the room for others singing their part. This aural experience is often a special moment for students who have not heard their own voice vibrating against the

sounds of a roomful of other voices before and gives the group confidence and enthusiasm to explore other repertoire.

Following success with some simple pieces, we explore a range of repertoire in four-part harmony representative of the Australian community choral repertoire. This includes South African songs (like *Ke Arona, Sinje-nje Ngemithandazo* and *Freedom is Coming*), gospel arrangements by Tony Backhouse, traditional Aboriginal Australian songs such as *Ngarra Burra Ferra* (a Yorta Yorta song), *Sao Roma* (a Romani gypsy song arranged by Stephen Taberner), folk songs (*Bring Me Little Water Sylvie*) and other rounds and part songs from around the world. We discuss the cultural significance of each of the songs and how they have come to be sung in community choirs in Australia, such as members of the African National Congress teaching South African freedom songs to Australian choirs during the anti-apartheid movement. The diversity of repertoire enables students to understand that there are many possibilities for ensemble singing, which students can partake in for their own enjoyment and as part of their future careers.

Improvisation

Improvisation forms a small but significant part of the module. It provides an alternative choral experience to that of being led by a director and connects the module with the previous performance modules of tonal and free improvisation. Students are guided through one or more improvisation exercises where the group is encouraged to listen to each other and to contribute vocally to a short collaborative improvisation. The process is inspired by Tony Backhouse's workshop improvisation activity where he suggests to "sing with our eyes closed for two minutes and that everyone stops when they think two minutes has elapsed" (2010: 60). He starts by suggesting a short vamp and will "invite everyone to either sing exactly the same thing, or invent a variation, or response, a harmony, or a whole new thing that interlocks with what's going on–but always listening attentively" (61). Students are exposed to vocal 1960s–70s framed/texted scores in the first semester of music performance (see Chapter 6) but this improvisation activity allows students to create their own vocal material aurally in response to other performers in the room.

Conducting experiences

In addition to developing vocal skills and part-singing skills, students are encouraged to explore conducting experiences within the workshops. There is not time within the module to explicitly teach conducting skills and principles but I introduce students to the experience of leading the group through a pentatonic warm-up activity. After singing a pentatonic scale, I introduce Curwen hand signs, which most students have not previously worked with. I ask students to sing the notes I am showing with my hands. I then ask for student volunteers to lead the group and eventually split the class into several

groups following their respective pentatonic conductors simultaneously. This activity gives students a taste of what it is like to use their hands to manipulate a choral sound in a basic way. While use of Curwen hand signs is not common, the use of "hand levels" to show the melodic contour of a vocal part (Kennedy 2009: 192) is widely used by community choir directors in Australia when teaching parts in rehearsal. The pentatonic exercise with Curwen hand signs to represent specific pitches facilitates students' use of hand gestures to evoke sound from their singing colleagues without the conductor also having to learn and/or demonstrate a vocal part to the group. The improvisatory dimension of this activity also connects the choir module with the improvisation studies undertaken earlier in their course (see Chapter 10).

Vocal technique, health and care

Vocal technique, health and care form an important part of the choir module. As many students have not received any vocal training, it is necessary for them to learn how to safely use and care for their voices. I facilitate discussions of basic anatomy and physiology of the vocal mechanism and strategies for vocal care, including approaches to the vocal warm-up and cool-down.

Practical understanding of breathing and vocal production is explored throughout the module, including the application of different vocal techniques for the varied repertoire presented. The short duration of the module restricts the amount of individual vocal development that can take place across the five-week period but many students demonstrate significant improvement and pursue further learning afterwards. As the time I have with students in the module is limited, it is important to create a safe space where students feel comfortable to ask questions as they arise. Many students approach me after class with questions about vocal technique, as this is one of the only occasions the students have access to a vocal/choral specialist. Students are provided with links where they can access further information such as The Voice Foundation website (The Voice Foundation 2018) and the Australian National Association of Teachers of Singing (ANATS 2018) as well as how to locate a choir through the Australian National Choral Association (ANCA 2018).

Students who have not sung much before or have not experienced singing in a choir are often unsure which voice part they belong to. Rather than placing students into voice parts immediately, I encourage them to try all voice parts and sing wherever they feel most comfortable. This experiential learning enables students to deepen their understanding of their own voice rather than being told that they belong in a particular voice part. Some men decide to try singing the soprano part in falsetto and some women want to see what it is like to sing the bass part in their own register. In the workshop context, this experimentation facilitates learning and self-awareness that the students may not be able to experience in a traditional choir format. It also allows students to experience what it is like for a director teaching via aural transmission to sing all the voice parts.

Assessment

Assessment for the module is based on the quality of student participation. Five assessment criteria are applied:

- Commitment to the repertoire at hand
- Application of vocal techniques as introduced in the module
- Quality of participation
- Attention to detail in the production of particular musical performances
- Consistent and punctual attendance and focus.

Students are encouraged to engage with the material presented and are assessed on the way in which they do so. The diversity of experience amongst members of the cohort does not disadvantage students with less vocal or choral experience; instead, each individual is assessed on their commitment to and application of material presented in line with their own stage of development.

Developing skills for a portfolio career

The nature of the music industry in Australia means that many musicians adopt a "portfolio career" comprised of a combination of different roles (Bartleet et al. 2012). These may include performance, composition, sound production, musical direction, education, arts management, academia and more. The choir module contributes several skills for a portfolio career. Confidence in singing is a useful tool for performing musicians across all disciplines. An understanding of the vocal instrument enables instrumentalists, recording engineers, music directors and managers to work more successfully with vocalists. Singing skills are valuable in music education, which many musicians include in their portfolio. Many graduates from the course go on to work as classroom music teachers or music specialists in schools or other organisations. As choral specialist teachers are rare, classroom teachers are often expected to direct choirs, vocal ensembles and musical casts.

Many musicians work in the community with musical theatre groups. Individuals with musical training (though not necessarily vocal training) are often responsible for rehearsing the chorus. A large number of community choir directors have not had training for their role either (Cooper 2017), so some experience of participating in a choir may be beneficial for musicians who find they are asked to lead a choir.

Lifelong enjoyment of singing for students

In addition to the benefits it can offer music students in their careers, developing a love of singing in a choir can also lead to lifelong enjoyment for individuals. The growing number of choirs around the country is testament to the value that members derive from participating in choral singing. There is an increasing body of research reporting on the benefits that singing in a group can

offer for physical, mental and emotional wellbeing (Bailey & Davidson 2005; Beck, Cesario, Yousefi & Enamoto 2000; Bungay, Clift & Skingley 2010; Clift & Hancox 2010; Clift et al. 2010; Clift, Nicol, Raisbeck, Whitmore & Morrison 2010; Gridley 2010; Kreutz, Bongard, Rohrmann, Hodapp & Grebe 2004; Stewart & Lonsdale 2016; Unwin, Kenny & Davis 2002). Recent reports on the mental health of entertainment industry workers in Australia have revealed alarmingly high rates of mental illness (Eynde, Fisher & Sonn 2014, 2016) and a report on music industry professionals in the UK yielded similar results (Gross & Musgrave 2016). Participating in a choir creates a sense of community and connectedness (Stewart & Lonsdale 2016), which can help support individuals experiencing mental illness.

One of the primary goals of the module is to foster students' confidence in singing. The aim is for each student to complete the module with the belief that they are capable of singing and of developing their vocal skills, which is achievable in the five-week period.

Conclusions

Community choirs play an important role in the lives of members of the hundreds of choirs in Australia as singing with others is enjoyable and has a positive effect on wellbeing. For students in the undergraduate Music degree at WSU, participating in the choir is one of the most enjoyable parts of the course. They also develop vocal, aural, collaborative, improvisation, performance, score-reading, analysis and conducting skills and experience. Informal discussions throughout the workshops allow for exploration of the cultural context of the music, processes for collaborative performance, vocal technique and other issues that arise. The flexibility within workshops allows for students with variable experience to develop in different areas and to challenge themselves as much or as little as they feel comfortable. The WSU choir module has been designed as a custom-fit for the course, students, time available and the Australian context. While it deviates from traditional choral programs, it is relevant for the individuals participating in the module, providing them with skills for a portfolio career in the music industry as well as experiences to contribute to a lifelong enjoyment of singing. My own experience, first as a member of the choir, which opened my eyes to the possibilities of choral singing, and now as a professional choir director, is evidence of how these experiences can shape a musician's portfolio career. Having thought directing a community choir would be an enjoyable addition to my multiple roles as a performer, instrumental teacher and workshop facilitator, I have now found myself working as the musical director of eight different choirs and this constitutes a large part of my workload. Students that have undertaken the choir module have found themselves directing choirs in various capacities including school and church choirs. The approach taken in the module, whilst situated here in an Australian context, can be applied more broadly across different institutions and countries. Choral music taught through oral and aural traditions is performed in many countries

and there are countless choirs across the globe using aural transmission as their primary teaching approach. This approach to choir would benefit students studying music in any degree program, offering an alternative perspective to music-making and connecting students with community music practices that flourish internationally. The relevance of this approach, however, is not confined to music students. The listening and collaborative skills developed in a choir, where the voice of each person is equally important to the musical outcome, is relevant in any field where a person works with other individuals. Graduate attributes across a range of subject areas often value skills that prepare students for success in the workplace, including "soft skills" like communication and collaboration, which are keenly developed through the process of group musical rehearsal and performance. Likewise, the investigation of the role of the conductor as a leader but also as the only performer that does not make a sound poses an interesting study for leaders in any industry. The inclusive philosophy of the teaching approach means that a module of this kind would be equally accessible to non-music students as it is to music students and could easily be included as a component of any other degree program.

References

ANATS. (2018). *The Australian National Association of Teachers of Singing Ltd*. www.anats.org.au/, accessed 23 January 2018.

ANCA. (2018). *Australian National Choral Association*. http://anca.org.au/find-choir, accessed 23 January 2018.

Backhouse, T. (2010). *Freeing the song: An approach to directing vocal groups*. Bondi, NSW: École de Fromage.

Bailey, B. A. and Davidson, J. W. (2005). Effects of group singing and performance for marginalized and middle-class singers. *Psychology of Music*, 33 (3), 269–303.

Bartleet, B. L., Bennett, D., Bridgstock, R., Draper, P., Harrison, S. and Schippers, H. (2012). Preparing for portfolio careers in Australian music: Setting a research agenda. *Australian Journal of Music Education*, (1), 32–41.

Beck, R. J., Cesario, T. C., Yousefi, A. and Enamoto, H. (2000). Choral singing, performance perception, and immune system changes in salivary Immunoglobulin A and Cortisol. *Music Perception: An Interdisciplinary Journal*, 18 (1), 87–106.

Bungay, H., Clift, S. and Skingley, A. (2010). The Silver Song Club Project: A sense of well-being through participatory singing. *Journal of Applied Arts & Health*, 1 (2), 165–178.

Campbell, P. S. (1991). *Lessons from the world: A cross-cultural guide to music teaching and learning*. New York: Schirmer Books.

Chadwick, S. (2011). Lift every voice and sing: Constructing community through culturally relevant pedagogy in the University of Illinois Black Chorus. *International Journal of Community Music*, 4 (2), 147–162.

Clift, S. and Hancox, G. (2010). The significance of choral singing for sustaining psychological wellbeing: Findings from a survey of choristers in England, Australia and Germany. *Music Performance Research*, 3, 79–96.

Clift, S., Hancox, G., Morrison, I., Hess, B., Kreutz, G. and Stewart, D. (2010). Choral singing and psychological wellbeing: Quantitative and qualitative findings from English choirs in a cross-national survey. *Journal of Applied Arts & Health*, 1 (1), 19–34.

Clift, S., Nicol, J., Raisbeck, M., Whitmore, C. and Morrison, I. (2010). Group singing, wellbeing and health: A systematic mapping of research evidence. *Journal of Multidisciplinary Research into the Arts. UNESCO Observatory, The University of Melbourne's Early Learning Centure. E-Journal*, 2 (1), 1–25.

Cooper, N. (2014). How community choirs learn if they do not sight-read: Profiling community choirs in Australia. *Paper presented at the International Society for Music Education, 31st World Conference on Music Education*, Porto Alegre, Brazil.

Cooper, N. (2017). *Sing to me: learning to direct community choirs.* (PhD), Western Sydney University, Kingswood.

Cooper, N. (2018). Techniques and tools for music learning in Australian community choirs. In D. T. Melissa Cain, Brydie-Leigh Bartleet, Anne Power, Mari Shiobara (Eds.), *Community music in Oceania: Many voices, one horizon.* Honolulu: University of Hawaii Press, 260–279.

Downie, E. (1995). *Why acapella? Why women? Why now? The acapella movement in popular music in Australia from 1987–1994.* Melbourne: Master of Arts (Music), Monash University.

Eynde, J. v. d., Fisher, A. and Sonn, C. (2014). *Pride, passion & pitfalls: Working in the Australian entertainment industry.* https://static1.squarespace.com/static/584a0c86cd0f68ddbfffdcea/t/587ed9dcd482e9a27b0cc03d/1484708332874/Passion%2C+Pride+%26+Pitfalls_Phase+1+Report.pdf, accessed 24 January 2018.

Eynde, J. v. d., Fisher, A. and Sonn, C. (2016). *Working in the Australian entertainment industry: Final report.* https://static1.squarespace.com/static/584a0c86cd0f68ddbfffdcea/t/587ed93e3e00be6f0d145fe0/1486006488652/Working+in+the+Australian+Entertainment+Industry_Final+Report_Oct16.pdf, accessed 24 January 2018.

Gridley, H. (2010). In the middle of the sound: Group singing, community mental health and wellbeing. *UNESCO Observatory, The University of Melbourne, Refereed E-Journal*, 2 (1), 1–20.

Gross, S. A. and Musgrave, G. (2016). *Can music make you sick? Music and depression: A study into the incidence of musicians' mental health.* www.helpmusicians.org.uk/news/publications, accessed 24 January 2018.

Heatwole, M. (2016). *Early history – 20th anniversary speech.* https://solidaritychoir.wordpress.com/2016/06/11/early-history-20th-anniversary-speech/, accessed 24 January 2018.

Kennedy, M. C. (2009). The Gettin' Higher Choir: Exploring culture, teaching and learning in a community chorus. *International Journal of Community Music*, 2 (2/3), 183–200.

Kreutz, G., Bongard, S., Rohrmann, S., Hodapp, V. and Grebe, D. (2004). Effects of choir singing or listening on secretory Immunoglobulin A, Cortisol, and emotional state. *Journal of Behavioral Medicine*, 27 (6), 623–635.

Masso, A. (2013). *Community choirs in Australia.* www.musicincommunities.org.au, accessed 24 January 2018.

Mara Music (2018). *Martenitsa choir.* www.maramusic.com.au/ArtistDetail.aspx?ID=1, accessed 24 January 2018.

Rickwood, J. (1997). *Liberating voices: Towards an ethnography of women's community a cappella choirs in Australia.* Canberra: Master of Arts, Australian National University.

Rickwood, J. (1998). Embodied acappella: The experience of singing a displaced eclectic repertoire. *Perfect Beat*, 3 (4), 68–84.

Rickwood, J. (2013). *"We are Australian": An ethnographic investigation of the convergence of community music and reconciliation.* PhD, The Australian National University, Canberra.

Smith, G. (2005). *Singing Australian: A history of folk and country music.* North Melbourne, VIC: Pluto Press.

Stewart, N. A. J. and Lonsdale, A. J. (2016). It's better together: The psychological benefits of singing in a choir. *Psychology of Music*, 44 (6), 1240–1254.

Townsend, R. T. (1996). *The music teaching and learning process in an African-American Baptist church.* PhD, University of Illinois at Urbana-Champaign, Michigan.

The University of Sydney. (2018) Performance and Ensembles Units. *Sydney Conservatorium of Music Handbook 2018.* http://sydney.edu.au/handbooks/conservatorium/undergraduate/units_of_study/performance_ensemble_descriptions.shtml, accessed 24 January 2018.

The Voice Foundation. (2018). *The Voice Foundation.* http://voicefoundation.org/, accessed 24 January 2018.

Unwin, M. M., Kenny, D. T. and Davis, P. J. (2002). The effects of group singing on mood. *Psychology of Music*, 30 (2), 175–185.

Voices From the Vacant Lot. (2018). www.voicesfromthevacantlot.com/, accessed 24 January 2018.

Western Sydney University. (2018a). *Bachelor of music.* www.westernsydney.edu.au/future/future_students_home/ug/creative_and_communication_arts/bachelor_of_music, accessed 24 January 2018.

Western Sydney University. (2018b) *Music applicants* www.westernsydney.edu.au/future/study/how-to-apply/music-applicants.html, accessed 24 January 2018.

10 Free improvisation

What is it, can it be taught, and what are the benefits?

John Encarnacao, Brendan Smyly and Monica Brooks

Free improvisation as a category or genre, and as a subject of practice and teaching in the undergraduate context, challenges preconceptions on a number of levels: it is difficult to define; it maps onto students' previous experiences poorly; the results are easily derided as not musical at all. And yet free improvisation has palpable benefits for the musical practice of individuals and beyond. In fact, the very openness of free improvisation engenders broad discussions, particularly regarding the political nature of social/musical engagements and the ways in which our musical lives are shaped by power structures that we partake of but wilfully ignore. Free improvisation avails itself of philosophical meditations as it invites conjecture about what music actually is. As such, students' responses to engaging with it are mixed. This chapter will explore the challenges and benefits of teaching free improvisation in an undergraduate context but in doing so will consider fundamental questions about what music is and what it can achieve.

The chapter will interpolate remarks attributed to one of the three authors where they have something to contribute that may not necessarily reflect a commonly-held perspective. This is the nature of free improvisation: contested, and able to be applied to various outcomes and ways of thinking. The context of this chapter is a module of free improvisation approximately half a semester in length delivered for many years to the first-year cohort of Bachelor of Music students at Western Sydney University.

Definitions

As with all nomenclature, the main purpose of giving a name to anything is to communicate a shared concept. In the context of the music industry, names are important to consumers in that they identify a genre or style they enjoy and further experience of this type of music is predicated on them being able to communicate what they are looking to find. So "free improvisation" becomes the term used to describe non-idiomatic forms of improvisation. The usefulness of the term lies in its ability to communicate a way of playing in which "style

parameters are a by-product of the process" (Sarath, quoted in Hickey 2015: 427). The term is useful in delineating the practice from more common improvisation practices aligned with genre. Derek Bailey suggests the use of the term "non-idiomatic improvisation", with the following rationale:

> Idiomatic improvisation, much the most widely used, is mainly concerned with the expression of an idiom – such as jazz, flamenco or baroque – and takes its identity and motivation from that idiom. Non-idiomatic improvisation has other concerns and is most usually found in so-called "free improvisation" and, while it can be highly stylised, is not usually tied to representing an idiomatic identity.
>
> (Bailey 1993: xi–xii)

The first year of the BMus at Western Sydney University was designed to provide students with experiences of music beyond what they may have had before. Most of us learn to play an instrument as our introduction to music practice (though this is changing with the increasing ubiquity of digital audio workstations since the turn of the century), and in that process learn tropes connected to a certain genre, or range of genres. Many students, even at the age of 18 (a great majority of students commencing undergraduate programs are straight from high school), have strong ideas of what they think "good music" is. They might say that they listen to a broad range of music, but it often turns out that they are particularly interested in musical theatre; or heavy metal; or hip hop; or RnB; or "classic rock"; or soul music; or EDM; or 18th and 19th century classical music. These listening preferences are often reflected in performance preferences. They can exist on a continuum, say from classic rock through to heavy metal, or from RnB to soul music, or from musical theatre to certain strands of contemporary pop or classical music, from soul to jazz, or even from EDM to RnB or hip hop; but each is relatively contained and relies on a definitive set of timbres, articulations, harmonic language and rhythmic tropes. Considering this context, free improvisation as a descriptor of the approach pursued works well in communicating the essential parameters: the music is relatively free of referents, and improvised. We also see that the musical practice students are obliged to engage with is indeed non-idiomatic, and that by definition the training and practice of the vast majority of students is likely to have included only idiomatic improvisation – that is, to the extent that improvisation has been practised at all.

Teaching free improvisation

Broad implications

Our experiences of teaching free improvisation (or perhaps facilitating would be a better term) have led to the integration of musical and other concerns, including the political and the philosophical. It has led to concern about the

sometimes-authoritarian nature of traditional teaching models and interest in the possibility of egalitarian models of music-making. Through free improvisation, students are obliged to interact musically with their peers in ways that they could not have previously imagined, and so the possibility of an evolution in the understanding of collaboration and ensemble is encouraged. In his chapter on improvisation in Australia, Jim Denley (2009) emphasises the collectivity of free improvisation (even if he doesn't use the term "free improvisation"). Implicit here is the undermining, or recalibration, of the idea of someone leading a group – what happens if no-one leads? The egalitarian aesthetic free improvisation accepts and encourages challenges traditionally promoted, almost morally imparted narratives of the pursuit of "excellence" in technical skill on one's instrument. Bailey notes that free improvisation may be used by children, beginners and non-musicians and infers that this may be an affront to those who place the utmost importance on their musical training (Bailey 1993: 83).

For Brooks, who experienced the free improvisation module at WSU from the perspectives of both student and tutor, these experiences are inextricably linked. Specifically, a disintegration of the boundaries between theory and practice, and between making music and broader social concerns, is one of the chief lessons learned. She was able to study with Jim Denley, Peter Blamey, Clayton Thomas and Caleb Kelly, musicians and theorists working both locally and internationally.

BROOKS: All four characters exhibited distinct differences from each another in their approach to teaching the subject. Thomas, being of aggressive yet charismatic persona, whittled the class down to a series of seemingly pragmatic ensembles, attempting a musical gaze beyond what was passable as music: encouraging the class to become involved in their musical communities, and sonic sensibilities, within and without an academic context. In Denley's classes, a performance of free improvisation by the whole class was required in every session, but it was the ensuing discussion that provided a landscape within which to position the music we were playing. Yes, there were musicians snoozing during some conversations, but for the majority it was the beginning of a world where musicology, politics, sounds, and identity became unified in an exploration of why one pursued music as a vocation at all.

By definition, the idea of freedom and all its ramifications is invested in the activities of participating in free improvisation.

SMYLY: In lectures I have included references to Chogyam Trungpa's *The Myth of Freedom* (1976), a fundamental look at the nature of phenomena in the mind of the individual, and an exploration of the largely misunderstood notion of freedom. In it, Trungpa calls for us to be in touch with the fundamental nature of phenomena, without preconception, and to relate with the immediacy of experience. These concepts support the pedagogical effort to inculcate musical actions

in an ever-present "now", with all our baggage and pre-conceptions becoming the musical stuff we work with in freely improvised pieces.

This being-in-the-moment is embodied in Bailey's thought: "[I]f you could play a record only *once*, imagine the intensity you'd have to bring into the listening" (Watson 2004: 416). This train of thought leads naturally to the rejection of the music industry as an outlet for product. The listening experience is degraded through the possibility of repetition. By comparison, the once-only event of a live improvised performance, not captured in recording for some misguided notion of posterity, achieves a kind of purity and transcendence.

Other philosophical concerns are more closely related to the practice of music and its dissemination. Although many of us would advocate for as many possibilities for musical production as can be imagined, free improvisation might be considered a challenge to the classical music default of communicating musical ideas via scores. Saxophonist Evan Parker asks: "If the score represents some kind of ideal performance, why does it ever have to be performed? Surely it would be better for the music lover to read the score, alone or with others … ?" He suggests that scores might be better considered "a recipe for possible music making". Music must take into account "much more than the composer and his muse … if anyone in the production of a music event is dispensable, it is the score-maker, or the 'composer' as he is often called" (Parker cited in Bailey 1993: 80–81). The logical conclusion is that the classical music institution of the symphony orchestra is undemocratic, with a composer and conductor wielding power over scores of musicians whose job it is to realise the conductor's vision of the composer's intentions.

The intention of introducing free improvisation to an undergraduate is not polemic, but the first year of an undergraduate program is a good time to consider polemical ideas. Exposure to such ideas can only help to engender a broader palette of possibilities than students have thus far considered, to bring into focus that all music is created from a philosophical standpoint, whether acknowledged or not, and that such philosophy is lived and experienced, rather than read, studied and theorised in the abstract.

Content and practice

The cooperative and collective nature of free improvisation does not always fit well with a traditional teacher-student relationship, where knowledge is imparted by the learned to the learner. In various ways, we have attempted to create some synergy between the practice of free improvisation and the students' experience of the module. The module was taught mostly in the practice room with groups of six to eight students, but also incorporated four hours of lecture material which included exposure to musical examples as well as many of the philosophical arguments detailed above. It is in the practice room that

particular strategies were pursued to bring students on board with an approach that was completely new to most if not all of them.

BROOKS: At first, I presented a traditional teacher character, ranting furiously as to the multitude of histories operating within the paradigm of what is known as free improvisation. This was predominantly met with a vaguely bemused and bored expression from musicians who had sought higher education to extend their literacy and confidence in an artistic vocation. Basically, that teacher-student model didn't work for me as student or teacher.

This "multitude of histories" is a significant thing to grapple with. Timothy Murphy presents a common understanding of free improvisation when he says that experiments with non-idiomatic improvisation in the UK by musicians such as Derek Bailey, Evan Parker and Gavin Bryars happened concurrently with developments in what was to become known as free jazz in the US. For the latter, he cites Ornette Coleman, Cecil Taylor and Anthony Braxton as exemplars (Murphy 2004: 136). This chronology is slightly troubled; rather than all these musicians being contemporaries, Coleman and Taylor (along with Sun Ra and others) were pushing towards free jazz in the mid–late 1950s, while Braxton, born in 1945, began releasing music in the late 1960s. Bailey and Bryars' group Joseph Holbrooke did not commence playing "completely improvised pieces" until 1965 (Bailey 1993: 86). Matthew Sansom follows a similar approach to Murphy but adds composers of the Western art music tradition such as Karlheinz Stockhausen, Luciano Berio and John Cage, all pursuing in their own ways the idea of "indeterminacy" in the mid–late 1950s (Sansom 2001: 29). By contrast, George Lewis, though not addressing Sansom directly, pursues the argument that historically speaking, words such as "indeterminacy" and "aleatory" are used "to bypass the word improvisation and as such the influence of non-white sensibility" (Lewis 2004: 266–267).

While the art music composers mentioned here would not be part of a free improvisation "canon" that we would construct, these competing historical claims provide a web of references, both theoretical and musical, to which to introduce students. Of course, it is just as vital for students to hear the music of free improvising contemporaries, including the work of their tutors where applicable.[1] Indeed, one approach used in the delivery of the unit was to begin the first lecture with a free improvisation by the tutors, and some effort has been made over the years to bring significant free improvisers to campus for concerts. It is also potentially of interest to consider the relatively rare instances where free improvisation has collided with pop and rock practices – from the experiments of Pink Floyd and Frank Zappa in the 1960s to the approaches of the early works of Gang Gang Dance and Animal Collective in the 2000s.

As much as it seems important to expose students to these contested histories and repertoires – and these can extend to abstract and performance art and other improvisatory practices – it is important not to present the idea that students need to jettison everything they already know.

SMYLY: I think an immersion in the recordings and performances captured in the past is both a help and a hindrance to students coming to this form of playing. Listening to and watching past performances helps to set free playing as a legitimate art-form to students who have not seen or heard it previously. A body of work sits as testament to the form, an undeniable edifice to st..ru-late comprehension. Due to the wide variety of playing styles and the equally broad spectra of sounds we can hear from free players, students can be encouraged to hear something almost familiar, or even be drawn in by some mysterious music. We are each attracted by different sounds, and by making available recordings of players and music from differing traditions or sound making processes, students can find a point of entry, even if the usual value judgements we bring to more traditional music forms cannot apply. And yet by presenting parts of this body of existent work, we could be undercutting the "natural" form of playing that makes free music exciting.

BROOKS: I tried to create the opportunity to discuss *why* we engaged with the musics that we did, directed by the students and mediated by the teacher. From here, we were able to explore the absurdities, traditions, reactions, and approaches to the varying styles of music put forward. The forum resembled an open-ended musicological aspect to the practices we pursued. Each student/musician made comment on the functions of the music of their peers, with topics ranging from how silence or rests can frame a musical theme or sonic event, to questioning whether music requires a degree of experimentation in order to expand upon its historical baggage.

SMYLY: Making a safe space within which young artists can experiment with sound-making helps in freeing inhibitions. Suspending judgement, allowing musical phenomena to stimulate our hearing without adding the filter of critical evaluation is a skill, and I encourage students to develop a deep listening practice not predicated on personal taste. Critical listening is important but the first step, in my view, is to open the space for creative play.

I'm keen to encourage students to develop their own strategies for making free music. One way I attempt to facilitate this is by describing a two-way approach, one internal and one external. The internal approach I call "attitudes" and the external "actions", and these two inform each other, constantly in conversation.

At first glance, this might seem at complete odds with the following strategy, but in a sense both have the objective of creating an environment where anything, musically speaking, is possible.

BROOKS: One of the exercises we attempted was screaming at one another. While unusual for ensemble work, for students who are either not acquainted with one another, or unwilling to have their insecurities delivered on a classroom level, screaming at one another as an exercise provided the necessary foundational intimacy required to work with one another. Students were asked to pair with someone, standing, in opposing lines similar to the beginning position of barn dances.

Student responses

The idea of free improvisation has proved contentious with some students because they receive it as another set of rules – things that you can't do, which include playing in known scales and time signatures, and things that are encouraged, such as extended techniques. As with many aspects of a Bachelor's degree, there can be a group energy or disposition towards unfamiliar material that can be key to individuals' attitudes towards it. There have been instances of general negativity, and instances of relative openness in particular cohorts to the project of free improvisation.

SMYLY: Mostly comments are positive with an approximately three positives to one negative ratio across the years I've coordinated the unit. I've found with most negative comments a degree of acceptance of the form is evident. The difficulties of "teaching" such a form of musical expression are acknowledged as well, although it is understandable that students are striving to do well, to achieve high marks and this sits at odds with a form of expression that, in some ways, avoids right/wrong dichotomies.

ENCARNACAO: Singers particularly tend to find the module challenging. There is something much more personal about producing sound in the body than on an instrument, like it is a more direct expression of the person. This results in a much higher level of self-consciousness and self-censoring than with instrumentalists, who may also feel challenged but tend to be more cavalier about making unusual sounds.

A quite common response from students to both the free improvisation module and the aleatoric scores (addressed in Chapter 6 of this volume) is for students to say, later in the degree, that they did not understand the value of these parts of the course until later, when either "the penny dropped" or they saw the benefit of the modules being expressed in their compositions, performances and thinking about music.

Benefits of studying free improvisation – musical

Studies by Koutsoupidou and Hargreaves (2009) and Burnard (2002) found that school-age students benefited from their engagement with free playing in various ways. An increase in creative thinking, positive group interactions, feelings of ownership of the creative outcomes and an egalitarian view of roles they played in ensembles were all observed. Building on these observations, we've found that students can exhibit a freeing up of the use of tropes and habits related to musical genres, but also the possibility of hybridisation of known musical styles with freer applications of instrumentality. Students are encouraged to reimagine their instruments, which extends their timbral palette, and also to perform with devices that they may not have considered before. Students also learn more about the possibilities of instruments that they cannot play than they might in other performance situations, where established roles for instruments in particular musical styles can be assumed in such a way that makes the

nuances of their capabilities all but invisible. Free playing also encourages an enhanced ability to adapt to unforeseen situations, an acceptance of "mistakes" as experimentation, a greater acceptance of less skilful or more skilful players as equals in group performances, development of a dedicated listening practice, an acceptance of silence as musical gesture, and a better understanding of the use of sound as a communicative device.

Also, all of these benefits are directly applicable to composition. The practice of free improvisation avails a musician of new compositional strategies, from a consideration of extended techniques and fine attention to articulation, timbre and temporality beyond metre or pulse to new ways of imagining musical structures. Being able to improvise non-idiomatically means that musicians become more resourceful. It allows them to think across possibilities in a performance or recording context that go beyond the norms of the practice in a particular genre. It encourages them to reconfigure equipment and reimagine their instrument in ways that benefit their practice and utility. It facilitates the development of being able to make creative decisions in the moment in a performance or recording context. If students are open to the possibility, it can facilitate participation in scenes that may previously not have been known to students.

Benefits beyond the musical

Improvisation, especially untethered from musical genre, is a tool that is applicable across many areas of artistic practice and, one might say, life.

ENCARNACAO: Beyond music, I think there's a good chance that practising free improvisation helps to promote a kind of problem solving that goes beyond the known and into the unknown. It helps to train a person to look for possibilities that aren't immediately apparent. It also teaches lessons about collaboration that are applicable to other circumstances. For someone used to playing in contexts from scores written by other people, it underlines the possibilities inherent in a different type of collaboration. For those used to leading groups, there can be a sense of democratisation, of finding a kind of role in collaboration new to them. For those used to a situation where various individuals take solos, and garner more attention than others because of their virtuosity, perhaps there is also a kind of levelling, a consideration of the gentler or less orthodox positions in any kind of collaboration; the possibility towards more generosity and selflessness.

BROOKS: Just as the age-old phrase of "practice makes perfect" rings both a shudder, and an engrained method of resolving music-based challenges, so should the requirement to reflect, discuss, and reassess what we purport to appreciate culturally, in order to maintain communication between what might be significant for students to learn, and what is delivered by their institution.

SMYLY: To me, and this may seem far-fetched for many reading this, free improvisation is nothing but the experience of life itself through the action of sound production. We are not disconnected from the phenomena around us,

we being an equal part of our perceived realities, acting and interacting through our senses, although this may not seem the case at times. Our thoughts, speech and actions determine the role we play as we go about the world, and our engagement with free improvisation is the same. Our thoughts, sounds and actions determine the shape of every piece. With no template to follow, only the understanding we have of our skill, the skill of those we play with and the situation we find ourselves in, we are free to make music. I have seen students open to new understandings of their personal situations through their free music learning process. By freeing their minds of preconceptions and criticism, to the acceptance of all sound, it is as though their minds become free in other ways.

Note

1 Among many other collaborations and music performance activities, Brooks plays accordion in improvising trio Great Waitress and performs and records as a soloist on piano. Encarnacao and Smyly are two-thirds of improvising trio Espadrille. Encarnacao also performs and records as a soloist on prepared and amplified acoustic guitar, and Smyly has worked with saxophone, guitar and field recordings for improvised performances and recordings.

References

Bailey, D. (1993). *Improvisation: Its nature and practice in music.* USA: Da Capo Press.
Burnard, P. (2002). Investigating children's meaning-making and the emergence of musical interaction in group improvisation. *British Journal of Music Education*, 19, 157–172.
Denley, J. (2009). Networks, playfulness and collectivity: Improv in Australia, 1972–2007. In Gail Priest. (ed.) *Experimental music: Audio explorations in Australia.* Sydney: UNSW Press, 135–153.
Hickey, M. (2015). Learning from the experts: A study of free-improvisation pedagogues in university settings. *Journal of Research in Music Education*, 62, (4), 425–445.
Koutsoupidou, T. and Hargreaves, D. J. (2009). An experimental study of the effects of improvisation on children's creative thinking in music. *Psychology of Music*, 37, 251–278.
Lewis, G. (2004). Improvised music after 1950: Afrological and Eurological perspectives. In C. Cox and D. Warner. (eds.) *Audio culture: Readings in modern music.* New York and London: The Continuum International Publishing Group, 272–284.
Murphy, T. (2004). Improvisation as idiomatic, ethic and harmolodic. *Genre*, XXXVI, 129–150.
Sansom, M. (2001). Imaging music: Abstract expressionism and free improvisation. *Leonardo Music Journal*, 11, 29–34.
Trungpa, C. (1976). *The myth of freedom and the way of meditation.* Boston: Shambhala Publications.
Watson, B. (2004). *Derek Bailey and the story of free improvisation.* London and New York: Verso.

11 Performativity and interactivity

Pre-paradigmatic performance

Ian Stevenson

Introduction

Tertiary music technology education is characterised by a great diversity of pedagogical methods, from theory-first approaches, to creativity and composition-led; from the rapidly disappearing one-on-one, to collaborative, group-based and student-centred models (Brown and Nelson 2014). As an arts practice discipline, music has also been caught up in sector-wide trends towards reduced funding and standards-based assessment practices (Morgan 2004; Tregear 2014) all of which have caused those teaching in music technology to adapt and reflect on our strategies to deliver relevant and future-focused learning experiences.

This chapter outlines attempts to develop an integrated conceptual and pedagogical framework for learning and making electronic music in an undergraduate music program. It maps practical responses to the problems that have arisen during the development and delivery of a second-year undergraduate subject in music technology entitled *Machine Musicianship*. It also addresses the notion of digital literacy as relevant to electronic music performance. The problems that define such an undertaking include but are not limited to the following: how to select appropriate pedagogical methods relevant to engaging "digital native" learners; how to orient students towards an experimental approach to music making where the lines between performer, composer and instrument builder are blurred; how to assess diverse musical outcomes and approaches where the results may not conform to conventional musical paradigms; how to encourage risk taking but value skills exploited in presenting work of quality; how to encourage concept-driven work that develops the artist's independent voice; how to express a set of explicit and inclusive musical values that avoids invoking the musical prejudices of assessors and that are not opaque to students.

A response, in part, to these questions in the context of the *Machine Musicianship* subject is encapsulated in the problematic of performativity and interactivity, a pair or series of pre-paradigmatic concepts that are explored, developed and evaluated in the design of the subject's content, delivery and assessment. The notion of the series as a concept or signifier in a chain of reference or sense is developed by Gilles Deleuze in the book *Logic of Sense* (2004,

36–41). This tool of thought, linked to the idea of the problematic, is used to encourage students to explore the concepts of performativity and interactivity in the understanding that the terms lack fixed definitions and require them to introduce and extend their own knowledge, within the learning context, towards a creative solution. In this sense the terms are pre-paradigmatic, not yet locked into a disciplinary or expressive paradigm. These problematic[1] concepts are taken up as assessment criteria that are explored in student-centred group learning activities that are intended to provide a demonstrable link between the learning outcomes for the subject, the content of the subject, in particular as stimulus for creative strategies and technical designs, and linked into an assessment framework.

A curriculum for making computer music

The subject under discussion is the fourth in a sub-major sequence in sound technologies delivered as part of the Bachelor of Music at Western Sydney University (formerly UWS). Over three successive semesters, students are introduced to a range of potentially challenging electroacoustic repertoire from the twentieth and twenty-first centuries. These exemplars are intended to challenge their listening assumptions, open a discussion on the nature of contemporary music and introduce them to canonical works that enable them to engage in an informed way with the discourse of electronic music. This repertoire also provides them with examples of how the practical topics in music technology that they are being introduced to relate to the practice of composers and performers.

The practical techniques covered in the first two semesters include conventional methods in stereo recording, MIDI sequencing, sound synthesis, and approaches to composition. The techniques are assessed in the context of practical projects framed by mainstream creative tasks such as performance documentation and production, sound design for sonic branding, and production music composition. These musical ideas are accessible to most musicians entering an undergraduate program. However, in what is probably a fairly standard approach to university-based music technology training, during the second semester, students are stretched by being forced through assessment task requirements to engage creatively with the everyday sound environment as a source for musical material that they must select, collect, and with which they must compose.

The third semester offers an introduction to conventional multi-track studio techniques that allows students to develop skills that many identify as being important to them at the time of enrolment for higher education. Studio production skills also facilitate the development and presentation of their work in composition and performance subjects and enable them to produce a portfolio of recorded work that may be useful in establishing their professional careers. Interestingly, many students choose in this context to develop the more experimental approaches to the use of a broad range of sound material that they have

been introduced to in their first year. These approaches could loosely be characterised as soundscape and acousmatic composition.

Throughout this process several forms of scaffolding (Sawyer 2006: 11) or staging (Collins 2006: 52) are taking place. Firstly, techniques, terminology and listening strategies advance hand-in-hand, each building on the other and enabling greater technical facility and access to effective methods of discourse and creativity. Secondly, the criteria that are offered to assist students to target their effort and by which students are assessed are introduced in stages in order to set standards and expectations that progress throughout the subjects. Criteria are aligned explicitly with assessment task descriptions and learning outcomes for the subjects. At first-year level students are introduced to simple objective measures of audio production quality and the listening skills associated with their aural identification and description; the need for organised and systematic presentation of materials; academic referencing standards to encourage reading, listening and attribution; the development and expression of coherent conceptual frameworks for creative work; and a concern for musical form. These criteria and associated standards descriptions start with simple values and build and integrate as students progress through the curriculum.

This approach is not novel and has become best practice in higher education (Morgan 2004; O'Donovan, Price and Rust 2004). The criterion and standards-based assessment approach described above has been evaluated in earlier work (Blom, Stevenson and Encarnacao 2015). As noted in that evaluation, many students use this scaffolding to target their efforts but many choose to ignore the institutional context of their learning. Many students aim just *to get through* while balancing the demands of earning an income and maintaining themselves and their families. These contrasts can be attributed to varying aspects of internal and external student motivation (Biggs 1985). One of the objectives of developing conceptual assessment criteria is to encourage students to reflect on their motivation by bringing into question the role of the assessment apparatus.

Subverting the assessment framework in the fourth semester

In an effort to achieve some of the pedagogical objectives outlined earlier, the criterion and standards-based approach is somewhat subverted at the point when students reach the fourth semester. In this subject we move outside of conventional pedagogical paradigms in order to encourage an experimental approach to music making, blur the lines between performer, composer and instrument builder, encourage risk taking, and develop the artist's independent voice. To achieve these objectives the learning environment is designed to develop what is known in the educational literature as *a community of practice* (Collins 2006: 51). This community shares a common set of goals including passing the subject and making music. Learning activities are structured so that students are thrown together to share and facilitate each other's learning. Social media is employed to stimulate an authentic sense of community and the normalisation of the learning experience. In the years 2015 and 2016, 98% of students

enrolled were active users of Facebook, whereas usage of the University's learn-ing management system as a communication tool was limited. Regardless of fluctuations in engagement with Facebook in preference for other platforms, stu-dents are encouraged to think of social media channels from the perspective of professional producers, not "prosumers".

The software tools employed in the subject present a problem and a challenge to this community. The media-programming environment *Max/MSP* (now simply *Max 7*, Zicarelli and Puckette 2014) is alien, in some ways archaic, and is diffi-cult to learn. *Max* is a computer program for musicians and media artists that adopts a graphical patching metaphor and a dataflow programming model. Data-flow programming is particularly useful for event-based, real-time processes typ-ical of musical and other interactive applications. This model attempts to make programming accessible to musicians thereby opening up the musical possibilities offered by computational approaches to music making. Despite its aims, *Max* harks back to a time when computer musicians had to build their own tools, when the term *computer music* had a distinct meaning that did not reflect the norm. This software does however encourage music making outside of the con-ventional musical paradigms. It challenges and encourages students to adopt some of the pioneering spirit of early computer music in which the computer was seen as a tool that freed composers and musical experimenters from the con-straints of conventional musical practice. The computer enabled musicians to imagine new compositional forms and procedures and new types of instruments. In truth, new tools often appearing on tablet computing platforms are rapidly sub-verting the conventional paradigms by offering new and interesting ways to con-trol the production of electronic music, for example, by avoiding the piano keyboard control interface. However, as Messerschmitt and Szyperski (2003) point out, these software tools continue to embed the representations of musical knowledge and processes adopted by their authors. The strengths and weaknesses of emerging tablet-based music software for teaching music performance are considered elsewhere in this book (see Chapter 5 by Stevenson and Blom). However, one of the values embedded in the design of *Max* is its openness to new forms of musical expression. In addition to allowing students to participate at some level in this creative and exploratory subversion of musical norms, the use of a patching environment is intended to develop some form of digital literacy (Jenkins 2009) without the need to write code. To this end it encourages systematic and programmatic logic, and a non-linear approach to music production. These aspects of digital literacy are considered in more detail below.

A difficult and unaccommodating software environment is not the only problem that binds this community of practice. In addition to giving an "introduction to music programming in a patcher environment", the subject aims to "provide a conceptual understanding of interactive or responsive sound works, a practical understanding of performance interfaces for digital instruments and an ability to design, plan, realise and assess substantial cre-ative projects"[2]. In this context, practical problems and learning challenges

proliferate and become a normalised part of work with music technology. This is in stark contrast to the "frictionless" nature of modern software interfaces that have been posited as the bedrock of the digital natives' expectations (Prensky 2001). In facing the questions and challenges posed by this process we hope that deeper forms of learning may result. Just as in conventional musical practice, examples of rich musical experiences form the impetus for continued perseverance; in teaching this subject, examples of engaging technology-enabled works are used to inspire students to develop the necessary skills to take the first steps in this direction. In addition to the practical problems, a conceptual problematic defined by two key concepts is embedded at the heart of the subject and expressed within the assessment rubric through which students must attempt to gauge their own progress and by which their assessors must evaluate their achievement. The two concepts of *performativity* and *interactivity* are explored throughout the subject and are tested for their ability to stimulate and produce new and interesting solutions in the form of creative works and performances and positive learning outcomes.

What is performativity?

The concept of performativity comes from the philosophy of language (Austin 1962; Searle 1979) and has since been adopted in a range of critical and cultural theory (Butler 1997). In the philosophy of language, a performative utterance is one that brings a state of affairs into existence. This usually relies on an institutional context. Examples include the recitation of marriage vows and a proclamation by an authorised celebrant that produce a marriage in the act of speaking. Performativity links performance with creation, a concept not unknown to the world of music, particularly in improvised performance. An improvisation is a unique instance of a musical work. Even in scored music a performance can be considered as an ontologically distinct token of a particular musical type that is brought into existence by its rendition in performance (Wetzel 2006; Wollheim 1980).

How then does performativity become a problem in electronic music performance? Electronic sound reproduction replaces the necessity for performance in the presentation of music. This challenge to the status of electronic concert music was realised by its pioneers in the middle of the twentieth century who sought a means to integrate some element of performance in the presentation of their otherwise pre-recorded compositions (Manning 2013). One solution adopted by early practitioners such as Pierre Schaeffer and Karlheinz Stockhausen was the use of multi-speaker playback systems that allowed sounds to be projected into the auditorium and required a performer to *diffuse* the sound live during the concert. An aspect of musical authenticity is related to the production of sounds in real-time and this issue affects audience reaction to the performances of DJs as much as it does those engaged in experimental electronic music (Auslander 2008; Emmerson 2007; Moore 2002). One of the aims of research into new musical interfaces is to enable expressive and visually

engaging musical performances (Paine 2015) that retain some of the embodied aspects of traditional instrumental performance.

Each compositional or performance strategy might be situated somewhere along a continuum of performativity where at one end is located the playback of fixed works and at the other are located works generated by real-time sound synthesis with continuous parametric control over the production of sound. An analysis of performativity in electronic music would likely reveal a great variety of approaches that would not sit easily on a single dimension. For example, real-time synthesis can be expressive and nuanced on a micro-scale, whereas interaction can produce variable structures on a larger scale. Highly engaging and successful musical works can easily combine more-or-less fixed sequences of material that are augmented by dynamic and expressive performance gestures on a limited range of vocal, instrumental or other ornamental resources. There are no simple rules for performativity, however it is an easily understood value linked to the concept of authenticity and a useful way of problematising electroacoustic music performance and stimulating creative design responses to the development of performance interfaces and sound generation algorithms.

The following guidance is offered to students in the learning guide:

> Performativity: a term used in this unit to describe the way in which sound is created or structured in performance. It borrows and develops the concept of speech acts introduced by philosopher of language J. L. Austin who described the way certain parts of speech bring things into being. A highly performative work with technology is one in which the performer or participant, unlike pressing play on a CD player, effects the creation of the sound or its low-level structures moment-by-moment. In traditional instrumental performance, this might be considered an expressive or nuanced performance. The concept of performativity is problematised by the notion of machine agency. With generative or artificially intelligent systems, the machine or algorithm may become more of an active agent in the performance of the work. In this case a highly complex algorithm may be constructed so that some analogue of decision-making or other forms of complex behaviour are exhibited without human intervention. This might also be considered performative.
>
> <div align="right">WSU (2016)</div>

Performativity is expressed as an evaluative criterion within the subject documentation with the use of descriptive text associated with standards of achievement. This text includes the following elements from poor performance to outstanding:

- Does not engage with the patcher environment as a performance or composition tool.
- Mainly pre-recorded material and playback.

- Relies heavily on preproduction, or, comprises large blocks of pre-made material.
- Good balance between preproduction and real-time structuring on macro- and micro-scale.
- Most sound material or structures created in performance, strong link between performance gestures and sonic material.
- Highly nuanced technique and expressive performance.
- Unique realisation created in the moment.

What is interactivity?

Interactivity describes a situation where two elements within a system respond to each other in more-or-less predictable ways. Artist and academic Garth Paine (2002) surveys a number of models of interactivity relevant to experimental musical practice. He initially discounts merely responsive systems such as a CD player which responds to a button press. Citing Todd Winkler, he describes a three-level model of interactivity:

- The conductor model in which a central musical intelligence commands a group of responsive performers coordinated by a score.
- The quartet model in which each player responds to the others, moment-to-moment with a form of organised but distributed musical intelligence that is coordinated by a score. Control can be subtly shifted from one player to another.
- The improvisation model in which the musical structure can be modified within an agreed framework and control is deliberately passed from one member to another.

Another model is that of the conversation in which each party responds to the less predictable contributions of the other with more-or-less spontaneous, novel and engaging results. As we can see, interactivity and performativity are closely related concepts. They are both tied up with agency and novelty. Interactivity may be associated with stochastic algorithmic processes, with aspects of artificial intelligence, or with physical interfaces that present a wide range of control possibilities.

The following guidance is offered to students in the subject learning guide:

> In the simplest terms, interactivity can be mapped onto a continuum between the play button of a CD player at one end and an ensemble free-improvisation at the other. There are several dimensions however, for example granularity of control, which might be placed on a continuum from high level (e.g. a few parameters control a complex algorithm that evolves by itself); note event control (e.g. piano); to low level timbral control (e.g. human voice, low level synthesis). Another continuum might be in terms of predictability of response; for example a piano is relatively

highly constrained and predictable in terms of its output for a given input, the violin a little less so, an improvising partner less predictable again. The concept of interactivity is also problematised by the notion of machine agency. With artificially intelligent systems and machine listening, the machine may become more of an interactive partner and so interaction becomes less about control and more about complex responses initiated by behaviours on the part of the system.

<div align="right">WSU (2016)</div>

Interactivity is expressed as an evaluative criterion within the subject documentation with the use of descriptive text associated with its own standards of achievement. This text includes the following elements from poor performance to outstanding:

- "Press to start" where no machine agency is present.
- Simple control systems inhibit expressive potential or variation in performance or limited machine agency.
- Adequate control and interaction or well-developed algorithmic complexity.
- Effective interaction with performance system or sophisticated algorithmic material.
- Novel performance interface, interaction with sonic material or audience.
- Outstanding integration of acoustic and electronic elements and development and exploitation of performance interface.
- Advanced and expressive performance system.

Digital literacies and constraints on creativity

The subject fulfils one further role within the degree by engaging with the discourse around digital literacy. Digital literacy as a learning outcome is a contested and evolving term having moved from a simple notion of computer literacy (an ability to operate standard computer software) to something less clearly defined and more diffuse. In their 2008 survey of digital literacies Colin Lankshear and Michele Knobel (2008) present a "web of literacies of the digital" including ICT/computer literacy, information literacy, technological literacy, media literacy, communication literacy, visual literacy, network literacy, e-literacy, digital competence, digital *Bildung*, web literacy and game literacy, amongst others (4).

An interesting parallel or inversion of the evolution of digital literacy can be seen in the transformation in the teaching of English in Australian schools. Fehring and Nyland (2012) identify a focus on "language and language proficiency" (8) in English teaching in Australian schools in the 1980s "reflecting the multicultural and pluralist perspective of the period" (8) and an absence of the term "literacy" implying knowledge of the rules of English grammar "associated with ideas of social class and power" (10). In contrast, more recent

developments particularly in the roll-out of the National curriculum (ACARA 2016) have seen a renewed focus on the elements of English grammar. To highlight the parallel with digital literacy, we might compare the approaches to English literacy of the 1970s and 80s (those experienced by this author) that aimed to teach students how to *use* the language with more recent approaches that attempt to highlight the way that the language *works*. Similarly, in the transition from computer literacy to digital literacy we have seen a shift from training on the use of software to a focus on how digital and networked media work as sources of information.

A further recent development (itself a throw-back to the use of high-level computer languages such as BASIC and LOGO during the adoption of early microprocessor-based computers in schools in the 1980s) is the inclusion of "coding and computational thinking across the curriculum" in primary and secondary schools in New South Wales and elsewhere (NESA n.d.). Citing Jeanette M. Wing, the NSW Education Standards Authority adopts the following definition of computational thinking:

> Computational thinking is the thought processes involved in formulating a problem and expressing its solution(s) in such a way that a computer – human or machine – can effectively carry out ... computational thinking is not just about problem solving, but also about problem formulation.
>
> NESA (n.d.)

In this aspect of digital literacy, once again we can see a parallel with an extension of English literacy from reading and writing, to forms of critical media literacy. In the case of digital literacy, we see an extension of computer literacy from reading and writing computer code to systematic or critical problem formulation. The hope of this pedagogic enterprise is that experience and understanding of the fundamental formulation of algorithms can foster creative and innovative approaches to a range of problems in the area of interest of students rather than merely reproducing or enacting existing strategies. In accordance with this hope, the approach to digital literacy in *Machine Musicianship* extends beyond information literacy to a notion of systems literacy in order to develop a critical understanding of the affordances and constraints offered by new and existing digital music technologies. It also embraces the evolving nature of such literacies by embedding problematic concepts such as performativity and interactivity as defining criteria that encourage and empower students to enact and perform their own creative solutions to their unique musical and creative problems. At a more basic level we hope that students will learn not just how to *use* software but how software *works*.

The limitations of computer systems in creative endeavours is highlighted by musician-researcher Andrew Hugill and computer scientist Hongji Yang in their formulation of the emerging field of *creative computing*. Hugill and Yang point out that: "although human beings increasingly turn to computers as aids to creativity, the way the software is engineered frequently enforces compromise or, worse, inhibits creativity through unwelcome constraints" (Hugill and Yang

2013: 5). As Messerschmitt and Szyperski (2003) assert, software embeds a representation of social or technical processes and an assumed understanding of the needs and wants of users, as modelled or imagined by the software designers. The awareness of these constraints or assumed models of creative process is a primary motivation in the design of the software environment chosen for the subject: *Max/MSP*. As its author Miller Puckette states: "The design of Max goes to great lengths to avoid imposing a stylistic bias on the musician's output" (Puckette 2002: 39). Unlike other music software that carry with them the conventions of a musically literate culture, "On starting Max, the user sees nothing but a blank page – no staves, time, or key signatures – not even a notion of 'note', and certainly none of instrumental 'voice' or 'sequence'" (39). This approach assumes that these conventions of a musical culture embody both pre-defined solutions to and statements of musical problems, whereas algorithmic and computation thinking demand a reformulation of the musical problems themselves that must be engaged with performatively by the musician as they develop their creative work. This creative work must engage at a fundamental level with the notions of instrument (Schaeffer 2017: 31), composition and performance. As can be imagined, this approach defies the imposition of stable and clearly delineated assessment criteria that might determine predictable forms of musical expression.

By choosing a software tool such as this rather than some more accessible and up-to-date software such as *Ableton Live* (Ableton 2017), we trust that students are able to rise to the challenge of formulating their own musical problems rather than adopting existing solutions to problems that encapsulate the creativity of artists who have gone before. Rather than expressing a prejudice against musical conventions we hope that this approach can empower students to become independent learners and creators. Learning to learn software and to imagine and adapt to new forms of creative process will be a necessary skill in the rapidly changing future of their professional and creative lives after university. By imagining musical creation through the lens of performative acts whether as instrumentalists or through machine agency, and by focusing on performance as a field of interaction with musical systems and structures such as ensembles, audiences and instruments, students are hopefully empowered to produce alternative paths to musicianship that may help them to find and produce the niches that will enable them to flourish in an uncertain musical ecosystem. Similarly, by subverting the assessment framework we attempt to challenge students not to rely on the formulaic strictures of institutions but to think and act for themselves and to devise unique solutions that build their creative strength and individuality.

Evaluation

The concepts of interactivity and performativity are debated by students and found to be unstable and problematic. They challenge students as composers, performers and scholars, and stimulate creative responses to the challenge of developing novel musical responses in the context of exploring new software. Situating these concepts within the assessment framework opens the possibility or necessity of

negotiation or demonstrating a claim for the validity of their own solutions to the assessment task requirements. This potentially shifts the authority from the assessor to the student and enhances their agency in their own learning and creativity.

Of course, many students prefer to ignore the institutional context and focus on their personal interests and needs, or find the not on of unresolved problems unsettling. In formal, written student feedback some students question the relevance of the subject content to their own musical aspirations and many find the prospect of mastering such a completely new paradigm in the available time unrealistic. While students do mention aspects of the assessment task descriptions in their feedback, the assessment criteria themselves are never addressed. However, the impact of a conceptual approach in a practical subject is regularly commented on by students. For some the challenge of new tools and new concepts is highly productive. Some students regard the experience as "challenging, new and innovative", enabling them to "discover something [they] didn't know before". Students noted the value of "expanding the idea of what is possible in creating new instruments" and found this approach "interesting and thought provoking". Students also responded positively to being "thrown in at the deep end" with music programming and "discovering new ways of performing". Students have consistently reflected on the subject's demand for "critical and logical thinking". The subject results in them "getting out of [their] comfort zone" and they respond positively to the range of "new musical possibilities" and the resultant encouragement of "new levels of creativity". Comments such as these attest to the capacity of this approach to produce a space for creativity and empowered learning.

Conclusion

The use of the problematic concepts of performativity and interactivity embedded in the assessment design for the unit aims to signal to students that they are operating in a different paradigm to the one usually signalled by clear actionable assessment criteria with explicit standards of performance. The goals of the unit are linked to this "pre-paradigmatic" mode of music creation in their aim to orient students towards experimental music making where the lines between performer, composer and instrument builder are blurred by the software tools they are learning. They aim to encourage a diversity of musical outcomes and to provide an assessment framework to accommodate these. The unit encourages risk taking and expects students to defend and argue for their choices. Above all the aim is to nurture student musicians as artists with a developing independent creative voice.

Notes

1 The term problematic is borrowed from Gilles Deleuze's reading of Kant in which problematic ideas provide a "systematic unity" to an enquiry without expecting solutions or answers (Deleuze 1994: 168–169).
2 This text is taken from the subject description published in the University handbook and subject learning guide.

References

Ableton. (2017). *Live 10 [software]*. Berlin: Ableton.

ACARA. (2016). Australian Curriculum Assessment and Reporting Authority. Retrieved from www.acara.edu.au/curriculum, accessed 24 January 2018.

Auslander, P. (2008). *Liveness: Performance in a mediatized culture* (2nd). London and New York: Routledge.

Austin, J. L. (1962). *How to do things with words*. Oxford: Clarendon Press.

Biggs, J. B. (1985). The role of meta-learning in study process. *British Journal of Educational Psychology*, 55, 185–212.

Blom, D., Stevenson, I. and Encarnacao, J. (2015). Assessing music performance process and outcome through a rubric: Ways and means. In D. Lebler, G. Carey and S. D. Harrison (Eds.) *Assessment in music education: From policy to practice*. New York: Springer. 125–139.

Brown, A. and Nelson, J. (2014). Digital music and media creativities. In P. Burnard, (Ed.) *Developing creativities in higher music education*. Abingdon: Routledge, 61–74.

Butler, J. (1997). *Excitable speech: A politics of the performative*. New York: Routledge.

Collins, A. (2006). Cognitive apprenticeship. In K. Sawyer, (Ed.) *The Cambridge Handbook of the learning sciences*. Cambridge, UK: Cambridge University Press. 47–60.

Deleuze, G. (1994). *Difference and repetition* (P. Patton, Trans.). London: Athlone Press.

Deleuze, G. (2004). *The logic of sense* (M. Lester, C. V. Boundas and C. J. Stivale, Trans.). London: Continuum.

Emmerson, S. (2007). *Living electronic music*. Farnham: Ashgate.

Fehring, H. and Nyland, B. (2012). Curriculum directions in Australia: Has the new focus on literacy (English) and assessment narrowed the education agenda? *Literacy learning: The middle years*. 20.

Hugill, A. and Yang, H. (2013). The creative turn: New challenges for computing. *International Journal of Creative Computing*, 1 (1), 4–19.

Jenkins, H. (2009). *Confronting the challenges of participatory culture: Media education for the 21st Century*. Cambridge, MA: MIT Press.

Lankshear, C. and Knobel, M. (2008). *Digital literacies: Concepts, policies and practices*. New York: Peter Lang.

Manning, P. (2013). *Electronic and computer music*. New York: Oxford University Press.

Messerschmitt, D. and Szyperski, C. (2003). *Software ecosystem: Understanding an indispensable technology and industry*. Cambridge, MA: MIT Press.

Moore, A. (2002). Authenticity as authentication. *Popular Music*, 21 (2), 209–223.

Morgan, C. (2004). *The student assessment handbook: New directions in traditional and online assessment*. New York: Routledge.

NSW Education Standards Authority (NESA) (n.d.). *Coding across the curriculum, digital technologies and ICT resources*. http://educationstandards.nsw.edu.au/wps/portal/nesa/k-10/learning-areas/technologies/coding-across-the-curriculum, accessed 24 January 2018.

O'Donovan, B., Price, M. and Rust, C. (2004). Know what I mean? Enhancing student understanding of assessment standards and criteria. *Teaching in Higher Education*, 9 (3), 325–335.

Paine, G. (2002). Interactivity, where to from here? *Organised Sound*, 7 (3), 295–304.

Paine, G. (2015). Interaction as material: The techno-somatic dimension. *Organised Sound*, 20 (1), 82–89.

Prensky, M. (2001). Digital natives, digital immigrants. *On the Horizon*, 9 (5), 1–6.

Puckette, M. (2002). Max at seventeen. *Computer Music Journal*, 26 (4), 31–43.

Sawyer, K. (2006). Introduction: The new science of learning. In K. Sawyer, (Ed.) *The Cambridge Handbook of the learning sciences*. Cambridge, UK: Cambridge University Press. 1–16.

Schaeffer, P. (2017). *Treatise on musical objects: An essay across disciplines* (C. North and J. Dack, Trans.). Berkeley, CA: University of California Press.

Searle, J. (1979). *Expression and meaning: Studies in the theory of speech acts*. Cambridge, UK: Cambridge University Press.

Tregear, P. (2014). Enlightenment or entitlement? Rethinking tertiary music education. *Platform Papers*. Vol. 38, Sydney: Currency House.

Wetzel, L. (2006). Types and tokens. In E. N. Zalta, (Ed.) *The Stanford encyclopedia of philosophy*. https://plato.stanford.edu/entries/types-tokens/, accessed 4 March 2020.

Wollheim, R. (1980). *Art and its objects*. Cambridge, UK: Cambridge University Press.

Zicarelli, D. and Puckette, M. (2014). *Max (Version 7.0) [software]*. San Francisco, CA: Cycling 74.

WSU (Western Sydney University). (2016) *101537 sound technologies and machine musicianship unit learning guide*. Internal WSU document.

12 Expanded practice

Facilitating the integration of visual media, theatricality and sound technology into music performance

Ian Stevenson, John Encarnacao and Eleanor McPhee

The turn away from, or expansion of, the traditional conservatory model of university music performance education (Don, Garvey and Sadeghpour 2009: 81) necessitates the broadest possible musical frame of reference. One approach is to build upon traditional notions of musicality by embracing sound technologies and other extra-musical elements such as video and theatricality. These approaches are particularly relevant to a 21st century world where a holistic artistic vision and flexibility in the delivery of musical ideas can be key to the pitching, delivery and reception of creative projects. They also invite the student to imagine, beyond their individual instrumental abilities, work that engages an audience in three-dimensional, embodied and immersive spaces. This chapter suggests teaching strategies that enhance the facilitation of such approaches to performance as well as thinking through the distinct pedagogical needs of students presenting this kind of work for feedback and examination. The notion of expanded practice also dovetails into the contemporary reality of portfolio careers, where collaboration across disciplines can be crucial (Gaunt and Westerlund 2013: 2). These skills also translate to teaching music at all levels, from the school musical to 21st century conceptions of the networked classroom (Savage 2005).

Background

The Oxford Dictionary of English provides two senses for the verb *perform* (2010). The first encompasses carrying out or fulfilling an action, task or function. The second sense refers to entertaining an audience. In the context of music performance there are a range of factors that lie between fulfilling the function of a competent instrumentalist or performer on the one hand, and entertaining an audience on the other. The work described in this chapter addresses concrete strategies to encourage student performers to expand and augment their existing performance practice with a toolkit of creative strategies and methods of presentation.

The subject in which these approaches were developed came about as a pragmatic response to the pressures of rationalising a larger suite of music subjects into a condensed form of the undergraduate music degree of which they were a part. It also carried on the values of an earlier subject in which students from four contemporary arts degree programs in dance, drama, music and electronic arts were required to collaborate on a single creative project. A lot was learnt from that experience, for example the resistance of some students to enforced collaboration on the one hand, and the positive impact and stimulus of cross-art-form and cross-media practices on students' creativity and learning on the other. A new third-year subject, *Expanded Music Performance* was designed to fulfil the requirements of progression through both music technology and performance specialisations. This presented challenges in terms of providing pathways for student performers who choose to develop their specialist technology skills and those who would prefer to avoid technology wherever possible. The compromise was to specify that performance outcomes must utilise electroacoustic and/or multimedia and/or theatrical elements, with a view to allowing students to define the scope of their own expansion and to follow their interests as emerging creative practitioners. This "and/or" approach offers little constraint on the scope of the creative outcome, whereby each student in the cohort conceives and performs their own 15–20 minute set. The instrumentation, personnel and equipment utilised for any given student's project is up to them, though this is vetted through formal proposal and workshop processes, both of which are assessed.

Industry relevance

Contemporary music has become an increasingly visual medium. From the launch of the dedicated music video channel MTV in the early 1980s to the subsequent dominance of the internet video streaming services such as YouTube, an increasing majority of music today is consumed in the context of visual material (IFPI 2017). Similarly, the staging concepts pioneered by acts such as Pink Floyd in the 1970s, incorporating film, surround sound, lighting effects and dramatic staging have become mainstream in today's touring concerts. The parallel transition of electronic dance music from the nightclub to the concert stage has seen the emergence of the art of the VJ and sequenced and audio-responsive lighting systems augmenting the otherwise performatively and visually unassuming presence of the lone DJ on stage. A contemporary example of this approach can be seen in the work of Brazilian composer Amon Tobin (2015). From the mid-1980s onwards, the importance of Broadway-style ensemble choreography, costuming and staging has found its place in the world of mainstream pop music both in live performance and in video. A high-profile example of this is the *Mrs Carter Show* tour by Beyoncè Knowles-Carter (2013). Outside of the world of pop and rock, the presentation of live orchestral movie soundtracks and live ensemble improvisation to film has also seen increasing popularity on the concert hall stage and further demonstrates the

demand for visually augmented musical performance. Steve Reich and Beryl Korot's live multi-screen video and chamber music work *The Cave* (1993) is an early example. Finally, various strategies to incorporate the music composed for video games in a live performance context have developed since the turn of the century, from music performed live by orchestras to games being screened, to the "chip-tune" phenomenon of artists using 8-bit technology for new compositions and performances, to the broader incorporation of various types of screen media and aesthetics in the concert music of composers such as Nicole Lizée (2016).

Each of these developments in the presentation of contemporary music has relied on increasing levels of collaboration with artists specialising in the various aspects of video production, staging, lighting, costume design, choreography, programming etc. It may be argued that it is unnecessary for musicians to develop capabilities in areas outside of their area of expertise as in a professional context these will be handled by experts. However, it is our belief that by engaging with these aspects of performance in a practical, low-risk context, student musicians can more fully gain an understanding of the creative aspects and technical challenges associated with the overall presentation of their music. This form of practice-based project learning can create more powerful and transformative experiences for musicians as they grapple with the details of staging their work and engaging audiences. The approach also allows students with existing interests and skills in areas such as visual design, video, theatre technical production, musical theatre, dance and other areas to exploit and develop their skills or undertake productive and creative collaborations with other students that can extend them into new creative territory. Students are also encouraged to see the expanded practice subject as an opportunity to collaborate with artists with expertise in mediums other than music. Students may position themselves as conceptualising and coordinating projects far beyond the scope of their individual talents and experiences, exerting a degree of creative control to realise a holistic vision.

Teaching and learning strategies

There are three principle teaching and learning strategies deployed in the subject. The first is a series of interactive lectures presented in the early part of the semester. The second strategy involves hands-on tutorial-workshops developing specific technical skills in staging and presentation, working with visual media and electronic music systems. These run in parallel to the lecture series. The final stage, taking up the second half of the semester, involves student-driven performance workshops in which student performers present fully-staged works-in-progress for feedback and evaluation by their peers. Peer feedback in these sessions provides essential training in giving and receiving constructive feedback and are also a valuable source of collaborative ideation. The subject culminates in a series of concert performances over several nights.

Case study analysis

The lecture series employs, among other material, the presentation and analysis of case studies in the form of concert videos and other media. Case studies are widely used in tertiary education and have long been central to training in law and business (Rakoff and Minow 2007). Case study teaching method has been adapted to develop critical thinking and skills development in areas as diverse as nursing (Popil 2011), sociology (Ruggiero 2002), accounting (Hassall and Milne 2004), psychology (McDade 1995) and science (Herreid 2007). More recently, case study method has become associated with project-based and problem-based learning in which students are guided towards or independently develop analytical frames for understanding real-world cases in their specific fields (Bonney 2015; Herreid 2007: 153–156).

In *Expanded Music Performance*, case study exemplars are chosen that can demonstrate aspects of staging, costume, choreography, use of music technology and visual elements. Often the most interesting aspects of these materials are in the mechanics of maintaining audience engagement through the overall structuring and timing of the show and in the interstitial linking elements including segues and verbal interaction with the audience.

One approach to conducting a case study analysis is to break a performance down into its structural elements. A model for this is given in Figure 12.1,

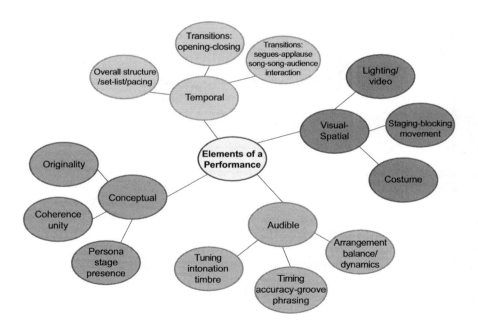

Figure 12.1 Elements of a performance

"Elements of a performance". This model helps students to identify and consider the temporal, visual/spatial, conceptual and audible aspects of their developing ideas for performance presentation. In this way, in dialogue with lecturers, students are encouraged "to work not only from the particular to the general, but also from the general to the particular" in the context of their own work (Rakoff and Minow 2007).

The model shows musical technique, included under the heading "audible", as one element amongst others and not necessarily the primary or sole concern of the musician-performer. The audible or musical aspects of the performance become the core from which a performance may be expanded. The expansion may move in the direction of an overarching conceptual frame, for example in the form of a narrative or unifying theme; visual elements in the form of video, props, costumes or staging elements; or temporal structure in the form of linking dialogue, set selection and formal design, audience interaction, etc. The audible may also be the location of expansion itself through the integration of novel sonic materials, electronic instrument design, or the spatial presentation of sound.

Any case study can be examined and evaluated in terms of the aspects identified in this model and used as a springboard to imagine new and engaging forms of performance. This approach provides a shared vocabulary of strategies and a means to develop self-evaluation and workshop-based critique and appraisal of developing student work.

All three co-authors are active as performers, composers or both. In addition to commercially released examples, case studies drawn from the lecturers' own output allow for a deep examination of process, aesthetics, rationale, problem-solving and lessons learned through experience. Lectures are devised with the aim of informing the broadest range of the expansion of practice and musical interests of students. Case studies offer opportunities to discuss each of the elements of performance identified in Figure 12.1, but will also concentrate on one of the defined areas of electroacoustic, multimedia or theatricality. Some examples describing the use of case studies are given below.

Electronic music performance

Students specialising in electroacoustic performance come in to the subject with a preliminary grounding in concepts such as synthesis, algorithmic music, interaction design, hyper-instruments and performance systems interfacing[1]. A stream of tutorials is offered on the popular music production software *Ableton Live* (2018). *Ableton Live* enables musicians to customise the software and integrate video, performance interfaces and synchronised control of external systems such as lighting through MIDI and other digital control protocols.

A case study of the work of Annie Clark, better known by her stage name St. Vincent, allows in-depth analysis of the technical means of electronic music production in her live shows using *Ableton Live*. Examination of her use of choreography, staging and stage persona is enabled by analysis of concert

videos such as the (2014) *St. Vincent Live on Letterman Webcast*, available on YouTube. Luckily, an excellent training video detailing the use of *Ableton Live* has been produced by Lynda.com in collaboration with Clark's musical director Daniel Mintseris (2014). The video includes discussion of the role of a performing music technologist, collaboration with the other artists and an in-depth analysis of the technical and musical design of the show.

This form of integrated case study makes the connection in a practical and creative way between the merely technological means of production and the overall performative impact of the show. The use of asynchronously available video material also extends the impact and accessibility of the lecture and tutorial delivery into the home-studio and rehearsal environment where much of the musical ideas are worked through. This form of blended learning promotes students' use of social media into a more strategically oriented resource for professional and creative development.

Interestingly, some of the simpler approaches to electronic music performance have stimulated some of the more successful musical outcomes. Brief case studies of single techniques have been valuable, for example, a brief analysis of concert videos of Miles Davis from the period from around 1971–1973 (for example, a Vienna Town Hall Concert of 1973) when he was both using a wah-wah pedal and exploring aspects of his personal image through clothing and costume has stimulated a number of wind-players to explore their instrument's extended expressive and performative capabilities through live signal processing. This has allowed what in a rock context is usually an accompanying instrument to take on the lead or solo role in a more dominant and performatively engaging manner. Here is an example of where the idea of expanded practice can lead, uncapping the latent performance aspiration of a musician who has been otherwise constrained by the performance conventions associated with their instrument and/or genre. The use of various types of pedals, including looping devices as well as the more standard range of distortion, delay, reverb and other signal modification (flanging, phasing, octave displacement etc.) provides a range of options for students less inclined towards the use of digital software, with applications that range from a one-person presentation of song material to long-scale improvisation and ensemble performance.

Sound and image

As a case study, Eleanor McPhee shows how composer and theorist Michel Chion's work (1994) applies to her own audio-visual project, *The Moving Picture Show*. This project uses silent films produced from 1912 to the end of the silent era in 1929, accompanied by live music from a nine-piece chamber orchestra and Foley sound effects. It uses sheet music collections from the Theatre Royal in Bradford, Yorkshire, in northern England and the State Theatre in Sydney, Australia. The aim of the case study is to introduce Chion's theories as ways of thinking about and analysing music as it works with film and to show

how these fairly abstract theories have become concrete musical choices within her own performance practice.

An issue raised by studying these films and the associated music collection is choosing music that allows the audience to embrace the world of the film. Effective musical accompaniment can provide an emotional bridge into a historical film genre that may otherwise prove to be inaccessible to present-day audiences and this is an issue that is also relevant to students creating a performance that incorporates some form of visual performance with music. Keeping this idea of music as an emotional bridge in mind, Gorbman (1987) suggests music can be used as a kind of mediator. She says that music can mediate between film and older dramatic traditions, between spectator and the circumstances of projection – the space the screening is in, the flatness of the screen itself – and the fact that film, especially old films, can seem ghostly. With these issues in mind, and using *The Moving Picture Show* as a case study, students are encouraged to find or create music that fulfils these criteria: 1. is recognisable for an audience; 2. closely fits with the mood and emotional content of what is being shown on screen; 3. is thematically associated with characters and places; and 4. considers the role of improvisation. These strategies encourage students to carefully consider their choice of repertoire and to consider the application of Chion's categories of horizontal and vertical audio-visual relations (Chion 1994: 35–65).

While creating sound that is subordinate to image is an option, as is a filmic realisation of some perception of the emotional or narrative content of music or songs, students are also encouraged to consider the idea of juxtaposition – what happens if the relationship between sound and image is not what we would expect? Problematising the relationship between sound and image focuses students on the idea that this relationship need not be fixed. In fact, live performances mean that it can be difficult to fix cue points between image and sound exactly. Some latitude for each live iteration of a multimedia work to vary somewhat can be a healthy way to conceive of it; this is even more the case if the visual component is rendered or manipulated live in some fashion.

Improvising can be an effective strategy as it allows performers the flexibility to respond immediately to the onscreen narrative. It can also provide an efficient strategy for developing new original material in the limited context of a semester-long project. Students are also well-resourced with collections of Photoplay music or mood music scores from the 1920s (Goldmark 2013, Rapee 1970) which can be a good starting point.

Another multimedia case study is provided by the work *Various Difficulties*, a collaboration between Ryszard Dabek (images) and lecturer John Encarnacao (sound). It is a work that is "fixed" – rather than a performance. Dabek and Encarnacao have committed to an alignment, of sorts, of image and sound as a work with a title and location on the web (Dabek 2011). However, the working relationship that resulted in the piece is one of live improvisation with sound and images alike. It is a work that could be performed, with the combination of images in the work able to be reconfigured in real time, and the same

is true of the sound. This aspect – fixed versus performed – is worth unpacking with students, as it uncovers the aesthetic choice that is at the heart of any film, TV show or music video where certain sounds and images have been chosen from a range of possibilities.

In the case of *Various Difficulties* the aesthetic field that informs, and helpfully limits the possible musical and visual choices, is described as having to do with Dabek's interest in memory, particularly the traces of earlier times inscribed in certain kinds of architecture. This is presented as aligning with Encarnacao's interest in primitive electronic musical instruments, in particular the marriage of a small early '80s Casio keyboard and its onboard radio, with guitar effects pedals. The process of collaboration is also unpacked, whereby an initial viewing of some of the footage, pre-editing and layering gave Encarnacao an idea of where the music might go. Three new pieces of music were created from two improvisations using the Casio/pedals array that had been archived, from which Dabek chose what he felt was the most appropriate. Viewing the finished work it is apparent that although the sound and image each proceed along their own trajectories, there are times where the image is cut to the music. Thus neither the sound nor image is accompanying the other; rather there is a sense of dialogue, even if to some degree the image-maker had the final say on this, having received the finished sound to edit to.

A number of working strategies emerge from sharing this process with students. First, as musicians, it is quite acceptable, and sometimes very appropriate, to work with materials you have already generated that can be reconfigured through improvisation and technological manipulation. Similarly, a musician might think of working with sound technology as using the tools already at their disposal, rather than a learning curve focused on a piece of software. It is also promoted as good working practice to generate more material than is needed. Rather than produce the exact number of minutes of material that will be performed, it is likely that a better product will result from being able to choose the best or most suitable material from more than is necessary. This goes hand-in-hand with a generosity of spirit in collaboration. Allowing the film artist to choose from three pieces of music demonstrates a trust in his judgement and an ongoing commitment to the collaborative project.

Music and theatricality

One of the difficulties of achieving the objectives set out in the subject design was the ability of the staff teaching the subject to deliver the specialist expertise that might be necessary to do justice to each of the modes of expansion. In the case of theatrical techniques, one solution was to provide guest lectures from artists with specialist expertise. When this was not possible, we relied on our professional experience in the theatre or early training experiences.

Fundamental theatre literacies such as an understanding of staging conventions including naming parts of the stage, typical curtain and masking arrangements, the roles of stage managers, key creative personnel and crew, stage

lighting systems and other practical aspects of theatre practice provide a foundation for thinking through and discussing practicalities of project design. These literacies should be useful in any performing career and have obvious benefits for those students intending to pursue high school teaching, considering the organisation of performance events that can be part of that role. The design of the performance venue in which the subject was taught, which includes both a thrust stage and proscenium, provided great opportunity to consider the influence of architecture on staging design and the relationship with audience. This led to useful discussions of historical aspects of theatre design and approaches to stage production.

Elements of theatrical presentation such as costume, blocking and movement, simple choreography, and staging elements such as props, sets, risers and projected scenery could each take up an entire lecture/tutorial session, an amount of time that was not available. As each of these elements opens up possibilities worth exploring, the solution was to analyse video-recorded examples to identify and discuss instances of these features. Two contrasting examples proved useful.

The Ted Swindley musical *Always ... Patsy Cline* (1997) offers an example of a simply staged two-hander musical and biographical tribute to the popular country singer Patsy Cline (1932–1963). The advantage of an example such as this is that while the musical content may not appeal directly to a broad student audience, the technical and imaginative scope of the project is well within the reach of student performers. Various production videos exist on YouTube demonstrating aspects of the dramatic presentation including an overall narrative arc supported by scripted elements, character development, period costume and set, physical and performative relationship between instrumentalists and solo performers, and the effective selection and sequencing of musical items.

In contrast to the relatively conventional theatrical format of *Always ... Patsy Cline*, students are also introduced to the crossover musical/performance art concert video of Laurie Anderson's (1986) stage production *Home of the Brave*. Laurie Anderson's work provides a useful historical reference point for discussing the blurred genre boundaries of the performance art movement of the 20th century. RoseLee Goldberg's survey text *Performance Art: From Futurism to the Present* (2011) provides many more stimulating examples. Anderson's work links to other crossover theatre makers and musicians of the '80s and '90s including Robert Wilson and David Byrne.

As a case study, *Home of the Brave* opens up a range of theatrical musical and audio-visual devices that expand the performance beyond the material presented on the CD album which was the basis of the soundtrack. The video offers a smorgasbord of production ideas that can be clearly demonstrated during an in-class analysis. These include musical, sonic or structural elements such as: use of an overture, dramatic contrasts in pacing between segments, use of humour, covering scene changes with dialogue and audience interaction, development of characterisation and unstable identity using vocal signal processing, subverting liveness by mixing pre-recorded playback of spoken elements and live-action video with segues into live presentation, use of scripted

spoken word, linking audio and video material between numbers, electronic body percussion, clever use of live percussion in an otherwise electronic track, extended instrumental performance and extended electronic instrument design.

Notable visual and staging elements include integral projection including live action and animation, use of costume and mask, simple quick costume changes, simple synchronised choreography, simple body-worn illumination, synchronised lighting cues, hand-held props such as fans, rear-projection, shadow play and puppetry, and comic oversized percussion elements. In addition to these production ideas, Anderson provides excellent examples of collaboration with noted artists such as William Burroughs, Peter Gabriel and Sang Won Park. This approach encourages students to consider the skills of their networks of friends and associates as sources of inspiration and as possible collaborators. This approach to practical networking is an essential skill for professional development.

Whereas *Always ... Patsy Cline* offers a highly focused, integrated and thematically unified approach to production, Anderson exhibits an eclectic postmodern everything-in aesthetic. Other approaches drawing on the theatrical are possible including a more deconstructed approach that chooses just one or two elements to help configure the staging of a musical performance. Theatrical conventions can be subverted by deconstructing narrative through isolation of particular elements such as location, character, mood and idiom such as sci-fi or gothic, resulting in a stage presentation with a poetic sensibility that invites freer interpretation for the audience. Several students have been highly successful in developing refined approaches such as these.

The program of case study based lectures and technical tutorials provide students with opportunities to suggest and discuss project ideas which result in a formal written proposal early in the semester. Feedback on the proposals allow students to develop their work to the point where it can be presented as work-in-progress during a live staged workshop.

Workshops

Students are assessed on both their workshop presentation and on giving feedback to their peers. In their workshop presentation students must provide evidence of the creative process that they have undertaken to arrive at the material presented. They present a substantial component of their expansion of practice in either theatrical, audio-visual or electronic dimensions, or some combination of these. This is necessary to provide peers and assessors material to provide feedback on and it gives performers an opportunity to try out their ideas on stage. In addition to these aspects the underlying musicality of the performance is also assessed. As a base-line there is an expectation that students are able to "perform" their role as musicians, instrumentalists or vocalists in addition to delivering a "performance" that entertains and engages the audience through the extended means explored in their work.

The role of assessing their peers is another key professional skill that the workshop process enables students to develop experience in. Students are coached on giving feedback using simple formulae such as "the best thing and ideas for development", or "two stars and a wish", for example "I'd like to give you a star for your awesome singing and a star for the choice of songs but I wish you had removed the text from your video and made it fade out at the end". In this situation students must consider aspects of both giving and receiving feedback as a means to engage in productive creative work. Expertise in this area is highly prized in professional practice.

Conclusion

The adaptation and revision of the traditional conservatory model of university music performance education has necessitated a broader musical frame of reference. The third-year subject, *Expanded Music Performance*, is designed to facilitate the integration of visual media, theatricality and sound technology into work that addresses the realities and diversity of contemporary performance practices. The subject is built on the assumption that to learn to perform, students must combine their abilities as competent instrumentalists or performers with a capacity to entertain an audience. The work described in this chapter outlines concrete strategies that encourage student performers to expand and augment their existing performance practice with a toolkit of creative strategies and expanded methods of presentation.

Three principal teaching and learning strategies are deployed: interactive lectures based on case studies of performance works by the lecturers and others; hands-on technical tutorial-workshops; and student-driven peer-evaluated performance workshops. Case studies are contextualised by relevant theories to help develop students' critical literacies in performance. A broad repertoire is presented, both to expand students' creative horizons and to help them identify creative practices that resonate with their own musical interests. Serendipitous connections arise between the musical interests of lecturers and students in an environment that is oriented towards professional development and co-constructed learning.

These approaches are highly relevant in a 21st century professional world where a holistic artistic vision and flexibility in the production and delivery of musical ideas can be key to success in a contemporary portfolio career where collaboration and networking across disciplines can be crucial.

Note

1 See Chapters 5 and 11 of this volume.

References

Ableton. (2018). *Ableton Live 10* [software]. Berlin: Ableton. www.ableton.com, accessed 1 August 2018.
Anderson, L. (1986). *Home of the brave* [film]. New York: Talk Normal.

Bonney, K. M. (2015). Case study teaching method improves student performance and perceptions of learning gains. *Journal of Microbiology & Biology Education*, 16 (1), 21–28.

Chion, M. (1994). *Audio vision: Sound on screen*, edited and translated by Claudia Gorman. New York: Columbia University Press.

Clark, A. (2014). *St. Vincent live on Letterman webcast* [video]. New York: CBS (YouTube user: TheSpiceOfLife). www.youtube.com/watch?v=slCwO9bBAJ4&t=888s, accessed 1 August 2018.

Dabek, R. (2011). Various difficulties [video], Ryszard Dabek. https://vimeo.com/50208663, accessed 1 August 2018.

Davis, M. (1973). Miles Davis (live concert) – 3 November, 1973, Vienna Town Hall, Vienna, Austria [video]. Mike's Music Archive (YouTube). www.youtube.com/watch?v=7CuRW3Ry464, accessed 1 August 2018.

Don, G., Garvey, C. and Sadeghpour, M. (2009). Theory and practice. In R. A. R. Gurung, N. L. Chick and A. Haynie (Eds.), *Exploring signature pedagogies: Approaches to teaching disciplinary habits of mind* (1st ed.). 81–98. Sterling, VA: Stylus Publishing.

Gaunt, H. and Westerlund, H. (2013). The case for collaborative learning in higher music education. In H. Gaunt, H. Westerlund and P. G. Welch (Eds.), *Collaborative learning in higher music education: Why what and how?*. 1–9. Farnham, UK: Routledge.

Goldberg, R. (2011). *Performance art: From futurism to the present* (3rd Edn.). London: Thames and Hudson.

Goldmark, D. (ed.) (2013). *Sounds for the silents: Photoplay music from the days of early cinema*. New York: Dover.

Gorbman, C. (1987). *Unheard melodies: Narrative film music*. London: BFI Publishing.

Hassall, T. and Milne, M. J. (2004). Using case studies in accounting education. *Accounting Education*, 13 (2), 135–138.

Herreid, C. F. (2007). Case studies in science, A novel method of science education. In C. F. Herreid (Ed.), *Start with a story: The case study method of teaching college science*. 29–39. Arlington, VA: NSTA Press.

IFPI. (2017). *Connecting with music consumer insight report*. London: International Federation of the Phonographic Industry.

Knowles-Carter, B. (2013). *The Mrs. Carter show: The biggest show*. New York: Parkwood Entertainment. www.youtube.com/watch?v=KWCLnFWymKQ, accessed 1 August 2018.

Lizée, N. (2016). *Australian Art Orchestra with Nicole Lizée (8-bit Urbex)* [video]. Melbourne: Australian Art Orchestra. https://vimeo.com/172065505, accessed 1 August 2018.

McDade, S. A. (1995). Case study pedagogy to advance critical thinking. *Teaching of Psychology*, 22 (1), 9–10.

Mintseris, D. (2014). *Performing with Ableton live: On stage with St Vincent* [video]. Carpinteria, CA: Lynda.com. www.lynda.com/Ableton-Live-tutorials/Performing-Ableton-Live-Stage-St-Vincent/167921-2.html, accessed 1 August 2018.

Oxford Dictionary of English. (2010). (3rd Ed.). Oxford: Oxford University Press.

Popil, I. (2011). Promotion of critical thinking by using case studies as teaching method. *Nurse Education Today*, 31 (2), 204–207.

Rakoff, T. D. and Minow, M. (2007). A case for another case method. *Legal Education Digest*, 15 (3), 597–607.

Rapee, E. (1970). *Motion picture moods for pianists and organists: A rapid reference collection of selected pieces*. North Stratford, NH: Ayer.

Reich, S. and Korot, B. (1993). *The Cave*. London: Boosey and Hawkes. www.youtube.com/watch?v=uh85lplBqdU, accessed 1 August 2018.

Ruggiero, J. A. (2002). "Ah Ha" learning: Using cases and case studies to teach sociological insights and skills. *Sociological Practice: A Journal of Clinical and Applied Sociology*, 4 (2), 113–128.

Savage, J. (2005). Working towards a theory for music technologies in the classroom: How pupils engage with and organise sounds with new technologies. *British Journal of Music Education*, 22 (2), 167–180.

Swindley, T. (1997). *Always ... Patsy Cline* [musical]. Houston: Ted Swindley Productions.

Tobin, A. (2015). *ISAM 2.0 live at outside lands*. London: Ninja Tune. www.youtube.com/watch?v=uh85lplBqdU, accessed 1 August 2018.

Part III

Student experiences 3

13 Play as a medium for active learning in vocal education at university

Lotte Latukefu and Irina Verenikina

Play is an accepted method of training actors (Barker 1977; Johnson 1998). It encourages actors to work things out for themselves in a fun manner rather than follow a formula set by the teacher (Barker 1977). However, in university singing teaching, it is not common practice to use play and games as part of the learning. The aim of this chapter is to explore the ways that play can be used to enhance vocal students' learning. To achieve this we first provide narratives to discuss a play approach used by the first author in her reflection on her teaching of university singing students. We then discuss the students' reflections and views on the usefulness of this approach. In continuation of a socio-cultural model of teaching singing (Latukefu 2010; Latukefu and Verenikina 2013), socio-cultural view of play (Vygotsky 1976) and the social constructivist notion of active learning (Palincsar 2005; Vygotsky 1978) are used to conceptualise the findings in this chapter.

Play and learning

Play is widely recognised as a powerful medium for effective learning, potentially stress free, and enjoyable to its participants. It encourages the development of imagination, socialisation, emotions and cognition over the lifespan (Sutton-Smith 1997; Vygotsky 1976). However, play is not driven by motivation to learn. Instead, it is motivated by playful goals. Most effective learning in play happens when the knowledge or skill to be learnt is a necessary tool to achieve the play goal. For example, at a computer games club young children's writing (the skill to learn) was embedded in play as the means of communication with an imaginative, playful figure who "lived online" and could answer any of the children's questions or meet any of their requests (Cole 1998). This resulted in the children's improved writing and reading for meaning which happened in a playful manner, outside of formal literacy learning contexts.

Out of the types of play outlined in the literature we focus on games with rules and imaginative (or socio-dramatic role) play (Pellegrini 2011). Imaginative role-play is motivated by the enjoyment of imagination and pretend. It does not have a limited set of rules but is bound by the characteristics of the roles and situations enacted in the play scenario; the rules have to be negotiated by

the participants and once established have to be strictly maintained, or collectively re-negotiated. Through accepting the rules and replicating the roles from real life the participants of the play can explore and master them in a playful and creative manner, linking them to their own individual experiences (Vygotsky 1976). Games driven by the desire to win include an established set of rules which have to be followed by all the participants. Both these types of play, however, are interrelated in that they both include an imaginary "as if" situation driven by the rules or framework. Vygotsky (1978) pointed out that the device of an "imaginary situation is the defining characteristic of play in general" (93), including games with rules, as they contain "an imaginary situation in a concealed form" (95). Both types of play are highly motivating and do assume active intellectual engagement of the participants in the playful activities.

Active learning

The notion of active learning takes its roots from the philosophy of experiential learning (Dewey 1938) and constructivist and social constructivist pedagogies of teaching and learning (Palincsar 2005). Active learning refers to the teaching model that engages students in constructing knowledge and understanding through personal experiences rather than accepting it at face value as transmitted to them by an educator or through other sources. This type of teaching is "much more … than the simple transmission of prescribed knowledge and skills" (Daniels 2001: 2); it assumes a specific paradigm of teacher-student interaction where the role of the teacher is that of collaborator and co-constructor. It requires students to engage in meaningful learning activities and reflect upon the things they are doing (Matveev and Milter 2010). To monitor their learning, active learners have to engage in a higher-order thinking (Ginsburg 2010), including analysis, synthesis and evaluation (Simons 1997).

To become active learners, students have to be motivated and self-confident (Simons 1997), undertake a dynamic role in their education (Petress 2008) and not be overly dependent on their teachers. The advantage of the method of active learning is in students constructing the knowledge, which attains personal meaning and can be applied to relevant activities beyond the educational setting. Active engagement in their learning sets the path for lifelong learning (Verenikina 2008).

In the theory of social constructivism (Palincsar 2005; Vygotsky 1978), which underpins this study, social interactions are seen as essential to learning. Active engagement in learning is enhanced by interactions with peers as co-learners who engage in collaborative activities and discussions by raising questions, solving problems and reflecting on their achievements (Drew and Mackie 2011; Keengwe and Onchwari 2011). Being actively involved in their learning through social interactions can help students discuss complex topics, converse with others about disagreements, and help them take part in negotiated understandings of the world (Palincsar 2005).

The study

The aim of this study was to explore how a play approach might be beneficial to learning for singing students. Singers need to be multi-faceted (Bennett 2007) and agile in moving authentically between genres if they want to have the portfolio career that is now a reality for graduates of performing arts university programs. In 2011, as part of the continued development of a socio-cultural model of teaching singing (Latukefu 2010), a play approach was introduced to singing classes in such a performance program. Games used in training actors to develop focus, memory and awareness were adopted and adapted to train singers to master the differences between classical singing techniques and contemporary techniques and employ the different requirements thoughtfully and immediately. This required students to understand what constituted quality in a particular genre, analyse what techniques were required in order to support that descriptor of quality and physically engage their voices using correct technique.

Approach and background

The example in the chapter relates to play orchestrated by the singing teacher (the first author) at an Australian regional university where the singing students practised and applied different vocal techniques related to classical singing such as creating an even, balanced, legato, beautiful tone and contemporary singing, where students explored a diverse palette of vocal effects using lots of different types of techniques such as breathy or creaky or belted tone. The teacher implemented weekly play in second and third year singing classes.

There were 17 students in the second year singing class and 18 in the third year singing class of a Bachelor of Performance. The students had already completed one or two years of singing classes where they learnt fundamental techniques of classical and contemporary singing. In the first week of class the lecturer and students took time to review fundamental vocal techniques and compare and contrast differences between classical and contemporary requirements. In subsequent classes the lecturer used games with rules and role-play to emphasise differences between classical and contemporary techniques.

Both the games and the role-play were organised to enhance students' learning. The content to be learnt was embedded in the rules of play necessary to achieve the play goals. For example, a game with rules that inadvertently helps students develop good breath control is one in which students stand in a circle pretending to be Samurai warriors ("Hoi-Ching-Ha"). One student lifts an imaginary sword above her head while saying "HOI" loudly, neighbouring students slaughter her with their imaginary swords shouting "CHING" and then the Samurai lowers her sword pointing at another player and shouts "HA". That student then becomes the Samurai. Anyone who makes a mistake with the movement or sound, or is too slow, must step out of the game. The game gets faster and faster and requires very good breath

control to maintain the correct vocal sound and movement. An example of a role-play might be to take on the role of Country Music Singer or Opera Singer and employ correct vocal techniques in order to authentically portray this character.

To collect the data, the sessions of each week of playing games were video-recorded. The recordings were then reviewed after each class and described in detail to create observational narrative records as a participant observer. Excerpts from the narrative records are used in this chapter to provide detailed description of the students' behaviour in play (Beaty 2006). To get students' perspectives, at the end of the semester the teacher sent out an invitation to all the participating students to take part in an anonymous voluntary survey answering the following questions:

1. Do you think games are a useful tool for learning?
2. Can you describe your favourite game from class and say why you have chosen it?
3. Can you give an example of learning a concept or technique by playing a game?
4. Have you mastered any broader skills by playing games in class?
5. Are there any games you found to be unhelpful and why?

Fifteen out of the 35 students completed the survey.

Findings and discussion

In order to discuss key issues around the relationship between play and learning, the findings are presented below as both excerpts from teacher narratives and analysis of students' survey responses.

The "games with rules" narrative example

The teacher narrative presented below demonstrates the importance of game rules to support students' active engagement in their learning.

> The second year students have arrived for the singing class. Without any prompting they immediately form a circle and begin a game called "multi-game" as a warm up. It is made up of all the games they play and they are supposed to switch seamlessly from one game to the next. It is easy to "get out" in this game so it requires high concentration. There are a couple of students who seem to have low energy and one student who regularly resists participating in the games. She prefers to get out immediately. The students are playful but they won't let the tired students get away with this low energy. The group requires a high effort level from each other when playing this game and the students are quite strict with each other.

They deal very differently with the student who is more resistant. Rather than insisting that she join, in the same way they insist that the tired students put in more effort, they take turns cajoling her to join and when she still doesn't, they leave her alone. Finally in her own time she does join in and everyone accepts her into the circle.

After the warm up I suggest that they play a game in which one person comes up with a theme and then each person points at someone else in the circle and sings something related to the theme using classical techniques and phrasing. Some people are very confident singers and they sing very floridly and exaggeratedly high which makes the group laugh. Some people don't have much confidence and tend to just sing one sound. We keep going round the circle until the order in which they sing has been established. Then another person in the group comes up with another theme and again one by one the students point at one another (a different person this time) and using contemporary singing techniques they go through the same process. Once this pattern has been established they try and get both patterns happening at the same time. This means that the students have to remember when their turn is in two different patterns and they also have to remember whether they are using classical techniques or choosing from a range of other more contemporary singing techniques such as breathy, creaky, belted or yodelling voices. It is challenging and it makes them laugh a lot. Again my eye is drawn to the student who tends to resist participating in play. This student began singing in the first pattern with a very small voice and literally chose a word that had one syllable, which she sang one note on in a light breathy and very small voice. As the round progressed and it becomes more difficult to remember which pattern is which and which technique to use, there was more and more laughter. The resistant student in particular was laughing a lot and seemed much more relaxed. Suddenly she improvised an absolutely beautiful soprano phrase, very high with lots of melisma. There was no breath in her tone; instead it was resonant and balanced. The entire game stopped because the students were so impressed by this outburst of song they spontaneously cheered. She blushed and gave a little bow.

In the narrative excerpt above, singing students practised concepts and skills in a playful manner necessary to follow the rules, play out the roles and achieve the goals of play. Thus the knowledge and skill of singing in different styles, understanding the difference between these styles and ability to engage in these styles of singing without delay became the tools to achieve the goal of the game. The students accepted that you either play by the rules or you sit out. The other students (not the lecturer) allowed this choice, which needed to be made by each student. Students chose to play or chose to be out. In this case it was important that the environment allowed students to join in when they felt ready.

By the end of the game the reluctant student was singing more confidently using a classical technique. The game and the rules of the game became her focus not whether she could sing classically. In order to play the game properly she had to follow the rules, which were to employ a classical technique to the improvisation. She was inadvertently learning through playing. While the group was supportive, it was her decision to eventually join the game, indicating her active involvement in her learning. This might be particularly important for shy or reluctant personalities as they get drawn out into participating in group learning.

Understanding the benefits of play for professional learning

When children play they simply enjoy their play without realising the benefits of it (Vygotsky 1976). Obviously, this is not the case with university students who, as adult learners, wish to know why they played a particular game. In the survey, the students were able to reflect on their participation in the games and articulate the learning outcomes, both specific and generic, that they perceived as valuable for their professional learning.

For example, the students mentioned that in games they learnt self-regulation skills that are important for performing:

> ... an intense game ... requires focus, ... remaining calm in high stress situations, making fast decisions ... All of these things are essential for a good performance
>
> (Survey Respondent #2)

> ... everyone enters the game committed and that feeling reflects in the class
>
> (SR #3)

> Multi-game ... it forces you to exercise absolute focus and control
>
> (SR #8)

The students reflected that being "in the game" allowed them to learn in a stress-free environment:

> When you're in the game, you're in it to win, it's life or death, that's the stakes. But as soon as you get out, you accept it and take it gracefully
>
> (SR #3)

> Being able to let go of insecurities ... being able to be yourself is freeing. You can learn to let go of these things in games because you have to get over yourself
>
> (SR #6)

The games were noted by students as "an engaging way of learning" (SR #5) which stimulated the creative thinking important for performance:

> Games as a creative tool for learning force my brain to make different connections. I'm a chronic over-thinker, and there's no time for that when you're in the heat of the game
>
> (SR #3)

> They [games] activate the mind, are engaging, and promote new ways of thinking and understanding
>
> (SR #12)

From the above examples we can see that students learnt a great deal from the games including important skills such as focus, commitment and letting go of self-consciousness in order to play freely. They are also able to see clear connections between these skills and their future profession.

Some of the concepts that singing students must understand require a complex integration of motor skills in the vocal tract. Often students need to engage somatic sensations to synthesise these concepts. Students' survey responses indicate that they found games helpful in this respect. For example, games were mentioned as important for "voice work (resonance, twang, articulation), reflex sharpening ..." (SR #8). Specifically, the games were mentioned as useful for developing "breathing techniques" to keep up with a fast pace of the game by taking "quick but full breaths filling the lungs" (SR #9). The students valued that the games provided them with the environment for "[k]inaesthetic learning" when you "don't just read, you DO" (SR #9). The game environment allowed the students "to practice correct vocal techniques" (SR #3) and to simultaneously "engage physical and vocal as well as dexterity" (SR #7) which were necessary to follow the rules and win.

We also see that the games stimulated the students to employ a number of techniques characteristic to active learning including learning through personal experiences rather than accepting knowledge at face value (Matveev and Milter 2010) and reflecting on their learning (Ginsburg 2010; Simons 1997) as they applied specific techniques, analysing each other's approaches and learning from others' examples; and deliberately practising the techniques they needed to win the game.

Play is experienced as helping with gaining understanding about how to apply these notions of vocal technique to singing, practise them and observe others doing so in an engaging and non-judgmental atmosphere. However, even though students were fully aware of the benefits of playing the games, during the process of play itself they were motivated and energised by playful goals rather than the learning goals (what Leont'ev called "only understandable" motives – in Engeström 2015: 104). The games were intentionally designed in a way that singing knowledge and techniques became the necessary tools to reach the playful goal of the group game. During the game the students did not

have the need or time to focus on the tools, but the desire to successfully participate in play encouraged them to intentionally practise the knowledge and skills of vocal technique prior to the play and therefore take an active role in their learning (Petress 2008). As adult learners, students understood the benefits of learning in a playful environment (Knowles, Holton and Swanson 2012) but also appreciated the fun and social side of it (Blanchard and Thacker 2012).

In the next section we discuss the use of role-play to encourage students' active learning in vocal classes.

A role-play example

It is the first week back and as always we are beginning the semester with classical techniques and studies. One of the students has a lovely bass voice and could be a very good classical singer but he has no interest in classical singing and prefers a slightly breathy "indie" sound. The only way that I can get him to sing classically is to get him to pretend he is an "over the top" opera singer. It is quite interesting to observe how he changes physically in order to achieve this. He wants to make the students laugh so he exaggerates everything including vocal tone, vibrato, facial expressions and body engagement. He does make the students laugh but he also sounds fantastic and a number of the students beg him please to keep singing like that. The student is not a beginner singer but he is a reluctant classical singer. Sometimes encouraging a beginner singer to just pretend to sing like an opera singer can have a strong effect that surprises the students and makes them laugh at themselves. This relates to role-playing and is especially helpful when introducing beginners to classical vocal techniques.

In the above example, in order to play and pretend being a particular type of singer such as an opera singer, the student had to reflect upon, analyse and try to mimic the characteristic ways of behaviour for different types of singers. He then had to choose which behaviours were required and display them in a convincing way in order to contribute to the fun of the group play.

Learning generic (work-related and life) skills

Apart from the content to learn, which was pre-planned and embedded in the students' play by the teacher, there are broader skills that the students learnt through play. As reflected in the students' survey responses, such skills go beyond professional singing knowledge and techniques and comprise a range of generic skills necessary for functioning in society. These include interpersonal communication skills, elements of leadership, self-confidence and self-management skills. As expressed by one student, "most of these games are condensed and metaphorical emulations of what you have to do in life" (SR #8). This resonates with the theoretical view of play as a medium which allows to reflect on real-life situations in

a conceptualised manner and therefore provides a powerful learning experience (Vygotsky 1976). The student continues, summarising his learning experience with the games as highly valuable for his social and emotional development as a person:

> I could argue that my interpersonal skills have improved, my reflexes ...
> I have grown more confident and grounded just from these games. You also learn how other people function psychologically based on their in-game tactics, which therefore allows you to assess how to treat a person in a workplace environment based on your in-game analysis

(SR #8)

Other students' responses resonate with this view, suggesting that "playing games helps with following rules, listening to others and sharing leadership" (SR #9) and helps learning "to focus, be balanced, and have a quicker reaction time" (SR #5).

One of the students pointed out an interesting effect of play in relation to a generic skill important for working in the entertainment industry through:

> The status pointing game. All walk around the room and when called upon the entire group must make a decision of who is the weakest in the group and point to them, they are out. The sole remaining player is the winner. This is a great game for playing to win, so often we can give up trying to win a scene as actors if we know that our character does not eventually do so. You must use different techniques to eliminate others and avoid being eliminated yourself, this is particularly interesting when the tables turn in the second round when the roles are reversed and the strongest are eliminated first. You must understand the rules and then use them to your advantage just as a character does in a scene

(SR #4)

In the above response the student suggested that play in the class allowed him to practise a skill of being competitive and a winner. Interestingly, the student did so as a member of the group of individuals who are in competition with each other! However, the playful environment allowed him to do so in a safe environment, with a lot of laughter and support for each other.

Conclusions

In this chapter we presented a study which explored the ways that the introduction of a play approach to learning a range of vocal techniques was beneficial for singing students, with the aim of identifying ways that play can be used to enhance vocal students' learning. Our observations and the analysis of students' reflections lead us to the preliminary conclusion that play provided a useful medium for singing students to actively engage in their learning in two ways:

learn the professional curriculum knowledge and skills; but also generic skills and knowledge necessary for their future work and life.

Play provided a safe space for students to make the scientific concepts they knew already personally meaningful to them, that is, to implement them in a playful manner within the group of peers who supported and validated their skills. Playing out roles of particular types of singers or simply applying the rules of singing in a particular style helped students to learn by reviewing course content and engaging in a series of learning processes that involved demonstration and making decisions (Blanchard and Thacker 2012; Kuo 2015).

There were indications that while playing the students were able to engage in construction of their own knowledge in collaboration with peers and the teacher (Palincsar 2005). To participate in the games they had to use the "content to be learnt" as a tool to achieve the play goals (Cole 1998). This motivated them to engage in active learning individually by reflecting and intentionally practising in preparation for the play. As a group they learned from each other and reinforced each other's learning by comparing their skills, encouraging and supporting each other in a safe and fun environment.

The students' reflections indicated that they all enjoyed the fun side of the play but also were aware of what they were learning. In addition to the content that was planned by the teacher for students to be learnt, they also reported on a number of generic skills which they were able to practise and learn in play.

> ... all of these games achieve a purpose even if it is accidental or incidental. This is because they are task based, they follow the same rules as human instincts, therefore you can always learn something about yourself and/or others by returning back to your base function
>
> (SR #5)

In the above examples the students engaged their imagination to be somebody else or engaged with the curriculum content in order to try and win a game. They reflected and explored and practised the required skills and were able to connect this knowledge to their personal experiences and feelings, as well as currently attained skills; and to do so without intimidation or stress because everyone was in the same position and supported each other with laughter and encouragement. Play offered a safe, interactive, collaborative environment for learning from and learning with peers.

References

Barker, C. (1977). *Theatre games: A new approach to drama training*. London: Methuen.

Beaty, J. J. (2006). *Observing development of the young child*. 6th Ed, New Jersey: Merrill Publishing Company.

Bennett, D. E. (2007). Utopia for music performance graduates. Is it achievable, and how should it be defined? *British Journal of Music Education*, 24 (2), 179–189.

Blanchard, P. N. and Thacker, J. (2012). *Effective training*. Upper Saddle River, NJ: Prentice Hall.

Cole, M. (1998). *Cultural psychology: A once and future discipline*. Cambridge, MA: Harvard University Press.

Daniels, H. (2001). *Vygotsky and pedagogy*. NY: Routledge/Falmer.

Dewey, J. (1938). *Experience and education*. New York, NY: MacMillan.

Drew, V. and Mackie, L. (2011). Extending the constructs of active learning: Implications for teachers' pedagogy and practice. *The Curriculum Journal*, 22 (4), 451–467.

Engeström, Y. (2015). *Learning by expanding*: *An activity-theoretical approach to developmental research*. 2nd Ed, Cambridge: Cambridge University Press.

Ginsburg, M. (2010). Improving educational quality through active-learning pedagogies: A comparison of five case studies. *Educational Research*, 1 (3), 62–74.

Johnson, C. (1998). *House of games: Making theatre from everyday life*. NY: Routledge.

Keengwe, J. and Onchwari, G. (2011) Fostering Meaningful Student Learning Through Constructivist Pedagogy and Technology Integration. *International Journal of Information and Communication Technology Education* 7 (4), 1–10.

Knowles, M. S., Holton, E. F. and Swanson, R. A. (2012). *The adult learner*. NY: Routledge.

Kuo, Y. (2015). *Building sustainable futures for adult learners*. Holtz, J.K. (Ed.) Charlotte, NC: Information Age Publishing, 157–182.

Latukefu, L. (2010). *The constructed voice: A socio-cultural approach to teaching and learning singing* (Unpublished Doctoral Thesis). University of Wollongong, Australia.

Latukefu, L. and Verenikina, I. (2013). Expanding the master-apprentice model: Tool for orchestrating collaboration as a path to self-directed learning for singing students. In Gaunt, H. and Westerlund, H. (Eds.), *Collaborative learning in higher music education*, England: Ashgate Publishing, 101–110.

Matveev, A. V. and Milter, R. G. (2010). An implementation of active learning: Assessing the effectiveness of the team infomercial assignment. *Innovations in Education and Teaching International*, 47 (2), 201–213.

Palincsar, A. S. (2005). Social constructivist perspectives on teaching and learning. In Daniels, H. (Ed.), *Introduction to Vygotsky* (2nd ed.). New York, NY: Routledge, 285–314.

Pellegrini, A. D. (Ed., 2011). *The Oxford handbook of the development of play*. NY: Oxford University Press.

Petress, K. (2008). What is meant by "active learning?" *Education*, 128 (4), 566–569.

Simons, P. R. J. (1997). Definitions and theories of active learning. In Stern, D. and Huber, G. L. (Eds.), *Active learning for students and teachers: Reports from eight countries*, New York, NY: Peter Lang, 19–39.

Sutton-Smith, B. (1997). *The ambiguity of play*. Cambridge, MA: Harvard University Press.

Verenikina, I. (2008). Scaffolding and learning: Its role in nurturing new learners. In Kell, P, Vialle, W, Konza, D. and Vogl, G. (Eds.), *Learning and the learner: Exploring learning for new times*, University of Wollongong. http://ro.uow.edu.au/edupapers/43/.

Vygotsky, L. S. (1976). Play and its role in the mental development of the child. In Bruner, J., Jolly, A. and Sylva, K. (Eds.), *Play: Its role in development and evolution*, NY: Penguin, Harmondsworth, 537–555.

Vygotsky, L. S. (1978). *Mind in society: The development of higher mental process*. Cambridge, MA: Harvard University Press.

Evaluating performance

14 Disciplinary perspectives on music performance through the lens of assessment criteria

Ian Stevenson

Introduction

In previous work (Blom, Stevenson and Encarnacao 2015), the author and colleagues reviewed literature relevant to assessing music performance processes using criteria and standards-based rubrics. In that work they considered their own application of selected rubrics in a number of undergraduate music performance subjects. They also compared their experience of the use of assessment rubrics to other assessment methods discussed in the literature. In this brief chapter the specific criteria used to assess a diverse range of learning outcomes across an undergraduate music program are considered. This collection of criteria provides a unique overview of the characteristic values associated with the conception of music within a music training institution. Standards descriptors, when analysed using content analysis methods, also provide a perspective on concepts associated with themes such as academic literacy and musicianship. The discourse embedded in these rubrics can provide insight into the musical conceptions of both their authors and of their sub-disciplinary areas of performance, composition, music technology and musicology. This chapter takes the evaluation of the assessment rubric in music performance beyond its effectiveness as a tool for learning and teaching and considers it as a reflection of the unique matrix that defines "the musical" within a specific institutional context.

Background

Assessment rubrics have become widely if not universally adopted within tertiary institutions as a means to communicate assessment criteria and performance standards to help students target their efforts in completing assessment tasks and to ensure equality and transparency in the assessment of their achievements (James, McInnis and Devlin 2002; O'Donovan, Price and Rust 2004; Stevens and Levi 2004). Assessment rubrics are a very concrete element within the institutional discourse that defines a particular academic disciplinary program. Standards descriptors are the extremities or leaves in a tree structure of curriculum documentation. A typical approach to mapping a tertiary curriculum (Kallick 2009) starts with the

graduate attributes or course learning outcomes that express a unique understanding of the current state of the discipline area and are the high-level objectives of an undergraduate program. These objectives are met through a set of subjects often organised into sub-disciplinary areas of study. The branches of the discipline (for example performance, composition, technology, musicology, etc.) that are selected express the curriculum designers' understanding of the relevance or significance of these branches in current musical practice. Each sub-disciplinary area is articulated through individual subjects which in turn contain a set of learning outcomes which are achieved through a program of learning activities in each subject. The subject learning outcomes are assessed (and hopefully learned) through a set of assessment tasks which in turn are defined as a set of criteria for successful completion of the task. The individual standards of achievement for each criterion are the final link in this chain of specification that define each aspect of what it takes to graduate with a music degree from a given course (see Figure 14.1).

Taken from a course level perspective, this mass of textual data defines what the curriculum designers understand as contemporary musical practice. A body of institutional discourse of this type is necessarily a collaborative effort and therefore the definition of "the musical" contained in it comes from the multiple perspectives of the specialists teaching in a given program. The idea of examining curriculum documents as a body of discourse is not new. Various modes of enquiry have been applied including Bernstein's analysis of pedagogical discourse (Bernstein 2000, 2003), and various approaches to critical discourse analysis (Janks 1997; Liasidou 2008).[1]

The pool of data available in the undergraduate program under examination includes the following:

24 subjects comprising:

- 174 subject learning outcomes (7.25 per subject) and
- 84 discrete assessment items (3.5 per subject) comprising
 - 350 discrete criteria (4.2 per assessment item) and
 - 1893 standards descriptors (5.4 standard levels per criterion).

To put this another way, focusing on assessment, the course contains 24 subjects with 3.5 assessment tasks per subject, 4.2 criteria per task and 5.4 standards per criterion corresponding to pass, credit, distinction and high distinction levels plus a number of standards at "needs improvement" level between fail and pass. The standard descriptor text alone comprises a body of 34096 words.

Examining musical performance discourse through the rubrics

This analysis focuses on the six performance subjects offered in the program. There are 40 subject learning outcomes (487 words), 23 assessment items, 85 criteria (520 words) and 413 standards (10744 words).

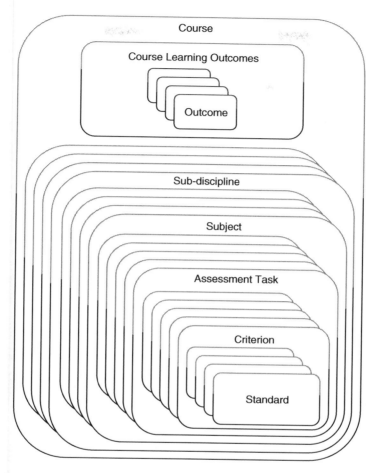

Figure 14.1 Generic curriculum map

Rather than listing individual learning outcomes or assessment tasks the analysis starts with a simple word frequency count. The weighted occurrences of key words in the text are displayed in Figure 14.2. This shows that, as expected, music performance is the focus of the outcomes for these subjects. These are followed by the key words: skills, develop and communicating or communication.

A further step in the analysis looks at the parts of speech. At its most basic level, as displayed in Figure 14.3, we have verbs, adjectives and nouns clustered around the key words of music and performance.

An initial inspection of this graphical presentation, weighted by word frequency, suggests that across all the assessment tasks in all six performance subjects the most significant learning outcome is to "develop written communication skills".

Figure 14.2 Performance learning outcomes weighted by frequency

While this might seem surprising, closer inspection shows that this anomaly in the data visualisation is caused by the great variety of descriptive language used to specify musical approaches across the three years. Musical performance, when presented as a staged sequence of development, cannot be reduced to a small set of descriptors. When taking word stemming into account, there are 36 separate adjectives, 42 verbs and 79 nouns, including a variety of concrete and abstract nouns. What this tells us is that the practice of the sub-discipline of music performance cannot be reduced to a simple formula. Its concepts, associated entities, behaviours and values are numerous and diverse. This conceptual diversity is reflected in the list of terms in Table 14.1.

However, what this does also tell us is that in the teaching of music performance within the university, written communication is considered an important skill to be developed alongside performance skills. A closer look at the written assessment tasks themselves reveals a range of text types including concert reviews, proposals and written reflections and therefore the students are engaged in practical writing tasks characteristic of professional practice writing within the discipline.

Assessment tasks

The activities that define music performance training in this course include seven rehearsal, workshop and process tasks; eight separate performances

Figure 14.3 Performance learning outcomes organised by word function

Table 14.1 Performance subject learning outcome word type and frequency

VERBS		ADJECTIVES		NOUNS	
Word	**Count**	**Word**	**Count**	**Word**	**Count**
develop	6	written	4	skills	7
acquire	4	critically	2	communication	5
extend	3	electroacoustic	2	group	5
incorporate	3	existing	2	improvisations	5
apply	2	expanded	2	project	5
collaborate	2	featured	2	material	4
consider	2	large	2	practice	4
construct	2	onstage	2	repertoire	4
contextualise	2	small	2	tasks	4
create	2	specific	2	techniques	4
engage	2	substantial	2	collaboration	3
enhance	2	theatrical	2	experience	3
evaluate	2	conceptual	1	instruments	3
including	2	contrasting	1	notation	3
rehearse	2	conventional	1	understanding	3
use	2	detailed	1	audience	2
administration	1	different	1	combinations	2
challenge	1	digital	1	context	2
compose	1	electronic	1	creative	2
conceive	1	first	1	dynamics	2
critique	1	foreground	1	elements	2
demonstrate	1	free	1	identity	2
emerge	1	generic	1	multimedia	2
exploring	1	greater	1	notion	2
identify	1	imaginative	1	persona	2
illustrate	1	informed	1	perspective	2
implement	1	interactive	1	player	2
involved	1	live	1	process	2
learn	1	melodic	1	proposal	2
make	1	middleground	1	register	2
meet	1	necessary	1	relationship	2
mounting	1	new	1	space	2
originate	1	personal	1	strategies	2
partake	1	physical	1	structure	2
presenting	1	responsive	1	timbre	2
produce	1	solo	1	units	2
refine	1			work	2
rely	1			accompanist	1
review	1			amplification	1

(*Continued*)

Table 14.1 (Cont.)

VERBS		ADJECTIVES		NOUNS	
Word	**Count**	**Word**	**Count**	**Word**	**Count**
undertake	1			arrangement	1
utilising	1			articulation	1
				background	1
				backstage	1
				choices	1
				composer	1
				concert	1
				duration	1
				envelope	1
				essay	1
				event	1
				expression	1
				facility	1
				frameworks	1
				functions	1
				gesture	1
				harmony	1
				issues	1
				minutes	1
				modes	1
				note	1
				number	1
				order	1
				parameters	1
				part	1
				plan	1
				principles	1
				production	1
				program	1
				reference	1
				rhythm	1
				roles	1
				scales	1
				soloist	1
				sound	1
				soundworks	1
				spontaneity	1
				style	1
				treatment	1
				variety	1
				ways	1

including solo, ensemble and larger scale performance projects; and seven written tasks including essays, proposals, concert reviews and portfolios. Performances include improvisation, original compositions, set repertoire and student devised programs.

Criteria

The 85 criteria by which performance assessment tasks are judged articulate the curriculum designers' understanding of what students should focus their attention on in order to learn the art of music performance. They also suggest the strategies that assessors choose to differentiate performance of various standards. Assessment criteria can be understood as a list of skills that should match the learning outcome for the subjects and course in which they are embedded. Blom and Encarnacao (2012) organise these music performance skill sets into various categories including technical, analytical, appreciative, personal and interpersonal, and organisational skills. These categories fall into two broad groups of so-called hard skills (musical, technical, etc.) and soft skills (interpersonal, organisational, etc.).

Criteria for assessing written tasks follow the norms for tertiary-level writing including structure, clarity, content, analysis, argumentation, spelling and grammar, referencing, etc. Some specific music performance topics are also assessed in written tasks including the need to identify and describe musical structures, performance roles, etc.

Hard musical skills can be broken down into those that are audible such as texture, balance, instrumental technique, ensemble and overall musicality; and those that can be inferred from the audible aspects of performance such as imagination, personal voice, awareness, listening, willingness to experiment and demonstration of process. There are also a set of inaudible hard skills such as stagecraft, presentation and persona. Extra-musical soft skills in music performance identified in criteria include consistent and punctual attendance at rehearsals and workshops, focus, participation, collaboration, sensitivity, leadership, commitment and professionalism.

As Blom and Encarnacao point out, "a strict delineation between the two [categories] is neither desirable nor possible" (26) and there is a grey area including criteria that identify skills such as a capacity for progress, experimentation and demonstration of process that apply equally in the musical and extra-musical domain.

Musical standards

Moving down to the lowest level of discourse we examine the standards descriptions embedded in the assessment rubrics for all performance tasks taken as one body of text. This approach holds in balance the global level of the overall performance specialisation across three years of the degree with the low-level standards. At the lowest level, the curriculum designers

Figure 14.4 Musical terms in assessment standards weighted by frequency

are required to identify the specific detailed characteristics of good perform-
ance. At the global level, curriculum designers are charting the path to
achieve this.

At the level of the standards descriptors, when removing words associated with
written communication, a picture of the detailed nature of musical performance as
taught in this program begins to emerge. This is displayed in Figure 14.4. At the
centre of music performance practice is attention. Attention is collocated in the
standards descriptors with a range of audible musical parameters including: atten-
tion to sound, timbre, intonation, balance, texture, articulation, rhythmic, harmonic,
modal, timbral and/or other motifs, phrasing, dynamics, rhythmic precision and/or
sense of groove.

Attention is also to be given to more complex musical phenomena such as
attention to their sound and its place in the ensemble, musical space, the
contributions of others, the group sound, details in the score, to matters of
musical style, to the piece's structure with successful demarcations of sec-
tion, development of material, climax and/or use of motif, and to contrast. In
this conception of musical performance attention is also given to non-audible
aspects of musical performance including attention to performance aesthetic,
to on-stage actions, to staging, persona and production, presentation of the

Table 14.2 Most common musical terms in performance assessment standards

Word	Frequency
sound	16
group	14
material	14
style	14
instrument	12
understanding	9
score	9
piece	8
presentation	8
structure	7
tune	6
equipment	5
personnel	5
pitch	5
repertoire	5
timbre	5
voice	5
inaudible	4
interpretation	4
practice	4
texture	4
time	4

work, stage presence and to the relationship between performer and audience.

Figure 14.4 provides an interesting picture of the musical domain encompassed by the standards descriptors. Words other than attention or musical performance with four or more occurrences are shown in Table 14.2. These are drawn from a pool of 101 discrete stemmed terms, the majority of which (75%) occur three times or less within the text, and 37% of terms occur only once. This range and diversity of key words gives an impression of the complexity that must be mastered by a graduating musician or at least the number of musical ideas that they have been exposed to in terms of the requirements of their performance assessments. These lists of terms suggest the range of musical elements considered important in musical performance by the curriculum designers.

Conclusions

Written institutional discourse in the form of subject documentation provides an insight into the ways that the musical imaginary is transformed into concrete measures of attainment communicated to student performers. These documents contain both high-level conceptions of music and musicianship and very low-level descriptions of the concrete concerns of musicians. The shape of these textual formations gives us a view of both the gross generalisations that must be made and the underlying complexity, diversity and specificity of musical practice that the high-level descriptions and goals conceal. By applying quantitative and computer-assisted methods to the reading of these consolidated bodies of text we can move beyond our personal imagined perceptions of musical practice, informed by our sub-disciplinary focus. In this process the imagined features that lie behind generalised learning outcomes are replaced by the actual concerns expressed in these large bodies of text.

A first examination reveals the unexpected significance of written communication, but on closer examination the real feature that is revealed is the diversity of musical descriptors employed in the communication of musical practice. Another finding is the way in which attention is positioned as the core value to enable student musicians to achieve more conventionally expressed learning outcomes such as skills, techniques and facility. In this approach to musicianship, attention is applied to fundamental audible musical parameters such as pitch and timing, but also to more complex musical phenomena associated with musical organisation and ensemble. In addition, attention must also be applied to the non-audible aspects of performance such as stage presence, and to the soft skills required to succeed as a professional musician.

Note

1 For a useful overview of discourse analysis methods see Gee, J. P. (2005).

References

Bernstein, B. B. (2000). *Pedagogy, symbolic control, and identity: Theory, research, critique* (Rev. ed.). Lanham, MD: Rowman & Littlefield Publishers.

Bernstein, B. B. (2003). *Class, codes, control. Volume IV: The structuring of pedagogic discourse*. New York: Routledge.

Blom, D. and Encarnacao, J. (2012). Student-chosen criteria for peer assessment of tertiary rock groups in rehearsal and performance: What's important? *British Journal of Music Education*, 29 (1), 25–43.

Blom, D., Stevenson, I. and Encarnacao, J. (2015). Assessing music performance process and outcome through a rubric: Ways and means. In Lebler, D., Carey, G. and Harrison, S. D. (Eds.) *Assessment in music education: From policy to practice*. New York: Springer, 125–140.

Gee, J. P. (2005). *Discourse analysis* (2nd ed.). New York: Routledge.

James, R., McInnis, C. and Devlin, M. (2002). Assessing learning in Australian universities. *Centre for the Study of Higher Education (CSHE) for the Australian Universities Teaching Committee (AUTC)*.

Janks, H. (1997). Critical discourse analysis as a research tool. *Discourse: Studies in the Cultural Politics of Education*, 18 (3), 329–342.

Kallick, B. (2009). *Using curriculum mapping & assessment data to improve learning*. Thousand Oaks, CA: Corwin Press.

Liasidou, A. (2008). Critical discourse analysis and inclusive education policies: The power to exclude. *Journal of Education Policy*, 23 (5, September), 483–500.

O'Donovan, B., Price, M. and Rust, C. (2004). Know what I mean? Enhancing student learning of assessment standards and criteria. *Teaching in Higher Education*, 9 (3), 325–335.

Stevens, D. D. and Levi, A. J. (2004). *Introduction to rubrics: An assessment tool to save grading time, convey effective feedback and promote student learning*. Sterling, VA: Stylus.

15 Engaging music performance students in practice-led reflective essay writing and video/recording analysis

Eleanor McPhee and Diana Blom

Practice-led research has been recognised as part of a performative research paradigm within which researchers working with music performance find they "need to engage a range of mixed methods, especially those which are instigated by and led from the demands of their practice" (Haseman 2007: 151). Outcomes from this systematic approach "promise ... to raise the level of critical practice and theorising around practice in a more rigorous and open way than professional practice alone is able to achieve" (156). Of music performers, Haseman asks for reflection on their performing and for thinking beyond performing alone. This reflection may require analysis of video footage taken of one's own performing/rehearsing. While the publication of practice-led research by professional performers is increasing in number and diversity, there is little, if any, writing about introducing these concepts to undergraduate music performance students. This chapter discusses several factors in the process of engaging second year university music performance students in practice-led reflective essay writing. Students were asked to enhance this reflection through videoing or recording their performing. The chapter outlines the topics designed to capture reflective essay writing, what equipment students find most conducive to video their performing, and levels of reflection drawn into the students' observations and writing. Asking students to shape this writing into an essay format requires that they formalise their reflective, often reflexive, thinking.

Literature review

Because of the multi-dimensional nature of the practice-led essay task, the review of literature includes discussion on practice-led research, research into student essay writing about their arts practice, studies focused on using technology to video oneself to enable self-reflection and, finally, research into levels of reflective thinking.

The performative research paradigm (Haseman 2007) includes research about arts practice, research drawn from and/or informed by one's own arts practice, and arts practice itself. Terminology and definitions are still being shaped. For example, the term practice-based research can refer to research "which uses artistic practice as a means of interrogating a pre-determined or theoretical issue"

(Rubidge 2004: 5) or where the creative artefact "is the *basis* of the contribution to knowledge … Whilst the significance and context of the claims [of originality] are described in words, a full understanding can only be obtained with direct reference to those outcomes" (Candy 2006: 3). In the first definition, the arts practice is the way into investigating an issue, and in the second, the arts practice is the source of holistic enquiry. For Rubidge (2004), artistic practice is "research into artistic practice, through artistic practice" (6), no explanation in words required. The term practice-led research refers to both "the work of art as a form of research and to the creation of the work as generating research insights which might then be documented, theorised and generalised" for Smith and Dean (2009 7); whereas, practice-led research for Rubidge (2004) is where "research is initiated by an artistic hunch, intuition, or question, or an artistic or technical concern generated by the researcher's own practice which it has become important to pursue in order to continue that practice" (6). Gray (1996) notes a difference between research "initiated in practice, where questions, problems, challenges are identified and formed by the needs of practice and practitioners …[and where]… the research strategy is carried out through practice, using predominantly methodologies and specific methods familiar to us as practitioners" (quoted in Haseman 2007: 147). Here the former reflects Rubidge's practice-led research and the latter resonates with her practice-based definition. In this chapter, the term practice-led research will be used to refer to knowledge which emerges from the artistic practice itself.

Although several studies from various domains discuss the ways students write essays, very few have focused on music. Research from higher education investigates the ways that students write essays (Kember and Leung et al. 2000; Lea 2016; Lea and Street 1998), the ways that staff give feedback (Ivanič, Clark and Rimmershaw 2000; Lea and Street 2000), the ways in which students evaluate each other's work (Creme and Cowan 2005) and the different styles of collaborative essay writing adopted by music performance students (Blom 2014). Baynham (2000) describes three perspectives of academic writing – a skills-based approach, a text-based approach and a practice-based approach – with the third interested in how "students as novices are brought into the typical discursive practices of the discipline" (19). He notes nursing and engineering as new and emerging practice-based disciplines. We would add music, as asking students to engage in practice-led essay writing on their music performing brings novices into "typical discursive practices" of the music discipline.

The role of technology in music learning has been investigated by several music education researchers in recent years (Dunbar-Hall, Rowley, Brooks, Cotton and Lill 2015) and the ways that people engage with new technologies creates new challenges and possibilities for teaching (Rossing et al. 2012; Stowell and Dixon 2014) and significantly influences the "ways in which music education has developed" (Dunbar-Hall et al. 2015: 139). A study into portable computer use in elementary schools in Sweden found that the piece of technology students use the most in connection with music is a mobile phone (Erixon et al. 2012: 11). An investigation into the ways students used portable

computing devices in a second year Bachelor of Music performance unit found they used laptops, tablets, mobile phones and portable media players to record their performances at the end of semester, as a key part of the rehearsal process which "influenced the ways in which students created a performance" (McPhee 2016: 10), and to aid reflecting on their own performing. Video as an aid for reflection has been used in various domains (Hulsman and van der Vloodt 2015; Leijen et al. 2009) including music (Daniel 2001; Lynch 1998; Smythe 2000). This can include the evaluation of music students being assessed via a portfolio of recordings which includes reflective comment from student and teacher (Stowasser 1996). Daniel (2001) initiated a new method for assessment at James Cook University, in Australia, in which students were required to write a 300-word reflective critique of a video of their Concert Practice performance. The marking thus became twofold with "the student's reflective contribution playing an equal part (50 per cent) in the assessment of their performances" (219). Findings suggested that this process led to a greater level of student independence in assessing their own performances. For the students of our research, videoing/recording their performing was an opportunity to reflect and learn.

Pivotal to practice-led research, and the use of portable computing devices to record one's performing, is the ability to reflect on one's work. For example, use of eportfolios was found to result in the "growth, development and enrichment of teaching and learning" (Blom, Rowley, Bennett, Hitchcock and Dunbar-Hall 2014: 138) because of the eportfolio's ability to engage students in reflective writing. Several studies conducted by one or other of the present writers show how reflective thinking informs student performances and their writing about them. Asking students to assess their music performance peers (Blom and Poole 2004) engaged them in the assessment process but also in reflective thinking about their own performing. Reflective thinking was required by students taking part in a study into music performance as part of an experience improvising collaboratively in an inter-arts process with actors and dancers (Blom 2012). Here, music students saw how the thinking and experiences of theatre and dance peers could be usefully drawn into their own practice. It was also at the heart of research into discussion of student practice-led experience preparing and performing 1960s–70s improvisation/graphic scores (see Chapter 6 of this volume), and in talking about their experience in semi-autonomous ensembles (see Chapters 3 and 5). Turning the observation and thinking lens onto the student performer requires reflective and, at times, reflexive thinking through a practice-led approach.

Moon (1999) identifies five levels of reflective learning: noticing, making sense, making meaning, working with meaning, and transformative. Several key researchers whose work underpins the determining of different levels of reflective thinking have been drawn together in Kember and Leung et al.'s (2000) study. They wanted to determine whether students engaged in reflective thinking and, if so, to what extent, excluding any terms "specific to particular disciplines or professions" (393) because the literature from which their framework derived "referred to reflective thinking as a generic construct" (393). Four constructs were identified to measure – habitual action, understanding, reflection and critical

reflection. Habitual action is "that which has been learnt before and through frequent use becomes an activity that is performed automatically or with little conscious thought" (383), drawing on Schön's (1983) type of behaviour *knowing-in-action*. Understanding or comprehension is Mezirow's (1991) "thoughtful action" which "makes use of existing knowledge, without attempting to appraise that knowledge" (384). It also resonates with Bloom's (1979) definition of comprehension as "understanding without relating to other situations" (384). For Kember and Leung et al. (2000), these definitions captured the issue of students reaching an understanding of a concept but without "reflecting upon its significance in person or practical situations" (384). Drawing on the definitions of Dewey (1933), Mezirow (1991), Boud et al. (1985) and Boyd and Fales (1983), experience is "the touchstone for reflection" (Kember and Leung et al. 2000: 385); reflective learning examines and explores issues that arise from practice and can change conceptual perspective. Critical reflection is recognised by Dewey (1933) and Mezirow (1991) and requires "a critical review of presuppositions from conscious and unconscious prior learning and their consequences" (385). We merged Moon's (1999) five stages of reflection with Kember and Leung et al.'s (2000) four stages to form a template (Table 15.1) which

Table 15.1 A template for identifying levels of reflection

Stage 1: Noticing (Moon 1999) Habitual action (Kember and Leung et al. 2000)	The student has to register the topic, event or incident as being interesting or important in some way (Moon 1999: 141); That which has been learnt before and through frequent use becomes an activity that is performed automatically or with little conscious thought (Kember and Leung et al. 2000).
Stage 2: Making sense/making meaning (Moon 1999) Understanding (Kember and Leung et al. 2000)	The student thinks more about what they have noticed and tries to understand it better (Moon 1999: 142); The student starts to ask questions and to connect ideas together (Moon 1999: 143); Students reaching an understanding of a concept but without reflecting upon its significance in person or practical situations (Kember and Leung et al. 2000).
Stage 3: Working with meaning (Moon 1999) Reflection (Kember and Leung et al. 2000)	The student makes links with other ideas and events. They would probably refer to literature and other research. At this point, reflection on the learning is likely to be taking place (Moon 1999: 143); Reflective learning examining and exploring some issue which arises from practice and which changes conceptual perspective (Kember and Leung et al. 2000).
Stage 4: Transformative learning (Moon 1999) Critical reflection (Kember and Leung et al. 2000) Reflexive thinking and action (this study)	The student has reached the point where they can formulate new ideas on their own. They know what they would do if a similar situation arose in the future (Moon 1999: 146); A critical review of presuppositions from conscious and unconscious prior learning and their consequences (Kember and Leung et al. 2000).

allowed us to identify four stages of learning. These stages, ranging from surface learning to deep reflexive learning, describe the kinds of meaning that students are making from their reflections on their group rehearsing and performing.

Discussing practice-led essay writing

The essay topics outlined below were offered to students over several years of delivering the subject. Each set up a different practice-led paradigm for undergraduate music performance, each sought to encourage reflective and reflexive thinking, and required the video recording of an aspect of the students' performing for this reflection. The essay topic would be discussed in a two-hour lecture. The subject's learning guide required an essay length of 1500 words and offered an essay shape.

The topic "Performing Knowledge" asked students to consider what they have discovered by watching and hearing their own group performance experience and comparing this with the performance of a professional group with the same or very similar style/instrumentation (a live performance or one from You-Tube/Vimeo). Performance issues of stagecraft, communication and onstage persona were to be discussed plus any two other issues students felt were relevant and that they could choose from a list. A video of the student's group was required to reinforce and highlight comments with the advice that the footage of the two groups (edited to 30–40 seconds each) was not just for illustration but to be analysed and discussed to demonstrate the point being made in the essay.

Another topic focused on the rehearsal space as an active learning environment. Students were to discuss this in relation to their rehearsing for this unit, focusing on collaborative styles, group dynamics, communication and development of a group persona, and developing an original interpretation. They were asked to include at least one video clip of their group rehearsal to demonstrate their argument.

Setting students the task of comparing two interpretations of the same piece of music, one interpretation performed by the student, the other by another performer(s), was a third topic which required submitting a recording of their own performing. Brackett's (1995/2000) discussion of the reception of music through "the connection between musical sounds and the kinds of interpretations made by performers" (35) was offered to focus students' responses. Brackett's notion of musical sounds included time, pitch, vocal/instrumental timbre and production, recording production, shaping and structure, lyrics, orchestration/arrangement and style.

These three essay topics asked students to engage in practice-led research as performers in rehearsal and/or in performance, focusing on different aspects of the performance environment and process, and to analyse video/recording of their performing. Predominantly students used the iPads issued to them by the university in first year for this filming, but some used their smart phones and one a laptop, editing the footage using Windows Movie Maker or iVideo (McPhee 2016).

Excerpts from five student essays indicate the range of levels of reflection students were able to engage in while completing the practice-led writing task. Stage 1, where students registered an event as interesting or important, featured in two ways. Student 5, one of three pianists playing a piano trio (all at one piano) realised the act of videoing would need getting used to, for her own performing stress levels as well as for the best performance. This showed strong aspects of Stage 2 thinking, predicting the possible challenges of videoing oneself performing. Adopting a first-person approach, she also showed Stage 1 thinking in noticing physical hand movement issues related to the topography of six hands on one keyboard, and trying (again) to successfully reach the note B.

> An issue I had was that practice is much more laid back than performing, so to get us used to getting the piece performance perfect we set up our overhead recording device about a week earlier and went from beginning to end many times. This was helpful as we all felt pressure when sitting in front of an audience and when being recorded. I find nothing as difficult as performing, and a common occurrence while under pressure is to not consciously include a lot of the things you have practiced. For example, there were many instances in which I needed to occupy a space that Martin forgot to move his hand from when he wasn't using the space. A similar occurrence happened at 3:20 of the video where it was known to us that I needed to hit the note B right on the beat after Paul had to hit it, and even though we had practised it, when it came time to performing some cases like that were overlooked.
>
> (Student 5 – 'rehearsal space' essay topic)

Student 1 used deep descriptive writing to build a clear picture of what the video was showing in relation to the atmosphere and communication in a rock band. Several Stage 1 habitual actions and points were raised but with no further information and connections about these. The group appeared to play together regularly and know each other well, so insightful comments were made "backwards", thinking of what has happened in the past, rather than reflecting forwards. This is perhaps because of the intimate understanding of each other.

> The atmosphere was friendly and convivial, with humorous interchanges between members. The support framework within the group is evident – although wry jokes are often made at each other's expense, the members all acknowledge their respective strength and weaknesses. This is evident early in the video, as the group attempt a first-time run through the Lovin' Spoonful song, *Summer in the City* (sic). Although scheduled for a vocal performance by myself, it because apparent that both the range and the delivery would be more suited to Bill, so the vocal is offered to him instead (video time noted). Bill, although the nominated 'front man' due to his propensity for verbosity and witticisms, harbors insecurities about his vocal

and instrumental ability; he considers himself a 'non-musician' for his lack of formal music training, despite his resonant baritone range and spirited delivery driving much of the band's repertoire. After some encouragement, the band rehearsed the song several times, with Bill managing the nuanced, rapid vocal delivery by the last run-through.

<div align="right">(Student 1 – 'rehearsal process' essay topic)</div>

In a different essay, Student 1 showed Stage 3 thinking when he was able to make links with different levels of communication that occurred in his ensemble. By comparing the surface communication which he describes as being "jovial and offhand" with the communication under the surface in which members are intricately bound to each other, he showed reflective learning about the way his ensemble operates.

Brady relies on Waters and Long for entry cues, and both cue Brown for endings of songs, Long sets up tempos and leads count ins. Godbould is often on his own, due not only to his role as lead guitarist but also his background as a busker; he is used to backing only himself, and in a band role he routinely misses cues, which can lend performances a risky, on the edge quality, as other members compensate for mistakes. However, logic usually prevails and invariably the band all arrive at their appointed destination in the song, perhaps by way of an occasional detour in the arrangement.

<div align="right">(Student 1 – 'interpretation' essay topic)</div>

Student 4, playing as a member of a marimba ensemble, adopted a third-person observational stance to blend reflective thinking Stages 1 and 2 together. The Stage 1 thinking noticed discussion of structure, direction and style but also sought to make sense, through Stage 2 thinking, of why the playing was uniform, and in turn, to then see this explanation as perhaps a narrow-minded assumption.

On the 20th May, the group was videoed whilst working on a piece they were going to perform during their next assessment performance. During this rehearsal, there was discussion about the structure, direction and style of the piece, and what elements were going to be incorporated into the final piece from their improvisation (the video link is given). When viewing their performance, we can see a uniform structure of playing, which may come from the lack of understanding of the instrument's full scope of capabilities, which could be related to the group's limited experience with the instrument. However, this assumption can be seen as quite narrow minded. Their playing style could be attributed to the players' ability to bounce off each other, with the final product being a blend of each player's own preferred playing style. This is evident in the eye contact between the players, as well as the adjustments each musician makes when the melody or "feel"

of the pieces is changed by another musician. Through this experimenta-
tion, the players adjust their own sound to suit the changes being made.

Another factor that can be seen in this video is how the musician(s) distrib-
ute the playing, sharing the playing equally and taking turn(s) with impro-
visation to achieve a sound or "feel" they like whilst the rest of the band
follows or mirrors the person playing in addition to this, the group partakes
in "active listening." When the group has stopped playing, and someone
believes a change is needed or something doesn't fit in the performance,
the rest of the group follows their lead, and takes the change on board.

(Student 4 – 'rehearsal space' essay topic)

Student 3, playing in a folk group, noted how a professional folk group, on
YouTube, discussed their in-progress album, provided constructive criticism of
it and talked of the stress of the time limit of their recording schedule. He then
wrote of how his folk group had gone through a similar process in relation to
communication and constructive criticism, thereby engaging in Stage 2 thinking
whereby he was making sense, making meaning.

In our video we begin by playing 'I'm not coming back' by Husky. From
watching the video it can be seen that there is a lot of work needed, in
terms of cohesion and also remembering certain sections and how to play/
sing them. The original A [section] is helped with the eye contact between
us as a group. Some issues with timing arise towards the end, hence the
confusion. Afterwards we discuss the parts that need improving. We discuss
how the performance is going to sound with the instruments mic'ed up.
The rehearsal was a product of trial and error. Earlier in the semester, I was
initially going to be playing on the kit, but shortly we as a group decided
that it wasn't necessary, especially since the soft vocal struggled to be
heard. The cajon allowed for a softer tone, and easier communication
between group members. The group eye contact also helps with the flow
state, from looking at each other we focus on each other in relation to our-
selves, so we gain confidence as we play.

(Student 3 – 'rehearsal space' essay topic)

Student 2, performing their own arrangement of Steve Reich's *Clapping Music*
(1980) with three others in an iPad Orkestra tried to record the group. However,
this raised issues of stage movement (or lack of it) and persona and their visual
impact, accuracy and emotion, moving through noticing and habitual action,
understanding and making meaning to reflection which moves into Stage 4 trans-
formative learning through understanding of what might be required to record
a performance of the iPad Orkestra successfully – and this would take time.

Recording the iPad Orkestra performances never produced a take that could
be used for my subject … We gave neither a visual nor emotional

performance. The objective gravitated towards accuracy, although my accuracy deteriorated further with every increase in tempo. We briefly experimented with the visual aspect by trying the individual walk-on and clapping then no clapping and finally we agreed to sit 'robot-like' when not playing. This was visual representation of the minimalist nature of the piece. A substantial amount of time was spent on finding contrasting sounds, to reduce clashing when any two performers ended and started their section ... I have come to the conclusion that a recording of the iPad Orkestra to be more than simply an archival artefact, would need to be performed with professional accuracy or in some novel re-interpretation of the piece. Slowing down and months of rehearsal would have helped the former [as would] dressing-up, stage antics, adopting characters.

(Student 2 – 'performing knowledge' essay topic)

Conclusions

The practice-led essay tasks each required several steps – short relevant literature review, engagement with a way of reflecting on their own performing, and that of others, through use of a video/recording device, analysis of the resulting video/recording and discussion of the findings – all leading to reflective thinking. Several issues emerged.

The topics need to be designed to encourage deep levels of reflective learning, and reflexive thinking. This reflection may take place through video/sound recording and can change a student's performing. One student showed evidence of reflexivity, understanding the time required to create an electroacoustic performance which was accurate but also aurally and visually interesting. Leading students to this level of reflection may require prompts and questions to guide the levels of thinking.

Reflective thinking about a group of musicians you are very familiar with and rehearse with regularly may be different from reflective thinking about musicians you are playing with for one semester. Too much familiarity may result in an expectation of one member acting in a particular way, because they always have done so. This results in less critical thinking about how things could change for the better. Less familiarity with fellow performers, however, seemed to allow reflection which looked for connections and ways of making the sound and the performing stronger, and in doing so, to be more critically analytical. We also wonder whether adopting a third-person stance in practice-led essay writing, for students, may require a different perspective and thus some objectivity when analysing one's own performing.

When students are required to video or record their rehearsing and performing, there is a realisation that this technology can be valuable for evaluating these activities. Students choose the portable computer device they are most familiar with but may need to be taught how to analyse a video/recording of their own work or the performing of others choosing specific moments which illustrate the reflection about which they are writing.

The task of writing an essay about one's own performing requires students to engage with relevant literature, and to undertake video/recording analysis. This strengthens the practice-led research paradigm and helps move this writing about performing from reflection to practice-led research itself. This is important in a university which offers a doctoral program focused on arts practice.

References

Baynham, M. (2000). Academic writing in new and emergent discipline areas. In M. R. Lea and B. Stierer (Eds.), *Student writing in higher education: New contexts*, 17–31. Buckingham: The Society for Research into Higher Education/Open University Press.

Blom, D. (2012). Inside the collaborative inter-arts improvisatory process: Tertiary music students' perspectives. *Psychology of Music*, 40 (6), 720–737.

Blom, D. (2014). Developing collaborative creativity in university music performance students through paired essay writing. In P. Burnard (Ed.), *Developing creativities in higher music education – international perspectives and practices*, 99–114. Oxford, UK: Routledge.

Blom, D. and Poole, K. (2004). Peer assessment of tertiary music performance: Opportunities for understanding performance assessment and performing through experience and self-reflection. *British Journal of Music Education*, 21 (1), 111–125.

Blom, D., Rowley, J., Bennett, D., Hitchcock, M. and Dunbar-Hall, P. (2014). Knowledge sharing: Exploring institutional policy and educator practice through eportfolios in music and writing. *Electronic Journal of E-Learning*, 12 (2), 138–148.

Bloom, B. S. (1979). *Taxonomy of educational objectives, Book 1: Cognitive domain*. London: Longman.

Boud, D., Keogh, R. and Walker, D. (1985). *Reflection: Turning experience into learning*. London: Kogan Page.

Boyd, E. M. and Fales, A. W. (1983). Reflective learning: Key to learning from experience. *Journal of Humanistic Psychology*, 23 (2), 99–117.

Brackett, D. (1995/2000). *Interpreting popular music*. Berkeley, CA: University of California Press.

Candy, L. (2006). *Practice based research: A guide*. Sydney, Australia: Creative & Cognition Studios, University of Technology.

Creme, P. and Cowan, J. (2005). Peer assessment or peer engagement? Students as readers of their own work. *Learning and Teaching in the Social Sciences*, 2 (2), 99–120.

Daniel, R. (2001). Self-assessment in performance. *British Journal of Music Education*, 18 (3), 215–226.

Dewey, J. (1933). *How we think: A restatement of the relation of reflective thinking to the educative process*. Boston: D.C. Heath.

Dunbar-Hall, P., Rowley, J., Brooks, W., Cotton, H. and Lill, A. (2015). E-Portfolios in music and other performing arts education: History through a critique of literature. *Journal of Historical Research in Music Education*, 36 (2), 139–154.

Erixon, P. O., Marner, A., Scheid, M., Strandberg, T. and Örtengren, H. (2012). School subject paradigms and teaching practice in the screen culture: Art, music and mother tongue (Swedish) under pressure. *European Educational Research Journal*, 11 (2), 255–273.

Gray, C. (1996). *Inquiry through practice: Developing appropriate research strategies.* http://carolegray.net/Papers%20PDFs/ngnm.pdf, accessed 15 February, 2016.

Haseman, B. C. (2007). Rupture and recognition: Identifying the performative research paradigm. In E. Barrett and B. Bolt (Eds.), *Practice as research: Approaches to creative arts enquiry*, 147–157. United Kingdom, London: I.B. Tauris.

Hulsman, R. L. and van der Vloodt, J. (2015). Self-evaluation and peer-feedback of medical students'communication skills using a web-based video annotation system. Exploring content and specificity. *Patient Education and Counseling*, 98 (3), 536–563.

Ivanič, R., Clark, R. and Rimmershaw, R. (2000). What am I supposed to make of this? The messages conveyed to students by tutors' written comments. In M. R. Lea and B. Stierer (Eds.), *Student writing in higher education: New contexts*, 47–65. Buckingham: The Society for Research into Higher Education/Open University Press.

Kember, D. and Leung, D. Y. P. with Jones, A., Loke, A. Y., McKay, J., Sinclair, K., Tse, H., Webb, C., Wong, F. K. Y., Wong, M. and Yeung, E. (2000). Development of a questionnaire to measure the level of reflective thinking. *Assessment and Evaluation in Higher Education*, 25 (4), 381–395.

Lea, M. R. (2016). Academic literacies: Looking back in order to look forward. *Critical Studies in Teaching & Learning*, 4 (2), 88–101.

Lea, M. R. and Street, B. V. (1998). Student writing in higher education: An academic literacies approach. *Studies in Higher Education*, 23 (2), 157–172.

Lea, M. R. and Street, B. V. (2000). Student writing and staff feedback in higher education: An academic literacies approach. In M. R. Lea and B. Stierer (Eds.), *Student writing in higher education: New contexts*, 32–46. Buckingham: The Society for Research into Higher Education/Open University Press.

Leijen, A., Lam, I., Wildschut, L., Robert-Jan Simons, P. and Admiraal W. (2009). Streaming video to enhance students' reflection in dance education. *Computers & Education*, 52, 169–176.

Lynch, M. (1998). Getting it taped. *Music Teacher*, 77 (10), 40–41.

McPhee, E. (2016). Investigating students' use of portable computing devices in a music performance unit. In *ePortfolios Australia Forum 2016 Book of Papers*, 10–17. Brisbane: Queensland University of Technology.

Mezirow, J. (1991). *Transformative dimensions of adult learning.* San Francisco, CA: Jossey-Bass.

Moon, J. (1999). *Reflection in learning and professional development.* Abingdon, Oxon: Routledge Falmer.

Reich, S. (1980). *Clapping music.* London: Universal Edition.

Rossing, J. P., Miller, W. M., Cecil, A. K. and Stamper, S. E. (2012). iLearning: The future of higher education? Student perceptions on learning with mobile tablets. *Journal of the Scholarship of Teaching and Learning*, 12 (2), 1–26.

Rubidge, S. (2004). *Artists in the academy: Reflections on artistic practice as research.* http://ausdance.org.au/articles/details/artists-in-the-academy-reflections-on-artistic-practice-as-research, accessed 1st February, 2016.

Schön, D. A. (1983). *The reflective practitioner: How professionals think in action.* New York: Basic Books.

Smith, H. and Dean, M. (Eds.) (2009). *Practice-led research, research led practice in the creative arts.* Edinburgh, UK: Edinburgh University Press.

Smythe, R. (2000). Off the record. *Music Teacher*, 79 (2), 17.

Stowasser, H. M. (1996). Creative students need creative teachers. In B. Broadstock, N. Cumming, D. Erdonez-Grocke, C. Falk, R. McMillan, K. Murphy, S. Robinson and J. Stinson (Eds.), *Aflame with music: 100 years of music at the University of Melbourne*, 545–555. Melbourne, Victoria: University of Melbourne.

Stowell, D. and Dixon, S. (2014). Integration of informal music technologies in secondary school music lessons. *British Journal of Music Education*, 21 (1), 19–39.

Part IV

Student experiences 4

16 Curriculum as catalyst

From rock guitarist to transcendent improvisation

Adrian Barr and Diana Blom

Within the three-year period of an Australian undergraduate music degree, a music performance major student can explore a variety of musical interests. And when an honours fourth year plus doctoral study are added to the curriculum time-period, this seven-year development can intensify and become transformative. The chapter charts, through a collaborative autoethnographic approach undertaken in 2014, the journey of Adrian Barr from undergraduate rock guitarist to experimental improviser and arts administrator. This journey is different from, yet has many similarities with, that identified by Naomi Cooper (2016) in her journey from classical guitarist to choir director. Cooper's chapter in this book (see Chapter 9) examines one aspect of her current choral teaching. Both Barr and Cooper were influenced by specific musical performing experiences in high school or early university years, both used the university curriculum to explore a musical path and through honours and post-graduate study, emerged as professionals in their music-making and beyond. Barr's developmental journey draws together many of the topics discussed in this book. The chapter identifies key curriculum aspects and pedagogical strategies, plus experiences and personal thinking in his development from rock guitarist to improviser, scholar, teacher, parent and arts administrator.

Autoethnography has been described as "a qualitative research method that uses reflexive inquiry to investigate a subjective phenomenon providing a case study of the self" (Brown 2009–2012: 3). Writing about becoming an improviser, a subjective phenomenon, cannot always be undertaken in the spirit of musical improvisation, but, rather, takes time and careful consideration. And when the writing is autoethnographic, extra effort is required to ensure a logic and thoroughness in the reflective process. This was Barr's first comment on starting to document how he moved from being a first year university rock guitarist entering an undergraduate music degree to his current suite of musical and professional activities. And yet Bartleet (2013: 452) acknowledges autoethnography as an "improvisatory mode of inquiry ... [which] entails interplay between a self and others [which] is both intuitive and based on shared understandings of artistic language, contexts, and relationships".

In autoethnographic writing the story inevitably involves other people. By adopting a written "dialogue" approach, used by Määttänen and Westerlund

(2001: 262) in their discussion on music and *context* in Keith Swanwick's inter-culturalism, we deliberately combined and shared understandings of the "intraper-sonal and interpersonal" into a collaborative autoethnographic mode (Ellingson and Ellis 2008: 449). Blom offered questions, prompts and requests to Barr, draw-ing on her own experience having taught all the performance subjects in the music degree, and supervising Barr's doctorate. These aimed to encourage deeper investigation of his learning journey over the seven years of study.

While autoethnographic stories themselves are analytic (Ellis 2004), the writer can choose to "add another layer of analysis by stepping back from the text and theorizing about the story from a sociological, communicational, or other discip-linary perspective" (196). This is "thematic analysis" where an emphasis is placed "on the abstract analysis rather than the stories themselves" (196). Ander-son (2006) calls this approach "analytic autoethnography" and notes five key fea-tures including: "(1) complete member researcher (CMR) status, (2) analytic reflexivity, (3) narrative visibility of the researcher's self, (4) dialogue with informants beyond the self, and (5) commitment to theoretical analysis" (378). We have chosen to adopt this approach for the chapter but begin with the story itself, before analysing the influence of the curriculum and other factors.

Our study adds to a growing body of autoethnographic writing by musi-cians on aspects of their musical lives. Outlining "how he 'learnt' to be a primary school music teacher" (de Vries 2000: 165), de Vries wove together his feelings on graduating and starting to teach, the roles (positive and negative) of significant others, his reflective and reflexive thinking while teaching, plus key literature on the topics arising. This emphasis on how his "learning" took place engages with our study and Barr's "learning" to become an experimental popular music improviser. Bartleet (2009) wrote about her arts practice as a conductor combined with discussion of "how music can expand the creative possibilities of autoethnography" (713). She selected "particular crisis moments" in her story "which reveal broader issues about the culture and practice of music-making at large … condens-[ing] the year's work into a month and collaps[ing] stories into one another …" all the time editing, reflecting and seeking deeper meanings (728). Barr focused his narrative on particular moments, catalysts (not crises) which developed his interest and experience in this style of music improvisation. Knight (2009: 74) describes how "my relationship with … [the trumpet] and my feeling for music changed when I was introduced to the idea of improvisation". What follows is a detailed description of his memory of the occasion and the musical events that occurred over the next 30 years, with a broader discussion of issues arising from his chapter and related literature on these topics. This approach resonates strongly with Barr's curriculum journey. Using her own story to inform research into how other pianists become piano teachers, Huhtanen (2008) asked participants to draw their "life stream" (85) which was shaped into their "embedded life stories" (84). She found that "sometimes in order to get a full understanding of the present situation it means one has to understand first the impact of

Table 16.1 Time-periods to consider when shaping retrospective field notes

Before university – what music had you engaged with prior to studying undergraduate music? Family influences.

First year undergraduate.

Second and third year undergraduate.

Memories of free improvisation workshops; improvisation frames.

Other curriculum and pedagogical strategies plus experiences/influences from university during undergraduate study.

Other experiences/influences from outside UWS during undergraduate study.

Honours – fourth year.

Doctoral studies – three years.

After undergraduate study – career and family – influences and opportunities.

past experiences on the person concerned" (84). This idea of one's life stream and embedded life stories influenced the shape of our chapter.

Ellis (2004) agrees with Huhtanen about past experiences, and has suggested starting autoethnographic writing "by taking retrospective field notes on your life … includ[ing] all the details you can recall" (117). She finds it helpful to chronologically organise the main events to shape the narrative. Blom mapped out for Barr time-periods which could begin to structure his reflections (Table 16.1) and these shape the autobiographic writing below.

BLOM: Let's start with your music-making before you entered university

BARR: Where did it begin? I started playing acoustic guitar at about 13 years old, quite late compared to many people I know. After being exposed largely to commercial pop hits from the '90s through the home environment as a pre-teen, as a teenager I encountered music through friends at school, rather than in school music classes, that was increasingly electric guitar-driven. Distorted guitar revealed a wide sonic palette that traversed from the fragile to the dynamic, rich and percussive. I found that the many colours of distortion would influence the landscape of a piece as much as the vocal. A big stage of development for me was being introduced to the band, Tool. I enjoyed the big guitars and big rhythm section but the vocals had a certain sense of phrase, intrigue and a wider gamut of emotional expression, including humour. For me, Tool's songs moved lyrics from being superficial and somewhat separate from my own experience of the world, to becoming avenues for research into explorations of consciousness, the spiritual and the esoteric. The rhythms included the big rock beats I had come to know and love but unfolded and featured odd metres, polyrhythms and polymetrics which have since provided a great source of inspiration for my musical direction and approach to improvisation.

BLOM: What music where you playing and listening to in high school?

BARR: In high school, I started a band with friends. I was the guitarist, there was a bass player who shared similar interests to me and a drummer four years our junior. As a 17-year-old, this age difference was quite significant, more so than I feel it would be nowadays. I was committed to playing in any metre other than 4/4. We played Tool and Rage Against the Machine covers – without a vocalist. I suspect these formative years without a vocalist catalysed a focus on instrumental textures.

As a veterinarian and electrical engineer, my parents are strong advocates of maths and science. As such, I didn't study music for my Higher School Certificate exams – chemistry scaled better, you see. I had an aptitude for maths and science, and enjoyed identifying the relationships between physical and abstract processes. Also, I believe this ability to quickly recognise and analyse patterns informs my interest in polyrhythms and polymetrics.

BLOM: And first year undergraduate study?

BARR: I started at university in a Bachelor of Arts (Psychology) program, figuring I should study for a year and develop musically a bit longer, and finally take my practising seriously. Two subjects made me feel I was thrown in the deep end, Ecological Psychology and Improvisation. Ecological Psychology focused on an intuitive approach to psychology, analytical psychology and the esoteric, with the emphasis on experiences rather than the laboratory. And Improvisation! What initially seemed like a barrage of noise, a cacophony of mashups often without rhyme or reason was overwhelming. For the first couple of weeks, I had this sense of my brain being rewired. There were other subjects too. My study in psychology cultivated my interest in the esoteric, spiritual, consciousness and its connection to psychology, specifically to Jungian analytical and depth psychology. Popular Music (another undergraduate subject) emphasised that popular music wasn't merely flippant and trivial gratification but had significant social, spiritual and historical implications. I remember a performance assessment for Free Improvisation where my effects unit stopped working and I had to (quite aptly) go with whatever came. From this experience, I learnt that gestures could become significant and musical through attention and purpose.

BLOM: Tell me more about the link between the non-music and music subjects

BARR: I think completing first year of an arts/psychology degree with some music provided a strong platform for my subsequent trajectory into improvisation. I quickly made links between the Arts/Psychology subjects and the improvisation subjects. Having experienced them separately, I felt better prepared for when the BMus material combined the two. After being thrown in the deep end of the improvisatory music electives, I felt that I had more at my disposal – a greater understanding of my instrument and its sounds. Where other students were apprehensive and struggling, I came to the surface of first year BMus finding the water to be somewhat more comfortable.

BLOM: How did first year influences move into your second and third year under-graduate music study?

BARR: Second year at UWS[1], particularly the second half was a significant moment. I assembled a quartet of guitar, bass, drums and clarinet. We impro-vised. It started small, it grew, it was glorious. We built on ostinatos – each instrument coalesced and receded through each cycle, only to build and coalesce again – and there was a shared sense of trajectory and purpose. It was something none of us had done before to that extent and our group Space Project was born. We quickly started performing around Sydney events, art exhibitions, UWS Fine Art events in the Z Block car park, band competitions. We developed a strong understanding of one another, anticipating and work-ing with each other's ideas and a strong sense of collegiality. Some musical ideas resurfaced across each performance, but each show gave something new. We all had our musical seeds that we would produce at different times, in each performance they would grow differently.

BLOM: What other experiences and influences came from UWS during your undergraduate study?

BARR: Inspired by visual artist Alex Grey, I enjoyed creating video footage to accompany Space Project's live shows. The footage was a combination of abstract patterns and movement with elements of the natural world (fire, water, cloudscapes). The imagery drew from a number of traditions, includ-ing Tibetan Buddhism, Jungian psychology and esoteric psychology systems that grew from my previous study of ecological psychology.

The group The Monstrous Now, another UWS improvisation group[2] fea-turing guitar, bass, drums, saxophone and electronics, were a big influence. They were comfortable dwelling on a single idea for a long period of time, but avoiding the sense of "just playing along" through the active exploration of texture. For me musical outcomes were inevitably a product of their parts. The Monstrous Now featured a number of jazz musicians and delivered a jazz aesthetic in a similar vein to Miles Davis' *Bitches Brew*. Sensations for me were intoxicating grooves juxtaposed and providing a reference point for a range of textures. However, TMN didn't go as far into progressive rock ter-ritory as Space Project, so some of these sensations weren't as cathartic for me.

BLOM: And what about experiences and influences from outside UWS during undergraduate study? For example, you were required to review concerts within and outside the campus as part of the performance subjects, and you had six months as an exchange student in your third year.

BARR: I went and saw the Australian jazz group, The Necks, a lot. Since discover-ing their music in 2004 I have been captivated by the spirit of improvisation. The Necks thrived on a sense of ongoing tension without release and this contrasted with the inevitable rock music climax. They establish an important sense of phrase, both as a group and individually and this encouraged me to find potential in even the simplest of musical gestures – even the smallest and simplest phrase could develop irresistible momentum, often unfolding

separately, at least rhythmically, from one another. Each performer had a distinct sense of phrase, but the length and use of rubato meant the relationship between each phrase was always in flux. I still enjoyed big, loud, distorted progressive rock, but my musical interests took a turn to focus on patience, repetition and timbral development of simple ideas incorporated into the music of Space Project. It encouraged me to be more comfortable dwelling on and exploring simple ideas, changing expectations of when and how to reach a dynamic peak.

Another benefit was studying for a semester as an exchange student in Canada. That time in Vancouver opened my horizons into a different culture where art and music are often more tightly integrated into the social fabric in comparison to my own experience in Sydney. Vancouver featured a number of public art works, had a vibrant and active music scene. Looking back, I guess that is probably part of being a tourist, though.

BLOM: How do you feel your undergraduate degree formed a basis/grounding for honours and doctoral years?

BARR: My honours project was a large form improvisation guided by the Tibetan chakra system, recorded, mixed in 5.1 surround sound and synced to video footage that reflects the structure of the music and the system. The purpose of this was to create an immersive sonic and visual world. The structure of the work was based around the different states of consciousness around each chakra, and paved the way for my doctoral research, which looked at the transcendent experience in experimental popular music. So here was the influence of psychology, Eastern aesthetics, improvisation, and experimental rock music that was synthesised through the skills and experiences from my undergraduate studies.

The doctoral project gave me rare insight into the creative processes of inspirational musicians. People such as Lloyd Swanton, Chris Abrahams, Tony Buck (the three members of The Necks), Leo Abrahams and Jeff Martin were interviewed about their experiences of transcendence in their performance practice – how it may manifest, and its influence in their creative practice. This deepened my understanding of performance experiences and inevitably reflected back into my own creative practice. I taught into music performance subjects at UWS while a post-graduate and felt a strong influence from the thesis study into my educational practice. It also permeated my other passion, music technology. I found a synergy between transcendent experience and the new sonic worlds and new performance interfaces facilitated by technology. This has catalysed new knowledge in teaching, and developing digital music education resources for children in my current employment with Musica Viva, a professional performing arts organisation focused on classical music. Through the university, I had the opportunity to play solo as a background musician at various functions, usually involving people drinking, talking and standing around. This gave me great scope for improvisation within a certain frame.

Ironically, however, the further I went with my studies the more structured the music of Space Project became. In 2009 we released an EP of songs – largely instrumental progressive rock tracks (from 4–11 minutes long). At the time, we

had been through some line-up changes, with our bass player overseas for 12 months. Recently (as of 2014), our drummer and I have enjoyed playing casually, improvising, occasionally revisiting old pieces. With both of us having new children to contend with, we were content with this arrangement for the time being. A big thing I have learnt is that there isn't a reason to rush things! Transcendent experience isn't just about the highs and lows of a moment, it's an ongoing process that informs the bigger picture.

BLOM: Now you've graduated, how have influences come together in different aspects of your music-making?

BARR: I love it when things connect and coalesce, but I also love how things can act independently, where they take some time to reconcile with one another and ultimately reward you with new musical and personal understandings. Discovering new connections and relationships between instruments and people is fascinating. The Necks provided endless examples of this – whether it was how the resonance of the piano was penetrated by the wash of a cymbal that elicits a sequence of notes, or the incessant scrapes of a drum kit sit atop of a low, lazy bass drone that slowly wakes from a slumber – inspiring new musical and timbral possibilities in my own practice.

The music course at UWS strongly resonated with the experimental popular music subculture and I absorbed it all. Improvisation can be where I put myself out there, unrestrained (in my own understated, polite kind of way, I'm sure …) where I turn myself inside out and I explore and respond through the lens of the guitar. Other times, it's nonchalantly noodling. Improvisation isn't always about serious musical outcomes.

Artists speak of a sense of freedom and unbridled expression through improvisation to achieve a sense of transcendence. While this can certainly be the case, I believe there is another dimension – facilitating such experiences in your fellow musicians. I've learnt that through collaboration I can derive much from providing that platform for someone else – this is about being aware of your own musical presence in relation to others, taking pleasure in the moment from supporting another player.

These experiences – my life as an improvisational musician and as an academic teaching performance – have led to a deeper curiosity about how others involved with improvisation perceive similar shifts in consciousness, and how understanding these shifts can inform the practice of education and pedagogy. Focusing on transcendent experience in education has helped me with overcoming issues of low self-esteem through both personal and collaborative means, progressing towards a state of "flow", then further allowing for the deeper experience. This approach has the assumption of multiple levels of engagement with music performance and I feel it is very important to be able to identify and cultivate these experiences in teaching, and something I strive for in my own teaching. I share my own awareness and enthusiasm for transcendent experience and invite students to have such experiences of their own. From my post-graduate studies, I have made modest but satisfying achievements. I've noticed many autoethnographic writings have "happy endings",

where the protagonist overcomes obstacles to realise themselves as a successful and renowned artist. I feel my outcome is more modest than that. I like the fact that I can often identify transcendent experiences in myself and in others. And with a young daughter, the music I share with her is driven by improvisation. I really enjoy pick..ng up her ukulele and just making it up, sharing the spontaneity of music-making with her.

Conclusions

We found that in analysing Barr's autoethnographic thinking, several key aspects emerged in relation to curriculum design and pedagogical strategies. Some involved formal learning, embedded within the degree program for a purpose, some informal performance learning through peer learning and serendipitous events, and others focused on and influenced career choices.

Formally, the subjects in psychology, popular music and improvisation extended Barr's musical thinking, and a requirement to review concerts of different musical styles and genres, inside and outside the university (e.g. The Necks), added their musical influence. Technology study created a synergy between the transcendent experience and new electronic sound worlds. Taking the opportunity to go on an overseas exchange year during undergraduate study extended artistic and performative thinking and an honours year allowed several strands of thinking and influence to work together. Furthering this braiding of curriculum strands, a doctoral project brought together psychological and musical thinking with the interviewing of professional performers at the heart of the study allowing the sharing of stories of transcendent experiences with other musicians.

Taking an informal learning opportunity to establish an improvising group, Space Project, and perform gigs around and beyond the university campus, plus the musical influence of other university bands, enriched Barr's musical ear and musical experience. Having to perform when technology didn't work properly moved performing beyond student thinking to professional real-time problemsolving. The environment of Space Project encouraged an awareness of social understandings through the collaborative aspect of improvising, making new connections and relationships between people and instruments, and recognising the collegiality of playing outside gigs. Personally, the group helped overcome low self-esteem and taught him to take pleasure in the moment. Musical development occurred through exploration of new musical ideas while playing gigs, understanding improvisation can be serious as well as unrestrained and fun, and establishing a sense of flow while playing which leads to a deeper experience, a deeper curiosity and a shift in consciousness. Barr noticed how Space Project became more structured as university studies progressed through a doctoral exploration of transcendence.

As a casual teacher, teaching into the undergraduate music program engaged students with Barr's artistic practice and research knowledge, a career-focused activity which synergised his skills and has influenced his current career in a professional performing arts and education organisation.

The autoethnographic approach of the research drew out a range of personal experiences which supported the curriculum influence. Barr was aware of the value of his home musical environment and exposure to his parents' 1990s pop musical tastes, of starting his own band at high school and gaining an understanding of the musical and personal collaboration of a group, and discovering the electric guitar sound world, in particular distortion, through friends at high school. His parents were influential in encouraging analytical thinking which led to an identification and appreciation of polyrhythms, particularly in the music of the band Tool while at high school.

As Barr moved through the university curriculum, playing, research and performance teaching resulted in an awareness of multiple levels of engagement with music performance and an active engagement with the nexus between music practice, research, teaching and professional work – the ARTE nexus – A(rtistic) R(esearch) T(eaching) E(mployment) (Blom and Bennett 2017). Barr's keen understanding of the influences of his parents, plus playing music with his own children potentially extends the nexus in two directions, creating a generational passing of knowledge. This is knowledge shared with fellow performers, students, interviewees, family and career contacts through collaborative personal and musical understandings, curiosity, sensation and experimentation. Barr's journey is different from that of Choral Director and Researcher Naomi Cooper (Cooper 2016) yet has similar twists and turns over a similar time-period. For both, how the curriculum acted as a catalyst on their development as a performing and researching musician is revealed through autoethnographic writing. The curriculum at all levels drew influences together and focused them, through formal and informal learning, on deeper thinking, shifts in consciousness, and the ability to take pleasure in the moment with satisfying achievements. As Barr said, the music curriculum "imbued in me a commitment to experimentation, improvising and realising the best experience. This continues to be an asset in my work, education and music practice".

Notes

1 University of Western Sydney, now Western Sydney University.
2 The Monstrous Now included one of this book's authors, Brendan Smyly.

References

Anderson, L. (2006). Analytic autoethnography. *Journal of Contemporary Ethnography*, 35 (3), 73–395.

Bartleet, B. L. (2009). Behind the baton: Exploring autoethnographic writing in a musical context. *Journal of Contemporary Ethnography*, 38, 713–733.

Bartleet, B. L. (2013). Artful and embodied methods, modes of inquiry, and forms of representation. In *Handbook of Autoethnography*, (Eds.), Stacy Holman Jones, Tony E. Adams, Carolyn Ellis, 443–464. Walnut Creek, CA: Left Coast Press Inc.

Blom, D. and Bennett, D. (2017). The Artistic Research Teaching Employability Nexus: Extending the nexus to students. *NITRO (Non Traditional Research Outcomes)* August 17, 2017, https://nitro.edu.au/, accessed 1 August 2018.

Brown, J. E. (2009–2012). Examining creativity in collaborative music performance: Constraint and freedom – Strengthening learning and teaching leadership in the creative arts, *creatED 2009-2012 TEXT* Special issue 16, Barbara de la Harpe, Thembi Mason & Donna Lee Brien (Eds.).

Cooper, N. (2016). *Sing to me: Learning to direct community choirs*, PhD, Western Sydney University. http://researchdirect.westernsydney.edu.au/islandora/object/uws%3A41391, accessed 1 August 2018.

de Vries, P. (2000). Learning how to be a music teacher: An autobiographical case study. *Music Education Research*, 2, 165–179.

Ellingson, L. L. and Ellis, C. (2008). Autoethnography as constructionist project. In *Handbook of constructionist research*, (Eds.), James A. Holstein, Jaber F. Gubrium, 445–465. New York: The Guilford Press.

Ellis, C. (2004). *The ethnographic I – A methodological novel about autoethnography*. Walnut Creek, CA, USA: Altamira Press.

Huhtanen, K. (2008). Becoming a piano teacher: Biographies in a narrative perspective. In *The reflective musician in a global society*, (Eds.), D. Blom and I. Paek, The ISME Commission for the Education of the Professional Musician, International Society for Music Education: Nedlands, Western Australia, 78–89.

Knight, P. (2009). Creativity and improvisation – A journey into music. In *Music Authoethnographies – making authoethnography sing – making music personal*, (Eds.), Brydie-Leigh Bartleet and Carolyn Ellis, 73–84. Bowen Hills, Queensland: Australian Academic Press.

Määttänen, P. and Westerlund, H. (2001). Travel agency of musical meanings? Discussion on music and *context* in Keith Swanwick's interculturalism. *British Journal of Music Education*, 18 (3), 261–274.

Conclusion

17 Provocations for change in higher music education

Glen Carruthers

Introduction

The last two decades of the twentieth century were a time of reflection, reassessment, and re-purposing of two of the three disciplines that had long dominated music study in the Western academy – the mighty triumvirate of musicology (including history and theory), education and performance. Kerman's *Contemplating Music: Challenges to Musicology* appeared in 1985 (Kerman 1985) and, while inciting a vehement response from his colleagues worldwide, paved the way for the many reflective essays and books that followed it. The "new musicology" challenged the very precepts of the discipline. The ensuing dialogue caused the academy to reinvent the kinds of musicology courses and degrees it offers. In music education, much the same sort of revolution occurred. No study had more influence and generated more controversy than David Elliott's *Music Matters*, which appeared in 1995 (Elliott 1995). Ten years later, when Elliot edited *Praxial Music Education: Reflections and Dialogues* (Elliott 2005), the reverberations of his earlier study were evident everywhere.

In the midst of these upheavals in musicology and music education, the world of performance, within the classical arena, remained strangely untouched. The early performance movement, it is true, influenced a wide swathe of mainstream performers, but then the early music performers themselves became mainstream. But that's about it. The tenets of musical interpretation have been relatively static for a very long time. Yuja Wang does today what Van Cliburn did yesterday, which is not all that different from what Liszt did a century before that. On the other hand, as we've seen throughout this book, the pedagogy of performance has changed considerably over time.

The conservatory model

It wasn't all that long ago that studying music meant receiving lessons in at least one instrument and often in two throughout the course of an undergraduate degree. This model seemed inviolable. This approach to music pedagogy was reflected in the professoriate, which comprised specialists in various musical

sub-disciplines including performance. For studio instructors to teach something other than voice or an instrument was considered, by many, to be punitive. If a clarinet instructor lacked sufficient students, a course in aural skills or music history would be assigned to them. This was sufficient incentive for instructors to build up a studio of a size that precluded teaching anything else. In other words, one-to-one lessons were the right of all music students and instructors were hired who had the right, as long as there were sufficient student numbers, to teach nothing but private lessons and maybe a weekly masterclass.

The move, described throughout this book, from non-autonomous, to semi-autonomous, to autonomous learning environments has presented challenges to this instructional model, because the model is predicated on non-autonomous learning. With the realisation that performance is an aspect of the study of music, but is not fundamental to it, exploring new ways of teaching performance becomes only part of the curricular conundrum. Performance itself is being redefined and repositioned within curricula which, in many cases, means diminishing its importance.

Performance and its meanings

The opening chapter of this book is both symbolic and portentous: symbolic of a new relationship between musicians and machines perhaps, but of a new relationship between music study and performance certainly. The fact that there is no performer other than the piano in Annea Lockwood's "Piano Burning" advances a new relationship between performer, composer, instrument and audience. The performer prepares but doesn't participate in the performance and the instrument and the audience are tightly complicit. In music study, emphasis is placed on creation and performance, but the third participant in any performance, the audience, has been left largely to its own devices. If performance doesn't require a performer – or, rather, the instrument is the performer – it follows that emphasis should be placed on training audiences, not performers.

Students have been exploring music without the intervention of traditional performing media, like an instrument or voice, for a century now, and digital technologies, particularly among digital natives, are so pervasive that their role in music teaching, learning and dissemination cannot be overestimated. This is likely the single most significant step forward in the democratisation of music, and of music teaching and learning (more on this later), since the advent of the public concert.

This trend towards greater inclusivity is foreign to the legacy conservatory, to which only the most talented students, which often meant the most privileged – socially, economically and so forth – were admitted (see Carruthers 2016). Those days will be, within a generation or two, behind us. Acknowledging that a program of study can include students from disparate backgrounds with different levels of achievement is an important step, and granting credit with distinction or high distinction, on the basis of achievement to date seems wrong-headed (88). Accommodating and celebrating difference makes more sense than continuing to distinguish

between levels of performance that reflect, more often than not, advantage or disadvantage (in effect, social status) rather than capacity. This represents a substantive rethink of the notion of higher music education. That there are "no weaker and stronger students" (McPhee, Chapter 3 of the present volume) undermines the assumptions upon which conservatoires have been built.

The challenge

In recent years, various drivers including financial exigency and the efficient use of time, space, and human resources have undermined the teacher/student paradigm to the extent that private instruction is no longer the hub, but only one spoke of the music learning environment. It was never central to many music programs in popular music. One-to-one instruction, far from being a gold standard, is often a prohibitively expensive model based on unsubstantiated suppositions about how young people learn.

There is also a more insidious element at play. Someone holds the knowledge – and knowledge is power – and imparts it in weekly doses to a small coterie of hand-picked students. This goes on for three or four years with one cohort graduating and another one entering each year. Implicit in this, is the belief that hour-long (or longer) private lessons, spread over, say, 24 weeks a year, stretched over the length of a degree, with several hours of solo practice daily, and with summative juries at the end of each term, is the best and even only route to performance mastery.

Changes to this model elicited resistance from some teachers and that resistance was echoed by their students as well. All this began to unravel when there was sufficient empirical data to illustrate that there were highly effective alternatives to private instruction to hone and improve performance skills over time.

Alternatives to one-to-one instruction

The many alternatives to one-to-one instruction discussed in this book include group instruction, with an emphasis on informal learning practices, threading individual lessons with group classes and studio workshops, focussing on ensembles, self-directed studies, requiring or encouraging solo or group creative projects, adopting a buddy system that pairs more advanced students with less advanced students, negotiated curricula including formative peer assessments, peer-to-peer learning more generally, and experiential learning including internships, placements, co-ops and community-based capstone projects. There are countless other models out there and the kind of group learning that occurs in rock bands or community choirs, for example, can inform other modes of instructional delivery. Collaborative learning can occur in the context of, or in tandem with, more formal studies. Games and role-play rooted in active and experiential learning environments can add another dimension to formal study. Learning can be inadvertent, and reticent students in group learning situations can be helped to find their voices, literally and figuratively, by games and role-

play. A collateral benefit of many of these models is that students assume facilitation and leadership roles, critiquing one another and taking responsibility for each other's learning. This encourages a high level of student engagement.

Alternative modes of vocal or instrumental instruction facilitate the integration of music with visual media, theatre, dance and sound technology, as an aesthetic end in its own right or as an adjunct to film or games. Expanded practices gained currency among artists and audiences in the second half of the past century and provoked change in higher music education. In keeping with a transition in the industry from the arts in isolation to the arts hand-in-hand or hand-in-glove with one another, higher education had no choice except to adopt alternatives to isolationist private instruction. This makes abundant sense, since portfolio careers often comprise not only myriad musical endeavours, but also myriad juxtaposed or integrated art forms. Awareness of the visual, technological and other aspects of contemporary musical practice is beneficial even if one remains primarily a solo performer.

There has also been greater collaboration and cross-over between professional and amateur music-making. In fact, participatory music practices are reforming performative music practices. This is as it should be:

> Schools of Music should teach to a curriculum that understands that community music making and elite music practice are not antagonistic but are co-dependant. At the same time as wanting to increase the aesthetic ambition and technical competency of the wider community, they should also be producing graduates with the skills and desire to work in and for that community.
>
> (Tregear 2014: 57)

As Percy Grainger put it pointedly over a hundred years ago, "a world divided between musically abnormally underdeveloped amateurs and over-developed musical prigs" (Gillies and Pear 1994: 32) results when some individuals and communities are privileged with, and others are deprived of, musical agency. Community Music programs, which are becoming increasingly prevalent in higher education worldwide, seek to repair this unnatural rift between performative and participatory musics (Willingham and Carruthers 2018; Carruthers 2016).

Professional development

Curricular reform that requires blending performative and participatory musics, or that introduces new pedagogical methodologies, requires retraining instructors who otherwise remain entrenched in their ways. It may be more accurate to say "training" instructors rather than "retraining" them. Although some instructors may have taken pedagogy courses during their own undergraduate or graduate schooling, or undertaken professional upgrading in teaching, most university music students are taught by instructors who have little or no training in the art

or science of teaching. This should make training for new pedagogies easier, since there is no earlier training to undo, yet the overbearing weight of past practice makes true reform challenging. In some cases, since instructors were not trained in the first place, training them to teach in new ways is anathema to them. If I didn't need to be taught how to teach before, why should I need to be taught how to teach now? Analogous situations arise regarding online teaching or instructing large classes. Online courses can't be designed and taught as if they were occurring in real-time and courses with an enrolment of 100 or 200 can't be designed and taught in the same way as classes of 30 or 40. Similarly, effective group music pedagogy has little in common with studio teaching. Best practices for group teaching are now firmly established and this makes it easy to transfer professional development modules from one institution to another. As Annie Mitchell discusses in Chapters 7 and 8, institutional support for professional development is critical. She describes from her own experiences what worked, what didn't, and what was done to address what didn't. There are important lessons to be learned here.

Democratisation of music teaching and learning

The ubiquity of digital technologies must be added into the mix. Music creation by digital means has its own aesthetic dimension so that "music software [has become] an entertainment product in itself" (Stevenson, Chapter 5 of the present volume). As McLuhan would say, the medium has become the message. As also noted in Chapter 5, well-designed software is sufficiently intuitive for digital natives, and ideally for others as well, that instruction in the form of a manual or teacher is redundant. If performers and teachers can both be replaced, the conventional information flow from teacher to student about performance that once formed the foundation of higher music education makes no sense at all.

Technology subverts the traditional notion of performance by melding it with musical creation and instrument construction. The "concept of performativity is problematised by the notion of machine agency" (Stevenson, Chapter 11 of the present volume). I will state the obvious here – that musical instruments are machines – to underscore that performance has always incorporated suprahuman dimensions. What is new is that young musicians are now learning their craft without recourse to analogue instruments. This makes music learning much more widely available than ever before, since it's easier to use software than to play clarinet.

As performance moves out of its central position within the curriculum, creation can supplant re-creation as the nucleus of music education. This is analogous to the process by which visual art has always been taught. To become an artist a student learns to create visual artworks; to become a musician a student learns to create musical artworks, not only, and certainly not exclusively, to interpret artworks created by others.

A shift in emphasis from re-creation to creation requires revamping auditions and assessment practices. Auditions must include creative components and what is understood as success or excellence must be defined according to context. A successful performance of classical repertoire requires accuracy, fluency and an awareness of form and style, while a successful Community Music interaction is built on diversity and inclusion. As we encourage more genre-crossing, audition criteria and expectations in juries must continue to evolve. Assessment in juries, in classical repertoire, weighed the extent to which students could replicate accurately and convincingly what they deciphered from the written page. Aural skills, too, involved singing melodies from notation and notating rhythms, melodies and harmonies. If accuracy in transcribing one medium to another is no longer the litmus test of musicianship, then new ways of assessing student achievement are in order. Many ways of teaching and learning music minimise or eliminate the need to read music notation. I have written elsewhere on this topic, most recently in an article entitled "Marshall McLuhan and Higher Music Education" (2018), so I won't repeat myself here. I will note that experimental and non-idiomatic improvisatory musics, as well as aural learning, are moving from the periphery to the core of higher music education as disciplines like Community Music and Community Music Therapy find a foothold within the curriculum. This widening of the curricular palette has far-reaching implications.

Case study: Wilfrid Laurier University I

As music programs that eschewed private instruction became normalised, there occurred a systemic shift from lessons as a right, to lessons as a privilege, to lessons as an option. In the Community Music program at Wilfrid Laurier University, entering students receive a letter that reads:

> While the Bachelor of Music in Community Music (CM) does not require private studio lessons, there are options available to you with respect to individual instruction.

1. Standard CM curriculum
 There is more active music-making in the CM program than in our other programs. Much of the learning will occur in groups, in peer-to-peer situations, and in facilitated workshops.
2. Laurier conservatory private lessons
 Optional private lessons can be pursued through the Laurier Conservatory of Music. The Conservatory is operated by the Faculty of Music and offers private instruction on any instrument or voice in a wide range of genres. Lessons will not count towards academic credit, nor will the cost be included in your tuition.
3. For credit lesson application
 CM students may request consideration for lessons for credit by contacting our Academic Advisor, who will forward requests to our

Advisory Committee. If approved, you will be eligible to receive twenty-four thirty-minute lessons. These lessons will count towards academic credit and the cost will be included in your tuition.

In 2016 – the first year of the CM program at Laurier – ten of 36 entering students (28%) requested studio lessons for credit. Nine were approved. By contrast, in 2017 only one of 43 entering students (2%) requested studio lessons for credit. She was granted lessons. In 2018, two of 42 entering students (5%) requested lessons for credit. Both were granted lessons.

It is telling that once the benefits of group and other kinds of instruction became widely known, only one or two students annually request studio lessons for credit. This situation is not unique to Community Music. In the Music Therapy program at Laurier, students lobbied to have private lessons eliminated as a core requirement. The students recognised that the skills they needed as music therapists would not be acquired in private lessons, and that many hours of daily practice took time away from pursuits they deemed more relevant to their careers.

Case study: Wilfrid Laurier University II

As an alternative to one-to-one instruction, meeting regularly in groups has many benefits revealed in this book. Groups facilitate the sharing of information of general interest (e.g., about performance anxiety or injury prevention) and encourage interdisciplinarity (e.g., the business of music or music and technology).

At Laurier, facing significant budget cuts in 2014, I resolved to leave student instructional hours unchanged, but to introduce modes of delivery that would simultaneously achieve budget efficiencies and address ongoing student concerns. Students were requesting more emphasis on career preparedness, including small-business skills for studio teachers, and for workshops to address persistent concerns about musician health and well-being. Replacing some studio lessons with group meetings made programming in these areas possible and also helped the performance program contribute to the overall bottom line, since growth in class sizes had previously impacted only academic courses.

Beginning in 2014, Laurier adopted a tri-partite masterclass system, which grouped students in classes several times each term. The size of the group varied according to topic. Sometimes just violins would meet, another time strings, and another time all performance areas together. This worked very well in some areas and less well in others and adjustments were made annually to address emergent concerns.

For a variety of reasons – including a Grievance filed by the Faculty Association, which took exception to masterclasses taught by non-union members – the model was modified in 2017. At this time studio lessons were supplemented by masterclasses, workshops and general assemblies:

Studio Masterclasses – there are eight per 12-week term. Attendance at Masterclasses is mandatory and comprises part of the student's final grade.

Workshops include such topics as practice habits, self-care for musicians including mindfulness and meditation, improvisation, field trips and so forth. Attendance at Workshops is strongly encouraged but is not mandatory and does not comprise part of the student's final grade.

General Assemblies offer unique opportunities for learning outside regular coursework. Topics are based on suggestions from students and faculty. Presenters have specialised qualifications and may be internal or external to the Faculty of Music. Attendance at General Assemblies is strongly encouraged but is not mandatory and does not comprise part of the student's final grade.

This structure remains in place and, like all other aspects of curriculum, is fluid and subject to ongoing review.

Further research

The concept of an instrumental performer who is not a composer is a relatively new one, as is the idea of private instruction. In the Western world, even the most famous nineteenth century performers, like Liszt and Paganini, were also composers. As recently as the late nineteenth century many of the most famous teachers taught only in masterclass settings. Liszt is typical in this regard. During his later years in Weimar, he taught many fine pupils, but always did so with other pupils present playing one after the other. The idea of taking only one pupil for an hour, and closing the door to exclude all others, would have made no sense to him. It is only later, with the rapid growth in music schools in the past century, that private instruction became the default means of teaching performance skills. More research into these changes, from versatile composer-performers to discrete performers and composers, and from public instruction, in the form of masterclasses, to private instruction, in the form of one-to-one lessons, is necessary to help place these developments in historical context. By doing so we will begin to understand what is possible and appropriate in the current context.

Although the cloud of financial exigency may herald the demise of private instruction, creative teachers and administrators are already discovering the silver lining. Educators have long acknowledged that everyone learns differently and that a standardised approach to teaching and learning inevitably fails many students (in both senses – it fails to meet their needs, and the students receive failing grades). This is hardly a healthy premise on which to build best practices. Such well-known educators as John Dewey (1859–1952) in the United States and Paulo Freire (1921–1997) in Brazil built their philosophies on the knowledge that no two people learn the same way. What this means for one-to-one instruction is still unclear. Does private teaching remain exactly right for some students and exactly wrong for others? What are the predictors that tell us which students need what kind of approach? How do we tell the difference between one group and the other

without waiting for students to flounder? And what about the gradations between exclusively group or exclusively private lessons?

More research needs to be undertaken in these and related areas. Yes, students learn differently from one another, but how do we accommodate these differences in institutional settings? What about different approaches for different genres? How are these accommodated within curricula that aim to educate students broadly? Where are the points of intersection between different pedagogical approaches? What can the scholarship of teaching and learning tell us about these intersections that can inform performance instruction? There is much research currently underway that will help us to understand how general research findings can inform specifically the teaching of performance.

Conclusion

By shifting emphasis away from performance, away from studio instruction, and away from the rendering of fully notated scores, students are encouraged to think expansively about what they do and why they do it. The linking of performance with research, and research with performance, continues to be a burgeoning field of study to which Nicolas Cook (1999) and others have contributed importantly.

Writing about music is never easy and may, indeed, be like dancing about architecture (a comparison attributed to everyone from Frank Zappa and Laurie Anderson to Steve Martin and Martin Mull, although Elvis Costello is an especially strong contender). We don't dance much about architecture, at least not in the sense of the built environment, and there are notable exceptions (Budds 2016), but we talk about music incessantly. This is true even though performance has long been recognised as an apt and valid form of criticism without recourse to language.

Written reflections are most effective when they move beyond cataloguing performance preparation processes. Comparative studies foreground differences and similarities between interpretations (Carruthers 2008a). However, the scope and breadth of reflection can be much deeper than this. Even quite young performers can be encouraged to keep journals as an aid to processing their reflective (passive) and reflexive (active) learning practices. To this end, students at all levels could be helped to develop skills in practice-led reflective writing.

There is considerable value in autoethnography, too, and both Chapter 16 of this volume, and Michael Hannan's contribution to Bennett's *Life in the Real World* (2012), are good examples of reflections likely to be illuminating to intending and practicing professional musicians. It has always been left to students to identify connections between the various subjects they study. Autoethnography has shown this can be done effectively retrospectively.

All the shifts in thinking about music education discussed in the current chapter and earlier in this book can be linked to diversity, equity and inclusion. There are obvious power dynamics at play in the Western classical tradition – some musics are better than others, the conductor or teacher always

knows best, performative musics are higher quality than participatory musics – that now seem anachronistic, but also, to many students, instructors and administrators, downright dangerous. Accordingly, the social and pedagogical constructs that define the Western conservatory are falling by the wayside. The shift in power from teacher to student, from exclusivity to inclusivity, from homogeneity to diversity, have been bitter pills for some instructors born and bred in the conservatory tradition to swallow. The changes wrought in school music (Carruthers 2008b), and the teaching methodologies employed for decades in popular music and visual art, are undermining the conservatory model in ways that could not have been imagined a few decades ago. This book has posited an array of current alternatives to the conservatory model and there are undoubtedly many others that cannot yet be imagined.

References

Budds, D. (2016). How architecture is invigorating ballet. www.fastcompany.com/3065466/how-architecture-is-invigorating-ballet, accessed 23 December 2018.

Carruthers, G. (2008a). The pedagogy of interpretation. In M. Hannan (Ed.), *Educating musicians for a lifetime of learning. Proceedings of the 17th International Seminar of the Commission on the Education of the Professional Musician.* International Society for Music Education. https://www.isme.org/sites/default/files/documents/proceedings/2008%20CEPROM%20Proceedings.pdf, accessed 5 March 2020.

Carruthers, G. (2008b). Educating professional musicians: Lessons learned from school music. *International Journal of Music Education*, 26 (2), 127–135.

Carruthers, G. (2016). Community music and the curricular core. *Arts and Humanities in Higher Education*, 15 (3/4), www.artsandhumanities.org/journal/ahhe-special-issue-june-2016/, accessed 23 December 2018.

Carruthers, G. (2018). Marshall McLuhan and higher music education. *Intersections: Canadian Journal of Music*, 36 (2), 3–11.

Cook, N. (1999). Analysing performance, performing analysis. In N. Cook and M. Everist (Eds.), *Rethinking music*. Oxford: Oxford University Press, 239–261.

Elliott, D. J. (1995). *Music matters: A new philosophy of music education*. New York: Oxford University Press.

Elliott, D. J. (Ed.) (2005). *Praxial music education: Reflections and dialogues*. New York: Oxford University Press.

Gillies, M. and Pear, D. (Eds.) (1994). *The all-round man: Selected letters of Percy Grainger 1914–1961*. Oxford: Clarendon Press.

Hannan, M. (2012). Reflections on the protean music career. In D. Bennett (Ed.), *Life in the real world: How to make music graduates employable*. Champaign, IL: Common Ground Publishing, 125–143.

Kerman, J. (1985). *Contemplating music: Challenges to musicology*. Cambridge, MA: Oxford University Press.

Tregear, P. (2014). *Enlightenment or entitlement? Rethinking tertiary music education*. Strawberry Hills, NSW: Currency House.

Willingham, L. and Carruthers, G. (2018). Community music in higher education. In B. L. Bartleet and L. Higgins (Eds.), *Oxford handbook of community music*. Oxford: Oxford University Press, 595–616.

Index

Please note: Page numbers in *italics* refer to figures.